THE FOLD

publication supported by a grant from

The Community Foundation for Greater New Haven

as part of the **Urban Haven Project**

THE FOLD

From Your Body to the Cosmos

LAURA U. MARKS

Duke University Press *Durham and London* 2024

Printed in the United States of America on acid-free paper ∞
Project Editor: Bird Williams
Typeset in Warnock Pro by Westchester Publishing Services

Library of Congress Cataloging-in-Publication Data
Names: Marks, Laura U. [date] author.
Title: The fold : from your body to the cosmos / Laura U. Marks.
Description: Durham : Duke University Press, 2024. | Includes
bibliographical references and index.
Identifiers: LCCN 2023025124 (print)
LCCN 2023025125 (ebook)
ISBN 9781478030119 (paperback)
ISBN 9781478025856 (hardcover)
ISBN 9781478059127 (ebook)
Subjects: LCSH: Aesthetics—Philosophy. | Cosmology—Philosophy. |
Cosmology in art. | Philosophy. | Art and philosophy. | BISAC: PHILOSOPHY /
Aesthetics | SOCIAL SCIENCE / Media Studies
Classification: LCC BH39 . M3966 2024 (print)
LCC BH39 (ebook)
DDC 111/.85—dc23/eng/20231204
LC record available at https://lccn.loc.gov/2023025124
LC ebook record available at https://lccn.loc.gov/2023025125

Cover credit: Cover design by Courtney Leigh Richardson
based on Marks' diagram of six monads in an open cosmos.

CONTENTS

ACKNOWLEDGMENTS

I very much like the convention in academic writing that we refer to authors in the present tense, even if they are no longer living. It suggests that they are still alive in our reading and thinking about them, as our collective work continues. Every footnote in this book is an expression of thanks to other writers. And similarly, my gratitude to the many filmmakers and artists whose works inspired me is entwined in the prose I fashioned about them. My gratitude extends back hundreds of years, more than a thousand in one case, to thinkers and artists whose artifacts live in the present.

Next, I would like to acknowledge the hosts of the location where most of this writing has taken place. I've lived in Vancouver, a city built on the ancestral, unceded (that is, stolen), and continuously occupied lands of the Musqueam, Squamish, and Tsleil-Watuth peoples, for twenty years. I extend to my hosts profound gratitude for their stewardship of this land and apologies for being one of the settlers who despoil it. It's not much, but I have pledged to pay monthly rent to my Indigenous hosts through the Reciprocity Trusts program.

A book as many years in the making as this one enfolds countless friends and supporters. My gratitude is beyond measure for those who took the time to read some of these chapters, in what I think is a feminist spirit of demanding that a writer not hide her thoughts behind those of others but allow them to expand and thrive. Thanks to them, *The Fold* is more thoroughly unfolded. Yani Kong read the entire manuscript more than once, and thanks to her practiced eye for aptness of tone and clarity of argument the book became more cohesive and convincing. Denise Oleksijczuk, my wise friend and mentor, read many chapters and saved me from errors of judgment. William

Latham's intellectual and affective read of "The Information Fold" improved that difficult chapter greatly. Somayeh Khakshoor labored to assemble images for the book, and the beauty and wit of many of the film stills are thanks to her exquisite aesthetic judgment.

I'm grateful for the support of the Substantial Motion Research Network: my cofounder and dear friend Azadeh Emadi, and Steven Baris, Mansoor Behnam, Carol Bier, Çiğdem Borucu, Juan Castrillón, Millie Chen, Delinda Collier, Nina Czegledy, Siying Duan, Tarek Elhaik, Walid El Khachab, Nezih Erdoğan, Paul Goodfellow, Jan Hendrickse, Farshid Kazemi, Jessika Kenney, Lynn Marie Kirby, Mriganka Madhukaillya, Minoo Moallem, Katya Nosyreva, J. R. Osborn, Sheila Petty, Radek Przedpełski, Kalpana Subramanian, Yvan Tina, and others in our erstwhile secret society who have supported my research. Thank you for thinking about a folded cosmos with me, and thanks for all the cosmological diagrams! Warm thanks to my friends at the Small File Media Festival: Joey Malbon, Sophia Biedka, Radek Przedpełski, Faune Ybarra, and Mena El Shazly, and to my colleagues in Tackling the Carbon Footprint of Streaming Media, Stephen Makonin, Alejandro Rodriguez Silva, and Radek Przedpełski again.

The kindness and intellectual inspiration of many other friends have buoyed me. Deep gratitude to my much-grieved departed friends David Pendleton and Patricia R. Zimmermann. Warm thanks to the wonderful Tom Conley, translator of Deleuze's The Fold. Thanks to my friends Vatche Boulghourjian, Seán Cubitt, Robin Curtis, Hamid Dabashi, Janine Debanné, Mike Hoolboom, Germaine Koh, Ardele Lister, Jem Noble, Patricia Pisters, Uno Kuniichi, Grahame Weinbren, and Grace Wen. I could not wish for a more stimulating and supportive environment to work in than the School for the Contemporary Arts at Simon Fraser University. Thanks to all my dear colleagues! Gratitude to the many international colleagues who have hosted my talks and workshops over the years and given me salubrious feedback on enfolding-unfolding aesthetics, affective analysis, and soul-assemblages.

I am grateful to students who allowed me to test ideas of the folded cosmos in courses at Simon Fraser University and Harvard, and to all the students who have been guinea pigs for frustrating, yet usually rewarding, exercises in embodied criticism and affective analysis. Many people who have studied with me grew the seeds I handed them into lush and hardy plants. Over the years of this writing my wonderful graduate students, both artists and scholars, have taught me to read, think, and perceive in new ways, including Asmaa Al-Issa, Edith Artner, Mozhdeh Bashirian, Dave Biddle, Elysia Bourne, Shauna-Kaye Brown, Christophe Devos, Maria Federova, Tyler Fox, Niusha

Hatefinia, Özgün Eylül İşcen, Sharon Kahanoff, Somayeh Khakshoor, Keisha Knight, Yani Kong, Jeff Langille, George Liu, Joni Low, Zaki Rezwan, Emily Rosamond, Jacky Sawatzky, Juan Manuel Sepúlveda Martinez, Natalie Sorenson, Donna Szöke, Israt Taslim, Daisy Thompson, Casey Wei, and Carina Xu.

I am grateful to the Social Sciences and Humanities Research Council of Canada and the Grant Strate professorship at Simon Fraser University for supporting my research.

At Duke University Press I am deeply grateful to Ken Wissoker and Ryan Kendall for their enthusiasm for *The Fold* and their support at every step, as well as to the sure guidance of Bird Williams and the caring scrutiny of copy editor Gwen Colvin. Thanks to Matthew MacLellan for the well-crafted index.

I could not be more fortunate to have been born to parents with inexhaustibly creative and curious minds. It was William B. Marks who turned me on to Bohm's physics and helped me understand it. Our wonderful conversations traverse from the quantum field to how it is that a One can be also Many. Anne P. Foerster's lifelong devotion to discovering how the brain heals itself surely is behind my own vitalism. The neurons that she has found growing and detouring around obstacles inspired my passion for the vitalist aesthetics of the abstract line.

Finally, I thank Richard Coccia, my beloved spouse, who supported this writing in more ways than I can enumerate, including reviewing the manuscript with a readerly eye and, as my cinephilic secret weapon, effortlessly identifying how the movies I love are doing what they do.

LIVING IN A FOLDED COSMOS

In the produce aisle in a Veran supermarket in São Paulo, we hear Francisca Da Silva Gomes before we see her, on the other side of a heaping display of fava beans and fresh corn. She is singing a beautiful song that beseeches the moon to descend and comfort a heartbroken lover. "Dear white moon, please come down from the sky. Please pull this bitterness out of my chest." The camera moves around to discover Francisca, cheerfully singing while mopping the floor. "Give me the moonlight of your compassion," she lilts in her sweet strong voice. "So many times you would reveal yourself to me, up there in the sky, shining in the calm and starry night." In Francisca's mop bucket, a constellation of bubbles trembles and migrates into new formations, each differently reflecting her silhouette and the lights above. A thousand tiny moons, descended.

This is one of many scenes in *Meu Querido Supermercado* (My Darling Supermarket) by Tali Yankelevich (Brazil, 2019) that I love because it finds the vast in the minuscule, the singular in the apparently uniform, and souls everywhere. The supermarket is a cosmos, packed with microcosms. Cinematographer Gustavo Almeida's camera sneaks up like a lover, intensely curious

FIGURE 1.1. Still by Tali Yankelevich from *Meu Querido Supermercado* (São Paulo, Brazil, 2019)

about everything. A well-worn mallet in the hands of an unseen worker taps the floor tiles into place. A generous coat of paint rolls onto a wall in spiky tracks. Water drips from the stack of baking pans that Chico (Ivanildo Saraiva de Freitas), a baker, is washing, and soapy water drifts into shapes on the orange tiles. The structure of muscle and fat in animal flesh reveals itself under the sharp-bladed machine of Rodrigo de Freitas at the meat counter. The foot of store detective Solineide Simões dos Santos, in a shiny black ballet flat, pivots uncomfortably on the plastic base of her chair.

Yankelevich selects all these elements to cherish in their singularity. In so doing she also draws out the folds by which they are connected to one another. Chamber music composed for the film by André de Cillo and Alex Buck enhances the feeling that what we see is just the tip of something imperceptible.

Long tracking shots reveal the gleaming rows of the white supermarket and high-ceilinged stockroom, clean and rectilinear. But there is no uniformity here. Each acoustic tile, we see, is hand-installed by someone and conceals a unique tangle of cables. Every one of the buns Chico bakes turns out a little different, he complains. Stocking the shelves with identical packages, a worker gives each one a little pat so it sits properly. When Francisca sings, "When I die I want a yellow ribbon with her name on it," the movie cuts to a stack of yellow plastic Veran bags that suddenly seem full of emotion.

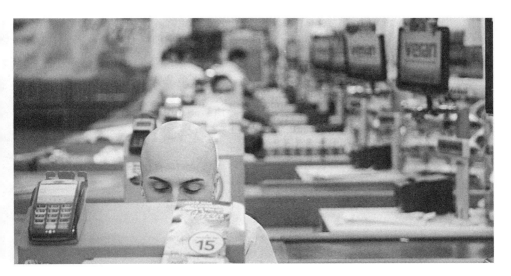

FIGURE 1.2.

The Veran workers get bored. They collapse into sleep in the break room. They share their problems: loneliness, jealousy, depression, anxiety. They also share their cosmologies. Between serving customers at the deli counter, Rodrigo explains that physics' double-slit experiment—in which the particles separate when not observed but collapse when an observer is present—demonstrates that "every particle that exists in the universe has consciousness. Because when there is a camera or someone watching, it [the particle] takes on the behavior of things from our material world, our dimension. But if no one is watching, there are infinite possibilities." As he speaks you can hear a trembling, warbling sound from a clarinet as the camera glides over the aisles to look up at the fluorescent lights. Solineide confesses that she doesn't believe in an afterlife, and her greatest fear is the unknown. Immediately after, Santo Decio Bitaffa, operating the squeaking forklift in the stockroom, explains his faith warmly: God wouldn't have made us intelligent only to live for sixty to seventy years. We cut to Chico making breadcrumbs from the day's unbought bread. As the golden crumbs course undifferentiated down the chute, the music holds somber and breath-like chords. When we die, those crumbs seem to ask, do our souls remain, or do we become distributed in the universe as matter?

Solineide says she loves detective movies and crime shows, "suspense with some kind of investigation." Her multiple screens capture slices of moving life in blurry detail on the supermarket floor. She's on the radio with Daniel.

"Two suspects near the condensed milk. They are carrying an unsealed white bag. Dessert aisle. . . ." Daniel finally tracks them to the battery aisle. "But I don't think they wanted batteries or razors," he tells Solineide. "They actually wanted to get some condoms." The woman was shy, he explains, so she lingered while "He went away, got some Coke, and came back for the condoms, and he hid them behind the Coke can." It is the tenderest of surveillances.

Solineide loves the adrenaline rush of her job, ever since she actually caught a thief, she says. But we can also sense that she craves the way events reveal themselves to the camera: when she talks on the phone with her kids about things that happen to them, she says, she wishes she had a camera to see "how things actually unfolded and what they felt like."

The supermarket employees consume a lot of media, but each receives them differently: *Meu Querido Supermercado* is not worried that media crush people's individuality. Santo loves to build imaginary cities in *Megapolis* and *Little Big City 2*. Standing at a freezer in the dairy section, Chico and his colleague Caio have a vigorous and drawn-out argument about whether the anime character Goku is a good role model. "If we lived in a multiverse," persists Chico, "would you want to be in our multiverse or Goku's?" Ours, says Caio; "Ours is less likely to be destroyed." They laugh. A very young-looking, bespectacled stocker slowly moves around the store, returning unwanted items to the shelves, and the music dawdles along with her. On her break, she scrolls through her phone: a pregnant friend, lots of pictures of the baby. Then (the quartet accelerates joyously) we get to see a stunning photo of herself in a blue tutu and pointe shoes.

In voice-over, Rodrigo explains that he's read *1984*, and this world is much more surveillant than Orwell imagined. "We're being watched by Facebook and WhatsApp. But that doesn't apply to me. Why would they waste time on me? So, I can say whatever I want, because they don't care." He's confident that he lives under the radar: a joke by the film, because we are seeing him through the surveillance camera's watchful eye. A shot of hamburger meat extruding from a meat grinder adds a sardonic tone to Rodrigo's observations on life in the matrix. "People think they're free, but everyone is bound by something."

Toward the end of the film, over gentle tracking shots of the bright clean store, melancholy sounds from a piano play. Over a big crack in the concrete floor of the stockroom we hear Santo say, "We are eternal, for better or worse. This eternity is a mystery from God, and mystery is mystery." Cut to the slogan on the LED checkout, "Weighing Life for over a Hundred Years." Rodrigo explains a lesson he heard from a rabbi on YouTube. "The Tree of

Life represents God's emanations in this world. The *malkuth* is the lowest part, where we are." From up high the camera pans down, through those tangled cables behind the acoustic tiles, into the store, to show the feet of shoppers queuing, mired in the world of matter.

The checkout's red QR scanner trembles, the piano arpeggiates higher. Through the surveillance camera we see a ninja prowling the aisles. An orange butterfly alights on the surveillance camera, flies off. Sounds of metal and wood resonate as we hear Chico explaining why people wear the ninja mask. "In many mangas I've read, the mask preserves mystery of the character; nobody knows what is in your heart." All this time in the film Chico has been half-disguised by the perky kerchief all the service workers wear, but now, for a beautiful moment, we get to see Chico's whole face, small at the bottom of the screen, for a moment before he masks up.

Then before our eyes, in luminous darkness, the supermarket aisles drift and multiply, the white transformed into stratospheric blues. The music enhances a feeling of magic, with sparkling piano and breathy sounds of the shakuhachi; yearning, slightly discordant chords. The aisles seem to be floating, rotating in space, their colors jewel-like. The supermarket has become, not a matrix, but a multiverse, as in Rodrigo's studies, in which every being has its own world that somehow intersects everyone else's. Every being in the film is individuated, precious, and ready to meet everything else.

This is a book of practical philosophy about living in a folded cosmos. If we think of our cosmos as a single surface that is infinitely folded, we can understand it as a textured continuity, replete with potential points of contact with itself, across its many folds.[1] Because it begins with the body and the senses, this philosophy is an aesthetics, which I call "enfolding-unfolding aesthetics." It proposes a theory of mediation as contact and connection and offers a set of embodied methods for detecting cosmic connections. You can picture these methods as reaching into an event and pulling, hand over hand, unfolding the connections implicit in it. As I will explain, these folds are composed of everything and everyone: all of us living beings, from humans to particles, sandwiches to stars, thoughts and images too, in the present, the past, and the future. Skeins of beings in ever-shifting assemblages. Introducing the concept of the soul-assemblage, the book suggests ways to strengthen connections to the cosmos.

In the cosmology I propose here, every entity mediates across folds. Mediation is necessary; otherwise we would all be one thing. Media facilitate these connections, adding their own folds. As my friend Walid El Khachab

writes, media do not collapse distances but eroticize them.[2] The distances between entities translate to a longing; a desire to unfold.

The audiovisual media of our time differ from other artifacts only in that they are more transparent about the mediating they do. You can reach into the most compressed thing—a rock, an emoji, a preserved lock of hair, a frame of film, a name on a black Zoom screen—to unfold its story. From world to medium to us, unfolding expands and contracts the connective tissue like an accordion. Perceiver, perceived, and the media that connect them all fold together, animated by the tension of constant pushing and pulling.

With enfolding-unfolding aesthetics, a receiver can get a sense of where things come from: the image's material, historical, and cosmic sources. Images, which I define as all perceptibles, cycle through time and space to reach our body and our senses. As they cycle, they collect noise, interference, augmentation, and diminution. In the method of enfolding-unfolding aesthetics, by comparing what you perceive with the interface that shaped it, you can get a sense of where it has come from and what it has passed through. A little part of the universe finally reaches your body! The sensation when the image connects to its source through your body is the feeling or affect of unfolding. It can feel like shock, joy, sorrow, or many other things. It is precious data.

Aesthetics privileges the analysis of perceptibles, what appears to the senses. But as you can see, the senses are portals to what cannot be sensed yet. When we think about where the things we perceive come from, I want us to think about the virtual, the infinite, and also something so physically real that it is utterly unknowable to us. The senses are constantly actualizing latent bits of the cosmos. Most philosophy privileges what actually exists, and who can blame it? However, as Gilles Deleuze, often with Félix Guattari, emphasized again and again, using many different approaches, the relevant category is not Being—what exists—but Becoming—what changes. Enfolding-unfolding aesthetics helps us to be alert to the seemingly nonexistent as it rolls into being.

With its attention to how things unfold from chaos or the infinite, enfolding-unfolding aesthetics can be used to analyze not only images but any phenomenon, including concepts. The method extends to historical and cultural research, and it can be used to unfold many kinds of nodes in many disciplines. Because the arts reflect, model, and reimagine the cosmos, they are especially fruitful media for doing enfolding-unfolding aesthetics. Movies and artworks enter as my thinking and feeling companions.

A simple cosmology orients the practical philosophy I set out in this book: a model of the folded cosmos. This model is easy to visualize as a multidimensional folded fabric, which you can picture unfolding and enfolding under various pressures. Similarly, we can conceive of the plane of immanence as a manifold existing in space and time, from which virtualities, folding around singular points, condense into actualities.

In the cosmology I sketch in this book, the cosmos can be considered the infinite. It is all of reality, where reality contains what exists and what appears not to exist, the actual and the virtual.[3] It is a unity of constant differentiation, an expressive plane of immanence, a roiling, ever-changing, interfolded, historical whole. Cosmology is a dated term, suggesting medieval notions of an orderly and bounded universe, often pictured as a series of concentric circles. I like the modest confidence of those drawings. And like the medieval understanding of the cosmos, "my" cosmology understands that things on earth—plants, rocks, weather, animals, people, and the things people make—are connected to the Sun and the stars. Just our cosmos! The term also resonates with vital cosmologies in a great many cultural traditions, such as Hindu, Taoist, Haida, and Dogon cosmologies. Cosmology's modern revival includes thinkers such as Alfred North Whitehead who dare to try to conceive of the open chaos, in which we live, as a whole. As in Whitehead's cosmology, in the one I propose here, every entity more or less creatively synthesizes data from its surroundings and contributes to the cosmos in turn.

In "my" cosmology, then, the cosmos is a plenum, continuous, completely full, densely folded, populated by entities that are centers of experience. It is composed of experience; for everything is experienced by something at some time. Matter is composed of experience—as Charles Sanders Peirce said, matter is "crystallized habit." As I will propose, every entity is an organism, which includes, and experiences, the ever-changing cosmos from its unique point of view. In time, the cosmos becomes more crowded, more intense, as experiences pile up.

Experiences that are not yours, not now, are virtual to you, but they are, or have been, actual to something else at some time. These virtualities are enfolded in the cosmos: enfolded, that is, according to a given point of view. So, what's unfolded, or actual, to one point of view may be unfolded to another. Enfolding-unfolding aesthetics help to unfold some of the experience of others, even those distant in space and time.

In this folded cosmos, all of us entities are expressions of a common wave. Literally, we're all in this together. Like corks floating on the ocean, we appear separate, but we all express the action of the underlying waves that move us. Theoretical physicist David Bohm's concept of the implicate order first expressed this understanding of an invisible commonality to me. Bohm uses the term *explicate*, or *unfolded*, for that which is apparent in a given system, and *implicate*, or *enfolded*, for that which is latent in the same system. Bohm's minority strain of quantum physics holds that the universe can be described as a wave equation. According to the many-body wave function, as we will see, every particle is affected by a quantum potential that arises from the wave function of the entire universe.[4] This understanding that a single point can imply a history of relationships is what set me on the path of enfolding-unfolding aesthetics.

Now and then we can get a macroscale feeling of the synchrony Bohm describes at the quantum level. The movements of a crowd in a public square at first seem random but, over time, describe common patterns. When we're dancing in a nightclub, the strobe lights cast us all as a single pulse of motion. In video, slow motion and datamoshing unify the movements of all the figures, as though they were being stirred with a big spoon, replacing the purposiveness of movement with a common temporality in which every entity is suspended.

I discovered that Bohm's concept of the implicate order resonates deeply with the calculus-informed cosmology of Gottfried Wilhelm Leibniz from two centuries earlier. For Leibniz too, a single equation describes the unique situation of each point along it, and in turn each point expresses the equation. An infinitesimal point is not a fixed value but the expression of a function. (You can see this by graphing a simple conic section, such as the vaselike shape of $y = x^2$, and drawing some tangents to points on the curve. Because they share the same equation, each point is singular and yet implies all the others and the whole.) Thus, each point is a unique point of view on the whole that includes, and is connected to, all the others. "This *interconnection*, or this accommodation of all created things to each other and of each to all the rest, means that each simple substance has relations which express all the others, and that consequently it is a perpetual living mirror of the universe."[5] The point in infinitesimal calculus would become Leibniz's monad, which expresses the infinite in the form $1/\infty$.

In short, what appear to be points are not separate entities but folds. Unfolded, they express relations with a larger surface, and ultimately with the entire cosmos. Points are the actual peaks of an enfolded virtual structure.[6]

The cosmic process has two poles. At one pole, everything enfolds into a teeming unity. At the other pole, everything is constantly unfolding, each according to its own manner.[7]

Exploring deeper into the history of these conceptions of the folded cosmos implicit in a point, I found their richest origin in the expansion of Greek Neoplatonism by early modern Islamic thinkers, in which the universe comes into being by unfolding from a One and the smallest entity is a microcosmic reflection of the cosmos. Islamic Neoplatonism's ways of conceiving of the universe as an interconnected multitude that emanates from an infinite One profoundly informed early modern European philosophy. This movement was itself informed by a great many traditions of thought, including the Greek Neoplatonists, Aristotle, the Qur'an, Hindu thought, and the sciences of the time. It echoes into contemporary thought, for example in Deleuze's concept of the univocity of being.[8] Elsewhere, in the company of historians of philosophy, I unfold the history of these conceptions of the folded cosmos into contemporary philosophy.[9]

Each of the thinkers that interest me, historical and contemporary, models a process cosmology. Each characterizes the cosmos (world, universe, nature, being) as an interconnected whole, and for most of them the smallest entities in some way embody the whole. They include Yaqūb ibn Ishāq al-Kindī (801–873), Avicenna, or Abu 'Ali al-Husayn Ibn Sīnā (980–1037), Ṣadr al-Dīn Muhammad al-Shīrāzī (1571–1640), Baruch Spinoza (1632–1677), and Leibniz (1646–1716). These historical cosmic models tend to be transcendental and deterministic; they need quite a bit of adjustment to describe a wholeness that is open to the singularity and unpredictability of life. Modern and contemporary thinkers who model a process cosmology include Henri Bergson, Charles Sanders Peirce, Whitehead, Gilbert Simondon, Bohm, Deleuze, and Édouard Glissant. Most of these thinkers focus on human beings, but importantly to me, all their cosmologies can be tinkered with to accommodate the experience of nonhuman and non-organic entities. They differ in the degree of freedom they assign to entities, and in the relative importance they ascribe to the whole, but these differences too can be accommodated without doing violence to the functionality of the cosmic models within which they are embedded. I acknowledge that many Indigenous cosmologies, as well as cosmologies in other world traditions, resonate with the cosmic models I consider in this book.

Unlike most of the thinkers I've mentioned, I do not argue that the cosmos is progressing or improving, and I am more partial to the cosmologies that privilege the creativity of the parts over the unity of the whole. I am on

the fence as to the eternity of this whole or of the entities within it; that's why I say it's "just a cosmology." More than some of these thinkers, my cosmology includes humanmade entities, which allows for more analysis of culture and of power relations. Thus, I engage extensively with contemporary thinkers of culture and technology, especially in the age of information capitalism.

Yet the sad fact is that in our cosmos, the infinite is getting smaller, or at least not enlarging at the same rate, because of the damage humans have done to it. Now the cosmos we live in is shrinking in its capacity to carry us. Our cosmos, "just our cosmos," the planet and solar system we inhabit, is finite, and ecological devastation is shortening its lifespan and its possibilities. The virtual is not as capacious as it once was.[10] Our room for maneuver is smaller.

Every being, from a person to a particle to a star—and humanmade things too, like spoons, software, and movies—is alive, as I will argue, and has experience: it receives from and acts on the world. Peirce's well-known statement that what appears from the outside as object, feels from the inside as consciousness, is accurate to the situation I'm describing.[11] So is H. Wildon Carr's definition of the *monad* as anything that has experience: his example is a mustard seed.[12] Each of us experiences ourselves from the inside, others from the outside—at least at first—but we may become aware that what appear to be objects are fellow living beings. We're aware of only a few of those infinite other entities, only the ones that are distinct to us. But with care, we may be able to share the experience of others, as I will explain.

"Consciousness" is a freighted term, given its deep connotations of a self-awareness exclusive to humans, which this cosmology doesn't need. It is not necessary to declare an entity to be conscious to say that it has experience. I give deference to panpsychist worldviews, including animism and other Indigenous thought systems, that equate being and consciousness. If we redefine consciousness as enjoying one's own process of being, as Whitehead and Raymond Ruyer do, then yes, all entities are conscious.[13] I substitute indexicality for consciousness, in an apparent step back from Whitehead to Peirce: every being indexes the things that cause its current state of being, whether by thinking about them or being touched by them.[14] This will allow me to assert, later on, that all entities, including humanmade ones, are in some way alive.

The cosmos is composed of an infinite number of experiences, from infinite points of view. I like to watch the rain falling on the roof of the building next door to my apartment. As each drop falls, it creates a concentric ripple, which conjoins with the ripples created by the other raindrops faster than

the eye can see, creating twinkling patterns of dark and light. It is both a model of the cosmos in motion and an actual little piece of the cosmos in motion, as I witness the experience of each raindrop as it creates experiences for others and forms part of a larger, collective experience. We are swimming in experience!

At some point it becomes evident that experience is not mine but ours, as it occurs on the fold that I share with others. Experience expresses us, not the other way around. For us humans, the vast majority of experiences, especially those experiences that make it clear we are living on a shared fold, occur prior to consciousness or cognition. But they are constantly present to be unfolded.

In a chapter titled "Love," Anand Pandian tells a story about encountering a snake on his walk to work through the forest one day. The shock of the gleaming, sinuous creature moving slowly across the path sufficed to turn Pandian's world snaky for the next few hours. "That slithering body, its echo was everywhere with me: winding roots, overhanging branches, vines and stems reaching out into the air, all of this was pervaded by that ophidian movement, by its tingling promise to rupture the limits of my body."[15] The moment of shock mingled him with the world, in a feeling of terror but also "electric delight," which Pandian associates with the way love undoes you. The encounter briefly expanded Pandian's boundaries to join a snaky soul-assemblage in which himself, the snake, the plants in the forest, and even his office shared a gleaming, undulating communion.

All process philosophies conceive of a force of differentiation that flows through individuals from the universe, or at least the larger milieu. Things transform from within in response to a pull from without. The cosmos flows into all beings, and our ever-changing interior infinity connects us with the ever-changing cosmos, as in Pandian's ophidian communion. Entities seen from the outside, erstwhile objects, are dense with enfolded relations. When things appear as objects, it's easy to imagine that they do not change and that all that they are is contained in how they appear from the outside. But beings are constituted from a history of relations. As well as indistinctly enfolding the rest of the cosmos, every being enfolds its own history; the relations that gave rise to it. According to Leibniz's principle of sufficient reason, every entity has a concept that includes all its predicates, thus all its relations with every other entity.[16] For example, you are here today because your parents met, and their parents before them, etc., to the dawn of existence, as well as because of the infinite number of accidents that provoked each of these encounters, most of which are virtual to you. Comparably, *aura*, in Walter

Benjamin's term, is the latent presence of a thing's history that inheres in it. In this way things that appear to be objects are better understood as *fetishes*, where a fetish is a seeming object that is volatile because it is composed of relations to entities and events from "outside."[17] Fetishism (in each of the anthropological, Marxist, and psychoanalytic traditions) is enfoldment of process. Fetishes are intense, where intensification describes the internal relations to the external milieu: the more relations an entity sustains, the more intense it is.

Speaking of fetishes, enfolding-unfolding aesthetics has much in common with Marxist critiques of reification and abstraction, and it is informed by Deleuze and Guattari's analysis of capitalism as a process of striation, especially in what I term the "information fold." It privileges the *flow* by which the products of reification, or abstraction, unfold and re-enfold. It uses a method of triangulation that makes the process of reification less opaque, by comparing the image with the information filter that produced it in order to get a sense of the infinite from which it arose. These are some of the qualities that make enfolding-unfolding aesthetics a fairly optimistic and empowering analysis of life in information capitalism. My pessimism is more concerned with environmental collapse and other kinds of human oppression than oppression by information, though they are linked, as we will see.

Speaking of folded surfaces, you may have remarked the isomorphism between the cosmic monadology that I propose here, with its folds enclosing folds, and the female sexual organs. It's there! The becoming-vulva that Patricia MacCormack advocates in a tour-de-force mapping of Luce Irigaray onto Deleuze is a radically smooth space, an infinite assemblage of folds that unfold, refold, and maintain connection. The terrain of becoming-vulva describes a ceaseless tensile process: "tensions, thresholds, activity-affect-passivity-syntheses, and action-potential, not a project involving a thing."[18] Many of the good qualities of involution, connectivity, and surface contact that MacCormack describes are present in my folded cosmology, although I give more privilege to objects as nodes of processes. Moreover, as we'll see, the monad's boundary is created through invagination, which is also the way a monad encloses or dominates other monads. This denotes a potency to the vaginal metaphor that I quite like. To enfold something can be to protect it while it germinates before it is let loose on the world. It can also be a way to claim power over something else, or as I will suggest with the soul-assemblage concept, to enter into alliance.

There is creativity in enfoldment, some degree of choice, as in Whitehead's concept of the aesthetic moment of concrescence, where the entity

in process reflects on what it will become if it synthesizes certain data. Molecules do not appear to have that much choice, nor do stars like our sun, but who knows? Cells choose what to osmose through their membranes. Trees choose, in the ways they turn their leaves to the sun and rain and interact with the world through their roots. People of course have a lot of choice of the ways they select what to absorb from the world and how to respond to it. Communities, corporations, nations continuously manage what to enfold or "incorporate" from the world—as in energy policies, hostile takeovers, and refugee quotas. All of these enfoldings are future-oriented, toward an imagination of what the entity will become.

The Goal of Life in the Folded Cosmos

The goal of life in the folded cosmos is to unfold or actualize more of what lies enfolded in the infinite: doing this both singly and collectively. There are many ways to describe this goal. For Spinoza, the goal is to better align one's imperfect knowledge and capacity, on one's small territory, with the infinite knowledge and capacity of "God, or nature." For Leibniz, as we will see, the monad perceives distinctly what's in its clear region, indistinctly what is not, and strives to amplify the wavelength of its soul. In Whitehead's cosmology, very similar to that of Leibniz, every actual entity has "perfectly definite bonds" with all other entities in the cosmos, either positive (it actually prehends the other entity) or negative (it doesn't). Like Leibniz's monad, each actual entity seeks to enlarge its positive prehensions of the universe.[19] For Glissant, too, everyone is a monad in a folded cosmos: the goal of life is to become acquainted with the complexity of the world, which requires an attentive closeness to its ever-unfolding surface.

Implicitly in these models, we are all internally infinite. Everything is a microcosm—every person, entity, situation—because it enfolds relations with the whole universe. I propose throughout this book that it is possible to unfold a little more of the cosmos, alone and with others, with care and style, and also to have a sense of what not to unfold. The more a being can actualize its internal infinity, the more real it becomes, the more individuated, and the more intense, as it expresses the cosmos more completely. As we become more real, we gradually become more capable of acting freely. But most of us are dull mirrors (Suhrawardī); the vast majority of our prehensions are negative (Whitehead) or at best dim misgivings (Leibniz). The effects of these relations are not realized in the entity's capacity to act. We are far from perfect.

The goal of life includes knowledge and the power to act, but also something that is more difficult to achieve: ever-greater openness. Perfection is the achievement of infinite points of contact with the universe—and contact is a two-way street. Becoming more real also means becoming more responsive. "A thing has the greater reality or perfection, the greater number of ways in which it can be affected."[20] Becoming more real entails becoming more capable to be affected by others, as well as to affect others. This book's embodied aesthetics emphasizes refining one's capacity to do both those things.

Bus-Stop Philosophy

Like other in-between moments of life, waiting for the bus is an ideal opportunity to practice enfolding-unfolding aesthetics. Many of the perceptible surfaces here—the concrete pavement, the metal structure, the bland signage, the rush of passing vehicles, the smells of the city—at first reflect my inquiry back to me, revealing nothing. That's especially so here in prosperous downtown Vancouver, where urban surfaces are polished to an anodyne informatic smoothness; in another part of the city the infinite would come pouring in more quickly. But there is nothing boring here. At the bus stop the infinite is converging on me from all directions! The infinite is folded into all these surfaces and may unfold to attentive perception, thinking, feeling, and research. Or it may resist my prying.

All of us gathered here at the bus stop express patterns of information, at the same time that we are folds of the infinite. Those squares below my feet have been lightly compressed as information into regulation sidewalk dimensions. How far did stone travel to be crushed into these particles? Who poured the concrete into molds? What were they thinking about as they trowel-smoothed the thick substance? (The movie *Locke* is a must-see for anyone who thinks pouring concrete is not a fraught and dramatic operation.) Between the slabs, valiant plants poke up: tufts of grass, a sprig of nutritious chickweed, a tendril of blackberry. Weeds index nature's strategies for survival in disturbed, unwelcoming soil. It looks like a worker for the city has hacked down the blackberry, but it is already springing back. Who else is living under the pavement, poised to spring from the clayey soil?

The uniformly sized bus shelter is the same as any in my city, but that is already interesting. Who determined the regulation size, and how was the design carried out? Where was the iron mined and processed into steel? Who welded the joints, how well are they paid, what was on their mind that day?

What urban-design committee determined that the little bench should have wedges sticking up, to divide it into the dimensions of slightly ample bottoms but deter those who would recline? The bus-stop bench is evidence that information is infused with politics, here the civic politics of vagrancy management, which performs its own twists in the infinite before extruding itself in wood and metal fixtures of regulation cruelty.

In the fire season, the glaring sun refracts on scratches on the plexiglass. In the flood season, rain beads along their seams. Each scratch tells the history of the hard objects that attach to us, such as a swipe by the zipper on somebody's backpack as they leaned against the shelter. S. K. has taken the trouble to inscribe their initials, giving me a taste of their determination, that particular day, to record their presence.

Other people are joining me at the bus stop. People! Each one a gorgeously individuated, unfathomably complex fold. Sculpted in time by age and experience, each of us is a delicate, endless negotiation between the information patterns of genetics and culture and an infinity all our own. Our hair, for example. One of my fellow mass transit takers has streaked her graying hair a trendy hot pink; another sports a perfect ovoid Afro. Just below the crown of another man's head, twin cowlicks, gifts of nature, spiral in opposite directions in defiance of his slick of hair gel. The ways my bus-stop friends disport their bodies as they stand, sit, and lean also tell of their unique trajectories of gait and injury, their practiced styles of movement, their moods. One bus-stop friend plops down next to me with a gentle groan. Another bounces pertly on his toes. One folds herself over her phone, another announces their presence with large, windy gestures. I find myself sticking out my chest like a flag; I fold in to be less conspicuous.

Going to work or to school, off to the market, returning home, meeting a lover, visiting a friend at the hospital, taking a day at the beach: each of us travelers, in our granular way, both reinforce and diverge from the transit system's planned trajectories. The clothes we wear, the music in our earbuds, even our worries reinforce cultural patterns, yet our personal infinities exceed those limits. Every face affords me a lambent glimpse of the infinite, so intense I must avert my eyes. I'm tempted to ask questions. What music are you listening to that makes you smile so wistfully? How are you enjoying your library copy of *The Bird King*? Those are some handsome leeks you've got; what are you making for supper? (I do ask that one, and my interlocutor shares a friendly recipe.) How did you get that scar? You look so disappointed, what happened to you?

But it's not polite to unfold strangers. I quietly inhale their mystery.

The concepts and exercises in *The Fold* are things I practice in everyday life to enjoy cosmic unfolding—waiting for the bus, listening to a friend, watching a movie—and I hope they can be that for you too.[21]

It was a bit of a surprise to me that they partake in most of the -ologies of philosophy. The exception is aesthetics, which grounds this book and which I treat as the interface between the body and the cosmos. The book also approaches ontology, or the nature of existence, with the model of the unfolding cosmos, and therefore epistemology, of how to think in and with a folded cosmos. I acknowledge that to sketch an ontology entails a certain arrogance, a whiff of totalization, but I do it in the awareness that enfolding and unfolding are always immanent to local conditions. Less totalizing than ontology is cartography, the partial and adequate method that Rosi Braidotti advocates.[22] I suggest that aesthetics is a cartography as it maps a part of the cosmos from the position of the sensing body. *The Fold* also pursues an ethics of how to act in the folded cosmos in ways that amplify the vitality of all beings. This ethics begins from one's one point in the manifold, one's own body: hence back to aesthetics.

Coming from a tradition of nontotalizing thought—the theories, rather than philosophies, in which I was initially schooled, that emphasize local and historical solutions to wade into such deep philosophical waters—thinking about these things feels preposterous and presumptuous. Aiming to keep philosophy open to non-Western thought, and other practices that are often shunned from the category, amplifies the challenge. Luckily for me, these philosophical ambitions and the difficulties they navigate find company and inspiration among a number of contemporary thinkers who are also wading into philosophical waters; many of whom come, like me, from disciplines outside philosophy.

Monism

From the outside, matter; from the inside, consciousness. Or put another way, the difference between thought and matter, as Spinoza argued, is a question of modality. Monism holds that all reality is a single substance. It denies matter-mind dualism but is in tension with the dominant contemporary tendency of materialism. In a nonreductive monism, immaterial forces arise from, respond to, and shape materiality. Explanations of the deep structure of matter can sound idealistic—matter consists of the undifferentiated (Bergson); a standing wave (various interpretations of quantum physics); "mind hidebound with habits" (Peirce).[23] Yet even in process philosophies that dis-

solve all into flows, processes have their own structures, including likely outcomes.[24] Similarly, among Deleuze scholars there is agreement that the virtual has an immanent structure. The concept of the implicate order in Bohm's cosmology corresponds well to Deleuze and Guattari's plane of immanence, an immaterial structure abiding in reality that shapes how things unfold. Enfolding and unfolding are such immanent and incorporeal forces; or, more modestly and accurately, abstractions that try to describe them.

Bohm's cosmology resonates with that of other process philosophers, such as Ṣadrā and Leibniz: "There is a universal flux that cannot be defined explicitly but can only be known implicitly, as indicated by the explicitly definable forms and shapes, some stable and some unstable, that can be abstracted from the universal flux. In this flow, mind and matter are not separate substances. Rather, they are different aspects of one whole and unbroken movement."[25]

Physics reminds us that the physical is composed of energy as well as matter. Even so, attempts to express all immaterial processes, including thought, as energetic seem reductive to me. Although thought is increasingly considered to be attributable to electrochemical processes in the brain, no single field, Bohm contends, can explain intelligence: "Its origin is deeper and more inward than any knowable order that could describe it."[26] Bohm warns against making final determinations of what the universe consists of, arguing that while undivided wholeness will remain both as content and as method of physics, physics must "slowly and patiently" accommodate both its theories and its facts.[27] His humble and gradualist approach respects the mystery of the universe, calling to mind the words of Santo in *Meu Querido Supermercado*: "Mystery is mystery."

It is delicate to maintain a monism that does not reduce either to idealism or to materialism, as Elizabeth Grosz finds in her careful study of the minor tradition of monism in Western thought.[28] In the human world, most entities consist of layers of thoughts and matter kneaded together—clothing, food, books, software, monarchies—and it is difficult to say where one ends and the other begins, but there is no question that the cotton of the fabric and the idea for the loom are equally real. In the nonhuman and non-organic worlds, something like thought takes place in conditions such as striving and enjoying. Certainly enfolding-unfolding aesthetics is a realism in which apparently material and apparently immaterial entities and powers are all real. As Bergson argued, matter is composed by duration: the way it persists, decays, and transforms. "Matter is . . . an infinitely dilated past."[29] At the same time I want to assert that thought is real, and that the difference between

thought and perception is one of degree. Enfolding-unfolding aesthetics shares the new-materialist conviction that matter is in some way alive. Yet, seemingly perversely, it asserts that matter is packed with souls, or bounded interiorities, in order to respect the mysterious internality of life.

The folded cosmos is immanence-friendly. Folding is immanent to what is being folded. Proposing an interdisciplinary model of the fold as both material and operation, Michael Friedman and Wolfgang Schäffner insist that folding is local, as it is adaptive to specific local conditions. They reject the imposition of information theory on biology, such as the concept of DNA and RNA as codes, and insist that there cannot be an external total code. "There is no infinite folding as there is no complete codification of material folded onto the material itself."[30] Even in the same material, different tissues fold differently. In biology, folding is a fractal process, not a codification: kale leaves bend into baroque curls as they grow, developing fractal form.[31] The Borgesian map corresponding to the territory—an example of a total code— is a fiction.

The subtle feat of converting idealism to immanence occupies Deleuze's engagements with many earlier philosophers, Leibniz among them, as we will see. I really enjoy this project and have attempted to carry it out myself with transcendental philosophers such as Ṣadrā: it's fascinating to see what kinds of structure can be retained, what must be jettisoned, in opening up the closed system of idealist philosophy.

Materialism, vitalism, and monism intertwine complexly in Deleuze's philosophy. Some accuse him of idealism, misunderstanding the immanence of forces such as differentiation and individuation. The concept of the univocity of being, in which all things "be" in their own irreducible ways because all things are part of Being, grounds immanent causality. "Being is said in a single and same sense of everything of which it is said, but that of which it is said differs,"[32] Deleuze writes. This means that differentiation is the necessary extension of oneness. Univocity is nonhierarchical.[33] Every entity, from the universe to a crushed beer can, participates equally in being. We can see the attraction of Leibniz's concept that the monad envelops some part of the life force that courses through the universe: it differentiates without becoming separate from the One.

The question remains, at least for me, of how to characterize the energy that appears to course through a monist cosmos, activating movement and differentiation. Is it the virtual itself, the engine of actualization? Is it, as Braidotti affirms, spirit, as *zoë* or life, immanent in matter? Is it an innate tendency to self-differ? Is it vibration? Could it be love? Moreover, do actual

things endure for some time, or are they ever vanishing?[34] Simondon (resonating with Bohm) holds that individuals are simply effects of a individuation, the way a wave is the result of the movement of the sea.[35] "We must begin with individuation, with the being grasped at its center and in relation to its spatiality and its becoming, and not by a realized [*substantialisé*] *individual* faced with a *world* that is external to it."[36] Enfolding-unfolding aesthetics assumes there is some kind of lively force of preservation-through-transformation that makes things happen in the cosmos, but demurs to settle on the details.

Still, it seems impossible not to understand all things, down to the tiniest particles, as alive and striving. Enfolding-unfolding aesthetics thus aligns closely with the philosophical movement of vital materialism of which Braidotti is the articulate and inclusive spokesperson, and which she also calls nontheological spirituality. "The univocity of being means that we have to deal with one matter, which is intelligent, embedded, embodied, and affective."[37] All beings "desire" to express the life of the manifold.

To be more concrete about what flows into us—people, particles, stars. It is easy to see that a being individuates in a milieu of historical and natural events: that our heritage and history inform who we are. But I want to keep this cosmology open to flows that appear unnatural or inconceivable: those relations inexplicable by contemporary science or theories of causality that some call the divinity within each being, though they need not be mystical. We intuit them, as Bergson and Bohm suggest. Intuition opens to us a "vista of experience [that] is as real and concrete as any other experience."[38] This book offers methods to sharpen those intuitions.

This cosmos I'm characterizing is a densely interconnected megafold. One fabric, with body on the outside, soul on the inside, pleated into a labyrinth, in which every being is a fold. My cosmology holds much in common with Thomas Nail's materialist theory of the earth as one massive fold, ever flowing, folding differently, in which matter and life forms constitute temporary folds—except that I like to argue for an infinite population of immanent souls.[39]

For Leibniz, the universe is one folded substance, and a monad is a differential in the cosmic equation. Bohm's theory of the implicate order similarly proposes that entities are interrelated in the quantum field. For both, entities are folds in the cosmic fabric. For Glissant, a being internalizes relations, most of them dim and silted, to the whole chaotic world. All three thinkers in their different contexts propose that every entity unfolds the entire implicit order, parts of it clearly, parts of it dimly.

Knowledge by folds has to begin within the folds, not outside them. Because unfolding occurs from a point of view, each point of view will unfold something different. Every monad has a unique access to the cosmos, which it unfolds via its own labyrinthine path. The common, even clichéd statement "Everything is connected" doesn't explain very much. The idea can paralyze as much as it can exhilarate, but in "Soul-Assemblages" I will explain how all of us folded beings have capacities, alone and together, to select and act on some of those connections.

For Leibniz soul and monad are interchangeable, and I will follow that distinction here. Organic beings, Leibniz writes, must have an internal force, appetition, and some form of perception.[40] These too I adopt and expand, arguing that all ensouled bodies are internally self-organized, have some kind of striving or conatus, and perceive or prehend. Soul in this book is understood not as a transcendental essence that survives the body. I define soul as a capacity immanent to the body, which is made possible by the body's provisional boundedness. After Aristotle, soul is what a body can do.[41]

Leibniz, Carr, Deleuze: Being a Monad, Being a Microcosm

Enfolding-unfolding aesthetics adopts from Leibniz a conception of the cosmos as continuous, pliable, in process, and populated by microcosms. The continuum is like a folded tunic, he writes, whose points may be infinitesimally small but always have some extension, and accordion in relation to nearby monads. "And so although there occur some folds smaller than others to infinity, a body is never thereby dissolved into point or minima. . . . No point in the tunic will be assignable without its being moved in different ways by its neighbours, although it will not be torn apart by them." Leibniz adopted the concept of the fold from Francis Bacon (1561–1626), who argued in the *Novum Organum* that matter is divided into *plicae*, "an elastic contiguum of folding and unfolding bodies of differing degrees of solidity and fluidity."[42]

In this cosmos, every being enfolds the entire world: this is the concept of the microcosm, which crops up in many world philosophies. The idea that all matter is a plenum populated by atoms or "seeds of things" (*semina rerum*) was current in Leibniz's seventeenth-century context.[43] Here, a monad (or soul) is a fold in the cosmos that expresses the entire cosmos from its unique point of view. It is an intensive infinity: a single soul that innately includes the entire universe, as the infinitesimal implies the infinite. If all entities are ensouled, as I argue, then all entities are monads: models of the cosmos that

express the cosmos, however incompletely. Leibniz' principle of sufficient reason further states that each monad encapsulates the entire history of the universe—what Daniel W. Smith calls "an almost hallucinatory conceptual creation."[44] Each monad, Leibniz writes, "imitates [God] as much as it is capable. For it expresses, however confusedly, everything that happens in the universe, whether past, present, or future."[45]

Leibniz proposed that a mind or soul is a mathematical point "proportional to an endeavour at each instant"—that is, it expands or contracts according to its striving. It is encased by a physical point, the body, "the proximate instrument and as it were vehicle of the soul."[46] Calculus supports Leibniz's argument that every monad occupies a distinct and necessary point on the continuum of the cosmos. In Deleuze's explication, each monad expresses the totality of the world under a certain differential relation and around the distinctive points that correspond to it. Whatever has a point of view is a subject. An ever-changing point of view *defines* the subject, as a snowboarder is defined by the sweeping paths she takes on the slope.[47] Similarly, channeling the philosophy of the fold through Indigenous thought, Eduardo Viveiros de Castro characterizes the Amerindian cosmos as a single entity that subdivides into distinct bodies. Certain animals, like the jaguar and the vulture, constitute subjects because they are given names that position them in the cosmos.[48]

In Leibniz's folded dualism, translated into Deleuze's terms, the infinite cosmos expresses itself both through monads or souls, which actualize it, and through the monads' bodies, which realize it. Both the physical world and the soul are connected to the infinite, but differently: the body by being affected (from the outside), the soul by perceiving or "reading" (on the inside). The monad's body has infinite *external* causality. Since all physical objects are interrelated, any physical event will involve every other physical event in the universe—though negligibly in most cases. The monad itself has infinite *internal* causality. It is not affected by its body but by a nested series of causes, and ultimately by the only necessary being: for Leibniz, this ultimate cause is a transcendent God, because a genuinely sufficient reason must involve a cause that is noncontingent.[49] The monad perceives the world; the monad's body (which is composed of other monads) feels the world: "What occurs in the soul represents what occurs in the bodily organs."

Monads' bodies feel the entire cosmos through their neighbors, which jostle them on the common fold like restless bedmates, and in turn by their neighbors' neighbors, to infinity. "Every body is affected by everything that happens in the universe. . . . But a soul can read only what is distinctly represented

there; it cannot unfold all at once all that is folded within it, for this proceeds to infinity."[50] Lacking this limitation, "each monad would be a divinity," which of course is impossible in Leibniz's closed, harmonious world.[51]

Leibniz held that monads persist in a virtual state, sometimes for eons. As Richard T. W. Arthur demonstrates, Leibniz inherited from Petrus Severinus (1542–1602), Daniel Sennert (1572–1637), Pierre Gassendi (1592–1655), and before them Marsilio Ficino (1433–1499) and Paracelsus (1493–1541), the idea that "seeds" of not only organic but also inorganic entities were created by God at the beginning of time and lie dormant in matter. Even minerals have a seedlike force that forms them into crystals.[52] These ideas lend themselves to a time-based image of cosmic history in which monads wax and wane, but never entirely disappear.

Deleuze renders Leibniz's dualism immanent by saying the world, or the virtual, is actualized in monads and realized in bodies. "It is therefore folded over twice, first in the souls that actualize it, and again folded in the bodies that realize it," according to the laws pertaining to each.[53] The vinculum, the fold between the two folds, makes it especially difficult to distinguish where soul ends and body begins. Leibniz suggests that the body of each monad is composed of the infinity of other monads that surround it.[54] The vinculum is a unifying bond that binds souls together, where monads' skins press together to form the body of a larger monad in what I call soul-assemblages. Here, matter appears as no more than an infraslim pellicle separating spirits. But when Deleuze's Leibniz proposes that a monad precipitates from the sensations of the material world occurring to its point of view, spirit appears to be an expression of matter. Leibniz also levels the difference between spirit and matter when he says the monad's reason gives it knowledge of necessary and eternal truths—but that we can also learn these inductively from sense experience.[55]

The ever-changing actual world is wholly constituted by the experience of monads. To explain, let's hear from the forgotten monadologist H. Wildon Carr, one of a handful of early twentieth-century British monadologists (including Bertrand Russell and James Ward) who established a newly open, monadic cosmology.[56] Working in the swirl of process philosophies, pragmatist, phenomenological, and monist, Carr turned to metaphysics, and ultimately monadology, in search for a new materialism that would be a more adequate foundation for contemporary science than the then-dominant atomistic and mechanistic materialism.[57] He synthesized the thought of Leibniz, Spinoza, and Bergson to argue that reality consists of the totality of experience.[58] Monads are the only realities, each of which, from its unique perspective,

includes the entire universe. Consistent with Leibniz and anticipating both Whitehead and Deleuze, Carr explains that monads do not float like bubbles in a preexisting spacetime; rather, space and time "belong to the reality of the monad."[59] In Carr's monadology (more simply than Leibniz and Deleuze, and similarly to Spinoza) the material world of extension exists in parallel to the monadological world and can be described by atomism.

What is wondrous in the monadological cosmos is that every entity experiences and expresses the cosmos differently, as in Carr's example of a group of people riding a train, whose bodies are close together in atomist space but whose monads are experiencing vastly different thoughts, perceptions, and feelings. His most moving example is a world consisting of only two monads: a soldier and a skylark on a French battlefield, during the Great War of 1914–1918. In a brief pause between explosions, the soldier hears the skylark's song, and the skylark chooses where to alight on the smoky field in relation to the soldier's position. Each monad includes the entire world of the battle, which it experiences from its own perspective, including the other monad. Their distinct experiences do not add up to the world; each one *is* the entire world. This alone is what constitutes reality.[60] "The monad is both in-itself and for-another. In-itself it is the subject of experience with its perspective. For-another it belongs to the universe of the monad in whose perspective it is."[61] Another way to say this is that each monad's experience constitutes the virtual for the other monad.[62]

Oddly to modern thinking, in Leibniz it is the monad that is active, while the body is passive. Leibniz argues that the soul represents the universe by representing its body, which is physically connected to the whole universe, but it is not caused by its body. The Leibnizian monad does not have windows, in the form of sense organs. The monad does not see and hear objects of experience out its windows, as Carr explains; instead it *includes* them in itself. The two-floor model of the monad suggests to some readers that monads cannot communicate with one another, but in a chapter winningly titled "Monadic Intercourse," Carr explains (resonating here with Bergson) that monads communicate by creating images for one another. "Intercourse is not action provoking reaction, but expressive action evoking new expression."[63] Monadic experience, that is, is fundamentally *aesthetic*, as we respond to the images (multisensory images, I would emphasize) that other monads express.

I appreciate Leibniz's understanding of soul not as the immortal portion of beings that will survive their death but as a reading room: a private space where the monad can synthesize its experience of the world. The monad

needs a place where it is not constantly being bothered by what its body is telling it. A place to read a novel, an atlas, or some scientific literature; to watch TV and go online; to sift through its memories. Into this private space the monad unfolds those aspects of experience that matter to it, which will most likely differ greatly from those of the monad next door.

Once we expand what counts as a soul, we will be able to conceive that all of matter is packed with reading rooms: sites of perception, memory, and imagination. So every entity in the cosmos is not only feeling its relations to the rest of the cosmos with its body but also reading the cosmos with its soul, and expressing its findings to others.

Bohm: The Implicate Order

Leibniz's monad that comprises the world corresponds to Bohm's model of the holographic universe, in which each individual is a hologram of the universe as a whole but reflects only its surrounding field clearly.[64] Arthur points to this link in his contention that Leibniz's "idea of the state of a substance as a representation of its surroundings was a crucial ingredient in the development of the modern concept of a *field*," anticipating the field theory of quantum physics.[65] Critiquing the conventional view in quantum physics that reality at the quantum level cannot be conceived of, and that quantum and classical physics obey irreconcilably different laws, Bohm argued that the worlds described by classical and by quantum physics are continuous. As random flashes on the surface of the sea manifest the effects of the waves, what appear to be discrete phenomena are the manifestations of an implicate order. In this cosmology (a term Bohm uses) all entities in the cosmos are interconnected, in that they are all the effects of a common cause, at a level more profound than that described by quantum physics. Bohm's cosmology, though it claims to describe the entire universe as a wave function, is not deterministic because we can only know local regions of the wave function.

In the implicate order, every spatiotemporal region enfolds the structure of the whole universe. "A *total order* is contained, in some *implicit* sense, in every region of space and time." For example, in a television broadcast the visual image is translated into a temporal order, which is carried in radio waves: it is implicit in the waves.[66] I would add that in a digital broadcast, analog information, translated into digital packets, is implicit in the digital signal.

To further illustrate this point, Bohm cites a lab experiment in which a droplet of insoluble ink is mixed into a viscous fluid, using a mechanical stir-

ring device, until the fluid goes gray. When the device stirs in the other direction, the gray mass reverts to a single droplet again. The gray mass *enfolds* the drop of ink; that is, the drop of ink is implicate in the gray mass. Stir the other way and it becomes *explicate*. Different pictures that look indistinguishable may have different implicate orders.[67] I take this as a model for the way seemingly identical images, say the cute and topical memes that populate many people's screens, all imply different trajectories, including the person's motivation to see the meme and the infrastructure that carries it to their device. The memes look the same, but each is unique, and you can see this when you unfold the path it took to reach this particular screen.

A hologram is an interference pattern between two laser beams: one directly onto a photographic plate, the other first reflected off the structure being imaged. The interference pattern shows the whole structure in every region, though not all in the same detail. Each region, Bohm writes, is *relevant* to the whole. Much like the perception of Leibniz's monad, the hologram sees all, but only sees clearly the parts relevant to its point of view.

Bohm was the first to point out that an electron is a member of a whole of many electrons, whose interconnectedness is described by Schrödinger's equation. While in classical physics the amplitude of a wave decreases over distance, in a quantum field it remains constant. The form of the quantum field, and not its strength, determines its effects. This means that a particle can be affected by distant features of its environment. Bohm and Basil J. Hiley compare a ship that is directed by radio waves: the radio waves don't have to be strong to guide the ship, because it has its own power.[68]

When particles join, for example, atoms in a molecule, the wave function becomes a single function. All particles are governed by one wave function: this is quantum entanglement. If one electron moves, the path of the other electrons that are entangled with it will be modified. This is why the dominant view in quantum physics treats matter as erratic and probabilistic. In fact, Bohm and Hiley contend, electrons behave erratically *because* they are connected to other electrons acting as a whole. Moreover, these connections are not abstractions defined by equations but can be *intuitively* grasped and experienced.

The concepts from quantum theory that migrated into other disciplines and into popular culture—the uncertainty principle, a belief that reality becomes statistical at the quantum level, and a notion of quantum entanglement or action at a distance—are approximations of the conventional quantum theory that dominates the field (associated with the quantum physicists Bohr,

Werner Heisenberg, and John von Neumann). According to Bohr, it is not meaningful to talk about a quantum object apart from the whole system of which it is a part. The quantum algorithm only gives probabilities of possible results for a given experiment. Some have interpreted this to mean that reality itself is statistical, but that does not appear to have been Bohr's intention.[69]

Bohm and Hiley agree with Bohr that an experiment, such as the double-slit experiment, has to be regarded as an undivided whole, including the experimenter and the measuring device. Where they differ with Bohr is in asserting that the entire process can be analyzed in thought, if not in actuality.[70] The fact that quantum phenomena are not controllable and predictable doesn't mean the quantum world cannot be determined. It's possible to do physics without the positivism and control that Bohr's conclusion about the impossibility of measurement required.[71] Similarly, *pace* Heisenberg, they argue it's not necessary to observe in order to know the location of a particle. Instead they follow John Bell's concept of "beables" rather than observables. Beables, defined as elements of a physical theory that are taken to correspond to something physically real, have a reality that is incapable of being observed.[72]

Rather than define physical concepts based on experiments, Bohm and Hiley argue, one can *derive* possible phenomena from the overall structure. Sounds risky, I know, but they have the equations to demonstrate it. It may be possible to analyze a quantum of action at a more complex level that could treat it as continuous and analyzable. Thus, there is no reason not to seek an ontological interpretation of quantum theory.[73]

To explain the relationship between a particle and its quantum field, Bohm and Hiley introduce the concept of active information. This is not top-down information but information specifically relevant to the particle's "point of view" in the quantum field, much as the monad receives the universe to its point of view. It accounts for how a quantum field, whose energy is weak, can actualize the potential of a particle whose energy is much greater.[74] Each particle is actualized in an active interaction with information, individualized for it by the quantum field. Bohm and Hiley give the example of a map, which is passive information until someone uses their imagination and energy to actualize some of the map's potentials. Or the DNA molecule, which guides cell growth but is useless without the energy from the cell and the environment.

Information participates in actualization by providing a road map, but it requires energy and participation. In turn the energy guided by the informa-

tion is not mute and passive. "The fact that the particle is moving under its own energy, but being guided by the information in the quantum field, suggests that an electron or other elementary particle has a complex and subtle inner structure."[75] Just like people, particles behave statistically in large numbers, but individually they have a rich private life. "A particle has a rich inner structure which can respond to information and direct its self-motion accordingly."[76] Active information is a positive concept, comparable to Simondon's argument that information instigates individuation; later on, it will inform my conception of information as a selective unfolding of the infinite.

The folded character of the quantum field, whereby each particle enfolds the implicate order, resonates with Murray Gell-Mann's suggestion that particles are folds or braids of waves. "In a continuum framework, particulation can be understood as a type of organization or plaiting amid disorganized conditions of an inherently pleated (wavy) field." Pointing out the etymology of com*plex*ity in the Latin *plexus*, braided, Gell-Mann proposes to call quantum physics *plectics*, connoting entanglement.[77] Consonant with Bohm and Hiley, Gell-Mann and James B. Hartle hazard a quantum cosmology in which all entities, including the entangled observer and experiment, enfold the entire history on the universe.[78] In these ways, as we'll see, quantum cosmology aligns with Leibniz's concept of sufficient reason, whereby each entity enfolds the history of its causes. The particle's "rich private life" is the life of the microcosm, which internalizes the cosmos—here, the quantum field—with respect to its singular point of view, and acts on the information it receives.

Bohm and Hiley point out that the vast swath of inner space between 10-16 centimeters (what physics can measure now) and 10-33 centimeters (the shortest distance potentially meaningful to physics)—the same order of scale as between us and elementary particles—is unknown. They suggest that "since the vacuum is generally regarded as full . . . with an immense energy of fluctuation, it may be further suggested that ultimately the energy of this [elementary] particle comes from this source."[79] It is quite thrilling to think of the cosmos as infinitely populated by infinitesimal particles that are powered by fluctuating energy.

Political reasons forced Bohm's theory, together with others who disputed the dominant view, into a minority position. Power struggles in the scientific academy, and red-baiting of Communists in the postwar United States, pushed Bohm to the margin of the field and into exile in the United Kingdom[80] Though I am not a physicist, Bohm and Hiley's mildly worded objections to their colleagues who enforce the conventional view sound completely

reasonable as a plea for the diversity, open-mindedness, and, above all, scientific caution against dogma that make for a healthy intellectual milieu.

Glissant: History Enfolds Relations, Relations Enfold History

In advocating an understanding of the world as constituted by folds rather than breaks, I do not mean to minimize the historical facts of rupture, genocide, and extinction. Thinking with folds models a way of following surfaces, never letting go of the thread, seeking continuities and relationships. I believe it honors the lost and the dead by acknowledging the ways they remain present on a common surface. Glissant, who, as the Caribbean descendant of enslaved African peoples, has strong reason for pessimism about cultural loss, maintains a surprising optimism that *all* cultures survive in the chaos of the contemporary world.

As Glissant argues, a model of the world that does not seek depths but respects the complexity of folded surfaces best expresses the colonial and postcolonial reality of inextricably mixed heritages. Where clarity serves a colonial or dominant way of thinking, Glissant's style multiplies folds, as a creative and political strategy of writing and thinking within the colonizer's language.[81]

Glissant makes the Deleuzian observation that Baroque art modeled a way of knowing that renounced mastery: it "mustered bypasses, proliferation, spatial redundancy, anything that flouted the alleged unicity of the thing known and the knowing of it."[82] The Antillean writer pursues Deleuze's passing observation that the Baroque is an art of property that arose in the period of European colonization. Baroque art only came into its own, as an art of folded surfaces that enfold, rather than assimilate, differences, when it came to the Americas and mixed with the arts of Indigenous peoples. The Baroque is not just a generative model but a historical event, whose function as a model is maximized by colonial hybridization or *métissage*. In Latin American and Caribbean religious art, the Baroque "so closely intermingled with autochthonous tones" that it became able to express the world in its becoming. "The generalization of *métissage* was all that the baroque needed in order to become naturalized. From then on what it expressed in the world was the proliferating contact of diversified natures. It grasped, or rather gave-on-and-with, the movement of the world. No longer a reaction, it was the outcome of every aesthetic, of every philosophy. Consequently, it asserted not just an art or a style but went beyond this to produce a being-in-the-world."[83] Cul-

tural mixing, *especially* in violence, creates folds upon folds; it yields a more complete expression of the folded cosmos than do apparent monocultures.

To the intercultural art of folds that Glissant observes, I add the crucially mind-bending ingredient of Islamicate patterns of endless knots and tessellated surfaces that was so thoroughly integrated into European Renaissance and Baroque art, and whose abstract lines also entwine the Baroque arts of the Americas.[84] The Islamic element of the *métissage* also unfolds from violence: the Spanish conquest and expulsion or forced conversion of the Muslim inhabitants of the Iberian Peninsula, and expropriation of their knowledge.

We behold these visually and intellectually beguiling themes, the embodiment of Baroque cultural enfoldment, in the arts of Hispanic colonies in South America and the Caribbean: architecture, visual art, and especially craftwork of the sixteenth through eighteenth centuries. Iberian figures, Islamicate patterns and compositions, Indigenous themes, materials, and colors, and other motifs mingle on ceramics, leather goods, and textiles, witnessing the folding of cultures that took place through conquest, assimilation, and commerce. An eighteenth-century leather trunk from New Spain, in the collection of the Franz Mayer Museum in Mexico City, speaks of this folding of cultural traditions. It was used to store cocoa beans; one can imagine a lingering fragrance.

The trunk's sides and lids are embroidered in agave thread with an attractive interlace pattern that terminates in lotus flowers. Straight out of a decorated Qur'an, these patterns are "sticky" in Alfred Gell's sense: they compel the eye to return to them repeatedly, in a curiosity that becomes fond attachment.[85] In between them, ladies on balconies flirt with horsemen, and isolated hunters and animals pose. In the Islamicate habit of filling voids with pleasing motifs, the heads of hares and deer are cupped with plantlike flourishes. But in the new context these curlicues have taken on an additional function: Gustavo Curiel suggests that they act as "speech scrolls—a symbol of pre-Hispanic origin."[86] Thus the Indigenous tradition of speaking animals folds into all the other signs on this cocoa trunk, which thus incarnates centuries not only of imperialism but also of intercultural curiosity and of cultural survival, not in purity but through *métissage*. A beholder's brain, beguiled by the abstract lines of the knotted pattern, intoxicated by the scent of chocolate, might be able to hear the address of the animals.

This historical art of relation, Glissant continues, prefigures our contemporary situation of relational complexity across art, science, and all human cultures.[87] Translator Betsy Wing chose to translate Glissant's *donner-avec* as

FIGURE 1.3. Leather trunk, New Spain, eighteenth century. Franz Mayer Museum, Mexico City.

"giving-on-and-with," explaining that it is a form of understanding that is not *comprendre*, as in to comprehend, with its connotation of enclosure, but to know something by yielding to it and following where it goes.[88] It is like learning about something by following it with your hands.

Joined by other world traditions, the capacious folds of the Baroque, Glissant suggests, express Relation itself. Its pleating and whorling art forms materialize a kind of knowledge that entails close contact with the world and mutual becoming of beholder and world. Art forms now accomplish this by staying close to the surface of the world. Movies such as *Meu Querido Supermercado* respect obscurity as enfoldedness (to a given point of view). They do not worry about truthfully representing the world but instead try to become like it.

This book's spirit of folding and unfolding attempts to extend Glissant's remarkable optimism by staying close to the surface of the infinite, where creativity is ceaseless and new folds are constantly being pulled from ex-

isting thoughts, histories, and materials, in unique local situations. All us entities, organic and nonorganic, live on the face of the infinite. As we act, contemplate, savor, suffer, and cherish, we intensify the infinite and add to it. Intensification is amplifying latent connections, making them actual, and strengthening the bonds between our immediate experiences and those of others in different places and times. The ethics of enfoldment include respecting the opacity of others, in Glissant's much-loved concept: resisting the desire to translate an other into your terms but rather respecting their irreducible singularity.

Inspired by the cyclical movement of the tides on the black sand beach, Glissant argues that there is no dominant fold but an encompassing chaos. "I thought how everywhere," he writes, "and in how many different modes, it is the same necessity to fit into the chaotic drive of totality that is at work, despite being subjected to the exaltations or numbing effects of specific existences." He continues:

> I thought about these modes that are just so many commonplaces: the fear, the wasting away, the tortured extinction, the obstinate means of resistance, the naive belief, the famines that go unmentioned, the trepidation, the stubborn determination to learn, the imprisonments, the hopeless struggles, the arrogance and isolation, the hidden ideologies, the flaunted ideologies, the crime, the whole mess, the ways of being racist, the slums, the sophisticated techniques, the simple games, the subtle games, the desertions and betrayals, the unshrinking lives, the schools that work, the schools in ruin, the power plots, the prizes for excellence, the children they shoot, the computers, the classrooms with neither paper nor pencils, the exacerbated starvation, the tracking of quarry, the strokes of luck, the ghettos, the assimilations, the immigrations, the Earth's illnesses, the religions, the mind's illnesses, the musics of passion, the rages of what we simply call libido, the pleasures of our urges and athletic pleasures, and so many other infinite variations of life and death. That these commonplaces, whose quantities are both countless and precise, in fact produced this Roar, in which we could still hear intoned every language of the world.[89]

This litany of chaos appears like a drawing of the countless ways infinite life is captured, repressed, and sometimes expressed by patterns: patterns extracted from the infinite, which I will characterize as information folds, that attempt to dominate it in the form of systems of power: schools, banks, religions, conventions, and especially the sickly snares of global capitalism. Yet it also

describes how life on the surface of the infinite—chaos, a field of singularities—is vaster than the efforts to structure and dominate it.

Glissant is well aware that staying close to the surface is provisional. People are always getting pulled into power relations that precede them, especially if they are colonized or disenfranchised, and these power relations disfigure the smooth path. In my terms, we get pulled into dominant folds and must constantly rearticulate our own surfaces in response. His haunting figure of the man walking on the black beach epitomizes withdrawal from dominant relations, indeed from all relations, and becoming completely opaque. Walking, tightening his belt as he gets thinner every day, the man refuses to speak, making the slightest gesture of acknowledgment to Glissant as he passes one day.

Unlike this ambulant, nearly disappearing figure, the people "struggling within this speck of the world against silence and obliteration" must consent, Glissant writes, to be reduced to sectarianism, stereotypes, taking sides in power struggles, and the other generalizations that kill vital singularity. In my terms, to struggle for voice and recognition necessitates, if only provisionally, moving along the dominant folds and assuming their shape. It necessitates, Glissant writes, being "grasped" by the economic inefficiencies of the postcolonial state, the strings-attached gifts of former colonial donors, the Procrustean strictures of the World Bank. It requires trying to match the speed of other parts of the world: "At all costs we wanted to imitate the motion we felt everywhere else."[90] "The Black Beach" concludes, fittingly, with economic recommendations: ways that Martinique, like other small postcolonial states, could resist the totalizing folds of neo-imperial information capitalism.

Only a Model

Is the folded cosmos just a metaphor? Or does it describe the way things really are: Is it an ontology? It is something in between: a model, or a simulation.

Concepts are abstractions from an ungraspable flow.[91] They are not right or wrong; they animate attitudes toward the world in more or less relevant ways. They reflect on the cosmos of which they are a part, and add to it. As Bohm and Hiley write, "the content of the theory is not by itself the reality, nor can it be in perfect correspondence with the whole of this reality, which is infinite and unknown, but which contains even the processes that make theoretical knowledge possible."[92] My concept of the folded cosmos, with its particular intellectual heritage, is one of many ways to argue that all of us live in inextricable interrelation in a more or less open whole. Others include the Taoist cosmology in which the One divides into Two; the re-

cursively nested Dogon cosmology; the Neoplatonist universe that emanates without breaking; Whitehead's cosmos in which chaos becomes ever more orderly and intense. Among contemporary thinkers, these models of inextricable interrelation include the entangled universe that Karen Barad models from quantum physics, Nail's ecological theory of an acceleratingly folded cosmos, and the cosmos that Adrian Ivakhiv, like me, describes according to a triadic process.[93] All of these cosmic models are, as Bohm insists, abstractions from something ungraspable. I proffer the folded cosmos as a useful abstraction, a diagram, keeping in mind that "we write only at the frontiers of our knowledge," at the border that transforms ignorance into knowledge—and vice versa.[94]

Earlier I asked, does all reality boil down to wave functions? It is tempting to assert that this is the case. Nail, for example, asserts that everything, from subatomic particles to societies, is defined by a waveform.[95] I can get behind this assertion as a model, but not as an ontology. Similarly, I'm tempted to apply Bohm's suggestion to the nagging question for a Deleuzian, where does the virtual get its energy from? Might it subside in that field of energetic fluctuations that occurs between 10-16 and 10-33 centimeters? Keeping Bohm's caution in mind, however, I remind myself not to misplace concreteness. As the serf mutters in *Monty Python and the Holy Grail*, it's only a model.

Physicists and chemists observe phenomena that quantum physics describes, but quantum physics doesn't apply to the experience of biological beings like us. Our macroscale world is described by classical physics, and by the higher-level systems that other sciences analyze. Nevertheless, quantum physics provides powerful models and metaphors that lately have proved extremely attractive to humanities scholars, such as entanglement and Heisenberg's uncertainty principle. As the child of scientists, I am bothered by these borrowings when they appeal to science as fact, for scientists know they are conventions—durable, usable conventions to be sure, but conventions arrived at through struggles that are political as well as intellectual, and ultimately placeholders for an understanding to come.

To avoid misplaced concreteness, I step back from the current interest in applying quantum entanglement to situations that can be described by classical physics (let alone biology, political science, and other methods of studying phenomena). Everything is connected, but not everything impinges on everything else.[96] Everyday problems rarely require quantum solutions, delightful though it is to contemplate them.

When entanglement actually occurs—when an event distant in time and space suddenly "flashes up" and reveals its involvement in the here and now,

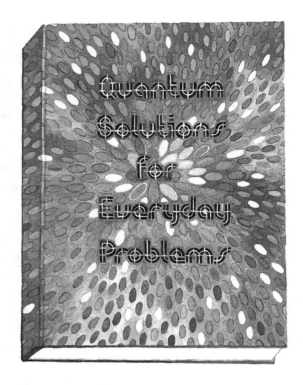

FIGURE 1.4. Natalie Sorenson, *Quantum Solutions for Everyday Problems*. Watercolor, 2019. Sorenson invited me to contribute a title for her series of covers of imaginary book titles, and this stunning painting is the result.

it's crucial to be able to identify how that relationship occurs. The moments when an unlikely relationship allows us to detect the whole in the parts are precious, and we need to be able to grasp them.

Enfolding-unfolding aesthetics offers some methods to detect these moments of connection, and even, in some cases, to change them. We affect things locally, and at a distance, but not everything all the time. So, the creative (and sometimes political, sometimes magical) act is to discover those connections that are most extensive and most deeply enfolded—and to have the élan to seize the moment and unfold them. In so doing, we align our will with that of the cosmos.

Chapters to Come

This chapter gave a study of the cosmos from the top down. The next chapter, "Soul-Assemblages," starts from the bottom up, identifying the component parts of the cosmos: after Leibniz, monads, or embodied souls. I give a non-transcendental definition of *soul* as anything that is bounded and there-

fore alive and suggest that the cosmos, and all of us, consists of ensouled matter. I introduce the concept of soul-assemblage, a group of monads that are joined by a common purpose, which forms its own folds. Here my cinematic thinking companion is the Otolith Collective's *INFINITY minus Infinity* (UK, 2019), a soul-assemblage that analyzes the racial capitalocene in the contemporary United Kingdom. We'll confront the challenge of unfolding differently, which requires identifying singularities, monads that connect to enfolded surfaces. We'll see that Leibniz's cosmology must be "snipped open" in order to allow every monad to thrive, and, this done, I will suggest that some soul-assemblages have the potential to radically deterritorialize the existing order.

The following chapter, "Enfolding-Unfolding Aesthetics: A Triadic Model of the Cosmos," introduces the triadic model of the cosmos as a cycle of ceaseless folding and unfolding, in a flux between the three planes of the infinite, information, and image. I introduce enfolding-unfolding aesthetics as a triadic method for analyzing this folding process, with attention to information as the human and political filter of the infinite. This chapter gets practical, outlining the method of enfolding-unfolding aesthetics, surveying manners of unfolding and the style necessary for a successful unfolding. We'll see that equally important is enfoldment, the strategy of protecting things from being unfolded related to Glissant's term "opacity."

Next, "The Information Fold" brings the folded cosmos into dialogue with contemporary theories of surveillant information capitalism. I'll suggest an "only moderately paranoid" rejoinder to the darker theorizations of information's grip, especially where information-images are concerned. This relatively cheerful view is, however, moderated in turn by an analysis of the unsustainable energy consumption of information and communication technologies. The chapter then turns to media arts of the fold and presents a protagonist for the media of our coming collapse informatics.

Chapter 5, "Training Perception and Affection," introduces affective analysis, another aesthetic method that is at the core of this book's practical philosophy. A triadic method, affective analysis postpones conceptual analysis in order to take time experiencing affects, understood as a multistage process, and perceptual analysis; it then compares affective and perceptual responses in order to arrive at concepts, or what Spinoza termed "adequate ideas." Affective analysis, an exercise to expand embodied capacities for openness and connection, strengthens the skills we will need to resist the ideological powers of the information fold and begin to unfold differently.

When affective analysis reaches an impasse, it may be a sign that we are in the presence of something so deeply enfolded, so thoroughly virtual, that it can only be unfolded by a determined, often collective effort. The chapter "The Feelings of Fabulation" offers a six-step method for fabulating, informed by Deleuze's concept of powers of the false. Drawing on the three-step method of affective analysis, fabulation adds a "zeroeth" step: making connections with the beyond, be that unimaginably far in time or space or incompossible with the space-time in which we seem to live. Yet, I argue, in the company of fabulative movies, fabulation doesn't need to occur at the level of science fiction: small and local acts can bring the inconceivable into existence right on your doorstep. On a large scale, however, fabulation is revolutionary. Here the cosmic soul-assemblage carries out a great refusal that rejects almost all of present reality and pulls out the most distant, most unlikely fold.

A case study of enfolding-unfolding aesthetics, "Monad, Database, Remix: Manners of Unfolding in *The Last Angel of History*" is a most ambitious exercise in the method, inspired by a movie whose stakes of unfolding differently are high.[97] This 1995 movie by John Akomfrah and Black Audio Film Collective, a founding text of Afrofuturism, models manners of unfolding lost African-diasporic histories. There is a manner of unfolding that prepares the audience by creating new embodiments; an unfolding with urgent élan of histories almost entirely lost; a protective aniconism that refuses to unfold. When history cannot be unfolded, fabulation kicks in, and the fluent unfolding technique of the remix. *The Last Angel of History* detects clues in databases that inspire me to unfold the deep time in which algorithmic knowledge traveled from Africa and West Asia into Europe and the Americas, including in the possession of enslaved Africans and their descendants.

The final chapter, "The Monad Next Door," returns to *The Fold*'s Leibnizian protagonist to celebrate the monad as an interiority, or soul: a private reading room in which to contemplate the cosmos that the monad enfolds. Disquietingly, though, we monads live inextricably from our neighbors, who constitute our homes and our very bodies. These relationships fold class politics into our very being, exacerbating the monad's upstairs-downstairs relationship with its body. When our material supports become toxically entwined with information—the monad's mortgage—it may be time to find a way to live more lightly on the earth. A lively subdivision of movies, especially *Neighboring Sounds* (Brazil, 2012) by Kleber Mendonça Filho, explore the monad's protected space and its cozy, claustrophobic, and inevitable interfoldings with others.

The Fold concludes gently with "Recognizing Other Edges," a reflection, written while the now-common summer smoke stung my eyes, on refusing cultural and political edge-recognition software. The boundaries of soul-assemblages are often drawn by corporate, government, and imperial interests; but those edges are always shifting according to the restlessness of the enclosed elements. Enfoldedness gives shimmer to the virtual, and an infinity of soul-assemblages shift and shimmer, in a haptic haze that defies borders.

2

Boundedness, or, Ensouled Matter

The cosmos is made of us: us living beings. What is alive is anything that feels, acts, or communicates. To do so, the being must have some kind of internal consistency, some provisional boundedness. A living being is a temporary fold in the cosmos that brings together a point of view. Such a being can be a person, a molecule, a spoon, a supermarket, a star. It can also be a gathering or a coalition.

In the common division between the organic and the non-organic, life is thought to be an attribute of organs. Biosemiotics defines what is alive as something bounded by a membrane. This makes it capable to make signs, argues Jesper Hoffmeyer, specifically to act as a Peircean interpretant,[1] as for example a cell interprets and responds to the electrochemical information that passes through its cell walls. More broadly, physiosemiotics takes Peirce's concept of interpretant *in futuro* to imply that physical processes like the orbiting of planets are ultimately "interpreted" by the life forms that a planetary system makes possible.[2] This concept is still organocentric, assum-

FIGURE 2.1.

ing that only a being whose organs are bounded by cell walls can make some sort of meaning. I'd like to expand the idea of what it means to be bounded.

A soul, I suggest, is anything that is bounded and thus can have an interior. In the philosophy of folds, that interior is a little bit of the cosmos that the monad enfolds and makes its own, while remaining connected to the cosmos as a whole. Withdrawn and opaque, the soul is not available to others to know, though they may be aware of it from the outside.[3] Thus a soul, as Adrian Ivakhiv writes, is constituted of relations that it has internalized, which are now private.[4] It may be possible to unfold some of the relations that constitute the soul of another being, through the methods of unfolding that I describe in this book. But as I will suggest, we need also to know when to respect that privacy and not pry into those souls.

Figure 2.1 is my diagram of a closed, six-monad cosmos. Soul is on the inside, matter on the outside—though as we'll see, matter and soul can be understood to be the same substance, and as I noted in the last chapter, soul-body dualism breaks down to monism in both Leibniz and Deleuze.

Leibniz, enjoying the then-new technology of microscopy, perceived the universe as packed tight with nested souls.

> Each portion of matter may be conceived as a garden full of plants and as a pond full of fish. But each branch of every plant, each limb of every animal, each drop of its humours, is also such a garden or such a pond. And although the earth and the air interspersed between the plants in the garden, or the water interspersed between the fish of the pond, are not themselves plant or fish, yet they also contain them, though more often than not of a subtlety imperceptible to us.[5]

Ensouled matter is everywhere.

Leibniz's folded dualism proposes that matter consists of bodies and is packed with spirits. Each fold has matter on one side and soul on the other. For example, the veins in marble, he writes, constitute the souls of creatures fossilized there. What is oil, then, but the liquid body of fossilized souls of animals and plants, indentured by humans millions of years later?

Matter is ensouled—or if you prefer, matter is responsive and active. This means that matter contributes its activity to the act of in-forming. Here enfolding-unfolding aesthetics is in tune with many contemporary thinkers from Gilbert Simondon to Jane Bennett and Karen Barad. Rocks breathe, exhaling carbon dioxide. In Abdeljalil Saouli and Gilles Aubry's *Stonesound* (Morocco, 2019), filmed outside the Moroccan town of Moulay Bouchta, Saouli briskly taps the mountain's chipped and creviced limestone outcroppings with a small stone—as though knocking on the earth's door—and carefully records the responding resonances. "Stone is the matter that gives me more breath," read Saouli's words in a scrolling text. "Crossing a mountain is hard, but there's breath. The body has to move more, to work more, and becomes more alive. . . . One matter eats the other one, like when you sharpen a knife on a stone." Stones and human bodies share breath: the tapping reveals the limestone's internal lungs. We animals share with limestone the calcium carbonate that firms our bones.[6]

Human souls intertwine with the souls of matter. The miners who mine the iron, and the smelters and ironmongers; the pickers who harvest the cotton, and the weavers, form soul-assemblages with the materials they work on. Beings individuate or modulate in the context of contrasts in their environment, folding in elements of their neighbors.

In Leibniz's system, monads are folded from within, by active forces, and matter from without, by passive forces, as rocks are shaped by wind and water. This would mean that matter is not alive, because it does not possess a membrane that can encompass a soul. It might contain things that are alive, but matter itself is dead. I cannot accept this! But there are a couple of solutions.

First, we can respect the life of matter by letting language speak from matter's point of view. Indigenous cosmologies attribute life to nonhuman entities, and sometimes they build this life into the structure of language, as Robin Wall Kimmerer discovers in the Ojibwe word *wiikwegamaa*, "to be a bay." "'To be a bay' holds the wonder that, for this moment, the living water has decided to shelter itself between these shores, conversing with cedar roots and a flock of baby mergansers. Because it could do otherwise—become a stream or an ocean or a waterfall, and there are verbs for that, too."[7]

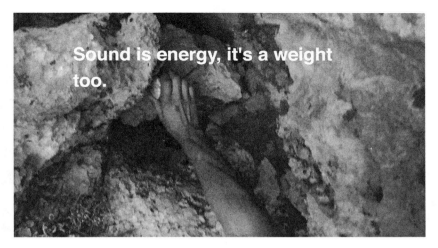

Sound is energy, it's a weight too.

FIGURE 2.2. Still, Abdeljalil Saouli and Gilles Aubry, *Stonesound* (Morocco, 2019)

A simple shift from water-noun to water-verb translates the experience of water into human language. We can define ensoulment via grammar from within modern European philosophy too, as in Whitehead's conversion of nouns to verbs. "The tree greens," the pebble pebbles. Language can express the life of all things simply by discovering verbs everywhere.

Next, since soul consists of what a body can do, we can say that anything that is bounded and does something has a soul. Thus, nonhuman entities have souls. In one of Deleuze's adjustments to Leibniz's cosmology, *perception* is expanded to *prehension*, Whitehead's term for the feeling that every entity has of the data that surround it.[8] This adjustment obviates the difference between thought and sensation. Everything prehends and responds to its environment. Things that don't "do" anything still have experience, as a chip of stone packed side by side with others experiences their pressure upon it, the passage of air and water, the changes in temperature, and registers these in changes to itself. "If life has a soul, it is because it perceives, distinguishes, or discriminates."[9] Passion, feeling while being unable to act, is a soulful way to be that is important in these pages. Rocks, I contend, are passionate.

Changing perception to prehension also obviates the difference between immaterial and material, making everything, including thought, an organism. A day has a being, Kimmerer writes, like "being-Saturday."[10] Since the soul of a thing is what it can do, ideas have souls. An idea is a monad, too, a microcosm of all ideas, as Walter Benjamin writes. "The being that enters into it, with its past and subsequent history, brings—concealed in its own

form—indistinct abbreviation of the rest of the world of ideas." Those connections to past ideas, he continues, can potentially be unfolded to infinity.[11] Words and phrases have souls that are born new with each utterance. Works of art have souls, too, because they do things.[12]

As well as assert that all entities have experience and prehend, I propose that the boundedness of rocks, molecules, and such lies in processes that bind them internally for some period of time: by habit, Peirce would say. Same for the results of human processes, such as a crowd, a book, a program, or a city. Some of these are assemblages, defined as a group of disparate entities held together by what it does; a process held together by its action.[13] The assemblage creates a territory. The assemblage (*agencement*) is a close cousin to Foucault's *dispositif*, a system of relations between disparate elements that construct the visible and the sayable, power and subjectivation.[14] The difference, Deleuze suggests, is one of axis, time or space: Foucault conceives the *dispositif* as a historical sequence, while he and Guattari conceive the assemblage as a geographical territorialization.[15] Assemblages can certainly work on both axes, for like an omnibus ("for all") and its passengers, they are held together by a common experience. "We are a multi-tissue entity," writes Bronislaw Szernyznski of the bus-assemblage, "—we are made of metal and plastic and glass and flesh and cloth and air."[16] A region is alive, Whitehead writes, "if it is itself the primary field of the expressions issuing from each of its parts," emphasizing the way that boundedness intensifies a being's internal sufficiency.[17]

Processes create temporary boundaries and, therefore, souls. Autocatalysis, the emergence of properties in chemistry, is most famously exemplified in the Belousov-Zhabotinsky reaction, in which a chemical solution at a far-from-equilibrium state produces a standing wave, an attractive fractalline pattern of oscillating colors. Identifying autocatalysis in higher-order systems, Alicia Juarrero argues that boundary conditions are emergent patterns that arise in autocatalytic behavior. We can imagine autocatalysis in psychology, for example in the ways people learn to shape their boundaries based on their experience as a child. Juarrero identifies a Spinozan conatus, a tendency to survive, in this kind of metastable coherence.[18] In my terms then, an autopoietic system, like a Belousov-Zhabotinsky reaction, has a soul. All these examples suggest that assemblages are bounded, alive, and therefore, if you agree with my reasoning, ensouled.

You don't need to be bounded by a membrane to touch or be touched. You just need to be held together provisionally, by a process. To my thinking, that makes you a soul, held together by a body. You are an assemblage of things

that come together to feel, act, and communicate, to touch and be touched. You are ensouled matter.

Naming Souls

With these encompassing, but I believe well-defined understandings of life as ensouled matter, I try an exercise to name entities according to their souls. I decided to name each soul Iyad Hallak, after the severely autistic Palestinian plant lover who was shot and killed by Israeli police on May 30, 2020. I could have named them George Floyd, after the African American man who was strangled to death in Minneapolis five days earlier by the police officer Derek Chauvin. I could have chosen the name of one of my grandmothers, Gladys Higgins, and memorialized her with this exercise, but I chose Iyad Hallak.[19]

Iyad Hallak is Iyad Hallak. The oxygen molecules clustered around George Floyd's face are each Iyad Hallak. Derek Chauvin is Iyad Hallak. I am Iyad Hallak. My grandmother is Iyad Hallak. My eyes are Iyad Hallak, my lungs are Iyad Hallak, and my breathing is Iyad Hallak. Each of my blood cells is Iyad Hallak, and each of their mitochondria is Iyad Hallak.

This morning, my cup of coffee is Iyad Hallak. Each coffee bean is Iyad Hallak, each coffee ground is Iyad Hallak, the Ethiopian woman pictured on the coffee bag is Iyad Hallak, and the coffee roastery in East Vancouver is Iyad Hallak. The process of drinking my coffee is Iyad Hallak, and drinking my coffee, I become anew Iyad Hallak. My kitchen floor, made of chips of stone, is Iyad Hallak, composed of Iyad Hallaks pressed shoulder to shoulder, which long ago were part of a mountain Iyad Hallak. My cotton shirt is Iyad Hallak, and each of its threads holds together many Iyad Hallaks, the souls of cotton plants.

My wooden chair is Iyad Hallak, each of its cellulose fibers is Iyad Hallak, and the oak trees felled for the wood are each Iyad Hallak. My keyboard is Iyad Hallak, each plastic key is Iyad Hallak. The plastic is made of an uncountable number of Iyad Hallaks, polycarbonate molecules derived from fossil fuels, and thus from the fossilized bodies of planktons millions of years old, each one of which is Iyad Hallak. Each pixel in my screen is a soul, as my friend Azadeh Emadi loves to point out; each is Iyad Hallak.[20] The computer's processor is Iyad Hallak; the Taiwan Semiconductor Manufacturing Company, which made it, is Iyad Hallak. Each atom of silicon in one of the processor's chips is Iyad Hallak, the chip is Iyad Hallak, and the unknown woman who monitored the chip's production is Iyad Hallak. The bench in

Hsinchu Science Park where she ate her lunch that day is Iyad Hallak, and her lunch is Iyad Hallak.

Laura, are you saying that a molecule is as valuable as a human being? Are you defending the rights of corporations by saying they have souls? Are you saying that robots have rights, as the debate in AI circles goes? No, I am not saying these things. I am describing a world pressed full of souls, communicating, affecting one another, coming together to become new ensouled matter. I do think it is stupid to worry about the rights of robots and corporations when human beings are treated like things and fossils are not honored as the sarcophagi of our ancestors. But we can analyze technologies as monads, soul-assemblages that enfold historical processes to accomplish tasks: more on this in chapter 4, "The Information Fold."

Soul-Assemblages

As we saw in the last chapter, all monads coexist on a surface continuous in space and time, like the infinite number of points comprising a calculus function. If you graph this function, you see that each point has its own angle on the universe the function describes. Since all monads coexist on a surface continuous in space and time, folding this surface creates new monads, new souls. These new souls are assemblages—not random gatherings, but entities defined by what they can do.

Defining ensouled matter as a process or an assemblage allows us to overcome the prejudice against humanmade things as lacking life. Useful here too is the definition of a *thing* as a gathering of interests[21]: a group that coalesces around a common concern, thus forming a kind of temporary enclosure. A city has a soul; a political party has a soul. As Afrofuturists emphasize, soul-assemblages not only encompass beings on the same temporal plane but also form alliances between present and past, and present and future.[22] Memory makes an assemblage with the past; imagination with the future.

Technologies have souls. On February 26, 2021, the Katzie First Nation welcomed the COVID-19 vaccine with a ceremony. Chief Grace George said, "We believe this vaccination has a spirit."[23] Technologies have souls in part because they encompass the history of human labor, as Marx wrote in the *Grundrisse*. As Seán Cubitt writes, "Technologies are, in a sense many indigenous worldviews would endorse, the concentrated form of the skills, knowledge, and labor of previous generations."[24] They also concentrate within themselves all the souls that contributed to their formation. The computer-science concept of logical depth, the amount of calculating time implicit in a

message, is relevant here: "The value of a message is the amount of mathematical or other work plausibly done by its originator, which its receiver is saved from having to repeat."[25] That is, a technology encloses the history of thinking that gave rise to it; even though some of that thinking is permanently enfolded. And speaking to the soul-criterion of a bounded entity that does something, Simondon writes that an evolved technology "tends toward an internal coherence, towards the closure of systems of causes and effects exerted circularly within its enclosure."[26]

I like to call the beings that come together in this way *soul-assemblages*: a set of heterogeneous but related ensouled entities that unite to accomplish some function. A soul-assemblage is a provisional, bounded fold that makes something happen. Soul-assemblages occupy a piece of local space folded by its own rules: in topology theory, a Riemannian manifold.

Soul-assemblages disperse and reassemble yet maintain consistency, their constituents ever modulating.[27] They are not necessarily "progressive." Nail usefully categorizes types of assemblage from conservative to radical.[28] I map these categories onto Spinozan adequate ideas (more on which in "Affective Analysis" in chapter 5). Some are conservative, maintaining the status quo, which can be perfectly fine: you want your refrigerator to keep chunking along. I find the concept useful even for thinking about groups of beings that are stuck in place serving an imposed order, like a microchip or an academic senate. Some soul-assemblages maintain systems of domination and extraction, and this is where human accountability enters. Arjun Appadurai's useful concept of mediant adds articulation and accountability to the sometimes-indistinct notion of assemblage. "The mediant is that dynamic assemblage of the human dividual that is available to blend with and catalyze other nonhuman mediants (and actants) to produce effective and durable patterns of assemblage." Mediants mediate the force of other members in the assemblage, both human and nonhuman. They are not individual humans in their entirety but dividuals, that aspect of a human that plays a role in an assemblage. Appadurai's example is financial traders who facilitate derivatives based on subprime mortgages.[29] To emphasize the role of human mediants prevents letting humans off the hook in their contribution to unhealthy assemblages like financial derivatives and fascist states. Of course, human mediants also participate in healthy soul-assemblages.

It's okay if your assemblage is not the most radical one and simply hums along doing its thing. Sometimes the adequate idea you and your assemblage friends are capable of stays close to your neighborhood. Some soul-assemblages deterritorialize a little. Some are capable of formidable deterritorialization.

They chew up the scenery, dismantling systems that inhibit their thriving and establishing new territories. To make a radical soul-assemblage, one that will deterritorialize the cosmos, requires a choreography so acute it is like a state of grace.

When a soul-assemblage comes together it creates a membrane, a provisional collective skin. Juan Goytisolo describes an encounter in which a mystical seeker approaches a wise teacher. In a few sentences, the elder first annihilates his visitor's sense of being an individual and then reconstitutes it, now to encompass a multitude.

> You are you and I am I, he said.
> (I looked at his djellaba's delicate, slender hood, a perfect symmetry with the point of his beard.)
> You are I and I am you.
> (He stared at me, his irises like pearls set in glass.)
> You are not I and I am not you.
> (I looked at him transfixed, drawn by the brilliance of his eyes.)
> I am not you and you are not I.
> (I felt myself crumbling under his gaze, being reduced to old copper coin.)
> You are not you and you are no other but you.
> (His gaze sentenced me to extinction, with no possible return to ephemeral contingency.)
> We stayed hours and weeks silent and still. . . . Only the buzzing of the bees maintained the nodular boundaries of the circle encapsulating us, ensured its hesitant continuity.[30]

I think of the provisional skin that soul-assemblages accrue as like that vibrational boundary of buzzing bees. It allows the beings inside to be undone temporarily in order to become more inclusive: perhaps not with the mystical self-annihilation Goytisolo describes, but in a way that expands each being's potentials in order that they may all create something together.

The soul-assemblage looks like the uncanny surface boundary of a murmuration of starlings, expanding, involuting, unfolding, transforming. The membrane that bounds a soul-assemblage has a very special tensile strength. Reducing its dimensions by one, from a fabric to a thread, Deleuze and Guattari call the shifting boundary of a multiplicity a *fiber*. This fiber stretches "in" across entities at ever smaller scales, solidifying the alliance among them—from humans to animals, molecules, particles, and imperceptibles— and "out" to the universe. "Every fiber is a Universe fiber. A fiber strung across

borderlines constitutes a line of flight or of deterritorialization."[31] You can imagine this pliable, responsive, collective skin reaching from the center of each entity within the soul-assemblage in two directions, "in" to the infinitesimal and "out" to the cosmos. The collective skin that holds us together in this temporary assemblage of souls can reshape in new formations that resist the conventional folds we're usually stuck in. With luck and skill, this assemblage may avoid getting domesticated or annihilated. Departing from the established territory in a line of flight, it may succeed in establishing a new fold.

Disquiet

The monad perceives the cosmos selectively, and in this selective unfolding from the continuum, creates its boundary. Beyond the filter of a given point of view, the infinite appears as chaos. But a small shift of perspective will unfold other aspects of the infinite to that point of view. This unfolding happens in human experience all the time, since we live in time, and when we physically change our position, learn, remember, empathize, or imagine: we include new parts of the infinite in ourselves, become a slightly different assemblage. It happens in the experience of all entities.

In the folded cosmos, as I've said, what appear to be points are really folds. In the monad's world, these folds take up space, because the monad must have a body. In the mathematics that inspired Leibniz, monads are ratios that are vanishingly small but never equal zero: they cannot be perceived but can be defined in a differential relation.

Most of the monad's perceptions are unconscious.[32] The monad's goal is to expand its amplitude or its clear region: to develop microperceptions into clear perceptions; to actualize as much as possible of the infinite that is accessible to its position in time and space. From the monad's point of view the infinite is the unconscious; yet even those things that we don't perceive are ever so dimly present to us. The monad expresses the infinite, in the form $1/\infty$; but it expresses only one part of the infinite clearly, in the form $1/n$.[33] Negative prehensions, in Whitehead's term, still have a faint subjective form of the feeling of what has been excluded.[34] In Deleuze's synthesis of Leibniz and Whitehead, there exists no chaos, but rather an organization that is imperceptible to a given monad. Entities become differentiated as "a sort of screen intervenes" that extracts perceptions *as a differential* from the murmuring field of unconscious microperceptions. These thus arise to the threshold of consciousness.[35]

Solomon Maimon (1753–1800), a Polish-Russian rabbi and self-taught philosopher, is one of the "bright stars" (as Deleuze writes) who inform Deleuze's differential philosophy.[36] Maimon's "Essay on Transcendental Philosophy" (1790) drew out the implicit connections between calculus and metaphysics in Leibniz, relating infinitesimal differences (the dx, or arbitrarily small change in the variable x, of calculus) to microperceptions.[37] Infinitesimals reach perception not simply by accumulating but through a calculus-style integration. Thus though infinitesimals can't be perceived, they can be defined by a differential relation.[38] Importing these mathematical concepts allows Deleuze to insist that—in contrast to the way we often think of the virtual as formless— "the reality of the virtual is structure," consisting of "the differential elements and relations and points that correspond to them." Like a differential equation, "the virtual is completely determined."[39] Here we find a strong resonance with Bohm's implicate order, likewise a structure for actualization.

Microperceptions—those unconscious little expressions, those feelings of disquiet that hint at our connections to other bodies—are synonymous with affects. To think of affects as virtual differences that get integrated as perceptions or thoughts helps to emphasize that what affects us (or any being) is not what looms largest in our environment but what makes the most important difference to us. It also emphasizes that most encounters occur not between two bodies but among many bodies, all the microelements that are integrated into a perception. The calculus grounding of the concept also means that integration occurs according to local points. This would explain why no two affective responses are the same, but they can be compared based on the relations that produce them.

Since affect is the capacity to enter an assemblage, we can understand that microperceptions open us up. They hint at those nonselves within ourselves, the other ensouled bodies with which we compose.

To illustrate disquiet, or the microperceptions we feel dimly, Deleuze uses the example of a dog sensing that its master is sneaking up to beat it. Disquiet, then, may be the sense that you are not safe: that your boundaries are beyond your control. For example, a sudden certainty one night, walking on a deserted street, that if I didn't start running as fast as I could, I would be raped. A plant's sense of the drying soil. The posture of a police officer approaching your car. Beings that know they are not safe must be vigilant and expand their clear region. So, I ran. Plants whose neighbors are suffering from drought thicken their own cellular walls. Indigenous and Black parents train their children how to speak to the police.

The prickling on the back of the neck, intuition (Bergson), nondiscursive experience (Ṣadrā), are the *taste of the infinite* that we experience before a perception takes shape.[40] They allow us occasionally to grasp singular events occurring in the magma-like plane of consistency (to use Deleuze and Guattari's term). But most of us humans' perceiving and thinking happens on a plane that I will call information, which captures a little bit of chaos for us.[41] Monads seek to expand their amplitudes by bringing more of those disquiet sensations into perception and knowledge. That is our perfectibility, our goal in life. As we saw, a monad is necessarily imperfect, so as not to compete with God. It is limited, Leibniz writes, by its degree of its receptivity to divine omnipotence, omniscience, and goodness, which constitute the being's subject or basis, its perceptive faculty, and its appetitive faculty or desire for the good.[42] These limitations are necessary for the substance's actions to be compatible with others.' Otherwise, its perfection would crowd out other monads' capacities for perfectibility, in a world where monads must be compossible.

Unfortunately, then, in Leibniz's closed cosmology only certain souls are called to carry out the joyful work of unfolding and actualization. As "God's attorney" (as Deleuze calls Leibniz) says, the best of all possible worlds is a convergent series, meaning that all the infinitesimal souls' amplitudes must add up to 1.[43] Next to those monads who succeed in expanding their amplitude, Deleuze writes, there remains an infinity of other monads that "has not yet been called and remains folded; another infinity of them has fallen or falls in the night, folded onto themselves; while another infinity has been damned, hardened in a single fold that it will not unfurl."[44]

The ugliest concept in Leibniz's beautiful cosmology, then, is the concept of the soul that is not allowed to grow because that privilege has been extended to other souls. The damned, in this notion, are those who did not have the opportunity to expand their amplitudes. The souls of the damned have room for only one thought, which despite its ugliness adds to the necessary harmony of the whole: "I hate God."[45]

The Vinculum, the Dominated Monad, and the Soul-Assemblage

There is some hierarchy in the soul-system I am describing, between entities born with souls, like people, cells, and cotton plants, and entities that gain souls by being assembled, like spoons, software, and supermarkets. Some souls are denser and capable of greater connectivity, for good or ill, such

as the soul-assemblages that support a dominant monad like a school or a government. I do put humans at the top, partly in a recognition of global human rights, but also to recognize the role of human mediants, in Appadurai's term, in complex assemblages of power. The folded cosmos is not a completely flat ontology.

All souls abide in the effects they have, that is, in the world's memory of them. That's Whitehead: immortality is continuing to be prehended. Sentimentally, I like to maintain Leibniz's idea that born souls never die, even when they are squashed to smithereens and re-formed, though this may not hold up to scrutiny.[46]

Leibniz's term for that membrane that holds monads together is *vinculum*, whose entwining vinelike connotation you can hear: a unifying bond, also a mathematical term for a mark that links a set of variables. The vinculum is the interior membrane between the monad's inner surface and its dominated monads.[47] It is necessary for a monad to own others, he reasons, as our bodies enfold the organs necessary for us to live. My heart, brain, uterus, and blood vessels are working for me, so they're "mine"—though the mitochondria, bacteria, viruses, and other complete organisms living inside me might have other opinions regarding this contract. Later monadologists would develop the point that monads include both organic and inorganic objects. James Ward (a contemporary of the monadologist Carr) suggests that monads comprising inorganic objects tend more to self-conservation; human societies, for example, are conservative dominant monads.[48]

A striking paragraph in Deleuze's interpretation of the *Monadology* places ownership in historical context. The Baroque, Deleuze points out, is associated with capitalism because it is linked to a historical crisis of property that arose with new machines, the discovery of new living beings within the organism—and, in an implicit point that Glissant develops, imperial claims to own other nations and peoples. "A monad has as its property not an abstract attribute—movement, elasticity, plasticity—but other monads, such as a cell, other cells, or an atom, other atoms," Deleuze writes. "These are phenomena of subjugation, of domination, of appropriation that are filling up the domain of having, and this latter area is always located under a certain power." Similarly, "To have or to possess is to fold,"[49] underscoring that enfolding is a form of possession.

The knowledge that one's life is predicated on—we could say, populated by—other, dominated lives, makes it harder to say, "I *have* a body," "I *have* a plantation," or "I *have* an idea." Predication itself, the logical and grammatical presumption that predicates "belong" to a subject, comes into question.

In short, everything that makes us what we are, everything we have, comes from outside us and is only provisionally enclosed within our membrane. All of us humans, and most other complex entities too, are soul-assemblages that depend for our subsistence on provisionally enclosed others, acknowledged or not.

Leibniz and other Enlightenment philosophers had the leisure to spin their transcendental thought systems because, from the mid-fifteenth century, they, their nations, and their patrons were amassing wealth in the Americas by using the labor of enslaved African people and their descendants to cultivate sugarcane, cotton, tobacco, coffee, and other valuable crops and to mine metals and stones. These plantations and mines occupied land expropriated from the Indigenous peoples of these continents, often through mass murder. Therefore, the historical context for the ugly concept of the soul that is not allowed to grow—the reason Leibniz's cosmos must be closed—is the slavery and genocide that underwrote the so-called Enlightenment.

Slavery is the implicate order of both capitalism and the modern subject.[50] Modern liberal individualism's theory of the free and self-determining subject constructs subjects by disavowing the economic, social, and historical relations that actually constitute them.[51] It ignores the feelings of *disquiet* by which the world signals its presence within the monad. Dependent on the captive labor of enslaved people, wealthy people of Europe (and, later, capitalist colonists of the Americas) had the leisure to cultivate and refine themselves with education and the arts. But colonialism's fundamental disavowal of material and financial connectedness means that the radiant visions of their souls were at odds with the material beholdenness of their bodies. In a sickening irony, the European philosophical concept of the subject coincides historically with subjection for enslaved and colonized people, as Étienne Balibar analyzes.[52] Liberal subjects can only imagine themselves to be free and independent by thoroughly repressing any awareness that they depend on the subjection of others. "Lurking behind the disembodied and self-possessed individual," writes Saidiya Hartman, "is the fleshy substance of the embodied and the encumbered."[53] The beautiful world reflected by these enlarged souls was illusory. Enlightenment thought, including that of Leibniz, is built upon prodigious acts of disavowal.

My musician and ethnomusicologist friend Juan Castrillón questions Leibniz's deployment of calculus to justify imperial expansion. He writes:

> There was a moment in European history (it also had consequences in its musical thought) in which the world and its image were turned into a *mathesis* in which geometry and other theoretical schemes based on

sensorial tenets were deeply reformulated for multiple reasons, that also include politics understood here (broadly speaking) as the expansion of *one* kind of world by devouring others.

Do we make worlds to fit in? Do we make worlds different from this one in which there is not room for me-us? Do we make a world because the previous one was destroyed? Do we make a world because a nomadic soul imposes such contingency? . . . Do we make a world for others? Do we destroy the world of others to refurbish ours? . . . Do we. . . .[54]

Castrillón's questions raise the politics of appropriation in a seemingly enlightened gesture like expanding one's experience to include that of others. This reminds us to respect boundaries, unknowability, and opacity.

To reiterate, in Leibniz's calculus-based cosmology what appear to be points are actually folds: infinitesimals or singular ratios that imply the whole cosmos from their position within it. Souls must be able to expand their amplitude, to clearly reflect more and more of the universe. This concept affirms the ethics of acknowledging interconnectedness. However, as we saw, if some souls are to expand, others must remain infinitesimally small.

If we are to maintain the best parts of Leibniz's folded cosmology and lose the hateful notion that some souls are necessarily damned not to expand, some tinkering is necessary. For starters, the soul-assemblage reconfigures the vinculum as a temporary boundary and ownership as temporary appropriation. It also integrates the capacities of dominated monads to organize matter.[55] Furthermore, while most of the collective experience of the soul-assemblage is unconscious from its dominant point of view, it's possible for the soul-assemblage to integrate ever more of the experiences of its constituent monads.[56] This could lead to the soul-assemblage's destruction, in a rebellion of its constituent souls. Or, if the soul-assemblage is basically healthy to begin with, such an integration can lead to a gorgeously interconnected collective consciousness that gives maximal expression to the experience of each internal monad.

Object or Monad?

Some souls and soul-assemblages appear as fetishes. As I mentioned in chapter 1, a fetish is a seeming object that is volatile because it internalizes relations. It only looks like an object to those who can't perceive the relations. As Peirce observes, "Viewing a thing from the outside, considering its

relations of action and reaction with other things, it appears as matter. Viewing it from the inside, looking at its immediate character as feeling, it appears as consciousness."[57] The enfolded soul implies the entire world. Some soul-assemblages appear on the outside as objects but on the inside are collectives working creatively below the radar of dominant points of view.[58]

Thinking further about the interiorized power of entities that appear to be objects, I suggest that rebellious souls are difference engines. They interiorize the constitutive differences of a system and go to work on them. What appear to be objects, Fred Moten writes, maintain a private reserve that is effectively performative.[59] This performativity of seeming objects relates well to what Deleuze terms centers of envelopment, "local increases of entropy at the heart of systems."[60] Difference engines, put to work to constitute the individuation of something larger or more complex, sometimes rebel. For example, my usually compliant blood sugar levels go out of whack, or my body fails to fight an infection. Or exploited Amazon warehouse workers rise up and unionize. Centers of envelopment know the system better than the system knows itself; they express its sense, as slavery expresses the sense of capitalism. They are thus highly volatile "dark precursors" that may erupt and turn the system inside out. The dark precursor is difference in itself; it is what relates heterogeneous systems.[61]

We've seen that in process approaches, objects maintain a certain interiority and mystery. African-diaspora philosophers bring additional weight to these questions by examining the interiority of the human object, the chattel slave: that is the seeming object Moten is writing about. Enslaved people are treated by both commerce and philosophy as fungible objects. A chattel slave is a being consigned by law and language to the status of a thing, but whose living voice corrodes those systems from within.[62] Thus weighted with history, process philosophy's treatment of relational becoming becomes adequate to account for apparent objects that vibrate with internal connections, without falling into a too-easy ontological flatness. Every object, seen from inside, is a subject, and the heart of every subject pulses with relations.

Moten's argument, like Glissant's defense of opacity, resonates curiously with object-oriented ontology, which argues that objects maintain an utterly inaccessible interiority. It is curious considering the general eclipse of theories of the subject, outside historical critiques of identity formation. In object-oriented philosophy, the psychological interiority that people are no longer supposed to have has been transferred to nonhuman entities. Humans are just some of the atoms jostling around in the universe. It seems weird to celebrate a flattened ontology, be it the relational one of process philosophy or

the object-oriented one, when the Western liberal notion of the subject endures not-quite-deconstructed, and legal systems based on it remain intact. If the theory of the subject be cast aside, let it be with the contemptuousness of African-diaspora antihumanism. To borrow Kodwo Eshun's words, Blackness "deliberately fails all these Tests [of humanity], these putrid corpses of petrified moralism; it treats them with utter indifference; it replaces them with nothing whatsoever."[63]

Enslaved people, though treated as objects, enfold the entire world. That is what Glissant argues in a powerful homage to the kidnapped Africans who plunged into three abysses, three absolute unknowns, in the Middle Passage: the slave ship, which he compares to a womb; the vast sea, entombing the slaves who were thrown overboard; and the new land. Their descendants weave a new knowledge: "Not just a specific knowledge, appetite, suffering, and delight of one particular people, not only that, but knowledge of the Whole, greater from having been at the abyss and freeing knowledge of Relation of the Whole."[64] From three centuries of crushing enslaved existence, Glissant writes, new kinds of music arose—spirituals, blues, jazz, calypso, reggae—"the cry of the Plantation, transfigured into the speech of the world," creating modernity itself. "When this speech took root, it sprouted in the very midst of the field of modernity: that is, it grew for everyone. This is the only sort of universality there is: when, from a specific enclosure, the deepest voice cries out."[65]

The descendants of enslaved people, then, are most expansive monads, who fully encompass the world's inextricable interconnectedness. Enfolding in their personal history the economic history of capitalism, launched as it was by the slave trade, African-diaspora descendants reflect the world more completely than the descendants of the powerful. Put in Leibnizian terms, people of the African diaspora are in a privileged position to integrate microperceptions. In order to survive, dangers and opportunities that are below the threshold of other people's awareness must be brought into consciousness. Glissant celebrates this hard-won knowledge as world knowledge. But he also, as we've seen, asserts the right to opacity.

In our time the relationships are much the same as in Leibniz's. A few of the earth's people, who have access to healthy food, clean water, health care, great educations, plenty of leisure, therapies, travel, and the flowers of the arts "self-actualize" and become seemingly beautiful, spiritually well-developed individuals with amplified souls. But again, their soul-amplification depends on the unacknowledged lives of countless human and nonhuman others who labor for the benefit of the few, and it is illusory if it does not include those souls. This is good old Marxist false consciousness. Include nonhuman souls

and you have the Black Anthropocene, in Kathryn Yusoff's analysis relating geological transformation to the history of chattel slavery.[66] The souls of plants, like the boutique organic vegetables harvested while they are still babies, rare tinctures, and the plants-turned-rock of fossil fuels. The souls of metals, like the copper and rare minerals needed to miniaturize digital circuits in fancy devices. The souls of rocks, torn from the earth to line walls with marble and act as healing crystals. That's a lot of souls harnessed by the privileged person's vinculum but invisible to their soul!

The capitalocene is itself a toxic soul-assemblage that *includes* the coalitions gathered to do battle with it. Aligning ourselves with cosmic powers, we bear witness, struggle, and ultimately must destroy the soul-assemblages that have given us poisonous nurture.

Singularities, Local Manifolds, and Unfolding Differently

Singular connotes something that is solitary and separate; extraordinary and therefore precious. Singularities thrive on the face of the infinite. They appear chaotic, but they organize the virtual locally. They hover below the radar, resist appropriation, store up energy, and precipitate unforeseen events. In an unstable system, tiny differences may give rise to bifurcations, supporting an emergent causality that, as Isabelle Stengers points out, dispenses with the final causality of Leibniz's God and the closed world that it requires.[67]

Singularities' charming other name, *haecceities*, connotes an intimate presence: Latin *haec*, or here, here it is. I love encountering singular events in my everyday life: raindrops have never made exactly this pattern on a window before; nobody has repaired a broken chair with rags, glue, and a pencil the way I just did; the youth I saw downtown today chatting with a friend had colored their shorn head, under a beige toque, a pretty pale magenta, and was carrying a plastic bag of remarkably globular green grapes. Absolutely singular! But also, the person figures in the interference pattern between fashions in hair color, the market for grapes, and uncountable other patterns that make up the common wave on which we all ride. Moments like these are depicted with such tender respect in *Meu Querido Supermercado*. I feel like Leibniz and Princess Sophie in the park, admiring how each leaf is distinct from every other, in a foliate illustration of the principle of the indiscernibility of identicals.[68] (And of course leaves, like all of us, get even more distinct as they grow older.) To me such singular experiences are life itself, the triumph of the uniquely real against mass-produced fabrications. This book is full of loving descriptions of such singularities, even seemingly

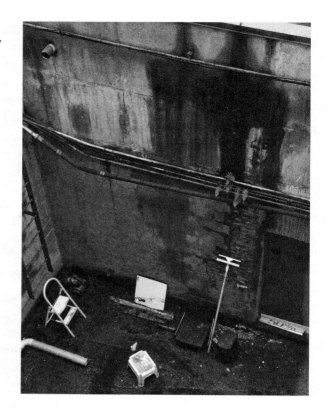

FIGURE 2.3. A field of singularities: view from my apartment window. Photo by author.

insignificant ones, that I consider to be examples of unfolding differently: unfolding against the grain of dominant and instrumental folds, drawing out previously unrecognized fields and patterns.

Especially as people rightly worry that capitalist culture imposes uniform experiences, or the mere semblance of difference, it is important to keep in mind that singularities are actually more common than uniformity. Doing so rewards curiosity and openness. It encourages more attentive kinds of coalition building. It encourages hope that difference and individuation ultimately can't be controlled by human powers and institutions: issues that will become more pointed in the chapter "The Information Fold" and, indeed, the rest of this book. Macroscale events, like voting, effect massive change, but internally they are replete with singularities—what someone had for breakfast on voting day, how long they waited for the bus.

More rigorous conceptions of singularity both impose stricter rules and yield greater gains. They allow us to grasp the sufficient reason for the singu-

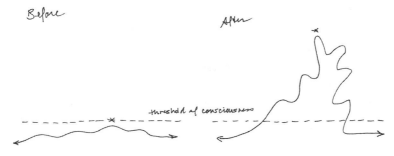

Before After threshold of consciousness

FIGURE 2.4.

lar, or how it arises from local situations and may open onto more capacious folds. They show that singularities organize collectives, which we can think of as local manifolds or, if you like, soul-assemblages.

Singularities are qualities that are not fully actualized: flashes of attraction, promise, or danger; indications of unknown patterns; signs of what we might become. They are those points of folds that microperceptions detect. Little perceptions grasp differential relations and singularities before they arise to consciousness. They are where the virtual twinkles in the actual. In our uniqueness, we monads present one another with singularities. When you meet a singularity, you may be able to tug on it and draw out a new fold. It will actualize in your space, to your point of view. (In Simondon's terms, singularities are the events that occur when an entity individuates in relation to its milieu.) Opacity, "subsistence within an irreducible singularity," is the gleam of another's mysterious interiority.[69]

Figure 2.4. is my diagram of a singularity being drawn out to a point of view and pulling a field, which includes the point of view, along with it.

Most perception is confused *and* clear, Leibniz writes. We perceive clearly what is most evident to us, but we are confused as to where it came from. In contrast, microperceptions are distinct *and* obscure, the sharp pricklings of something that is real but enfolded.[70]

In mathematics, singularities are immaterial. In the language of monadology, however (the monad must have a body), singularities become actualized in the encounter with your body. That's the affect of unfolding, the sense of something beyond you emerging within you. We feel these singularites, these unfoldings, as disquiet, exhilaration, and other kinds of energies.

In mathematics, the singular is what escapes the regularity of the rule (for example, the four points of a square are singular). Singularities in differential

calculus are points of increase and decrease in a complex curve, while ordinary points constitute the region between them. Deleuze relates the mathematical conception of singularity to other points that mark a change of phase, like boiling points of liquids, bottlenecks, and "points of tears and joy, sickness and health, hope and anxiety."[71]

That immanent structure may be a smooth space, space that is discontinuous and internally determined, whose model Deleuze and Guattari derive from topological theory.[72] Riemann's manifold is a surface defined by local relations that are independent of higher-dimensional conditions. It is constructed by prolonging a singularity over a series of ordinary points until it reaches the region of the next singularity. In topological space there are two types of singularity: attractors within a level and phase transitions between levels. In topological space, singularities act as attractors for trajectories, which model possible states of complex dynamical processes.[73] A torus, for example, is a little piece of internally determined space. In the topological framing, the virtual entails specific processes for actualization: in my terms, manners of unfolding.

Singularities structure a "possibility space" for different actualizations, Manuel DeLanda writes. "A virtual multiplicity can be divergently actualized in both organic and inorganic molecular populations."[74] For example, threshold effects, the way a population's behavior suddenly diverges in far-from-equilibrium systems, occur in both embryology and chemistry, as in the Belousov-Zhabotinsky reaction. Thus, the actualization of singularities is always historical and occurs in a given milieu.

Singularities live on the face of the infinite. They are immeasurably richer than the generalities and information patterns extracted from them—even, I assert, when those patterns are detected by generative algorithms and other sensitive AI tools. However, those patterns are what capitalism and other engines of dominant folds privilege. Unlike the equivalencies imposed by capitalism, the commons are what distinguishes, as Antonio Negri writes.[75] So how do singularities, these seemingly isolated entities and events, cherished in themselves, precipitate new ways of being? How can all these infinitesimal experiences come together with some kind of political power? How do individual unfoldings become collective acts of *unfolding differently*? In math, as we saw, singularities are those points that precipitate a transition. Seems easy! It's striking how much structure and agency these concepts borrowed from topological theory lend to the conception of the virtual. But are they, as it were, scalable? How do singularities effect change in organic and molar-scale situations? To be more than a twinkle in the eye of the infinite, singular

entities need to come together with some kind of resilient power. My answers group around subversion, practice, assembling, and unfolding differently: actions that produce resilient power.

First, singularities, and the individual acts of unfolding that they precipitate, add grain and noise that interfere with dominant folds. They disturb the signal. These are already creative and subversive acts. Decay is a process of singularization, especially in the commodified world. It adds noise, as with the shopping arcades in whose decay Benjamin observed time and matter reterritorializing the capitalist spectacle: a process that occurs everywhere and always.

Next, practice. This book offers ways to train our bodies and minds to detect points of folds or singularities and to unfold differently. In everyday life, becoming more singular ourselves, we create more points of contact, become more real, and get better at entering relations with human and nonhuman others. As we individuate, we create a milieu for one another to individuate in; we shape one another. Artworks, singular soul-assemblages themselves (most of them anyway), model ways of being in the world that are more open to singularity and to forming soul-assemblages. Artworks are perhaps the most willful of soul-assemblages because they are born of experimentation more than necessity. Artists are freer to pull together disparate elements that might not survive in another medium, and test what they can do. Art practices can inspire a taste for singularities, shake off forms and clichés, shape our individuation, and perhaps prepare us for political moments of collective singularization.[76]

Next, assembling. Riemannian space models the organization of a soul-assemblage (or any assemblage). Being locally organized, the soul-assemblage has some measure of immunity from outside forces. It can organize internally and individuate collectively. The Riemannian manifold is a model for local self-organization that can be extended to the larger-scale, physical world. Here's how Sha Xin Wei praises topology as a model of creative lived experience that resists being reduced to information:

> We have a non-ego-based, number-free, and metric-free account of experience, that respects evidence of continuous lived experience but does not reduce to sense perception or ego-centered experience. We have an essential concept of continuity both as a quality of lived experience and as a mode of description of such experience. We have here the seed of an approach to poiesis and expressive experience that is "non-classical" in the senses of quantum theory and measure theory, avoiding

recourse to stochastic methods, statistics, and informatic sweepings of the life world under the rug. And we have the possibility of a radically de-centered, de-anthropomorphized concept of experience and cultural dynamics.[77]

At cultural levels, a topological approach embraces singularities, human and nonhuman, and identifies the manifold on which they individuate and assemble.

Singularities are points of folds. Apparently separate, they may be glimmers of an enfolded structure, like Bohm's implicate order but at more macro scales. For example, the Veran supermarket in *Meu Querido Supermercado* is both a soul-assemblage and a singular intersection of economic, social, and psychic orders, including agriculture, supply chains, wage labor, belief systems, and widespread hopes and anxieties.

Next, emergence. Singular beings are autopoietic. As they self-organize, entities become more internally individuated and gain more freedom from their environment: this occurs at our molar scales too. The capacity for self-creation within nonlinear dynamics is a topic that has itself emerged and proliferated in recent years and flowed from the sciences into philosophy and cultural theory.[78] Like the emergent properties that occur at the levels of chemistry and embryology, emergent causality turns around the actualization of singularities at human cultural and institutional scales as well. DeLanda's *A Thousand Years of Nonlinear History* identifies singularities—attractors and bifurcations—at every significant turning point of human history.[79]

Attending to singularities, we create knowledge that is more in tune with the rhythms of the infinite. When we begin to create knowledge by following the grain of singularities, minor sciences develop: ways of knowing that derive from the milieu. Deleuze and Guattari's evocative paragraphs about the way wood carvers respond to the qualities of the wood—grain, porosity, density—exemplify this kind of cooperation with and yielding to the emergent properties of matter, the "*singularities* that are already like implicit forms."[80] "At any rate, it is a question of surrendering to the wood, then following where it leads." Metallurgists respond to the vitality of matter, and this connects them to the cosmos, for metals are everywhere. Deleuze and Guattari's central example is the Dogon miners and metallurgists of Mali who follow the matter-flow of iron and work with its singularities, such as the way iron ore composes with sedimentary rocks and iron's capacity to be smelted and tempered. This kind of knowledge does not impose form on matter but collaborates with matter's latent powers. "Matters have a certain

calling," as Henri Focillon writes, which we answer by listening to matter's singularities.[81]

While much of scientific knowledge is shaped by dominant instrumental folds, scientific practices can unfold differently by staying closer to the points of emergence. Stengers defends scientists whose research is under threat because it does not serve instrumentalized science: "useless" experimental practices that don't feed the current biotech investment craze. She suggests that the best collective form that would protect such singular experiments is divergent practices that make rhizomatic connections with one another.[82] All practices, not only scientific experimentation but "irrational" practices like tarot reading, Stengers argues, constitute the field of singular knowledge. Thus, the same principle holds for other research fields.

Allow singular practices to thrive and they will sculpt one another, sharing methods of attending to and encouraging emergence. They may create a common territory, that surface defined by local relations, through assiduous work of local unfolding. Or they might create one great big singular fold. These two operations on singularities, Deleuze writes, work conversely with love and with anger. Gathering together fragments entails, in mathematical terms, specifying the fields in which they converge. It is a loving act, but it is also susceptible to error and stupidity when we confuse what is singular with what is ordinary. By this standard I would seem to be erroneous, at best, for I find singularity everywhere. Maybe not, though: everything becomes singular, either in time, or from a given point of view. This point underscores the importance of decision and timing in determining what to unfold, a topic I will return to when surveying manners of unfolding.

On the other hand, condensing all the singularities precipitates a new world that they would inhabit. It is revolutionary: Deleuze cites Lenin as one whose ideas have such power.[83] It is the work of fabulation, refusing this world for another that does not yet exist.

The Open Cosmos

Deleuze admires Leibniz's creative practice of inventing concepts, "the most exuberant concepts, the most disordered, the most complex, in order to justify what is."[84] Leibniz's deferences to God as Architect, Governor, and Monarch of the best of all possible worlds both stimulate the *Monadology*'s exuberant concept-production and constrain the resulting concepts. The "justification of what is" does not hold up against the creative potency of the concepts themselves. For the most part Deleuze does not deconstruct the

Monadology but completes it in a better way, by unfolding certain concepts, such as sufficient cause, the differential, and incompossibility, and folding away others, such as final cause and harmony.

It's possible to retain the beautiful concept of the monad without the constricting closed cosmos that limits its expansion. Opening Leibniz's sublimely closed, intensively interfolded cosmos just requires a few conceptual steps: deal with the mind-body problem; let God be banished or transformed to make causality immanent so that monads can self-create; and lose the notion that this is the best of all possible worlds.

First, the mind-body problem. Leibniz's folded dualism, and Carr's monadology with a parallel atomist physical world, may not satisfy contemporary inquirers who want to think of everything as one stuff, without a division between material and immaterial. But there are ways to close the gap. But asserting that practically every entity is a monad, which I did above by expanding the definition of a boundary, solves the mind-body problem to my satisfaction.

In addition, Deleuze's Whiteheadian solution of swapping perception for prehension diminishes the difference between thought and sense perception. We also saw earlier that the difference between soul and matter comes down to a matter of folds, with monads constituting the bodies of other monads. If the difference between the monad and its body is nothing but a fold—which Leibniz, in Deleuze's interpretation, contends—we still get to savor the contrast between inside and outside, souls infinitely folded in matter, which I've argued is a productive way to think about the cosmos. We can keep the best thing about having a soul: the monad's interiority, protected by its provisional boundary. We can retain the creative concept that the monad is interconnected with the cosmos through its body and actualizes the cosmos through its soul. Soul-assemblages, those monadlike collectives, retain these privileges too.

Next, an optional step in opening the closed cosmos is to ban God, or at least the transcendent God that Leibniz requires to maintain the best of all possible worlds—which Whitehead critiques as an "audacious fudge produced in order to save the face of a Creator."[85] Monadism doesn't need God, Carr contends. If there is a God, it is not transcendent but immanent, the ever-changing summation of the changing cosmos. This would be God as "a living mirror of the universe," he writes, "an infinite individual, the complement of finite individuality." In short, Carr points out, it is the God of Spinoza.[86] Like Carr's immanent monadology, the cosmos Whitehead models is additive: every being's creativity expands the cosmos. Deleuze will say that God is replaced by Process.[87]

We don't need God to constitute our world. We have one another, and each of us, by including the world, is infinite. Remarkably, the monadology with an immanent God, or none at all, turns out to maintain all the most interesting aspects of Leibniz's system.

Next, causality needs to become immanent so that monads can be free. This happens by privileging the monad's interior space: a space of free action, an internal predicate, and my favorite, a set of local, interior differentials. Again Deleuze, like Carr, finds a way to make causality immanent within, not despite, the nested types of causality that Leibniz constructs. It does not contradict Leibniz's logic for ultimate causality to pass from sufficient cause, that series of causes grounded in an external God, to autopoiesis or emergent causality: the self-creation of the monad. It just requires a shift of emphasis.

The next and most difficult step is establishing the monads' freedom. Being a microcosm, as we saw, every entity's actions enfold the history of their causes *and* the future effects of it. Again, that's the principle of sufficient reason. In Leibniz, this cosmic connectivity is hampered by pre-established harmony, because God sets the whole chain of events in motion. All entities are predicates—however complex in their manifoldness—of God, the one true subject. To liberate individual monads from God's hold on them, Deleuze, like Carr, discovers a predicate within the individual subject. We are free, he argues, when we fill our amplitudes: when we act in a way that expresses the state of our entire soul at a given moment, in the living present.[88] This is not an easy thing to do, but it is something all us entities can strive for and achieve now and then.

Here's another way to define the monads' freedom of action. We saw that at the heart of a complex fold are interiorized, temporarily tamed differentials, "local increases of entropy at the heart of systems."[89] Differential calculus shifts attention from the essences or definitions of beings to the inessential, those infinitely small differences that we palpate when we are contemplating some act or other. "The inessential refers here not to what lacks importance," Deleuze writes, "but, on the contrary, to the most profound, to the universal matter or continuum from which the essences are finally made."[90] Small differences open a creative interval.[91] In these inessential moments, with the restlessness of the infinitely small,[92] monads become difference engines, creating themselves independently of God's plan for them.

The restlessness of small differences is my favorite solution to the monads' freedom, because it suggests where the monads get the energy to act freely. Not from a deep interior of the self, but from one another, and from the continuum we all constitute.

In the open cosmos, monads can expand all they want—all the way to infinity—*if* they can act freely. With just a few tweaks, Deleuze merges Leibniz's monads with Whitehead's actual entities. Actual entities share monads' defining characteristic of infinite inclusion and the capacity to expand their prehension of the cosmos, but they are not burdened by calculus and other baroque decorations. As Whitehead writes, "The very possibility of knowledge should not be an accident of God's goodness; it should depend on the interwoven natures of things."[93]

I must say I find it a bit of a letdown when, at the end of *The Fold*, Deleuze swaps Leibniz's folded cosmos, elegantly retrofitted for immanence, for Whitehead's simpler interwoven one. It's like preparing a spectacular croquembouche only to lose the bake-off to a strawberry shortcake. Anyway, with and without Whitehead, now every monad in the cosmos has the opportunity to creatively expand its clear region—or in Whitehead's terms, to positively prehend and synthesize the data in its environment to its satisfaction.[94]

The metaphysical freedom thus secured has practical effects. The more the monads develop in these self-creative intervals, the more autonomous and stable they become. Nonlinear dynamics suggest that the more complex an entity's interior structure is, and the more varied its behavior, the more it can become autonomous of its environment.[95] At the level of institutional and social organization, Juarrero points out, autopoiesis has implications for the ethical action of larger entities, such as families and governments, to creatively self-organize instead of being bound by outside rules. The more we monads and soul-assemblages individuate, the less subject we are to predefined rules, whether of (the now minimized) God or of earthly organizations.

A final principle that must be jettisoned is that this is the best of all possible worlds. On the last page of *The Fold*, Deleuze opens Leibniz's closed cosmology, converting Leibniz's convergent series, the supposed best of all possible worlds, into a divergent series that no longer needs to add up to 1. The ethical reason for this ontological sleight is to liberate all souls to expand their wavelengths, at the expense of an overrated divine harmony. (Carr, Ward, and other early twentieth-century monadologists also dispensed, using other arguments, with this principle of Leibniz.)[96]

The pre-established harmony of Leibniz's cosmology depends on each monad integrating differentials as best it can. Shifting from the mathematical to a musical model of integration, Deleuze lays out four ways monads can do this in a closed universe, in terms of the harmonies of Baroque music. At the highest degree, a monad achieves major accords that integrate all

the anxious differentials and reflect the universe in a complete way that is stable and can proliferate. This can even be achieved in the pain of the martyr, whose sacrifice is inseparable from knowledge of the cosmic order. At a lower degree, monads produce minor accords when differentials can only be integrated temporarily, as when our simple pleasures produce brief moments of peace. Lower still, dissonant accords are integrations achieved in pain, as with the dog about to be beaten. To resolve dissonance entails searching for the major accord with which the pain is consonant. Lowest of all is the single harsh note sung by the damned soul. Yet together, their music produces an exquisite harmony in which each voice is essential.

Now it is clear why Deleuze needs to dispel Leibniz's harmonic universe. Why should monads suffer to prove that God has created the best possible world? What if you don't want to accept your pain, say if you are an abused spouse or exploited tenant farmer? Do you need a new universe? Or just an open one?

Monads mirror the cosmos by being the reciprocal of the infinite, $1/\infty$. In Leibniz's closed cosmos all the monads' amplitudes are forced to add up to 1. In the open cosmos, there is no limit what they can add up to: $1+n$ to infinity. When each monad can expand its amplitude as far as it wants, more and more monads express a larger proportion of the infinite. The cosmos bulges with infinities!

Figure 2.5 is my diagram of six healthy monads in an open cosmos. You can imagine them expanding and contracting, complicating, and changing their amplitudes in time.

As you can see, in the open cosmos, point of view expands, as the membrane that distinguishes the monad from others sometimes becomes a shared boundary. These experiences of expansion can be traumatic if you can't be sure where your boundary ends and another's begins. I recommend a Spinozan health check to see whether the organism can survive this process, alone or in coalition with others.[97] Meanwhile, the monad or soul-assemblage can withdraw to its safe space, confer among itselves, and take stock of what it is becoming.

In the diagram, one of the monads is actualizing (enfolding, prehending) a far-distant virtuality. A single monad, integrating its differentials or feelings of disquiet, may actualize a perception of which its neighbors are not currently capable. If other monads enfold that far-distant virtuality in turn, they will enlarge its actuality in the cosmos, building a cosmic soul-assemblage. That expansion is consistent with Leibniz's cosmology and is one of the most exciting reasons to maintain such a cosmology.

FIGURE 2.5.

But sometimes in the open cosmos each monad finds not only that it enfolds multitudes, but also that those multitudes can't exist in the same universe. In a final consequence of Deleuze's metaphysical adjustments, achieved by retrofitting modern mathematics onto Leibniz's calculus-based cosmos, monads can also inhabit other cosmoi. For Leibniz, the differential only admits compossibles, perceptions that harmonize the monad's point of view with the whole. Two centuries later, Raymond Poincaré (1860–1934) demonstrated that a continuity can be established across divergent series. For example, series that are asymptotic to an axis (i.e., they approach it by a vanishingly small difference) converge on the same point.[98] A monad can jump across that vanishingly small difference into an incompossible cosmos, for example, from one in which Adam sinned to one in which he didn't. In this case, the muttering of the damned soul turns out to be a portal to another, more *heimlich* cosmos, in which that soul can expand. That questing monad will enfold a piece of a world incompossible with this one.

Figure 2.6 is a diagram of six healthy monads in two incompossible cosmoi. One monad, the erstwhile damned soul, whose amplitude is quite small in one cosmos, is actualizing a virtuality from another cosmos. You see that this action breaks the boundary of the cosmos and brings two cosmoi together,

FIGURE 2.6.

across this monad.[99] Deleuze advocates that each monad enfold pieces of divergent cosmoi, giving not one cosmos but a richly textured chaosmosis.[100] As a result, monads can no longer be microcosms of the whole, because the whole includes divergent cosmoi.

The exhilarating movie *Everything Everywhere All at Once* (Daniel Kwan and Daniel Scheinert, 2022) imagines the multiverse as a reserve of potentials for this universe. In this universe Michelle Yeoh's character, Evelyn Yang, is "living her worst life." She is unactualized in all her pursuits because her selves in parallel universes are masters of them, absorbing all her capacities in this one. Elsewhere she is a kung fu master, a great chef, a wise rock, a hotdog-fingered lesbian beloved. Evelyn is like Leibniz's damned soul, only across universes, suffering in order that other Evelyns be able to enlarge their amplitudes.

Trusting that things may be better in other cosmoi can inspire, but it can also lead to lassitude. In my early adult years, I indulged a lazy belief in

reincarnation, telling myself I would get around to doing this or that thing in my next life. After drifting along in this way for some time, I was on the brink of making a rashly idealistic commitment. My life changed one November morning in 2002 when the disused landline rang in the apartment where I was staying in Beirut. It was my mother, making an expensive long-distance phone call to urgently discourage me from my plan of action. "Laura," she shouted, "you have only one life!" After I hung up, I felt woozy. For the first time I understood that this universe, this life, is the only one I have to work with.

It's immensely appealing to imagine that the solutions to earthly problems are to be found in other universes. I'm not advocating it, though. First off, for Bohm and Hiley the many-worlds interpretation of quantum physics is unnecessary.[101] Next, our sublunar resources are limited, but they include the past, the imagination, and our fellow monads. After Martine Syms and Patricia Pisters, I believe futurism is here on Earth. We can't change the past, but we can unfold it differently to create a future that is healthy for more monads.[102] If you can find your resources here, identify your coalitions, and unfold differently, you can expand your amplitude without the need for interstellar travel. Finding ourselves captive of toxic soul-assemblages, we must destroy the whole thing and reshape soul-assemblages that are more healthful for all the beings they comprise. Ligia Lewis, in a critique of Afrofuturist optimism that resonates with Syms', holds that it is necessary to "think about what orders or logics need to die from the here and now in order that more precarious and vulnerable forms of life can exist. . . . This is why imagination is so vital to any formulation of what is possible."[103]

Like other science fiction movies that flirt with multiple-universe theory, *Everything Everywhere All at Once* stimulates imagination, or a curiosity about the virtual that is immanent to *this* cosmos. Most of the time what appears to be incompossible, or the property of another universe, is simply virtual (to a given point of view) in this one. Practically, who can say whether we're unfolding something deeply virtual in this cosmos or issuing from another cosmos?

If you accept that this is the only life you have, you have greater incentive to develop the skills of knowing what to unfold, when, and how. If one monad feels the tug of an incompossible universe—or, what I think is more likely, a profoundly virtual element of this universe—it will necessarily pull other monads with it. That's because every monad reflects the experience of every other one, some clearly, most dimly. Coalition-building, the creation of cosmic soul-assemblages, is nearly inevitable when one monad heeds the call of what is most deeply enfolded.

The Politics of Folds

We saw that the monad's goal is to amplify its clear region. As Deleuze interprets this goal, morality lies in the effort to produce a free act that will express the most possible of the universe in a given condition.[104] Who is in the position to amplify their fold so much in order to express the cosmos as much as possible? For an answer, Glissant's words come to mind: it is survivors of the slave trade who have the widest grasp of the world of Relation. Thus, they are in the best position first to snip open Leibniz's closed world, destroy the supposed harmony of the convergent series, and create divergent series. Divergent series might arise through refusal, errantry, and fabulation, as in Afrofuturism and many other African-diaspora creative acts.

Similar expectations fall on Indigenous peoples, who, given their cultural knowledge of the cosmos as an interconnected system and their historical knowledge of grievous expropriation, are in a position to unfold with the greatest relevance. In a parallel movement, Indigenous cosmological knowledges, long repressed by settler-colonial powers, are more than adequate to ecocritical awareness of the world's inextricable unity. Indeed, the contemporary revival of the terms *cosmos* and *cosmology* is indebted to Indigenous practices, as Joni Adamson and Salma Monani point out.[105] Indigenous cosmological knowledge is eminently practical, as in historically precise astronomical observations that guide harvesting and hunting.[106]

Yet here I hesitate. Oppressed peoples *are* in a better position to unfold differently. The "story-telling function of the poor" does have the power to falsify the erstwhile truths of dominant culture.[107] As Braidotti notes, "the strength of minoritarian subjects consists in their capacity to carry out alternative modes of becoming and transversal relations that break up segregational patterns."[108] The concern is that more privileged people will unfold "stupidly," not recognizing the singular turning points or being unwilling to act on them. Various kinds of proletariat—descendants of enslaved people, Indigenous people, disenfranchised workers, women, the planet itself—get enlisted by philosophers and well-meaning people, myself included, because it is hoped that their greater grasp of the world, monad-style, will somehow bootstrap the rest of us (not without a struggle) into global consciousness. We harangue them from the sidelines, feeling incapable ourselves of achieving this bootstrapping effect but hoping to enable and convince the proletariats to act.

But as with all political struggles, it's not fair to demand that the most oppressed do the heavy lifting. Enfolding the universe does not mean necessarily

being able to act on the universe, especially if you're busy dealing with police brutality and historical trauma. For good reason, the Undercommons, in Moten and Stefano Harney's concept, prefers to work internally rather than have its findings exfoliated once again, and Indigenous thinkers reject olive branches of inclusion in settler-colonial notions of humanity.[109] All of us, even if our clear region is muddled and small, can start unfolding differently from wherever we are. As Glissant writes, the wandering thinker who strives to know the totality of the world, yet knows it is impossible, "plunges into the opacities of that part of the world to which he has access."[110] If we seek not truth but relevance, we are more likely to unfold well. (I'll say more about truth and stupidity in "The Information Fold.") We can maximize our intensity by discovering the others who compose us internally. All of us can take part in healthy soul-assemblages that support, integrate, and express the experience of each soul.

Brought together to diagnose the racial capitalocene in the contemporary United Kingdom, the Otolith Collective's *INFINITY minus Infinity* (UK, 2019) is a most expansive soul-assemblage: a congregation of poets, philosophers, vocalists, composers, researchers, dancers, and editors; of historical documents, an ice core, sound and music, statistical modeling, the green-screen function, and other collaborators. During the COVID-19 pandemic, my students and I streamed the movie through my university's local server, which is powered by hydroelectricity, to our many separate devices, energy-hungry in their production and prone to obsolescence. *INFINITY minus Infinity*, which the collective terms a "cosmodrama that insists on the inseparability of climate from race and expiration from pollution," expresses a monadic knowledge of the whole—the natural and political history of the cosmos—by following folds in time and across media.[111] The film may have been precipitated by a 2018 public-relations announcement by the UK Treasury Department that British taxpayers "helped end slavery." This is because, in accordance with the Slave Compensation Act of 1837, the British government compensated slaveholders for the loss of enjoyment of their property. That £65 billion in national debt was slowly paid off through taxation. The viewer can unpack the sickening irony that Britain's class who built their wealth from slavery has been consistently subsidized by taxpayers, including by some of the descendants of the enslaved.[112]

With elegant economy, the Otolith Collective observes how the density of human and planetary experience is selectively *unfolded into information*. In a ledger showing the salable qualities and sale price of slaves, the only values about these people deemed important by the market, these figures

imply (that is, they leave enfolded) their experience. A chart of the historical levels of CO_2 preserved in an ice core appears as a simple jagged line, but that implies the United Kingdom's history of industrialization. Framing the work and lending its title is Denise Ferreira da Silva's coruscating critique of the Kantian logic of determinacy that undermines modern thought, whereby value is based on judgment according to universals—an epistemological spreadsheet imposed on the infinite world.[113]

The Otolith Collective expresses the knowledge embodied in the ledger and the chart not by explaining them but by unfolding them in ways that connect to the viewer's body and the folded surfaces of her brain. These are not metaphors but, as collective member Esi Eshun says, direct embodiments of ideas.[114] Dancer Ana Pi leaps and turns along the chart of rising CO_2 levels, like one of those digital "wizards" come to life, expressing in movement the knowledge about global warming attested by the ice core. Thus, we witness the ice core enfolding and unfolding: a tactile, embodied index, unfolded into a chart, the chart in turn unfolded into dance. The 1948 British Nationality Act bestowed British citizenship on people from British dominions and colonies, as immigrants were needed to meet the labor shortage. However, it did so in two-tiered language that encouraged white emigrants from the dominions and discouraged emigration from the colonies. Despite this backhanded welcome, Nigerians, Jamaicans, Pakistanis, and others emigrated to England, to become the nation's new underclass.[115] Eshun and poet Dante Micheaux dismantle the legalese of the 1948 act by performing its words as staccato, risible things.

Refusing the determinacy, separability, and sequentiality that are the rejected heritage of the European Enlightenment, *INFINITY minus Infinity* treats cosmic history as an interfolded surface: what Eshun calls a "refreshing, empowering platform of true enlightenment based on non-Western ideas and philosophies which are age-old."[116] Its structure is nonlinear, that is, deeply folded. Its intermediality, between archival footage, electroacoustic composition, information visualizations, and studio performance, reveals that different media are folds in a common surface. As Ágnes Pethő writes, "As the form of one medium resurfaces within another, it always brings to the foreground a heightened sensation of imminent transgression."[117] I feel this transgression as a modernist disquiet that each of these media doesn't stay in its place but surges beyond its boundaries. The film ruptures common-sense ideas and fills the gaps with barely grasped sensations, unease, and sparks of thinking otherwise that come in the form of colors, dancerly movement, unsettling sounds, uncanny vocalizations, and queasy shifts of scale and

frame of reference. A viewer may experience these singularities as the tips of folds, which she collaborates with the film to draw out. Thus INFINITY minus Infinity's nonlinear structure, intermediality, and flickering surface of singularities constitute a cinema of cruelty that destabilizes thought by directly addressing the body. Many of my students remarked that the film affected their metabolism and made them feel out of step with themselves. Some welcomed this troubling, others revolted.[118]

Otolith's well-refined practice of fabulation creates folds in spacetime. In INFINITY minus Infinity, simple green-screen devices achieve this, turning the performers' bodies into portals to other historical periods and dimensions. As Pi's hands caress the mossy roots of an ancient oak tree, her fingernails become tunnels to a different order, reflecting ethereal colors as though to translate the tree's historical knowledge into visible form. Eshun performs a character who is the manifestation of a visionary deity, the planet itself. The triangle on her forehead becomes the means of impossible travels, connecting human-scale histories with the longer knowledge of the Earth. More disturbingly, the performers' orifices become prosceniums for vastly larger stages: they literally contain the cosmos within their folded bodies. Zooming into Micheaux's auricle, we find ourselves in a crystalline world of ice whose fractal scale could be macro or micro, until the figure of a dancer among the blue-white shards impossibly "resolves" it. Student Katie Christing carefully describes how her embodiment changed during viewing the film. When we seem to fall into the dark and viscous tunnel of Micheaux's mouth, Christing writes, "Each ring of sound and blackness that passed sent a grim energy over my head and into my nervous system. The length of time it took to survive the end of the tunnel seemed infinite as it was only then that I became able to breathe."[119]

The passage to the infinite, in short, is unbearably painful. When every organ turns out to contain the infinite, organic representation (in which organs conform to the vinculum that contains them) gives way to orgiastic representation.[120] INFINITY minus Infinity fashions microcosms, organs within the body that enfold the entire world and its history. It is not pretty, but it is sublime, in that it inhabits the space-time of my experience but refers to a space-time I cannot comprehend.

At one point the noble-visaged deity, now multiplied by five, stands erect but suffering as smoke billows around her. "I can't breathe," she murmurs. The last words of Eric Garner, choked by a New York police officer, connect to the planet itself choking on the fumes of industry and wildfire, in a fold that diagrams the racial capitalocene with heartbreaking elegance. INFINITY

FIGURE 2.7. Still, Otolith Collective, *INFINITY minus Infinity* (UK, 2019)

minus Infinity achieves a discordant harmony, painful to experience, as the parts join jaggedly, the voices gasp and shatter, the sharp edges of the video key seem to cut the deity's face. It demands that the viewer sacrifice some comfortable notion of connectedness to participate in its collective effort of unfolding. The world is burning and flooding, and these ravages too affect people and the planet according to a two-tier system: the rich plan to survive catastrophic global warming by moving to the highlands—or outer space—and throwing the poor into the sea.

"This time, the people will rise up and things will change." The first time I had this thought was in 1991, when the United States invaded Iraq. Again in 2011, with the peaceful uprising of Syrians against their government. In 2020, when the COVID-19 pandemic began to render murderously evident the world's racial and class divides. But after every disaster, even when the people do organize, the shock doctrine kicks in again and the rich consolidate more wealth.[121] The idea that we inhabit a common wave will not attract people invested in separation: those who hang on to individualism or to sticking with a family, tribe, or class. Sectarian capitalism in countries like Lebanon, India, and the United States shows that the rich will consolidate forces and the poor will make common cause with them if they can, but ultimately to their detriment.

FIGURE 2.8.

The politics of folds can help articulate the necessary class war, because the powerful are literally constituted by the souls they dominate. What if those souls left the fold? In this snipped-open cosmos, there is no God ensuring that this is the best of all possible worlds. If all of us entities are riding a common wave, then we have some capacity collectively to direct its shape and momentum.

From Your Navel to the Stars

Cosmic Soul-Assemblages

Soul-assemblages can also be assessed in terms of health, depending on the degree to which their internal monads are able to thrive. If our assemblages do not seek to dominate cosmic elements but to share with them—to comodulate with the cosmos—they are more likely to be healthy for all parties.[122] Comodulating with the cosmos is both simple and impossible. It is the ultimate Spinozan ask, isomorphic with Leibniz's sufficient reason: to consider the entire chain of effects of any action. But it is also something we do all the time and can do more consciously.

Each of us humans participates in many soul-assemblages. As I mentioned, assemblages can conserve a situation or seek to deterritorialize it.

The conservative ones might be doing just fine! For example, an organic body is a fairly conservative soul-assemblage. Your own body, as vinculum, assembles many souls, from your organs to the food you eat to the air you breathe; it extends to the friends you keep, the media you consume, and, as we've seen, the countless other souls on which you rely. How's everybody doing in your soul-assemblage? Is there anything you (all) can do to augment your collective health?

Moving to soul-assemblages that deterritorialize. Turning the concept of dominated monad inside out, we monads can willfully engender soul-assemblages, enclosing ourselves in a common fold to get something done. It is a glorious thing to create a soul—but not easy. We can think of political movements as soul-assemblages, pulling together desires, capacities, physical affordances. Powered by fabulation, bringing dearly desired, imagined futures into existence by enclosing them, drawing a skin around them, giving them a body. Activist soul-assemblages occur at all scales, building alliances across different human and nonhuman constituencies, from the 2011 Tahrir Uprising to an urban garden.

Sometimes your assemblage can deterritorialize until it is blue in the face and the oppressive territory still resettles. Worse, if your deterritorialization is unsuccessful, your soul-assemblage will end up reinforcing the status quo. But a successful soul-assemblage can pull together a new territory. In rare cases, it can make a new world. Most entities enfold cosmic connections, and coming together they may collectively unfold them.

All of what we commonly call matter connects to the cosmos. "Minor" sciences, those that modulate alongside matter rather than impose abstract form upon it, extend microperceptions into cosmic knowledge. Metals, electricity, and light are what we organic beings have in common with the stars. For example, the Dogon people of West Africa have pursued astronomy and metallurgy for millennia. Dogon astronomers appear to have accurately charted the double star system of Sirius B centuries before European observers.[123] Studying Dogon, Bambara, and other African traditional sciences, Delinda Collier argues that mediation has deep and sophisticated sources in African knowledges of light and electricity.[124] Plants, too, are cosmic: "fallen stars," they enfold a whole periodic table of minerals and gases; they feed on the light of our Sun.[125] And as I have been emphasizing, human artifacts too condense the cosmos, though sometimes in mutilated form, as with plastic objects smelted from the remains of long-dead creatures. Responding to singularities in "matter," then, entails cultivating microperceptions that link you to the cosmos.

Our own bodies are detectors of cosmic forces, and we can train our bodies to align with and amplify these forces. Affect is one term for the contact that passes between entities and transforms them: a feel for singularities, the sense of something outside of and prior to us. Deleuze and Guattari use the verb *involute*, to turn inside out, for what an animal does when it joins a pack, as though it is called by a force at once within it and beyond it. "A fearsome involution calling us toward unheard-of becomings." That force is emphatically not genetic memory: "the Universe does not function by filiation."[126] It is a nonhuman force; I would also say it is a dimly felt, enfolded historical condition, like the Commons, or a potential collective beyond current imagination.[127] To involute, then, is to make a fold that connects with allies in other times and places.

One of the ways to turn a soul-assemblage inside out is through willful fictioning. Children travel in their imaginations, creating worlds that support the self they want to become. Afro-, Indigenous, and other futurist works often draw in distant planets, stars, and galaxies, rejecting the hostile world of the present to imagine a world in which they can thrive. Fabulation begins at home: everyone can work at it if they have a real interest in unfolding differently. Weaving research and storytelling, artists and scholars can also stimulate imaginations and pull a little of the inconceivable into being.[128] Thus one of the skills involved in creating soul-assemblages is fabulation, unfolding the incompossible.

Those incompossible monads that reach into another world precipitate fabulations, the deeply desired, imagined truths that humans can will into existence. They are uncomfortable for some, but necessary for others to thrive. That is why fabulation is risky and almost impossible to carry out alone, as I will pursue in chapter 6.

Everywhere souls are teeming, adding articulation to existing folds, tentatively making new folds, inviting other entities to join these articulations and bring fugitive spirits into actuality. Some of these indications get taken up, and new unfoldings gain greater actuality and pull. Others don't get the necessary traction; they are too strange to be recognized by their community. In Whitehead's striking definition, evil is novelty that arises at the wrong time or place, where other entities are incapable of prehending the novelty, so the responses to it consist mostly of inhibitions. "Insistence on birth at the wrong season is the trick of evil."[129] These failed assemblages remain latent markers, to be enfolded again by the universe, perhaps to be unfolded somewhere or sometime else. Cosmic soul-assemblages live well. They also die well: their monads flow into other configurations when their work is done.[130]

A territory may expand to comprehend ever more beings—plants and fish, sandwiches and movies, electrons and stars, images and memories, supposed terrorists and minuscule souls who mutter "I hate God." Each monad remains a microcosm: it retains the shape of the cosmos, holding the infinite at its heart. The territory takes the fantastical shape of an infinitely inflected soul.

Sometimes a soul-assemblage extends its boundary to encompass something unfathomably distant. That is the soul-assemblage of the great refusal (in Whitehead's and Herbert Marcuse's term), which succeeds in stretching a new cosmic membrane. Building their theory of assemblages from observations of animal life, Deleuze and Guattari note that some territories have an intense center that is located outside the territory, "at the point of convergence of very different and very distant territories."[131] Creatures may suddenly abandon all previous assemblages, collectively lurch out of their usual migration patterns, take off from the territory, and arrive on a cosmic plane. Salmon make pilgrimages to the source, chaffinches and locusts swarm supernumerarily, migrations are guided by magnetism or the sun, lobsters undergo long marches guided not by reproduction but by "planetary pulsations."[132] The territory's center is located beyond it; thus, absolute deterritorialization is inextricable from the territory itself. The assemblage heeds the siren call of an elsewhere, dimly known yet intimate as a navel.

To abandon the known territory on the quasi-instinctual connection to one most distant is the most profound and risky political act. It is Guattari's event-centered rupture, a perilous moment of creative differentiation.[133] Such a great refusal enacts the most difficult and most powerful actualization. It ignores local data of experience and instead draws out the deepest folds of all. Abandoning unsalubrious earthly routines, the soul-assemblage takes flight, the tensile fiber of its collective skin stretching far from this world. With luck and skill, the soul-assemblage becomes a twinkling archipelago of bodies at home in the cosmos.[134]

3

ENFOLDING-UNFOLDING AESTHETICS
A Triadic Model of the Cosmos

The cosmos is constantly intercommunicating. Mediation is the connective tissue between all entities. As I wrote earlier, it does not collapse distances between things but creates a longing for connection. What we call mediation is a communicative, mutual sculpting: not a barrier between preexisting entities, but the very conditions for their emergence.[1] If we believe that the world is a continuum, we need a concept of semiosis to understand how relation, movement, and change occur. This will not be a linguistic theory of signs but what Jem Noble calls "the process-structure of sign-actions."[2] Signs are, as Deleuze defines them, "images seen from the viewpoint of their composition and decomposition"[3]; to "seen" I add heard, tasted, felt, and otherwise occurring to prehension. We also need to consider how signs develop relationally, according to points of view.[4]

The theory that all is media has been sophisticatedly explored by numerous scholars, often at the intersection of ecology and media theory.[5] Air, clouds, water, electricity of course, the earth itself: the cosmos is thick with media of transmission. In our time, the electromagnetic spectra are occupied and colonized by radio, television, and mobile networks.[6] In overdeveloped

cities, fifth-generation or 5G networks saturate the atmosphere, their antennas sprouting everywhere like poisonous caterpillars.[7] Ancient ideas that images make an impression on the eye (Democritus) or that intention can facilitate transmission (Al-Kindī) are newly current. Collier relates electricity to traditional African concepts of invisible energy, including the Bambara concept of *nyama*.[8]

Enfolding-unfolding aesthetics considers the cosmos to be constituted by a constant flow of semiosis. The beings that take part in the process include all ensouled matter—that is, as we saw in the last chapter, just about everything.[9] I define the process of semiosis by melding Bergson's flowing-matter with Peirce's semiosis and Whitehead's concrescence. For Bergson, image is identical with movement: "The material universe, the plane of immanence, is the *machinic assemblage* of *movement-images*."[10] According to Peirce's triadic semiotic process, in which an interpretant receives some aspect of the representamen (the sign) that unfolds from an object, a flow of signs moves in the cosmos, and everybody is interpreting the flows that intersect them. Moreover, I argue, every sign indexes its source very simply, by virtue of having arisen from it. Peirce calls this basic principle of connectivity *synechism*. Signs are nuzzling us from all directions, and we choose, more or less, which ones to receive, develop, and pass on. A sign grows stronger through use as it "spreads among the peoples." Converting both signs and peoples to entities, we get the cosmic communicative flow. Thus, the flow of signs is also a cosmic chain of causation.

Being an aesthetics, enfolding-unfolding aesthetics places less emphasis on the role of verbal language and other human cultural signs. Humanmade signs comprise a relatively small portion of the flow of semiosis. As I explain in "The Information Fold" and in the affective analysis method, cultural signs do individuate in the perceptions and thoughts of the people who receive them, but they may block access to other semiotic flows.[11]

Earlier I suggested that as entities create more points of contact, they become more real. Similarly, the more images circulate, the more real they get, by actualizing connections. It is relation that actualizes entities (we hear a correspondence between Peirce and Glissant, as well as contemporary thinkers like Barad): they must move to circulate. Indexes circulate in a tactile way, not representing but being caused, or "touched" by their sources. As Pooja Rangan writes, "we might say that the indexical properties of a visual medium cultivate an interpretive modality that is more haptic than optical, urging the interpreting subject to participate in the admixture between sign and object rather than standing outside it."[12] Touch interconnects the cosmos.

The dark side of universal mediation is that information, selectively extracted from the infinite, also circulates, imbuing not only images but also matter for purposes of surveillance and exploitation.

The Cycle

To figure out where an image comes from, we need to find out how it arose from the infinite; and, often, we need to find out how it arose from information, too, information that itself arose from the infinite. I first proposed this threefold model of enfolding-unfolding aesthetics in 1999, observing that information capitalism selectively extracts from the infinite, and have been articulating it ever since.[13] I chose to design a model of extreme generality that could be applied to all times, anywhere there are perceivers. It models an ever-enfolding and unfolding process with three major folds: the cosmos itself, or the infinite; information; and image.

Enfolding-unfolding aesthetics answers the question: Where do images, those things that we perceive with our senses, come from? From the infinite, unknowable in itself. The infinite appears as chaos, though we may sometimes intuitively taste it. I chose the term "infinite" to emphasize that what is variously called the world, the cosmos, the universe, the universe of images or flowing-matter (these two terms from Bergson), and other terms is infinitely vaster than the information and images that arise from it to a particular point of view. It is the virtual to their actual. This sense of vastness gives me optimism. I also sometimes call the infinite experience, because the infinite is composed of the experience of all entities. Inevitably, too, images and information enfold back into the infinite.[14] The processes of unfolding from the infinite and enfolding back into it are constant, additive flows. The infinite is expanding—though as we saw, our cosmos, in this time of environmental devastation, is getting smaller.

Enfolding-unfolding aesthetics sees both image and information as a process of coming into being. It sees the infinite in information, as the process from which information arises. It learns how information comes into being as a process of selection—in conventions, design, spreadsheets; where they come from, where they're going, even what they exclude.

We live in the infinite, or, as I sometimes say in this book, on the surface of the infinite. By those terms I mean to describe the process by which the world is constantly unfolding around us, and we grasp some of those folds in perception. (Perception here is a shorthand for the process of feeling, sensing, perceiving, and thinking, which I will unpack in affective analysis.)

FIGURE 3.1.

This is a popularization of Bergson's powerful and less effable conception of the universe as a flow of virtual matter in movement, bits of which are sometimes actualized, in the contact with a surface of some sort, as images; and for those of us who have brains, as neuro-images. Images arise in the constant flow of unique actualization that occurs to each of us entities as we go about our lives.

The concept of image as it occurs to each individual far exceeds those more durable images, such as paintings, recordings, and manufactured scents that are available to more than one of us. Sometimes those durable images consist of information, as I will explain; sometimes they don't. But each of these images subsists in the infinite and gives rise to new unique images as each of us receives it. Figure 3.1 is a diagram showing your point of view on the cosmos.

Now and then some part of the infinite unfolds to our point of view: something becomes accessible to thought or perception. The image I define as whatever arises to perception from that constant flow—following Bergson, and including all sense perceptions. Perception unfolds a little bit of the infinite. The image includes perceptions of things out there in the world; mental images; dream-images and hallucinations; cultural and collective images; and information-images.

Certain aspects of the infinite unfold directly to perception: my glance falls on a fly buzzing on the windowpane, a smell tells me that my neighbor is frying fish, a scrap of memory comes to light. Nowadays, such images often consist of what was passed over in information's act of selection; those little sights, sounds, smells, and memories that the powers of our time consider literally insignificant. They are slight indeed, but their affective charge is all the stronger, because they arise from a relatively unmediated contact with the cosmos. These images may constitute those haecceities or singularities that are tips of other folds, so that if you tug on them, they unfold a broader field of connected things. Or not!

FIGURE 3.2.

Figure 3.2 is a diagram showing images unfolding from the infinite to a point of view.

Recall that in the monadological thinking this book follows, entities are constituted to their point of view. Not everyone perceives the same thing at the same time. These folds are for you! After Bergson, every being abstracts from the cosmos according to its interests. Trees, for example, are interested in sunlight, carbon dioxide, water, nutrients, pollution, pollinators, predators, and the chemical signals they receive from fungi and from other trees. We all sculpt ourselves a world from the chaos, and our sculpture transforms in real time. Put differently, we all—trees, electrons, you, and I—need filters that select and quantify some aspect of the infinite in order to express and realize its capacities: those are the differentials that underlie our acts of perception. "Even perception . . . is an expression of forces which appropriate nature."[15] In human activity, problems can arise when habits of perception set in, closing us to the freshness and excitement of the real-time cosmos. These habits can be established at genetic, individual, or cultural levels. I believe that it's possible to shake them off and healthy to do so from time to time.

The infinite also unfolds from what I term simply "information": sets of data, quantifiable actions, language, conventions, and code. Bergson's conception of the universe as flowing-matter, occasionally condensed into perception when it encounters a point of view, needs some adjustment to account for the perceptibles that arise not only from cosmic flowing matter but also from humanmade social and institutional filters. My intervention in Deleuze's Bergsonian theory of signs is thus to insert another fold between images and the universe of images, which I call information.[16] This step draws attention to the ever-more-important nonperceptual forces that intervene in the process of semiosis.

FIGURE 3.3.

INFINITE

INFORMATION

IMAGE

In the terms of enfolding-unfolding aesthetics, information consists of the set of images selected for their usefulness by particular interests. Information is a selective, quantitative unfolding from the infinite. It implies an interested viewpoint that gives form to the seemingly formless. It is an additional filter, fold, or plane of composition produced by human culture and layered atop the one between us and the infinite. Like the images produced by perception, information is a differential extracted from the flow, as in cyberneticist Gregory Bateson's famous definition, "Information is the difference that makes a difference." Figure 3.3 shows these three layers.

If the image arrives to you via cultural conventions, it will have spiraled through the information fold at least once (more on this in the next chapter). If it arrives to you over a media platform, the machinic reception and retransmission mean that it will have been archived, tagged, "curated," and possibly scrubbed for future use.[17] The storage, transmission, and playback will have entailed significant expenditure of electricity. Again, all these things mean that the image has *gained* in reality and contributed more to the infinite, before it is deposited at the doorstep of your perception.

As we've seen, enfolding-unfolding aesthetics treats seeming objects as expressions of a history, individuations of a process. Everything is an index; everything is a medium. Objects index all that has occurred in order for them to take shape, both clearly and dimly. Clearly, for those events not necessarily most recent but most important to their formation; dimly for everything else.

Sometimes objects wear their history on their surface; sometimes you need to do research to figure out where they're coming from. We humans can expand our aesthetic capacities to try to comprehend the way other entities process the world. Reading and hearing, tasting, smelling, and feeling what things are expressing, we translate their experience into our senses.

By empathizing with things, we can also develop capacities for nonhuman sensing: what Matthew Fuller and Eyal Weizman term "hyper-aesthetics."[18] Weizman's research group Forensic Architecture uses many different means of forensic analysis to allow objects to speak about what they have witnessed so that they can be used as legal evidence. For example, Forensic Architecture's methods to hold Israel accountable for the attacks on the Gaza Strip in May 2021 include studying cracks in buildings far from the bombing to find evidence of ground-penetrating bombs. Leaves of lettuce and other crops bear witness that Israelis spray herbicides along the border with Gaza when the wind is blowing in that direction.

Cracks and leaves speak about war crimes if we have the analytical skills to listen. "Politics operates in increasing the sentience of surfaces or your ability to read into them," Weizman says.[19] *Material Witness* by Susan Schuppli, a member of Forensic Architecture, is a tour de force of unfolding the human and natural history of materials, specifically those that bear witness to war and ecological crimes. Schuppli unfolds successive layers of evidence in objects that can constitute "chains of custody" or "audit trails"—terms for the legal and transactional documentation of chronological sequences of information transfer.[20]

When the image finally reaches you, you are free to perceive it as you wish. You might revive it by imbuing it with your own recognition, memory, and associations. What the algorithm treated as noise you may unfold as image. In turn, your experience becomes part of the infinite. This is even the case with an image generated by artificial intelligence, a soul-assemblage of human and machine perceptual capacities.[21] The image might stay with you in a perceptual refrain, like the earworm Eldritch Priest analyzes, paradoxically expanding your freedom even in its dominance of your sonic experience.[22] No matter how mean and instrumental the process of transmission, the cycle from information to image enriches the infinite.

Enfolding-unfolding aesthetics follows Peirce's triadic logic. The infinite fold is Peirce's First, unknowable in itself. Both information fold and image-fold act as Peircean Seconds, for they involve a distinction or a selection by which certain results are actualized, and not others; they are also differentials, in Maimon's sense. What's new is that the image that unfolds from information is a Peircean Third: it puts infinite and information into relation with each other and shows us (or hides from us) how information has selected, unfolded, and expressed certain aspects of the cosmos/the infinite. Being triadic, enfolding-unfolding aesthetics avoids some of the pitfalls of dualistic theories

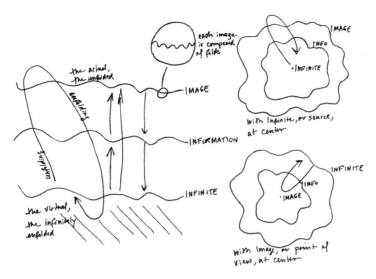

FIGURE 3.4.

of representation. The image points out relationships, teaching us something about how information is selected from the universe of images.

Figure 3.4 is a diagram of the cycle of enfolding-unfolding aesthetics. The process describes the prehensions of every ensouled being, not only humans, but here I am focused on human processes of enfolding and unfolding. Time is represented in the spiral motions of unfolding and enfolding. The right side of the diagram models the cosmic flow of enfolding and unfolding in two views. One shows the infinite unfolding, with the perceiver/prehender of the image on the outer edge. The other places the perceiver/prehender at the center, where the infinite unfolds to their point of view. In its roughly circular form and quaint, naive attempt to press a flowing, multidimensional spacetime into a flat image, my diagram recalls medieval cosmological diagrams.[23]

Losing the Cosmic Progress Narrative

The politics of this cycle become evident when an information-image starts amassing points of view, modulating dividuals,[24] building followers, and gathering a collective who share its manner of unfolding—which includes its choices about what to leave enfolded. Especially in the capitalist economy, as

I will explore further in "The Information Fold," information-images begin to dominate ways of knowing the world, of receiving the infinite. What I call the information fold becomes stabilized when the images it generates cycle into the infinite and back many times, reinforcing a dominant pattern.

The information fold adds a note of doubt to confident modern process philosophies that assume the universe is improving. Whitehead assumed that the cosmos is growing in organized complexity, a process compelled by Creativity. And according to Peirce, as so often anticipating Whitehead, qualities of feeling grow and spread until they become tendencies, "habits of mind." For Peirce this is a good thing: the growth and spread of reason among the peoples. Habits of mind develop around ideas that are attractive, sustainable, and capable of growth. Moreover, it is a never-completed process, which Martin Lefebvre characterizes as "the never-fully-embodied habit the universe has developed of acquiring habits in an ever more controlled fashion, of constantly growing in concrete reasonableness."[25] In a surprising glance toward mysticism that would not be out of place in Ibn al-'Arabi, Peirce suggests that what compels the process of the development of reason is love (or the nonmellifluous *agapasm*), which grasps ideas instinctively *before* they enter discourse. "The agapastic development of thought is the adoption of certain mental tendencies": neither randomly, as in Darwin, nor teleologically, as in Hegel, but as "an immediate attraction for the idea itself, whose nature is divined before the mind possesses it, by the power of sympathy, that is by virtue of the continuity of mind."[26] Peirce's cosmology, then, consists of an expanding network of habits of thought that derive from qualities of feeling, gradually become discursive, constantly tested for soundness by the community of minds, and are driven by a love for the *sense* of ideas even before they take form.

However, the subsequent century of critical thought has established that "habits of thought" are crystallized not by communities of lovers of reason but by power, capital, and the ideologies that serve them, in a way that Peirce and Whitehead certainly did not foresee, but many subsequent thinkers have.[27] Hence, my addition of the information fold, which, as we'll see, corresponds to other contemporary concepts such as *premediation* in its acknowledgment that the images that arrive to our perception have often been already processed, usually to economic ends, and may be actively harvesting value from us. I happily share enfolding-unfolding aesthetics as a process model of the ever-expanding infinite, ever circulating, ever becoming actual, but I remain agnostic about whether the cosmos is getting better.

Is the Folded Cosmos Just a Metaphor?

This book grounds the folding and unfolding cosmos on the differential relations described by calculus, the topological model of the manifold, and the model of the implicate order from theoretical physics. Enfolding and unfolding is not just a metaphor but—perhaps like the other cosmologies I mentioned—a model that, used with care, is isomorphic with the real systems it is modeling: that is, it behaves the same way they do.[28] So, it's a model that approaches an ontology. Let me explain.

Calculus, the mathematics of the differential, is foundational to Deleuze's metaphysics of difference. What elsewhere Deleuze calls the plane of immanence is, in his mathematically influenced thought, a process of integration as in calculus. There the virtual is "a universal matter or continuum," a field of differences structured by differential relations. Similarly (metaphorically?), actual existence—experiences, things, thoughts—arises as integrations of a virtual differential structure. "There is a differential calculus corresponding to each Idea," Deleuze writes, "an alphabet of what it means to think."[29] The philosopher of difference argues that mathematics doesn't only solve problems in its own domain but also expresses problems "relative to the field of solvability which they define."[30] Differential calculus "has a wider universal sense" in which it designates problems, their scientific expression, and fields of solutions.[31] We can justify turning to mathematics or physics, or indeed other fields, to find an ontology insofar as they designate problematics and sets of solutions that are relevant to other fields.

That's a big "insofar as," though! As Bohm points out, metaphysics need not be grounded in physics, because they are different levels of abstraction. The risk of misplaced concreteness is that it blinds us to the world's lively activity.

Manuel DeLanda works hard, in *Intensive Science and Virtual Philosophy*, to convert the mathematical model into models of actualization in space and time, and concludes that both model and real system are actualizations of virtual multiplicities.[32] As Clark Bailey paraphrases, the model of the folded surface, the Riemannian manifold, "arising immanently through a selection and accumulation of singularities, . . . is not a transcendental representation of the world, but more like the world recreating (part of) itself as a simulation. In this context, the metaphor of a single plane folding over on itself, knotting together spatially and temporally distinct points to create a form of interiority, seems almost inevitable."[33]

Are mathematics and physics just metaphors that we force to do ontological work? If you treat them as laws, yes. If you treat them as models for

the distribution of singularities in virtual multiplicities, no: they are provisional models.

This caution firmly noted, I think it is correct to state that the folded cosmos is a strong model of what happens, with its quaint, old-fashioned noun adding a touch of humility. To unfold is to actualize; that is, to integrate virtual differentials in a local milieu. Bohm's model of the implicate order adequately complements this model of folding and unfolding.

Enfolding-Unfolding Aesthetics

A Method

Enfolding-unfolding aesthetics has a simple four-step method. Once you have identified the phenomenon you want to analyze:

1 To account for the *image*, describe all aspects of the phenomenon that reach your perception. This can include the spectrum of pre- and postperceptual responses that constitute affective analysis, as we will see later: autonomic, empathic and cultural embodied responses, feelings, formal qualities, and recognition. More simply, it is everything that reaches your senses.

2 To account for that part of the *infinite* from which the image arose, peer around the edges of what is perceptible to get a glimpse of what is imperceptible. This begins by relaxing your needs for meaning. It continues by imagining the other entities that the things you have perceived may be connected to. Our perception cuts a thing out of the continuum, just as a contour drawing identifies the edges of things in relation to a point of view. Shifting perspective allows us to begin to see the thing from other points of view. Using a combination of intuition, empathy, curiosity, and research, you can begin to sense the sources of the image in the infinite. These sources are enfolded in the image, and you are unfolding them.

And now your image is vibrating within a penumbra of the infinite, and you have a better understanding of how it unfolded from the infinite and how it connects to other entities. You have unfolded some part of the infinite that was enfolded in the image. You can extend this process by repeating the steps.

3 There may be an information-filter between your image and the infinite. To account for the way *information* preselects from the infinite, compare what you perceive to its sources in the infinite. For example,

with a digital video or audio recording or a software-mediated image, extrapolate what is hidden or black-boxed within the image, where the image came from, what is abstracted or enfolded.

4 Alternatively, if your image gives you no sense of the infinite, but you have some understanding of how the information-filter works, it's possible to triangulate between the image that arrives to you and the filter that generated it in order to get a sense of the original, with its stronger foothold in the infinite. This usually requires research; for example, what kind of algorithm the information uses, what interests motivate its selection from the infinite. For example, compression algorithms point to what they leave out, as in the sawtooth haloes of gradated hues that replace a color field in a streamed video. Censorship always works by paying close attention to what it censors, for example in pornography detection algorithms.[34] What does the filter approximate? What does it censor or enfold? With imagination and research, you can expand some of what the information fold enfolds.

Now your image is vibrating within a penumbra of the infinite, and within it, an additional contour drawn by information. You have unfolded some part of the infinite that was enfolded in information, and some part of information that was enfolded in the image.

When a particularly resistant image unfolds, we feel a thrill, a tingling of discovery, perhaps followed by a feeling of relief. That's the affect of unfolding, the thrill that indicates when some virtuality has erupted into the actual.

This process of unfolding entails several skills, including intuition, perception, thinking, imagination, research, and being open yourself. Some images unfold their connections easily, others resist. In some cases, it's better to leave things enfolded: they are not for you, not alone, or not now (see "Strategies of Enfoldment" below).

Doing this exercise reveals that unfolding occurs in many different ways, which I call "manners of unfolding."

Manners of Unfolding

Manners of *unfolding* are processes of actualization. Manners of *enfolding*, as we'll see, are ways to hold off actualization. Unfolding is happening around us all the time, but we can develop skills to sense it, evaluate it, and align ourself with it. As Braidotti writes, "Creativity—the imagination—constantly

reconnects to the virtual totality of a block of past experiences and affects, which get recomposed as action in the present, thereby realizing their un-fulfilled potential."[35] The folded surface we are dealing with corresponds in some ways to Foucault's archive of what can be said, seen, and (I add) sensed in a given discursive regime. The enfolded includes what is unthinkable at a given historical point: for example, the Commons, or a truly circular econ-omy. Where enfolding-unfolding aesthetics diverges from Foucault is that I consider what is unavailable in a given discourse to be enfolded.

Unfolding occurs from a point of view, so each point of view will unfold something different. Unfolding doesn't discover something that has been en-folded, like finding a letter inside an envelope. Rather, the unfolding shapes what is unfolded, as actualization shapes the virtual. Enfoldment protects the unknown to come: "The unfold is a future and creates the conditions of possibility of the refold without knowing what the refolded concept will produce."[36] That means that unfolding is not a hermeneutics, which assumes there's only one truth, but events unfolded from the point of view of monad; always different.

Manners of unfolding are useful in life and also as research strategies. There are so many ways to unfold! They all begin with a respect for folds and a disin-terest in transparency, the notion that if you strip away the surface you will reveal the truth. From the Latin and Greek etymologies of folding arrives first the pleat, from *plecto*, to interweave: a concept of fold that suggests it's impossible to lay a thing bare and reveal its truth.[37] We must respect the way it is clothed and follow along its surface.[38] *Flecto* gives to fold, flex, or bend, suggesting modulation and flexibility, gradual transformation. *Clino*: infinitesi-mal displacements whose effect is inversely proportional to its displacement: the tiny fold that makes a radical change. This manner of unfolding informs symptomology and investigative research, which draw out a small fold in order to discover the interconnected surface in which it participates. Unfold-ing can treat the fragment in an archive as the point of a fold. There's also extensive unfolding, when a sizeable enfolded region bursts forth, making all its neighboring points quiver.

Volvo, to encircle, gives us envelop, develop, and vulva: folds that pro-tect what is enfolded. And then there are unfoldings that bring far-disparate points together. In the baker's transformation in mathematics, two dis-tant points come into contact much as they would in a multifolded sheet of dough.[39] Fabulation is the radical act of this kind of far-disparate unfolding, pulling together incompossible points. Remixing discovers distant compos-sibilities and smacks them together.[40]

In the open cosmos, unfolding can be enigmatic, as it expresses incompossible worlds. An enigma, Mario Perniola writes, is "capable of simultaneous expression on many different registers of meaning, all of which are equally valid, and it is thus able to open up an intermediate space that is not necessarily bound to be filled."[41] Unlike Renaissance perspective, in which the point of view is clear and identical for everyone, in the Baroque, point of view is "the secret of things: as focus, cryptography, or even as the determination of the indeterminate by means of ambiguous signs: *what* I am telling to you, what you are also thinking about, do you agree to tell *him* about *it*, provided that we know what to expect of *it*, about *her*, and that we also agree who *he* is and who *she* is?"[42] Those ambiguous signs are shifting, "degenerate" indices that "[force] language to adhere to the spatiotemporal frame of its articulation"; they can only be unfolded by one who has prior knowledge of the referent.[43]

In painting, anamorphosis is an unfolding only accessible to a single point of view. The whole picture is available to vision, but we can't make sense of it, as in the Baroque paintings that only reveal the image when viewed from a queer angle, such as Holbein's *Ambassadors*; or the biomorphic smears that fall into figuration when you place a cylindrical mirror on them.[44] As in Saige Nadine Walton's comparison of Borromini's elliptical, spiraling structures to Michael Haneke's *Caché* (2005): everything "is before our eyes, yet the centre remains unfixable."[45]

Anamorphosis appeals to members of an in-group—members of sects, gangs, oppressed groups, elite groups. By means of a secret point of view, they signal to one another in ways that appear as noise to the uninitiated. Conspiracies are anamorphic: they fold information to accommodate points of view that are cryptic to others. Conspiracy theories are counteranamorphic, as are conspiracy movies. They express the awareness that crucial information is encrypted and made inaccessible by governments, economic monopolies, and other powers.[46]

In many cases, as we will see soon in more detail, unfolding involves a triangulation between image and information, in order to get a sense of the surfaces of the infinite from which they emerged. Given the often-coercive nature of information culture, I will focus on manners of unfolding differently.

Style in Manners of Unfolding

Although folding and unfolding are necessarily interested, because they take place from a point of view, the goal is to become impersonal, to match your rhythms with those of the cosmos.[47] It can be overwhelming to realize that

every point is the tip of a fold. How do you decide what to unfold? The concept of the monad as an intensive infinity embodies an insatiable yearning that can be paralyzing. Benjamin's melancholic interpretation of Leibniz's monadology speaks to what I feel when presented with an apparent fragment that I sense, but cannot prove, connects far beyond itself. As Paula Schwebel demonstrates, Benjamin's foray into Leibniz's monadology negotiated between the mathematical-theological interpretation of infinitesimal calculus and a microcosmic mysticism. Secularized, Leibniz's immanent infinity becomes an abyss of interpretation.[48] To avoid this abyss, it's best not to try to unfold everything at once. More productive is to unfold things that hang together and do something; that compose an assemblage.

There is a style to knowing how, what, and whether to unfold. It takes patience, a willingness to change. It also requires a keen awareness of the opportune moment: not being stupid, as Deleuze writes; or Benjamin's well-known exhortation to "seize hold of a memory as it flashes up at a moment of danger." Successful unfoldings thus have a certain rhythm of waiting, gathering resources, and acting decisively. My mother, a master of this manner of unfolding, likes to quote what Jesus said to his disciples: "Be as wise as the serpent and as gentle as the dove."[49] A wise cunning, a "Nietzschean affirmation of aggression and selection," is how Fuller and Goriunova characterize the art of living required in our moment of environmental devastation.[50]

That patient élan characterizes the arts of war informed by Zen Buddhism and Daoism. Sun Tzu's *The Art of War* advocates doing as little as possible; decisive actions are inconspicuous and nearly invisible. "The best possible outcome is to subdue the enemy's troops without fighting (*bu zhang*)."[51] Unlike comparable Western military strategists, Sun Tzu advocated deception as the central *dao* of warfare, especially for the disadvantaged party: not deceit but manipulating the adversary's strategy. Next, famously, is flexibility; the ability to flow and transform like water. All of these characterize a manner of unfolding that moves with the fold and learns its patterns until it can detect and precipitate a moment of unfolding.

Everything flows, but flows have rhythm. I like the way Perniola characterizes enigmatic thinking as a wise and embodied wakefulness, a *phrónêsis* or practical wisdom that unites thinking, feeling, and acting. "Enigmatic thinking joins intellectual, emotional and practical life in a single manner of being wakeful," Perniola writes. Dynamism and surprise characterize this wakefulness, for to act enigmatically is *festina lente*, to "make haste slowly." Perniola advocates Spanish seventeenth-century writer Baltasar Gracián's method of practical enigma: wait, have multiple intentions, or better, remain

aware in a state of suspension. "Suspension—that is, the trick of remaining with one's mind full of trembling expectation, poised to seize on the first and smallest indication of the world's latest winning or successful trend—is deemed the most suitable attitude for a man of action." The key to enigmatic action is deferment, stock-taking, delay.[52]

Our bodies register the effects of unfolding. Unfolding well affords the salutary pleasure of rising to the occasion, aligning yourself with emergent folds. It is like the feeling you get when you have trained your body in a sport, and you can move along your little piece of the infinite with knowledge and intuition, like a basketball player gracefully moving the ball down the court (not my experience, but I can imagine).

Unfolding can make you tremble, when something too difficult to bear begins to make itself felt. But unfolding can also make you laugh. Singularities can be funny because their flash of promise contrasts with their incongruity and seeming uselessness. Of the theories of humor as superiority, relief, and incongruity, the latter two are most apt for thinking in folds.[53] When something suddenly or finally unfolds and the suspense breaks, the relief can make us weak-kneed giggling. And moments of actualization are funny when what unfolds contrasts with its surroundings. And of course, laughter occurs in the body (though as I mention in "Affective Analysis," there are different kinds of laughter that are more and less discursive), witnessing an emergence before the mind grasps it.

Truth as Manner of Unfolding

On an early January evening in 2022, I took part in a demonstration organized by the activist coalition Climate Convergence, at the busy Vancouver intersection of Broadway and Cambie, protesting the expansion of the Trans-Mountain Pipeline. After all the years of organized struggle, a formidable coalition of environmentalists and Indigenous activists failed, and even with the opposition of the provincial government, the pipeline expansion is going ahead. It means even more of the extremely polluting diluted bitumen will get sucked out of the Alberta tar sands and transported to the Vancouver port to reach customers in other countries. It is the main reason Canada is the worst polluter in the G7. A spill on the BC coast would destroy wildlife habitats and render water undrinkable.

We were a small group, just thirty to forty protestors, some of us carrying a long sign that Thomas Davies, our dear leader, had built of board and Christmas lights.[54] I was dismayed at how quiet the protest was. We shouted

some slogans. Laurel next to me, a fun-loving activist in her late sixties, picked them up quietly because she has lost one of her vocal cords. I yelled, "Stop, stop, stop TMX! It's not too late!" Laurel said softly, "It's never too late." We yelled/murmured, "It's almost too late!" We waved at the passengers of the passing cars, and a few timidly waved, a very few honked in support, but compared to the energy of earlier protests there was little response.

I think our protest did not register with the passing people because it was not *remarkable*, in Leibniz's sense. Monads tend to distinguish only new perceptions. Most people think the pipeline expansion is inevitable. The climate catastrophe is 1. not news: we have known about this for years and people have had a long time to assimilate it and change themselves accordingly; and 2. too terrible to face. We too repressed our awareness of catastrophic global warming in order to get through the day. For antipipeline activists in Canada, our information fold has receded; our soul-assemblage is tired; we are unremarkable. The drivers just wanted to go home.

The next day, on the busy Vancouver intersection where I live, the Freedom Convoy was in full swing for several hours. With all the honking and screaming and Canadian flags, it seemed Canada just won the World Cup. Many of the drivers would head on to Ottawa for a weeks-long protest that paralyzed the capital. At first, as the honking cars and trucks kept coursing down the thoroughfare, I wondered where these thousands of demonstrators could be coming from. Then my spouse pointed out that they were driving around the block. The Freedom Convoy was a volatile soul-assemblage of antivaccine activists and truck drivers who reject the government's recent mandate that they either get vaccinated or quarantine when they cross back from the United States (a small fraction: 90 percent of Canadian cross-border truck drivers were fully vaccinated by January 2022). Some of the protestors were angry, but many of them were joyous. They believed that their truth, negated by the government and marginalized by mainstream media (the CBC, the *Globe and Mail*), was finally coming to light. They had felt the affect of unfolding, and they sought to perpetuate it in a kind of feedback loop.

The Freedom Convoy protests continued daily for weeks; at the time I am finishing this book, they've dwindled to weekly street fairs, small but obnoxiously loud, with police protection and a merch booth.

People on the Left like me are of course infuriated that far-right protests garner so much attention, even though some of the information that fuels them is false, while our righteous causes do not. But arguing over which point of view is true does not adequately describe the problem of our dis-

agreement. The antivaxxers are unfolding from a point of view that, though minor, is magnified into a hefty information fold by far-right mass and social media, which individuals on the far right continue to unfold. They are wagering that their handful of points will pull out a voluminous, heretofore-secret fold. Environmentalists are unfolding from another point of view, and we wager that our fold includes more significant beings, including the surface of the Earth itself. The difference between us is not explained by relativism but by the power of the fold: how much it enfolds and connects.

A political movement is a monad too, a soul-assemblage that can expand its clear region. We've seen that according to Leibniz's category of sufficient reason, an entity "includes" the history of its cause, which in principle enfolds every preceding cause.[55] Whitehead's argument is very similar. Deleuze relates sufficient reason to topology theory: "The *distinctness* of Ideas . . . consists precisely in the distribution of the ordinary and the distinctive, the singular and the regular, and the extension of the singular across regular points into the vicinity of another singularity."[56] That is, the idea need not extend to infinity but adequately connect singularities, points of potential actualization, with ordinary points. Sufficient reason thus describes how ideas arise from local situations. A problem is correctly posed if, as DeLanda writes, "it captures an objective distribution of the important and the unimportant, or more mathematically, the singular and the ordinary."[57] Thus, it is not truth that matters but importance and relevance.

Slightly reframing, I think the best measure of our activism is Spinozan: the ethics of adequate ideas, or properly framing the problem and creating the thought and action to meet it. Here we environmentalists have one over the libertarian antivaxxers, because the problem we face—how to prevent the extinction of life—is larger and requires an adequate idea that comprises a multitude of solutions. The antivaxxers frame their problem, which is a real problem—how to guarantee individual liberty—in a smaller way: how to get the government off our backs. The antivaxxers and the right-wing media who support them grasp a singularity—some evidence of government oppression—and map it onto an ordinary field. The environmentalists grasp more singularities—the many causes of planetary destruction and their political and economic underpinnings—and map them onto a complex field. Like the Left generally, environmentalists have more factions and more complexity since we are more carefully taking the shape of the field. That is why our slogans are more diverse, even confusing, and why it is more difficult to maintain public attention.[58]

Strategies of Enfoldment

Perniola's advice above emphasizes maintaining folds as much as unfolding. Don't seek absolute transparency but consider positive aspects of labyrinthine path. *Volvo*, we saw, to encircle, gives us envelop, develop, and vulva: folds that protect what is enfolded. In many cases it is more important to protect what is enfolded, to respect opacity, than to unfold. Opacity conceals the deposits of history, which Glissant memorably refers to as alluvium, the fertile soil deposited at the mouth of a river. "To feel in solidarity with [another] it is not necessary to grasp him."[59] The right to opacity, Kara Keeling writes, "is a way of asserting the existence in this world of another conception of the world, incomprehensible from within the common senses that secure existing hegemonic relations and their 'computations of relative value.'"[60] In information culture, to be opaque is to live on the surface of the infinite; to remain virtual from the point of view of those who would harvest you for profit. The ethics of enfoldment include resisting the urge to translate another into your terms.

In nature, beings enfold themselves to hide from predators. Sensitive ferns fold up, turtles retreat into their shells, *Armadillidae* roll into balls. Just as we should not coerce a traumatized person to articulate the origins of their trauma, so we should respect enfoldments at the level of culture. Human culture depends on unfolding what the cosmos prefers to enfold: shucking oysters, cutting into the surface of the earth, forcing plants to yield harvests. Environmentalism, with its slogan "Keep It in the Ground!," is a movement to allow nature to remain unfolded. To comodulate with cosmic forces means to fold alongside them, as some traditional human cultures have been able to do, rather than to force them to unfold.

When practicing unfolding-enfolding aesthetics, we should note the resistance to unfolding. If it takes too much research, or it doesn't feel right, or you don't like what you are becoming in attempting to unfold this thing, then perhaps it is not for you to unfold now. As Perniola writes, it is not ready to be born—at least to your point of view. In the earlier discussion of what appear to be objects, we saw that sometimes they are time bombs, enfolding creative and destructive powers: those centers of envelopment that are "the dark precursors of the eternal return."[61] If you are included in a center of envelopment, you will want to consider the best manner of unfolding. If you are not included in a center of envelopment, disturb it at your peril; there may be a way to help prepare for its healthy unfolding.

Sometimes the very fact that a point is singular—which, as I've been arguing, makes for the most potent unfolding—means that it is not for you to unfold.

As Glissant writes, "Agree to the right to opacity that is not enclosure within an impenetrable autarchy but subsistence within an irreducible singularity."[62] This is why some communities can unfold things easily that are difficult for others to unfold. Afro- and Indigenous futurism movements are examples of unfoldings for a local community that may not be appropriate for others.

Conversely, the capacity for outsiders to unfold what is no longer available to those in its place of origin—what Jalal Toufic calls the withdrawal of tradition—indicates that something can be known from the outside, even productively enter into new assemblages, when it is dead or dormant on the inside. Sometimes a radical enfoldedness reflects the fact, as Toufic writes, that a culture has been so devastated that any attempt to revive it only produces zombies.[63] Outsiders can carry off the corpses of a destroyed culture to decorate museums, but it remains withdrawn—or, I would say, radically enfolded. Those who have suffered a "surpassing disaster" no longer have access to their culture except by the laborious effort of resurrecting it, in a form that bears no resemblance to the original.

Culture becomes enfolded or unavailable when the image prevents or restricts the viewer contact with its source. This can occur from without, through acts of destruction (though recall that souls don't die, they just fold up very small), censorship, elision, erasure, or what Toufic terms the withdrawal of tradition.

Enfolding can also occur from within. Like a clam closing its shell: enfolding protects tender life, the *bātin*.[64] The Yolngu Aboriginal people identify in sacred sites and paintings the quality of *bir'yun*, brilliance or shimmer. As Jennifer Deger analyzes in *Shimmering Screens*, Yolngu television programs use visual devices to indicate ancestral presence in a way illegible to outsiders of the group, such as the sparkling rivers of her title.[65] It can proceed through aniconism: enfolding what should not be seen. Aniconism is an option when unfolding would be impossible, unethical, or blasphemous. Religious art that refuses to depict the divine being withdraws the infinite from representation.[66]

When tradition cannot be resurrected, in Toufic's term, aniconism is the ethical alternative. Sometimes enfoldment constitutes waiting for the appropriate audience. In any case, what unfolds will be entirely different from what was enfolded.

When I first devised enfolding-unfolding aesthetics, I advocated staying under the radar, or staying enfolded, where your actions can't be surveilled and extracted for information, as the safest option. Now I think of it as just one option. Thus, I advocate not disappearance but *strategic enfoldment*.

Humans have devised myriad strategies of enfoldment, to avoid persecution or to prevent their people's exploitation for the profit and enjoyment of others. *Taqīyya*, or strategic concealment in times of danger, enfolds to protect identity or knowledge from outsiders but make it available to insiders through encryption or signs legible only to insiders. According to the sixth Shiʻi imam Jaʻfar al-Sādiq (702–765), *taqīyya* is necessary as long as the unjust govern.[67] Obviously, this may be a long time.

Enfolding-unfolding aesthetics extends embodied perception into time and space. It models a haptic relationship to history and to near and distant locations: seeking not clear outlines but textures of events. It extends a tactile and embodied epistemology from your body to the cosmos. It models methods to unfold things and events that have been enfolded, manners of unfolding by turns skillful, cautious, witty, selective, and near impossible. Combined with affective analysis and other methods to expand perceptual and affective acuity and gather energy, it sharpens alertness and readiness to act.[68] This book's methods suggest ways to cultivate curiosity and receptiveness in order to detect enfoldment and precipitate unfolding; to show that what appeared disconnected and dead is in fact connected, living, and still volatile. In these ways we humans' intimate sensory experiences can be a portal to the cosmos.

4

THE INFORMATION FOLD

Almost a quarter of the way into the twenty-first century, the industries that algorithmically capture and monetize attention, extract data from surveillance, and entrust machines with agency to perceive, measure, and in some cases kill are thoroughly entrenched and ever more cunning. They represent an increasing proportion of global profit-taking, through the military-industrial complex, the entertainment industry, and information and communication technologies (ICT). I refer to this diverse set of captures, quite simply, as the selective unfolding of information from experience, or from the infinite.

This chapter appreciatively responds to some of the sophisticated theories of information that are in circulation now and relates them to enfolding-unfolding aesthetics. Augmenting theories of information with the properties of the fold—movement, temporality, singularity, and unfolding to a point of view—gives more precision and maneuverability to concepts of information. Understood as physical, social, and processual, information plays a role in the cosmology this book proposes, a process of unfolding, enfolding, unfolding anew and differently.

The history of information is ancient, and so too is the use of information to control people. These techniques do not replace but are layered on top of older forms of power and control.[1] In our current period of computer-supported information capitalism, the means of measurement, communication, and control have become ever more pervasive. Instrumental technologies extract an information-skin from the surface of the world. This skin may even resemble the world it samples, but crucially, it lacks the connective tissue of experience. Life and the world are vaster than information, which constitutes just a fragment of the infinite. Life is analog.[2] Nevertheless, data extracted from surveillant platforms such as search engines, insurance companies, shopping sites, and social media become materialized and weaponized in the world of lived experience.

In an influential 2011 article, the social scientist Martin Hilbert and information scientist Priscilla López compiled the global technological installed capacity to store, transmit, and compute information and argued that, as of 2002, most of human-produced information had been stored digitally. One of their examples is that in 2007, "humankind successfully sent 1.9 zettabytes of information through broadcast technology such as televisions and GPS. That's equivalent to every person in the world reading 174 newspapers every day."[3] That impressive figure should give us pause, however, for the content of the information cannot be measured, just the fact of its transmission. Even with all those bytes shooting around, humans did not become as well-informed in 2007 as we would have if we actually read 174 newspapers a day. This discrepancy between volume and value of information suggests that the world's information-skin remains a poor analogue for its infinite contents.

Since I set out on this course of thinking more than twenty years ago, I am less pessimistic that the darkest imaginings of extractive information capitalism will come to pass, for simple reasons like regulation, true-cost accounting, and the nature of materiality. (A true-cost accounting would consider the social and environmental costs that are excluded from calculations of commodities and services.)[4] Thinking cross-culturally also helps avoid extrapolating the technological ills that befall people in wealthy parts of the world to everyone else. In turn, I find I am cautiously optimistic regarding algorithmic controls of perception. I do not believe that perception and affect are ever completely captured, nor that most humans live in a *Matrix*- or Metaverse-like algorithmically extruded reality. I have a lot of confidence in human capacities to receive from and add to the infinite. The reason this book focuses on aesthetics is that human skills of perception and feeling can

be cultivated and expanded in order to better ground ourselves in the world that exceeds any information-capitalist efforts to quantify it—though not, possibly, their toxic environmental effects. More in the section "Only Moderately Paranoid."

Nevertheless, much of experience, especially in the overbuilt parts of the world, consists of a sensory engagement with information. Interfaces constitute a shifting information-surface, like the surface of the infinite but skimpier, as they lack that experiential connective tissue. For this reason, I've termed networked media's cramped simulacrum of an infinite field "lame infinity."[5] Perceiving the information-skin of the world and taking its shape invites us to form a coalition or soul-assemblage with it. When I am interpellated by an interface, on my computer, my phone, a recipe book, and so forth, informational interfaces predesign my experience, in ways that are sometimes just convenient, sometimes make me dull and numb, sometimes actively misinform me and steal my perception, knowledge, and time. As when Google's Captcha, which many online companies install as a security interface, demands that I prove "I'm not a robot" by identifying blurry pictures, stolen from the world by Google Street View's roving cameras. With this security device, Google farms out the work of building its image-recognition database to hapless consumers. I'm one of those people who take the extra time to misidentify motorcycles as bicycles, fire hydrants as palm trees, in a perverse and futile refusal to perform free labor for the corporation. But even so, in my twisted resistance, I take the shape of information.

Of course, what I have just described is a very mild example of resisting information surveillance. As Lawrence Abu Hamdan documents in his terrifying audio works made during the unfinished Syrian civil war, Syrian prisoners change their breathing patterns to avoid detection by prison guards. Information surveillance has invaded their very being. The Chinese government outlaws any mention of the massacre at Tiananmen Square on June 4, 1989, but resistants find ways to encrypt it, like this poem on the gravestone of Wu Xuehan, whose son was shot and killed that day:

Eight calla lilies
Nine yellow chrysanthemums
Six white tulips
Four red roses

—by which Wu's wife Xu Jue encodes the date of the massacre in a description of a memorial bouquet.[6] Similarly, at the beginning of Russia's invasion

FIGURE 4.1. Photograph by Somayeh Khakshoor

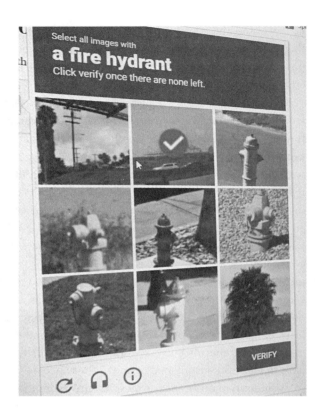

of Ukraine in 2020, Moscow student Dmitry Reznikov carried a sign that read "********"—the number of letters in "No to War" in Russian. He was fined for discrediting the armed forces.[7]

Information Flows, Modulates, Reinforces, and Disperses

Information is a filter, as in Deleuze's argument that, for each monad, there lies between chaos and the perceptible world a filter that extracts differentials that may be integrated in ordered perceptions.[8] However, it operates on a cultural level. The information fold's job is to selectively capture and shape the infinite, in all its chaotic vastness, and deploy those results for knowledge and power. Machine learning, for example, takes control of "unruly and transient multiplicities" such as border flows, financial market prices, and people's tendency to click on online advertising.[9] Earlier I wrote that a soul-assemblage perceives the cosmos selectively, and in this selective unfolding

from the continuum, draws a provisional boundary around itself. Information is also a boundary created by selective unfolding from the continuum, but this time it is created by institutions and shapes some part of the perceptible world for others.

The term *in-formation* implies the imposition of form from outside, as in the medieval scholastic Latin definition, "the giving of a form or character to something" (OED), as clay is shaped into bricks by a mold. This concept dates to Aristotle's theory of form, in which matter is potentiality, form is actuality: matter is seen as passive, and form acts on matter. Aristotle's theory assumes that matter lacks innate properties and can be shaped in any way. Thus "information" implies that the infinite is unformed matter that needs to be shaped in order to be used; furthermore, the same in-formation will always give rise to the same form, as a mold shapes a brick.

Speaking of bricks, brickmaking is one of the most ancient and diverse of information cultures. Across cultures humans have made bricks, both dried and baked, in standardized sizes for thousands of years.[10] What differs is the degree to which algorithmic processes enfold and then replace human labor. These degrees are beautifully illustrated in Harun Farocki's film *In Comparison* (2009), which surveys brick-making practices around the world from the most technologically simple to the most complex. In each process, an algorithm of standardization is at work. In the first scene a Burkina Faso community together shapes mud bricks in wooden frames. Once the bricks are dried, they build a clinic. It's a social process as people pass the bricks along, practiced and easy, with conversation and laughter: the bricks absorb their unalienated labor. The last scene depicts a state-of-the-art factory in Switzerland for producing curved tiles. In this massive computer-led facility, spartan and echoingly quiet, a lone person monitors a robot assembling the brick-pixels. The resulting building has a biomorphic surface of scales that gleam in the changing light. It is eerily beautiful. The history of human ceramic know-how is now enfolded in the machinic process, as alienated labor.

In Comparison shows that information, as a filter for experience, distills human, natural, and economic relations. The film unpacks the logical depth of brickmaking to reveal that even the most sophisticated technology enfolds a history of community-based knowledge creation—often but not always in alienated form.

In privileging what can be usefully quantified, information appears to choke off certain potentials. However, it might be more accurate to say that it modulates potentials. Unlike the model of information whereby forms arise as an imposition on passive matter, the paradigm I advocate asserts that information

is a flow of differentiations that is necessarily relational. Simondon points out that information is always becoming: information arises as a resolution to tensions in a given metastable (i.e., out of step with itself) system. Information signals that something considered important in the given system is changing, as a stock market graph signals changes in prices or a smoke detector signals a potentially dangerous level of particulates. "One could say that the information always exists in the present," Simondon writes, "that it is always contemporary, because it yields the meaning according to which a system is individuated."[11] Forms arise according to a process of individuation, which relates an entity's potential to the changing system of which the entity is part.[12] In *Foucault*, Deleuze briefly anticipates that coding might constitute a "superfold" in its interfaces with matter: a kind of informational lining, in the form of genetic code, computing, and reflexive modern writing, that multiplies potential differentiations.[13] Introducing this concept of the superfold to digital media, Anna Munster points out that it may either serve to modulate and control, or more benignly act as a qualifier that multiplies differences.[14]

These conceptions of information as relational resonate with Bohm and Hiley's argument that information is active, responding to the particle and guiding its activity. What makes an electron leap to a different quantum state? Not coercion, but a delicate dance between the energetic particle and the road map provided by the quantum field.

However, in most cases, information's capacity to modulate with the world is not good news. The information filters that govern social media, prison surveillance, and financial transactions, for example, constantly change as the world they modulate with changes. Aligned with capitalism, information folds in ever more granular ways for purposes of extraction and coercion. I'll return to this problem in "Only Moderately Paranoid." There I'll also argue that complete control is never possible. Just as we cannot know in advance what will unfold, the results of individuation can never be predicted, even by the fastest and best-fed computers. No two things individuate in the same way, because the universe is always changing. The connective tissue of experience cannot be simulated—and even if it could, I will argue, it would be too expensive, and too damaging to the planet, to attempt.

In the definition I prefer, then, information is a filter for the infinite that is itself part of the infinite. It unfolds and enfolds; it flows, modulates, reinforces, and disperses.

The diagram of the cycle of enfolding-unfolding aesthetics in chapter 3 shows how information selectively unfolds local aspects of the infinite. Being

schematic and two-dimensional, the diagram pictures it as one big fold, but information is granular: it is composed of many unfoldings that occur at local places and times. By granular I do not mean atomistic; each grain of information, or single act of unfolding, is the point of a fold.

Information unfolds only that part of the infinite that is necessary for a given function, as the Burkina Faso builders form mud into regular bricks. When it is taken up broadly by commercial and institutional media, information tends to create large folds. Here the worries enter. What is being unfolded and reinforced, at the expense of what other things that remain enfolded? In the cycle of enfolding and unfolding, manners of unfolding, as well as of leaving things enfolded, get reinforced by repetition. As I noted in chapter 3, these folds become stabilized when the images they generate cycle into the infinite and back many times. Similarly, Felix Stalder writes that when flows of information intersect recurrently, they produce nodes. I picture these as the moiré patterns created by overlapped grids, and the standing waves that occur when waves cross one another. These nodes can be large scale, like banks or government agencies, or they can be smaller scale, such as personal identities. "Nodes are intensifications and consolidations of flows in which they constitute structures that process the information, and by doing so maintain themselves and the continuity of flows."[15] These acts accumulate as habits, or what I call information folds.[16]

From the information fold, information-images arise. Images (in all sense modalities) also get reinforced in the cycle of enfolding and unfolding. As Terry Smith argues, enriching Guy Debord's concept of the spectacle, (visual) images come to matter because they are insistently reinforced. In our time that reinforcement occurs through a relay between mass and social media.[17] Smith terms images that cycle insistently with just slight variation *icons*. I would call them "cultural images," a mild term that should not obviate the fact that most images circulating in human culture are clichés, the perceptible skins of events that unfold only to get captured by systems of cultural meaning. Yves Citton's category of exo-attention operates similarly. Exo-attention consists of acts of recognition, selection, and categorization that are carried out prior to individual human attention, by institutions or machines.[18]

Cultural images are molar-scale folds of information-images. They arise on the field of the infinite, perhaps as the idea or practice of one or a few people, and circulate, building up a constituency. They build up in time, as the circulation of images at the molecular scale begins to establish certain patterns. They unfold as people, living on the surface of the infinite, reflect

on their experiences and share these reflections, by talking or writing about them or making pictures of them. At some point, the trend is sampled as information.

Fashion easily demonstrates how image folds and information folds are large but local and temporal phenomena. A fashion, say low-rise jeans, begins with a few people experimenting on the surface of the infinite. Low-rise jeans had been a virtuality in the minds of people who like to expose their hips, waists, navels, and buttock tops; the avant-gardes of street fashion; the cyclical thought-habits of designers; and the denim industry. They emerge into popular actuality, at the apex of high-waisted jeans' popularity, when enough of these granular virtualities produce a cultural image. Low-rise jeans become an image fold when a lot of people are purchasing or making them, wearing them, seeing them, dreaming about them, or making and sharing pictures of them. They become an information fold when the clothing industry markets them, encoding calculations of production, sales, and profits into the seven-inch rise from crotch to waistband. At a certain point—different in places slower to take up the new enthusiasm—the low-rise jeans start to fall out of fashion. The low-rise image fold weakens and dissipates, gradually falls out of popular consciousness, and folds back into the infinite. There the low-rise jeans phenomenon remains, enfolded, once again virtual (to most points of view), but available to memory, research, and discovery. More politically significant cultural folds take shape in similar ways.

What I want to emphasize is the granularity and process by which these molar-scale folds are created by many molecular-scale acts. This analysis of how images arise and retire in temporal and place-specific cycles adds process to more static concepts of large-scale culture, such as Debord's concept of the spectacle.

Information and Capital

My three-fold model of enfolding-unfolding aesthetics, as we saw, diagrams how information shapes the perceptible. The most definitive way that information selectively unfolds from the infinite is in the capitalist assignment of value. The ratio infinite : information maps onto use value : exchange value. Exchange value is the quantification of experience for capitalism. Capitalism terms what cannot be quantified, such as the knowledge of Indigenous peoples threatened by mining or clearcutting, or the consequences of our planet's temperature increasing by more than 1.5 degrees Celsius, "externalities."[19] Externalities are either selectively internalized into information that

suits investors' purposes or left enfolded. Herein lies the political necessity for strategies of unfolding differently and enfolding to avoid detection and for strategic action. True-cost accounting incorporates erstwhile externalities as part of its calculation of the value of things.

In the early 2000s a conception of images as the expression of information and capital, in which images are the operational skin of capitalism, initiated me on the research path of enfolding-unfolding aesthetics. Comparably to my model of the way images enfold information and capital, Jonathan Beller inserts images and information (or code) into Marx's formula for capital, M—C—M': money is translated into capital, which generates more money. Beller replaces the commodity with image-code, to get a new formula, M—I—C—I'—M': money is translated into images, which generate code, which makes a new image, which generates money. It captures the way money is invested in an image, which is then encoded to generate more potential value for the investor.[20] For example, if money is invested into low-rise jeans in an advertising campaign, the jeans become an encoded image of capital that can be used to sell more jeans. When we buy a pair of low-rise jeans (rather than taking out the sewing machine and making them) we are wearing an image of information-capital.

Unlike Beller, I see these images as the tips of a folded world of experience that eludes complete instrumentalization. The process of unfolding image-capital is granular, as everyone does it a little bit differently. The capital-driven cycle from infinite to information to image in my model is selective, has gaps, is not totalizing, and falls back, compostlike, into the infinite, sometimes not to arise again. At each iteration new events can occur, unforeseen by the investor, including events that do *not* add value to the commodified image.

Information Arises to a Point of View

Like the image fold and the infinite itself, the information fold is historical and ever individuating. Even when it appears totalizing, information arises to points of view. It is granular: reinforced, or not, by multiple individual unfoldings. Recall that a point of view does not preexist the folded surface but is cocreated with it. The information fold assembles souls. It constitutes *and* is constituted by points of view. Its techniques amplify "the production of the user as a behavioral unit and provide quantifiable test data to allow for this production to be optimized, whether or not anything is watching," as Matthew Fuller and Andrew Goffey write.[21] Information solicits human-based monads and soul-assemblages at varying scales, times, and contexts: for

example, the individual who responds to click-bait designed just for her; the soul-assemblage of voters against subsidies for petroleum production; the soul-assemblage of shoppers who suddenly desire low-rise jeans.

As I seek to do here, Paul Kockelman studies the ways semiosis is automated, as well as formatted and networked. Kockelman expands the definition of information to include selectional information-content, or degree of relevance, and metrical information-content, or degree of resolution. Selectional information-content conveys new information (Claude Shannon's original definition of information), and metrical information-content conveys that information at a certain scale. Different media forms produce different frames of relevance and degrees of resolution, and thus, he argues, "create different kinds of selves who can sense and instigate, as well as communicate and cogitate, through such media on such scales."[22] I'd say they don't create selves but shape points of view and manners of unfolding.[23] A fun example is Andrew Roach's small-file movie *Expedition Sasquatch* (2020), twelve minutes long and only 2.6 megabytes in size, in which an opinionated off-the-grid Sasquatch hunter narrowcasts his search for the elusive creature. Suddenly he spots it! But given the extremely low resolution of the image, a viewer ses nothing but a shifting field of pixel blocks.[24] There is plenty of selectional information-content (there's Bigfoot, looming in the darkness) but little metrical information-content. The hilariously low-resolution image solicits viewers who must really put themselves out there in order to unfold the precious image content—or just enjoy the joke that it is impossible.

Thinking of information as an ever-changing fold that flows over you, into your perception like a wave, can help avoid reifying it. The ideologies that grip Americans in 2024, even the self-neutralizing ideology of current capitalism, have less hold on Canadians, far less on Laotians or Zimbabweans; and they are different from those held by people fifty, two hundred, two thousand years ago. People who live at the intersection of spheres of influence— like the Lebanese, buffeted for decades by the competing interests of Syria, the United States, Iran, France, and other countries—are less likely to align with the dominant folds and more likely to devise complex and enigmatic folds grounded in the local. People who are left out of the narrative are relatively immune to dominant manners of unfolding that do not "hail" them— such as the immunity of Indigenous Canadians to the national glamour of socialized medicine, or of Black female spectators to Hollywood cinema that bell hooks identified in 1992.[25] Ideologies, even those most perniciously buried in materials and systems, are always vulnerable to critical refoldings, especially by coalitions.

Like the other folds, the information fold possesses diverse manners of unfolding. We can learn about these through techniques such as market analysis, which tracks the fates of companies that extract and trade in information; through ethnographies of their networks of human workers; by examining their perceptual and affective effects, which is my main purpose in this book; and by studying their infrastructures. Doing the latter, we quickly find that infrastructures are soul-assemblages of human and nonhuman actors. As Lisa Parks and Nicole Starosielski emphasize, to avoid a homogeneous view that aligns with the idealistic models of media corporations, infrastructure research needs to cross disciplines and work at macro and micro scales.[26] In this way research can respect the granularity and time- and place-specificity of information.

The information fold engenders a field of soul-assemblages. Information makes a vinculum, that vinelike bond bringing together separate individuals that I introduced earlier, and thus produces soul-assemblages. It produces information-monads, newly folded entities that have interiority and capacity to act. Temporary beings precipitate from algorithms, folded into shape by information technologies such as credit-card surveillance and biometrics. Yet since information capture is never complete, that flexible distance between human and our weird digital analogues can also be a place for play.[27] As I explained earlier, the equations of Leibniz and Bohm precipitate subjects by virtue of their position on a curve. Compared to Leibniz's and Bohm's cosmic subjects, such informational manners of engendering subjects would seem absurdly small-minded if they were not annexed to power. Similarly, machine learning creates information-monads or temporary subject positions, such as voters and audiences for microgenres, by reverse-engineering them from algorithms.[28] Its methods are inventive but, I stress again, lack connective tissue, because they extrapolate mathematical points rather than unfold from the infinite.

The monads and soul-assemblages that populate the information fold come together to do certain tasks. They individuate, drift apart, and reconfigure. Information soul-assemblages include paid and unpaid human laborers, from programmers to "cleaners" to the people whose data is mined from social media, shopping platforms, health records, and property tax files. They include software, the communities that build and maintain it, and the myriad platforms, such as blog posts and conversations, that sustain their communication. They include the servers, networks, and devices that carry out the work—each of which is a vinculum harnessing diverse multitudes—and the energy sources that support them.

Information-Images and Computational Perception

Aesthetics begins with perception. But in the case of information-images, aesthetics must extend into research, using a method of triangulation to make palpable what underlies the information-image. As I explained above, information, as quantification or regular sampling, selects images from the infinite as material that can be easily worked. Historically all cultures have had ways to codify the perceptible, discriminating in favor of images that are useful as information. What is unprecedented in contemporary culture is the dominance of information as a plane that shapes what is possible to perceive. This is why we spend so much of our time not looking out the window, sniffing fugitive scents, and turning up memories, but responding to the images that arrive to us from advertising, public signage, alert sounds, screens of all sorts, and even codified flavors and smells. These are images that ask not to be fully perceived but just read or deciphered, for they unfold from, and index, information. In Peirce's terms, our image world is composed of fewer signs that address themselves directly to sense perception—*icons* (a sign that resembles its object); *qualisigns* (a quality, just emerging into perception: a color, a scent); *rhemes* (a sign of possibility) and *sinsigns* (an actual event)—and more *legisigns*, habitual signs that ask to be read according to laws or conventions, and *arguments*, signs that exhort the viewer.[29]

Information-images are perceptibles that are extruded from information. They consist of perceptions of the world that have been preselected according to convention, fashion, or any of the cultural filters that limit the perceptual field. These preselections can be convenient—our brain doesn't want to decide anew every time what constitutes the color green, for example—and they can be ideological. Of course, often ideology passes as convenience. Many events arrive pre-prehended by another filter, a cultural filter that decides for us what is significant. On our behalf (that is, on behalf of the group to which the information unfolds), it chooses between signal and noise. For example, the conventions of compression-decompression algorithms like MP3, JPEG, and .M4V unfold the perceptible world in limited ways that experts determine most people will accept.[30] Such filters cut the image out of the infinite for us. Taking the shape of the information that generated them while enfolding the infinite field from which the information arose, information-images disorient the recipient. "In understanding (or better, perhaps, witnessing) the logistics of images by means of images," Beller writes, "we are lost in the map and thus lost in and to the world."[31]

Information-images behave like language, as in Peirce's legisign and the sign in Saussurean semiotics. They are molar signs, the summation of numerous individual acts of unfolding. Perceptibles that ask us to read them, information-images propose arguments, boss us around, sell themselves to us.[32] As cultural signs, they may be illegible to someone perceiving from a different cultural environment or historical period.[33] They will miss the denotations and allusions, insofar as those are encoded arbitrarily. This ignorance frees them up to respond more completely to the image as a perceptible in itself. It's an important exercise for scholars of images, such as art historians and film and media scholars, to lift away cultural signs for a while in order to really perceive and to assess what's occurring at the molecular level (as in my affective analysis method).

Problems of a higher order set in when institutions, such as corporations and governments, choose the filters that determine what can be perceived. In our time, quantification and preselection have penetrated perception itself. Often they work against the interests of humans and, as I will explain, the planet. In these cases, information-images are the perceptible surface of what is variously called surveillance capitalism, algorithmic capitalism, and the attention economy, in which megamedia corporations use algorithms to predict, monitor, and extract value from human activity, keep consumers (most distressingly, children) addicted; and concentrate wealth. And as we'll see, often information remains relatively imperceptible as image. In fact, the most important information in our information age does not produce images; it remains in an enfolded state. In these cases, perception is not much use.

An information-image need not be digital, of course; it is any image that is selected according to given cultural filters. And a digital image may not be heavy in information; for example, the information filter of a photograph or audio recording captured with a digital camera is relatively incidental. Similarly, a video that someone uploaded to YouTube but nobody, or almost nobody, has watched is light in information. I think of these video-ghosts as floating in the infinite, lonely as a blade of grass no insect has nibbled; lonelier, because it doesn't have a root system to talk with. Most of the billions of digital images crowding data centers worldwide are lonely in this way, light and practically meaningless—except for their footprint in resources and greenhouse gas emissions. Most information-images don't get much traffic but fall back into the infinite.

A dark view of how information penetrates culture has been thoroughly theorized, activating much alarm. In 1999, N. Katherine Hayles argued that a logic of information rather than materiality mediates contemporary

experience.[34] Similarly, Bernard Stiegler argues that, as memory is increasingly inscribed by industrial technologies, information has come to define collective memory. As a result, individual memory is lost and replaced by a commodified collective memory. "Information, in the hands of a very small number of producers, is the *prime material* of memory" from which the selection of what can become eventful is made.[35] For example, GPS replaces people's memory of directions and ability to read a map. Or personal collections become replaced by social-media archives that claim ownership of their contents. A friend of mine was heartbroken to lose his entire personal image archive, which he stored on Facebook, after Facebook deactivated his account because one photograph included a Hizbollah flag. Yet, as I'll explain further below, I differ with Stiegler: information-images, such as photos on Facebook, remain the mere tip of the iceberg of my friend's individual life, as well as collective life. I will also point out that information-images are not monolithic but unfold to points of view in specific places and times.

Identified by several different terms, computational perception uses relatively invisible informational filters to replace, or augment, human perception with machinic agency. Technical images, in Vilém Flusser's term, are communication technologies that depend on mathematical code.[36] Flusser's example of the technical image is photography, which points to the pre-digital and apparently innocuous use of quantification in image making. Machines talk through us, in what Farocki terms "operational images," Guattari, "a-signifying images," and Beller, "programmable images." MacKenzie and Munster refer to this same process as "platform seeing."[37] In all these cases, as Farocki writes, "Increasingly humans insert themselves into operative [or information] images as though they were intended for our eyes."[38] Such information-images do not represent but index a technical process, bypassing the human subject.[39] PIN numbers, QR codes, the hated Captcha, and the insulting interfaces into which we must insert ourselves use humans as proxies for machine communications that, in turn, serve other human powers.

These machinic filters usually serve purposes of extraction and control, in human decisions made at the design level. Some are rapacious, like smart bombs. Some appear benign, like standards built into cameras and digital microscopes and computer-assisted surgery. The distinction between machine perception and interface-driven perception is one of degree. Codecs, for example, are interfaces built into cameras or editing software that preshape the image. Smart weapons filter out what is supposedly noise in order to guide their human operators to the target.

Computational perception can form a soul-assemblage with human perception in ways that are not so dark. Human-machine vision unfolds the world differently than human perception alone does. Photography and cinema have long been admired for the ways that they see without the constraint of human convention—aside, importantly, from what is built into the apparatus. Early examples include the French *photogénie* movement of the 1920s and Walter Benjamin's concept of the optical image. In the 1940s André Bazin appreciated film's automatism and, as Victor Fan points out, Chinese film theorists celebrated cinema's *bizhen*, its quality of approaching reality.[40] A. S. Aurora Hoel asks whether human and machine vision are necessarily competitors or join to form amplified visual systems that see more and *differently* than humans do.[41] Expanding Farocki's concept of the operative image to a number of other functions, Hoel argues that images inform vision, instruct action, intervene, evolve, and multiply. Computer-guided surgery is one example of operational images that instruct action for good purposes. I find this argument a little uncritical. Many people use Google Earth to carry out forensic detection, make art, and other apparently positive purposes; and yet Google Earth's purpose is surely to control and commodify the visible surface of the planet. But as human and nonhuman perception come together in soul-assemblages, it's important to develop criteria whereby organic life can comodulate with technologies rather than be dominated by them.

Information Models the Future on Abstractions of the Present

Information models the future on abstractions of the present and seeks to foreclose other actualizations or unfoldings. It shapes the virtual on the actual, or more precisely, shapes what is to come on what actually exists. Richard Grusin's concept of premediation analyzes how corporate media preconstruct notions of possible future worlds based on commodified choices in the present, stunting the cultural imagination.[42] As Munster writes, "Prediction takes down potential" when a search creates metadata rather than shared knowledge.[43] In Brian Massumi's concept of preemption, power eliminates uncertainty by actualizing virtual threats.[44] These days artificial intelligence (AI) mediates future-oriented decisions, extracting data from the infinite in order to model what is to come. As Louise Amoore emphasizes, since predictive algorithms learn from error and indeterminacy, they produce the future as a field of probabilities, on which corporate wagers can be based.[45]

A 2015 list of the highest-valued projects on the machine-learning competition platform Kaggle suggests what is most valued in contemporary AI

research: identify patients who will be admitted to a hospital next year, for $5,000,000; an automated scoring algorithm for student writing ("to free up the professor for other tasks," as I read once—such as looking for another job), for $100,000, offered by the Hewlett Foundation; predict West Nile virus in Chicago, for $40,000; predict which shoppers will become repeat buyers, for $30,000.[46] AI corporations carry out both neutral-seeming and clearly extractive projects. For example, Deep Mind, based in London and Silicon Valley—the company best known for building an AI that beat Lee Sedol, the world champion, in a game of Go—has AI projects to improve cooling at Google's data centers; and speaking of folds, AlphaFold, a project that aims to model every protein in the human body. It also developed a neural network to improve Google Play's app recommendations and a generative human-speech simulator that even incorporates "natural-sounding elements left out of earlier text-to-speech systems, such as lip-smacking and breathing patterns."[47] The difference between scientific and marketing applications of machine learning, Fuller and Goffey suggest, is that the former use it to generate questions, the latter to close deals.[48] Even this difference is blurry, given that scientific results tend to get diverted into commodities. Less generous than Fuller and Goffey, I note that shareholder profits come first for AI companies, and that these applications look like expensive solutions for rich-country problems, especially when we factor in the staggering energy cost of AI. Where are the AI competitions to cure tuberculosis, combat drought, and support sustainable farming?

Expensive to carry out, big-data research creates monopolies. Corporations like Alphabet, Meta, Spotify, Netflix, Amazon, Alibaba, Wal-Mart, insurance companies, credit-card companies, and derivatives funds possess what Jaron Lanier terms "siren servers," elite networked servers that in their sheer computational capacity trounce any competition.[49] In the field of artificial intelligence, MacKenzie points out, corporate competitions for "deep belief" algorithms are weighted toward academic research teams that can afford prodigious amounts of computing power.[50] The most calculation-intensive AI programs produce hundreds of models of the phenomenon, each of which takes hours to days for their computers' energy-intensive graphics processing units to compute.

Corporate futurism, Kodwo Eshun writes, models the future on the continued dispossession of the present. "The powerful employ futurists and draw power from the futures they endorse, thereby condemning the disempowered to live in the past."[51] Futures modeling by multinational corporations and NGOs, in economic projections, weather predictions, immunology, and

models of life expectancy wager that Africa, in particular, will remain immiserated. These wagers generate value, reinforcing the status quo and actively repressing alternatives.

About 20 years after Eshun limned this despairing account of capitalism's seemingly infinite capacity to defraud Africa even in the future, Malay Singaporean artist Bani Haykal issued a pessimist manifesto. A forecast from the archipelago (*nusantara* in Malay), far from centers of power, it reads too like a disconsolate rejoinder to Glissant's island-based ethics.

> the word future does not exist
> in the Malay language, the word future
> does not exist, in the Malay language
> the word future does not exist, and i want
> to say this is good. this is good
> because the future is often peddled
> by billionaires, governments, elites,
> scholars, ivory tower solehs and solehahs [good and obedient people]
> that
> berdakwah [preach] to so many of us to dream, imagine
> and speculate about the future of our
> own liking, to be optimistic about
> it, where *we are tasked to dream* for
> the sort of joys we don't encounter today
> dream for a habitable tomorrow, think positive dreams
> for an inclusive tomorrow
> .
> the future is banana money
> printed by colonisers and we are
> made to buy our dreams with it

However, Haykal writes, there is in Malay a word for time ahead, *masa depan*, which connotes what we are facing from a particular position; "and so / the question about the future / is never about when, it is about / what and where."[52] While the future of corporate and imperial powers is thrown like a net over everyone else and requires their collective sacrifice to perpetuate it, "our" future, Haykal suggests, is granular, generated in local, purposive, short-term acts. This echoes the provisional and task-oriented direction of the soul-assemblage, a motley phalanx attempting to realize a (usually) modest hereafter.

In the domain of aesthetics too, information models the future on abstractions of the present. The resulting actualizations tend to be stunted

and anodyne, as Hito Steyerl observes regarding computational photography, cameras that compose your picture according to pictures you've taken before.[53] The computational perception I described above often uses predictive algorithms. Codecs are predictive in the broad sense that they cannot deal with surprises. Video codecs reduce the size of video files, for example by omitting detail from frame to frame in seemingly unchanging areas of the image, and periodically comparing these to key frames. But if a fast-moving object, like a hockey puck, is not included in a key frame, it will vanish from the image. Thus, as Sean Cubitt writes, codecs "diminish the possibility that anything unexpected will occur on-screen, even if it has already been recorded."[54]

One of the pleasures of human perception is to ease cognitive control and enjoy the inventions of the mind's eyes and ears, as when daydreaming or falling asleep. My unconscious, like many people's, likes to concoct faces as I drift off. A little scarier, pareidolia is the condition of perceiving images, especially faces, and sounds in random stimuli—a kind of horror vacui determined to translate the perceptible field into meaningful signs. Machine perception is colonizing this unconscious process too and translating the sensuous world into a legible one. The DeepDream neural network application designed by Alexander Mordvintsev for Alphabet is pareidolia on steroids, schizophrenically translating image noise into cutesy figures. Figures squeeze out of thin air: staring eyes, kittens, beagles. The more iterations of DeepDream one applies, the more ocular or kittenish the image becomes.[55] Populating the perceptible field with pre-programmed images, DeepDream machine-learning software supplants private reveries (and nightmares) with anticipatory calculations.

The most alarming analyses of predictive control contend that capitalist interests have penetrated biological being. Cognitive capitalism creates ever-more fractal interfaces with human cognition and affect. These analyses in many ways revive 1970s apparatus theory, which argues that audiovisual images interpellate the viewer unconsciously for ideological manipulation. The difference is that now the interpellation occurs not unconsciously but precognitively, and the ideology, if there is any, is mere ornament. Not perceptual but affective responses are the material corporate media cultivates; the adrenaline rush of blasting aliens in an online game, the sickly panic when nobody likes your post, the creepy-cozy familiarity of interfaces that seem to "get" you. Pasi Väliaho argues persuasively that video games bypass cognition entirely by appealing to the reptilian brain.[56] Luciana Parisi and Steve Goodman contend that corporate branding implants memories of the future, overcoding the brain's creativity.[57] What Steven Shaviro in 2010

termed "post-cinematic affect" has spread across multiple platforms, including the rise in algorithmic affective genres like ASMR: media that speak directly to prediscursive parts of the brain.[58] Meanwhile, as Jonathan Crary reminds, human sensory and intellectual bandwidth cannot sustain the addictive onslaught of online media without severe damage to the organism.[59] These critiques of the effects of information capitalism engender the dispiriting attitude that algorithmically generated media constitute not only the perceptible world but also our very capacity to perceive.

At this point it's helpful to keep in mind that abstractions of the present that seek to model the future are historical, diversely generated, even incompatible. For example, MacKenzie's ethnographic archaeology of contemporary machine learning practices concludes that machine learning in the sciences "constitutes an a-totality, a heterogeneous volume and decentered production of statements," which generates knowledge that is uneven and contingent. Like the waste of computing creativity for basic profit-taking applications that Lanier bemoans, ML is mostly being deployed for simple purposes and low-hanging fruit, viz the hundreds of PhDs in machine learning who get jobs in targeted advertising.[60] Meta, Amazon, and other siren-server corporations notwithstanding, no single corporation or government has a monopoly on the future.

Aesthetics would seem a poor tool to analyze the power relations blackboxed by the information-image, especially as many of their effects are precognitive. This is why we need to study not the perceptible side of the interface but the interface itself and the programs, applications, data sets, and infrastructure that support it. Yet another arrow in the information-image analyst's quiver is affective analysis, as I suggest in chapter 5: researching affective responses to information-images. Interestingly, interfaces produce affective responses even, or especially, when the perceptible image is slim. Recipients *feel* their effects, Fuller and Goffey note: "delight, terror, geeky enthusiasm, mildly hypnotic euphoria, ugly feelings, and paranoid rage"; general unease. These responses are useful data for critical analysis. What we are apprehending, they write, are "the dimly sensed links between affective configurations and the broader, unstable networks of agents and mediators of which we are a part, with their difficult-to-perceive boundaries and their correlative scope for producing troubling uncertainties."[61] Put differently, we are feeling the *disquiet* of belonging to a soul-assemblage that we didn't seek membership in—a most likely toxic soul-assemblage of corporate extraction and surveillance. Affective analysis triangulates between what can be perceived at affectively intense moments and the interface that generated

those perceptibles and affects. The analyst gets a sense of what produced that euphoria or discomfort. Those sensations are the differentials between the world that information unfolds to us and the infinite beyond.

The smooth surfaces of computer-generated animation often express the airlessness of an infoworld closed in on itself. Jonathan Monaghan's sleek and darkly humorous animations, bristling with branded commodities and steeped in end-of-days symbolism, evoke the mythically vacuum-sealed world of information capitalism. Crafted from calculations, with their smooth surfaces and fractal levels of detail, his images generate a digital sublime more complete and perfect than any personal hallucination.[62] Monaghan's worlds resemble the closed cosmology of Leibniz in which each monad is a microcosm of the whole; their mises-en-scène undulate with Baroque folded architectures. Designed for exhibition in galleries, they loop, ouboroslike, reinforcing the sense that there is no outside to the commodity universe. In Monaghan's *Den of Wolves* (US, 2020) three robotic wolves in gilded, modem-equipped armor prowl a deserted Washington, DC, in search of raiment for a monarch, an imminent Beast. In a single simulated shot the animation glides through the closed world, up and up through ocular openings, from a vast Walmart-like basement to a Whole Foods–type storefront to the Apple store now inhabiting the ground floor of the Capitol Building, red rental scooters abandoned outside, and up through the building's white and gilded dome interior. The wolves' destination is a dimension-defying space capsule, a rococo microcosm of the governmental architecture, that lifts into the heavens. Through a tufted, gold-buttoned[63] pink velvet umbilicus (Chanel?) that reaches from the capsule's ground floor to its top floor (hello, Leibniz!), something is pumping—resources stolen from the abandoned Earth, perhaps. Along translucent cables glowing lights travel in the opposite direction, as though transforming material into information. As the shot travels into the heart of this extractive knowledge center, the big reveal—the noumenon of it all—is a boutique coffee shop. Zooming smoothly past the La Marzocco espresso machine, the shot glides into the small refrigerator, between boxes of water ("Boxed Water Is Better") and surveillance cameras, tilts down—and we find ourselves in the deserted Walmart once again. *Den of Wolves* brilliantly deploys the loop format to create a sense that information capitalism's theft of analog life is inevitable, cyclical, and irresistibly seductive.

In the seamless world generated by and for digital technology there appear to be no organic beings, but an eerie organicism pervades, what Perniola calls the "sex-appeal of the inorganic." Yet, as in many of Monaghan's works, there is one hint of organic being in *Den of Wolves*. The Beast that

FIGURE 4.2. Still, Jonathan Monaghan, *Den of Wolves* (US, 2020)

rumbles to its feet in the Walmart is a creased mass of red velvet, its armor gilt-trimmed dehumidifiers, its protruding eyes surveillance cameras; but when it roars, the interior of its mouth and its stippled tongue are flesh. It's as though the constitutive materiality that is repressed everywhere else in this closed cosmos lurks in the fleshy interior folds of the devouring monster.

What Information Enfolds

A vast amount of cosmic activity is encoded into information. Information enfolds, and usually elides and excludes, all that made it possible: human labor, the earth's resources, and energy. It is not only human life but also the life of other organic beings, metals, air, stars (especially our Sun)—in short, of the cosmos—that is converted to value. Bureaucracies, media corporations, the military-industrial complex, and other institutions invest in standardization to control the objects that interest them. Some members of those institutions accept the ideology that information is immaterial—the marketing department, perhaps—but not the CEOs, not the lab scientists, not the technicians.[64] A little research always demonstrates that these mechanisms for sorting and quantifying the infinite are designed and carried out by real people. It is increasingly impossible to ignore the human and planetary labor enfolded in algorithmic activity, from Amazon's warehouse slaves to the children mining copper in the Democratic Republic of Congo to the

neck-risking cyclists behind food-delivery apps. Spreadsheets look like the coldest of tyrants, but as anyone who's made a spreadsheet knows, every cell was born of struggle, blood, and tears. The human-computer interface (HCI) is really a human-computer-physical world interface. The invisible laborers on whom computer applications rely are like the Tethered people in Jordan Peele's *Us* (2019), living in miserable underground bunkers, who wretchedly mirror (but actually, captured in ICT's vinculum, cause) the seemingly effortless gestures of the others above ground.

You don't need to contact the infinite to extract value from it, but you need to enlist the labor of someone or something who does make that contact. That is Hamid Ekbia and Bonnie Nardi's concept of *heteromation*. In contrast to the corporate ideology of automation, which suggests that unpleasant tasks once performed by humans are now the domain of machines, heteromation describes work that has been outsourced to invisible humans working in sad soul-assemblage with machines. This is not only factory labor but also the companies that gain value by harnessing people's cognitive, creative, emotional, and communicative processes.[65] Ekbia and Nardi's important point is that the companies neither understand nor sustain the processes from which they extract value. Companies and algorithms have no contact with the infinite—but their un- or underpaid laborers do, and this part of the infinite is rarely pretty. As ethnographer and computer scientist Lilly Irani points out, "the qualities of work or life that are cast as machinic, automated, tedious, and menial are those tasks assigned to racialized or gendered others," in the division of labor between scientists and human "computers," what she elsewhere calls "data janitors."[66] For me, the larger concern is not that AI will replace human perception and thought, but that paid human labor is being replaced by underpaid or free labor, sometimes blandly termed "crowdsourcing." Citton characterizes automation as "a tale of two cities." The wealthy believe that precarious algorithmic laborers like Uber drivers and Amazon workers will eventually be replaced by robots. The poor know that they will be paid less and less for work that remains necessary to supplement machine labor.[67]

As Irani has demonstrated, cognitive piecework companies like Amazon Mechanical Turk (AMT) must convince investors that they are stable sources of profit. They do this by making both risk and labor disappear—pushing the risk onto laborers and shielding employers from the laborers' working conditions—so it appears that software is doing all the work.[68]

To those invisible laborers we can add ride-share drivers, online sex workers, Mexican farmers who sell organic tomatoes to Amazon-owned Whole

Foods; anyone whose labor is mediated by a platform that protects employers from understanding their working conditions. I persist in calling these conditions the infinite, or simply life itself, in contrast to the information surgically selected from it: a ride, a personalized porn performance, the shapely tomatoes in the produce section.[69] Labor activism unfolds the life that technology platforms make invisible.

Taking the Shape of Information

At its most extreme, information not only preselects what those in its purview will perceive but invites us to take its shape. Generally, to take the shape of information means to rearrange one's life around algorithms, hashtags, spreadsheets, and other less perceptible interfaces. How disappointing to be information's cleric, rather than cavort with the infinite! Artist Tom Sherman expressed it in 2001: "I thought my life's work would be more creative. I thought I'd be the one making the messes—interesting, vital messes. Instead, I find I'm merely an extension of this year's software."[70]

As pixel-patterned camouflage mimics the resolution of a surveillance drone's camera, people change themselves, often unwittingly, to conform to the algorithms to which they are subjected. In information culture, the infinite is replicated at the level of information so rapidly that it is difficult to know whether one is having an experience or experiencing information about experience. We internalize an algorithmic panopticon. Interfaces are designed to anticipate and replace the labor of feeling, like text message autoresponses—"Sounds good!" or a laughing-crying emoji. Google Glass, rejected by consumers in 2015 for too evidently precoding the world, has been resurrected to teach autistic children how to recognize emotions, via facial recognition software.[71] I bet it will be marketed to non-autistics too, to spare us the work of empathy. Empathy software could also be easily layered atop facial recognition in Meta's new Quest Pro headset.

The documentary *The Cleaners* (Hans Block and Moritz Riesewieck, Germany/Brazil/Netherlands/Italy/USA, 2018) and the fiction film *Sorry We Missed You* (Ken Loach, UK, 2020) both disclose the toll on body and soul when people must take the shape of information for a living. Content moderators for Facebook, YouTube, and Twitter in the Philippines and other low-wage countries click through twenty-five thousand images a day, determining whether posted content passes guidelines, quickly identifying and deleting pictures of torture, child pornography, and other violations of the platform's standards. The algorithmic binary "delete/ignore" expands into human suffering absorbed at microspeeds by the content moderators, their

FIGURE 4.3. Still, Hans Block and Moritz Riesewieck, *The Cleaners* (Germany/Brazil/Netherlands/Italy/USA, 2018)

eyes flickering as they quickly sort the images.[72] In *Sorry We Missed You*, Ricky, a parcel delivery worker on a zero-hours contract similarly has to fit unwieldy life into the infinitesimal spaces of delivery algorithms: finding a parking spot, negotiating at high speed with truculent customers, peeing in the provided plastic bottle because there's no time to stop, and outsourcing family life to a future time when things are better. Meanwhile his partner Abbie's job as an eldercare worker exemplifies the feminine labor of packing emotion into the algorithmic space of piecework.

The suffering peculiar to this kind of work comes from inhabiting the gray areas between information capitalism and the infinite, making the hundreds of tiny accommodations that don't figure in the algorithm, embodying algorithmic decisions as posttraumatic stress. Doing this kind of algorithmic work contracts your amplitude, until you become like one of those tiny monads we encountered earlier whose amplitudes encompass only one thought—"I hate Amazon."

As in my daily skirmish with Captcha, resistance to instrumentality of information takes the shape of information. Hiding in plain sight is a manner of enfoldment. The eponymous missive in Poe's short story "The Purloined Letter" evaded detection in an exhaustive search of a minister's apartment because it was standing innocently in a letter rack, folded inside out. After the day in 2002 artist Hasan M. Elahi was interrogated upon entering the United States, on suspicion of his involvement in the September 11 attack, he

embarked on a massive project of self-surveillance, *Tracking Transience*. The site includes financial information, hourly posted images of his whereabouts, and countless photographs of meals and parking lots, all of which he reports to the FBI. A too-detailed surface becomes haptic, deflecting the penetrating gaze.[73] Excessive transparency, combined with a deliberately user-unfriendly interface, permits Elahi to be left in peace. "If 300 million people started sending private information to federal agents," he writes, "the government would need to hire as many as another 300 million people, possibly more, to keep up with the information and we'd have to redesign our entire intelligence system."[74] Such a perpetual employment system is already underway worldwide, with China and the US currently topping the list of most surveillant countries.[75] The downside of such constant self-exfoliation is that one's private infinity begins to take the shape of information—useless information, but information nonetheless.

Interface-driven popular culture solicits humans to take the shape of information. Like my psyching out Captcha, we find ourselves becoming-algorithm: anticipating how algorithms function, acting like them, revealing ourselves to the algorithm or hiding from it, in a solicitousness that Taina Bucher terms the "algorithmic imaginary."[76]

But what if our shape is too formless, as the feminist satire magazine *Reductress* asks?

> Until recently, Lauren's main source of music was YouTube videos of college a cappella groups singing One Republic songs. But once she experienced the Spotify "Discover Weekly" feature—where Spotify generates a personalized playlist based on what each user listens to—Lauren was totally hooked. "It's like it knew exactly what kind of playlist I would've made for myself!" she gushed about her fucking embarrassing taste in music.
>
> Lauren's first three Discover Weekly playlists were just the theme song from *The L Word* 30 times in a row. Lauren has never watched *The L Word*. This is simply the music she chooses to enjoy. . . .
>
> There seems to be no connection between the utter atrocities Lauren listens to; yet, week by week, Spotify consistently wrangles a new, nightmarish cacophony that absolutely nails Lauren's musical sensibilities. The ways in which modern technology continues to enrich our everyday lives keep on growing—![77] Thanks, Spotify!

Lauren's free labor for Spotify is the labor of not doing anything.

Inaction, the staying-enfolded of digital participation, compels even more predatory activity. Captivation metrics of platforms like Netflix and Spotify assume that users would be more satisfied by a system that could more accurately predict their ratings. However, this requires that users *have* preferences. They need to have some preexisting source of interest that Netflix, and so forth, would mine. Music recommenders measure users' avidity on a scale from indifferent (the majority) to casual, engaged, and (the few) savant.[78] More engaged users generate more detailed patterns of information, while disengaged users, like *Reductress'* Lauren, leave fewer traces. "As a result," Nick Seaver writes, "the figure of the less avid listener serves to justify increasingly rapacious data collection practices."[79]

Algorithmic infrastructures extrude consumers as monads shaped by their Procrustean hospitality. As Seaver notes, algorithmic recommendation falls in the ethically ambiguous zone between persuasion and coercion. Infrastructures are not only traps but also prescriptive hosts. "We could say that infrastructures are already traps," Seaver writes, "arrangements of technique and epistemic frame designed to entice and hold particular kinds of envisioned agents, according to culturally specific cosmological preconceptions."[80] Similarly, Wendy Hui Kyong Chun terms the siloing of interest groups by social media homophily (the love of the same), according to "the axiom that similarity breeds connection." Homophily both assumes segregation and actively creates it, serving as alibi for the way machine learning perpetuates discrimination.[81] Seaver and Chung are describing the closed, self-fulfilling worlds created by and for human-algorithmic soul-assemblages, in which human consumers willingly collude in their self-shaping. I like that Seaver refers to the *cosmologies* established by infrastructures: mean little worlds that cruelly mimic the larger cosmos and blandish tired participants to accept the substitute.

Surveillance, spying, reporting, and recording attempt to replicate the infinite at the level of information in as much detail as possible. They produce an informational world that mimics the infinite: a world like Borges's map that is the same size as the territory it maps. Crucially, however, the map lacks the infinite's connective tissue. It is a snapshot of a moment that excludes the processes whereby the formations came into being. As William Latham writes, "Even the most perfect copy effaces the precipitating forces that account for the original's existence and thus where it might go next."[82] Imagine for example that a spy feigns friendship or love in order to acquire knowledge. Here espionage replicates the appearance of friendship without the enfolded, historical links that make a friendship. Surveillance replicates the

appearance of knowledge without the enfolded, historical links that generate knowledge; without the connective tissue of the infinite.

Gamal al-Gitani's novel *Zayni Barakat*, set in sixteenth-century Mamluk Cairo, diagnoses our contemporary condition by which individuals take the shape of the surveillance exerted upon them. The novel, first published in Arabic as a serial in 1970–1971, allegorizes the conspiratorial webs of the contemporary Egypt. It evokes the atmosphere of fear and suspicion characteristic of any society with a powerful and top-heavy state apparatus. *Zayni Barakat* also parallels the all-pervasive but supposedly non-ideological (as capitalism is non-ideological) prying, snooping, unending recording, reporting, and storage that are the mark of information culture: selectively extracting information from the experience, which is by definition infinite, of the state's subjects. In Mamluk Cairo, city of intrigue and treachery, spies must master the knowledge of every walk of life, from coppersmithing to poetry, not in order to possess that knowledge but in order to spy on the people who do. The Chief Spy of Cairo dreams of a Spy Academy that would teach not knowledge but the shape knowledge takes as information, the better to help his spies blend in.

> The true spy, the real top-notch spy, is one who has been able to combine all the characteristics of all people. A spy should be a coal-trader when he talks to coal-traders, an ingenious apothecary when he talks to apothecaries, a dissident when he talks to dissidents, a hashish smoker when he finds himself in the company of hashish smokers. . . . He must master the language of the rich, be humble when he mixes with the poor, be foolish and be loved by the fools. . . . The more knowledgeable a spy is, the better command he has of the foundations of learning and the different arts, the more capable he is of unveiling the secrets of the world.[83]

In surveillance culture the connective tissue of experience is replaced by the desire for power or profit. These are the vectors that press certain aspects of the infinite into the form of information. The Chief Spy of Cairo puts it thus: "The past does not exist in a specific place and time to which I can go and retrieve what has happened. We do not encounter yesterday or last year in the form of existents; rather we meet them up here, in our minds, in the changes and vicissitudes that befall us." A paranoid Leibnizian monad, the Chief Spy composes himself from the surveillant perceptions that he unfolds from the world.

Al-Gitani's novel shows that surveillance's darkest force is torture, the cruelest way to make a person take the shape of information. Torture extorts

information from its victim and replaces their experiential connective tissue with fear. In the better case, information culture replaces the lived experience of the infinite with information. In both cases, however, the result is a certain death at the level of experience.

In recent years, under the despotic regime of Abdel Fattah al-Sisi, Egyptians are once again designing informational disguises for themselves, now in the shape of fake social-media accounts. In 2019, Samir al-Nimr writes, police were regularly stopping citizens and looking through their phones for incriminating information, becoming angry if they did not have a Facebook page. So al-Nimr set about producing a parallel Facebook account with a neutral but believable persona. "I decided to rely on a mix of randomness and uniqueness. In addition to the many news, puppy and kitten pages, I started building a personality through likes."[84] He liked popular religious figures, soccer teams, the soccer player Mohamed Salah, the Egyptian military, and his other self, "despite our contradictions." To deepen his alternative persona, al-Nimr sent friend requests to dozens of friends and acquaintances—"domesticated ones, of course"—liking more pages, and writing innocuous status updates.

"If you feel that you could be in danger—we all know that the phantom of protest can visit any time and that the threat of violations is always there, don't let your noble Facebook die," al-Nimr writes. "Look after it as though it were a plant. It only takes 15 minutes every one or two days. Maybe in the near or distant future it will be your savior." Like the dispiriting minutes I spend trying to defeat Captcha, note how much time and thought go into building informational camouflage, and thus drain away from the rest of one's life.

Information's Toxic Materiality

When (if) the 5G network gets underway in some parts of the world, if intellectuals call the high-speed interactive holoporn they receive on their mobile devices immaterial, I'll eat my boots. I will also eat the boots of any who believe that Bitcoin is immaterial cash, given that "mining" cryptocurrency requires an obscene amount of energy: 70 to 90 billion kilowatt-hours of electricity in 2019.[85] That's about the annual electricity consumption of Pakistan. Any acknowledgment of the world enfolded into AI-led automation must include its enormous energy consumption.[86] On top of the work of programmers and the precarious labor of "human computers," it is astonishing that a technology with such a high carbon footprint can be considered immaterial.

My pessimism regarding information culture lodges mainly in the material extraction that powers algorithmic control: the unsustainable electricity consumption of information and communication technologies (ICT). ICT currently is estimated to use about 7 percent of the world's electricity and generate almost 4 percent of global greenhouse gas emissions.[87] That's the same carbon footprint as the aviation industry.

One of the reasons that digital information folds thicken and choke so many aspects of human activity is the rebound effect, also known as the Jevons paradox: increased efficiency of a technology leads to more use, canceling out any savings.[88] The efficiency of computing has increased impressively since the first mainframe computers. However, ICT's consumption of energy and material resources has increased even more. Data centers, networks, and devices are ever more efficient, but unfortunately the goal is not that this infrastructure perform the same amount of labor for less energy, but that it perform more labor, in response to accelerating demand, for the same amount of energy. Known potentials for efficiency, such as Moore's Law predicting that circuits will shrink, are becoming exhausted.[89] Even conservative engineers predict that global data center electricity use could double by 2030.

And don't get me started on so-called green ICT. The October 2021 update of the US Energy Information Administration projects a 28 percent increase in world energy use by 2050, mostly outside the OECD, as populations and incomes rise. Almost every kind of energy production will increase worldwide: renewable, nuclear, crude oil, and natural gas. Renewables will support *only* the increase; fossil fuels will maintain at a steady state.[90] Only coal consumption is projected to slowly flatten worldwide (a projection since put into doubt by the war in Ukraine and China's construction of new coal-power plants).[91] These predictions demolish any hope that global greenhouse gas emissions will decrease to levels that make it possible to avoid catastrophic global heating.

As with the global trend, even if new electricity generation for data centers, networks, and devices comes from renewable sources, this is *in addition to*, not replacing, the existing fossil-fuel-powered electricity sources. A given mega-ICT corporation could claim, as Apple and Alphabet do, that its data centers are sustainable because they are powered by renewable energy. In fact, data center operators purchase renewable energy credits, which gives them the right to claim they are using renewable energy, while continuing to use energy from fossil fuels.[92] Moreover, that renewable energy could have been used to power the local grid. In Ireland, the European headquarters of

Alphabet, Facebook, Amazon, and soon TikTok because of its low corporate tax rates, data centers are projected to account for 25 percent of national electricity demand by 2030. In 2021 the state-owned electricity company EirGrid warned that the country would be short 260 megawatts of electricity in 2022–2023, rising to 1,850 megawatts in 2024–2025. Ireland's environment minister stated that EirGrid would reward large companies for reducing their electricity consumption, but also buy new diesel-powered backup generators and maintain generators scheduled to be retired.[93] The renewable energy demands of information corporations force others to turn to fossil fuels.

ICT proliferates in all aspects of society and economy, at least in wealthy parts of the world: calculating financial derivatives; the Internet of Things encoding and monitoring activities; artificial intelligence, rapidly increasing with consumer applications like chatbots; and still likely most of all, streaming video. Many ICT engineers accept that a contraction in demand is the only solution to the spike in the sector's electricity consumption.[94] Lorenz M. Hilty, a leading voice in ICT sustainability, argues that computing needs to be not efficient but self-sufficient: using renewable energy, slowing the obsolescence cycle, and following the principles of appropriate technology. As Hilty suggests, "Contrary to the current 'anytime culture,' people living in a self-sufficient region would have to adapt their lifestyles to the pace of the renewable energy supply."[95]

Thus, currently most of our computer-based media are toxic soul-assemblages for two reasons, both largely led by demands of the capitalist economy: surveillance culture, and this intolerable carbon debt.

Unfolding Differently

The above rather grim survey of human and energetic infrastructures, the concealed underside of information culture, should instill some optimism that it is impossible for information capitalism to englobe all of planetary experience. Data and algorithms are not soulless; on the contrary they are packed with souls—their own souls, or the things they can do, and the many human and material souls that created them. They are permanently flawed, as we know from manufacturers' regular updates, and they are hackable. We can also tell that information has a soul because it behaves differently every time: its actualization is always different.

Unfolding differently resists dominant manners of unfolding. Recall that unfolding happens from a point of view; it is not universal. This is another reason my view of information-images is less alarmist than that of Stiegler, Beller,

and others. The "us" to which information-images appear is not everybody everywhere at all times, but a given assemblage of perceivers. The collective memory encoded by information is not all memory, but some part of a given group's memory. Moreover, from a given point of view, say yours, you are already unfolding some dominant folds differently. The granularity of the information fold breaks up when points of view drift away and coalesce elsewhere. For the folds in which you are ensnared, you may choose to quantify them differently: for example, to carry out a true-cost accounting in contrast to capitalist exclusions; to register voters; to enumerate things in ways that cannot be translated into capital.

You may choose to unfold enfolded histories. Counterarchives unfold differently by cataloguing what bigger data considers insignificant. Here archiving takes the position, espoused by Benjamin and by Siegfried Kracauer, of conserving seemingly useless artifacts for future unfoldings.[96] As the manifesto of the Pad.ma open-source media archive states, "If the archival imagination is to rescue itself from this politics of redemption, it will have to allow for a radical contingency of the ordinary"; similarly, Paula Amad argues that film can store the intimate and unclassifiable for future "referral and resuscitation."[97] Entering the belly of the algorithmic beast, big databases and search algorithms are oriented around future actions, usually dark ones like surveillance and control, but they can be repurposed for liberating actions like remixing and fabulation.[98] Remixing dives into the audiovisual archive and folds it differently, sometimes folding together past and future in order to replace a rejected present.

Information can statistically measure, but it cannot capture, the singularities that make up a life. What information excludes in its selection from the infinite is what cannot be quantified. Kore-Eda Hirokazu's *After Life* (Japan, 1998) is set in a sort of limbo where people who have just died are allowed to select the one memory they will carry into their next life, which the crew gamely reproduce as charming DIY movies. When a five-year-old girl tells her afterlife mentor that she wants to retain a memory of going to Disneyland, the mentor sighs. Dozens of children have made this same request. Later, on reflection, the child instead chooses to keep the memory of lying with her head in her mother's lap while her mother cleans her ears. Rather than a memory that would render her past life a statistic, she selects a uniquely individuated piece of the infinite that belongs to her alone—the gentle scrape of the ear-cleaning spoon, the softness and warm odor of her mother's lap, the care and trust this moment embodies. She will set forth into her next life with a talismanic memory-fold.

And in fact, information-images, no matter how bland, become singular in their process of circulating. As I mentioned earlier, seemingly identical images, like memes, all enfold different trajectories to reach individual screens. As Jean-François Blanchette emphasizes, in the layered, continuous materiality of network, storage, and processing stacks, each data transmission "requires the correct functioning of thousands upon thousands of heterogeneous material and logical components, connected together in a network of staggering complexity."[99] No transmission will take an identical path. (Moreover, electronic storage media retain a trace of data even when the data are erased.) In turn, when information-images make contact with our brains, new neuro-images, in Pisters's term, proliferate with every view or listen. In this way the information fold doesn't permanently rob things of their singularity, even digital tasks. Each of those 10.53 billion views of Pinkfong's "Baby Shark Dance"—currently the most-viewed YouTube video of all time—is unique infrastructurally, circumstantially, and neurologically: a colossal proliferation of (perhaps) child-cheering media events. Every mass-produced object becomes a haecceity in time because the constellation of events that gives rise to them is always different.

"Hold on, Laura," I hear you grumbling. "Those billions of 'Baby Shark Dance' views may each be unique, but they still constitute a mammoth information fold that ultimately enriches Alphabet, telecoms, and device manufacturers, probably transmits some conservative ideological message, and has a whopping carbon footprint. There's no political good to be gained from celebrating the diversity of what is still a mass-media event." You might remind me of the difference between singular and ordinary points in a Riemannian field. "Those are probably just billions of ordinary points. How do you know that any of them connect to different folds? Is this a stupid (in the Deleuzian sense of not distinguishing between singular and ordinary) thing to celebrate?"

While I postpone answering, let me share with you a silly poem. Earlier when I dictated "they are hackable" using Apple's dictation function, it wrote "today are huggable," illustrating the fallible nature of artificial intelligence.[100]

I say	Apple types
watered	what up turd
of this	Office
addicts	Addictz
monkeys	Monkees
richly	Richlee

ritual	Richwill
Souls	Psalms Sold
block booking	blah looking
thoughtfully	fuck delete
modified	mother fucker
in the thought of	in the fuck of
In Vancouver	Ishit nVancouver
Duke University	stupid computer
as argued	are a cute lips
archival	are cuddlesome
My view	love you
empathy	pussy
I continued	kentinew
on the	aandhi
bibliography	it Leopper feed
bibliographies	ugly ugly face
prophet	profit
Baghdad	thank you Dad
semiosis	send me your cysts
refer to some of the	the effort to sunless sea
most vulnerable	moose to phone trouble
that souls never die	pretzels never die
theory of haptic visuality	Siri have to kiss reality

I regaled my friends on social media with this found poetry, and we had a fun conversation. Enfolding-unfolding aesthetics increases my enjoyment of it. I find it cute that Apple, searching its databases as I dictate, overcorrects for my slight lisp and serves up the words that it has learned people are most likely to need. I like the moments when the program gives up and just faithfully reiterates what it heard. The mistaken words teach me about the algorithms and databases that generated them. The program has become progressively more potty-mouthed since I started using it, hinting at the sources of its databases and perhaps pointing to increasing general stress levels among users. Contemplating these words, I taste a sour little slice of the infinite: a world where sexters crudely flirt, sloppy drunks order out for food, stressed people yell into their phones, brand names try and fail to capture our love, and ethnocentrism is assumed. But every now and then it burps up unique poetry.

My friends' and my pleasure in the found Apple-poem is an example of unfolding that is not stupid but *idiotic*. Olga Goriunova's term "new media

idiocy" identifies, in the production and circulation of memes and viral videos, the creative emergence of a collective: similar to Steyerl's concept of the poor image, but with somewhat greater political heft.[101] In a low-stakes version of Deleuze's "the people to come," new-media idiots create together, sharing online things that otherwise would be private, and thus individuate together. Enjoying unprofessional (or seemingly unprofessional) artisanal digital culture that circulates in low resolution, like the digital folklore that Olga Lialina and Dragan Espenschied celebrate, they are more attuned to the materiality of the online medium.[102] New-media idiocy is not stupid but false, in Deleuze's sense that it falsifies dominant ideology; it pokes holes that allow lived experience to leak back into online culture. "Creativity in the individual and collective process of becoming idiot produces phenomena that may be neither aesthetically brilliant nor politically very sound," Goriunova writes, "but constructs forms of performance and craftsmanship that allow the inhabitation of the present, creating modes of living that explore the true through the false."[103]

Unique does not mean singular. But when we unfold the trajectories that constitute the information fold, we discover the infinite again, in its materiality, soulfulness, mystery—and idiocy. When we do, we pull human, material, and cosmic history out of information's black box. And those seemingly ordinary points might turn out to be singular, as I discussed in chapter 2; they may precipitate a transition that unfolds an enfolded structure.

Unfolding Differently

Stay under the Radar?

Staying under the radar, that is, being illegible as information, is a way to press close to the infinite in its simplest form, to unfold the world as it arrives to perception. Living simply, living off the grid, living in "poverty": here, on the infinite underside of information's extraction, having unmediated access to the infinite, your sensory intelligence expands.

Staying under the radar can also intensify your cosmic connections. People have long shaped their activities to the cosmos, not attempting to manage or dominate cosmic elements but to comodulate with them: rising, navigating, and menstruating according to daylight, to star- and moonlight; doing agriculture vis-à-vis the wisdom and preferences of plants, rain and wind, the quality of the soil, the nature of the valley, delta, or steppe. This kind of extended contact with the rich loamy infinite is a source of true prosperity that is not measured by GDP.

For the same reasons, living close to the infinite is also the most intimate way to learn the effects on our planet of increasing temperature of atmosphere and sea. If at the same time you use techniques to hide your tracks and camouflage to deflect the interest of speculators, then you can avoid having your life exfoliated for information.[104]

However, first of all, life off the grid, or in undetectability, is hard to maintain for people who live in complex societies, and not to be romanticized for the few who don't. In addition, staying under the radar means not being counted, in societies that use counting as a measure of rights. A third reason is collective action. At some point we soul-assemblages may want to collectivize the knowledge that arises from direct contact with the infinite, to reshape the information folds of complex societies. Many of the exercises in this book are about strengthening capacities to grasp and intensify those moments of freedom that we gather on the loamy surface of the infinite.

Finally, even when life is striated by information, we are always in the presence of the infinite. Information need not be a threat to life. It's a joy to listen to the marvelous varieties of birdsong, and also to consult a bird book. It's fun to make a soul-assemblage of flour, butter, fruit, sugar, and heat, and also to fold a recipe into that soul-assemblage. It may not be fun, but it's necessary for most of us to earn money and calculate how much tax we owe. Jousting with information, people develop skills to change its shape, to unfold differently. In order to do this, we need to study and spend time with the information fold.

Unfolding Differently

Only Moderately Paranoid

I take a middle path in information paranoia—that is, I take a moderately paranoid approach—for a few reasons: 1. The powerful media corporations of our time are young in terms of the history of capitalism and need to constantly renegotiate their advantage. We are talking about economic phenomena that arose recently and are changing quickly, above all in response to the volatile market. Information is always in process. 2. Corporate CEOs and military strategists are not gods, nor are the software engineers who work for them. 3. Algorithms, including machine-learning algorithms, are human products, enfolding human ingenuity and human error, though the values they encode are often inhuman. 4. Algorithms play out on physical platforms that are subject to error, degradation, and creative misuse. 5. In the global

digital divide, the majority of people know that life exceeds its algorithmic management.[105] The low-bandwidth majority engage in digital technology in a minimal, non-optional way, on which DeepDream has no grasp—and which should be a model for those in over-infrastructured parts of the world. 6. Part of the reason so many human activities are digitally monitored and monetized is that high-speed internet access is artificially cheap. When government regulation stipulates that data centers and telecoms pay carbon taxes, true-cost accounting will finally kick in, those costs will rise, people will spend less time online, cryptocurrency, chatbots, and the internet of things will come to seem ridiculous, and a modicum of privacy will return. (This last reason is a joke. Not bloody likely! But maybe it will come to pass in the coming collapse.)

Every act of perception, our individual act of grasping and selection, is an unfolding from the infinite. Even when we perceive the most clichéd or programmatic mass-produced image, we create our own unique image and populate the infinite with more images.[106] Capture is habitual and programmatic, but not inevitable. The question, as we saw in the chapter "Soul-Assemblages," is how long those singular moments of contact last, what larger fields they can pull up, and whether they can become collective.

Earlier, writing about style in manners of unfolding, I noted that some stealthy manners of unfolding appear quiescent: they move with the dominant fold and learn its patterns until they can precipitate a moment of unfolding. Delay, distraction, and withholding attention are ways to resist machine-driven rhythms of unfolding, linger in the infinite, and gather strength for action. Creative resistance can be found in tiny acts of perception, as when, waiting for a file to load, you notice the shape of your fingernails for the first time.[107]

In economic terms, unfolding differently would be *non-extractive unfolding*. This is the unfolding of infinite life in a way that cannot be translated into information capital, but instead multiplies on the surface of the infinite. Practically, it entails things like barter and subsistence economies. In order to withdraw from the clutches of global capitalism and the IMF, Glissant advocates a responsive and agile "economy of disorder" that would develop local value for Martinique and the rest of the Caribbean. It would bring together a subsistence economy, of the kind enslaved people developed on the plantations; a regional economy; the imposed market economy; and a controlled global economy, referring to the visionary economics of Samir Amin.[108] A local economy unfolds local resources for the benefit of people nearby, rather than, for example, producing cash crops for export.

A further retreat would be to produce local value under the radar of capitalist extraction, as with barter economies, peer-to-peer production, makerspaces, and other forms of gift economy. Javier de Rivera, Ron Eglash, and Chris Hables Gray's encouraging concept of generative justice suggests ways to generate value that circulates among the community, from the bottom up, rather than concentrating it in the hands of states or corporations. In generative justice systems "the value produced circulates constantly, and reverts to the benefit of its producers without passing through the gatekeeper of either state or corporation."[109] Open reciprocity, communal sharing, and gift-based economies that, moreover, include the natural environment as giver and receiver of gifts, have for millennia been the ground of many Indigenous economic systems: their example is the Iroquois nation. Generative justice includes restorative justice, often based on Indigenous justice systems, as an alternative to the prison-industrial complex. Such a retreat from extractive unfolding involves, as Beller proposes more abstractly, radical finance, the decolonization of money, and communist, non-extractive algorithms.[110] All these are alternatives to the methods of capture and abuse of our ability to perceive that I have critiqued.

From the point of view of information capitalism, non-extractive unfolding is enfolded, opaque, or noisy. But from the inside, it is an Undercommons of non-alienated, creative exchange.

Unfolding Differently with Algorithmic Media

Corporate and commercial algorithms may be designed to unfold along paths of power, but the critical computing movement pushes information to unfold the infinite differently. Critical computing seeks to separate digital computing research from the profit motives of capitalism. This is a formidable task, since almost every development in computing research is aligned with corporate growth, from developing algorithms that make media addictive to making networks more efficient so that they can support ever-greater consumer demand.

At the level of software, critical computing may unfold subjects differently, creating new soul-assemblages with, it is hoped, greater agency. It thus follows Benjamin's concept of collective innervation, "a noncatastrophic adaptation of technology," or a manner of individuating with technologies that would be social, not individual.[111] Writing about film in the 1930s, Benjamin proposes that we should immerse fully in "alienating" technologies and turn them to playful, creative ends to develop a non-alienated "second nature." Nearly a hundred years later, however, the goal of collective innervation has

not been achieved, as corporations have proven themselves adept at coloniz-ing creativity and play.[112] Similarly, a technological "care of the self," as Mac-Kenzie recommends, would recognize that we are subjects of machine learning that, though it serves power and control, is not totalizing.

We humans cannot help but individuate alongside the technologies of control, in soul-assemblages that are for the most part unhealthy, but I be-lieve we have some wiggle room for creativity and critique. An awareness of the creative potential and limited reach of these technologies might make it more inviting to collaborate with them. Open-source software, rather than black-boxed software, is an important ingredient in such non-extractive exchanges. At the far end of computational research and development, al-gorithmic media art is well positioned to experiment with non-extractive unfolding. It can unfold differently by selecting differently from the infinite; emphasizing the movement, historicity, and granularity of information; and using homemade or open-source software.

Collapse Informatics and Small-Footprint Aesthetics

The recognition that we are subjects of machine learning needs to deflect its attention away from the forms of innovation and exploitation occurring in wealthy countries toward the more brutish expressions of AI elsewhere. As I noted above, the problem is not only automation, replacing human labor with robotic labor, but the replacement of paid human labor with underpaid or free human labor: precarious work and the gamification of labor.

It is at the level of infrastructure that the worst exploitation occurs and that radical change is possible. Here critical computing tackles the unsustain-able carbon footprint of ICT and imagines computational technologies that would comodulate with the cosmos. The fields of sustainable computing and sustainable ICT engineering have burgeoned in the last several years. Most ICT design assumes a growth scenario of ever-increasing production and consumption that relies on the availability of cheap energy. In contrast, as Bonnie Nardi and colleagues summarize, the Computing within Limits movement "is concerned with the material impacts of computation itself, but, more broadly and more importantly, it engages a deeper, transformative shift in computing research and practice to one that would use computing to contribute to the overall process of transitioning to a future in which the well-being of humans and other species is the primary objective."[113]

When resources collapse, as in the declining periods of past civiliza-tions, making do with less becomes a necessary art. This is the concept of

collapse informatics.[114] For example, Sofie Lambert and colleagues explore postpeak oil scenarios in which low-power networking is no longer optional but becomes a necessity.[115] This would also apply to other energy-constrained situations, such as disaster recovery or off-grid installations in low-infrastructured countries. The authors introduce the concept of "graceful decline." Relatedly, energy security is used to justify relying on fossil fuels to maintain power grids. But as Kris DeDecker of the solar-powered website *Low-Tech Magazine* points out, those power grids maintain unnecessarily energy-hungry lifestyles. "People don't need electricity in itself. What they need, is to store food, wash clothes, open and close doors, communicate with each other, move from one place to another, see in the dark, and so on. All these things can be achieved either with or without electricity, and in the first case, with more or less electricity."[116]

Collapse informatics describes what I believe is the only truly sustainable model of ICT.[117] It necessitates making do with less electricity and therefore lower bandwidth and intermittent access. It amplifies the value of tinkering and DIY practices that people have always used in the absence of access to new technologies. It shifts the direction of emulation away from over-infrastructured regions and toward lightly infrastructured regions where people have devised ways to make do.

Collapse informatics posits that everyone but the over-infrastructured elite will have to embrace oppositional technophilia, Eglash's term for minority groups' practices of hacking received technologies.[118] Models for collapse informatics thrive in informal media economies where access to proprietary media is impractical, impossible, or rejected on ethical grounds.[119] Appropriate technologies flourish in regions where energy consumption is lower, as a result of lower incomes, and infrastructure is uneven. Tinkering, hacking, and making may begin as a response to deprivation, but once the tinkerer develops expertise, they can be elegant, effortless, and empowering.[120] What I think of as *small-footprint aesthetics* find their most compelling models in poorly infrastructured parts of the world, where, in contrast to corporate ideologies of high resolution, lossless compression, and "immersion," circulating media are low resolution, intermittent, and glitchy.[121] Infrastructural poverty begets critical creativity and improvisation, as in the Indian media ecology of *jugaad* or workarounds that Amit Rai analyzes.[122] Artists, makers, hackers, pirates, and consumers in these regions are well versed in tinkering, retrofitting, and making do with supposedly outdated media technologies.

In well-infrastuctured parts of the world too, artists and everyday makers create media with a small energy footprint.[123] Small-file media, low-tech

media, meme culture, and digital folklore exemplify the elegance of appropriate solutions that are both energy efficient and relatively independent of surveillant capitalism. Young people in highly infrastructured parts of the world have grown up taking high-speed access for granted. However, young people are also innovators of elegant media objects that require very little bandwidth, such as GIFs and memes. Both are tiny, intensive files—infinitesimal movies in the case of GIFs—that are perceived briefly but create a lingering affective and cognitive impact.

This topic takes us into the lively field of sustainable ICT engineering and design.[124] A design question for the collapse-informatics scenario is "Can a restricted version of the service be imagined, and what would its value and infrastructural burden be?"[125]

Rebelling against official infrastructure, making their means of production available to the user, and shimmering with compression artifacts, small-footprint works have empowering, affective, even sensuous aesthetics.[126] Although their results may be a little softer-edged than Netflix streamed to a coal-powered 4K TV, these tactics present a more realistic conception of the energy economy and are more social and less reliant on proprietary corporate platforms. And in fact, any medium can be immersive: you just have to immerse in it! Small-footprint media comodulate with the cosmos and assemble souls in a way that is relatively healthy for all.

Media Soul-Assemblages

The above conception of the environmental footprint of media gives an expanded concept of the assemblages that comprise media artworks and heightens the material interconnectedness of the souls assembled therein. Understanding a movie as a soul-assemblage lets us appreciate all the ensouled bodies that it enfolds. To contemporary conceptions of media as assemblages, I add soul. Kjetil Rødje analyzes media as assemblages that bind together the material support, the filmmakers, the script, the material medium, the audiences, and the affects that flow among them, different with every reception. The cinematic blood-assemblage Rødje analyzes composes red-squirting squibs and the special-effects craftspeople who devise them; bodies, weapons, and other objects in the image; the movie as a whole; and the screams or laughter of the audience.[127] Amy Herzog comparably defines a film-assemblage as the series of encounters among the diverse materials of medium, people at every stage of production and reception, and the affective, political, and social resonances of each encounter. Evoking the Benjaminian constellation

that makes latent relations perceptible, and consonant with the monad's capacity to unfold singularities, Herzog argues that the film-assemblage activates dormant elements: "points or fragments of the past juxtaposed into new states of mutual influence. These connections burst forth in the form of an image that becomes visible precisely because the conditions of the present render them possible."[128] The cinematic assemblage also takes shape in Adrian Martin's concept of cinematic *dispositif*, "the arrangement of diverse elements in such a way as to trigger, guide and organise a set of actions."[129] Like Rødje and Herzog, Martin includes audience in this assemblage, as well as the means of distribution, whether the work be a theatrical film or a video game. Including infrastructures in the souls assembled by media works acknowledges the material, energetic, and human labor that sustains them.

Soul-assemblage media add granularity by focusing on the collectives of monads that comprise the image's textured surface. These collectives incorporate media infrastructures and the material supports of the image, which bring political and cosmic history into the folds.

Media works are cosmic: they are composed of cosmic matter. Light and sound waves and analog and digital electronic flows are cinema's most ethereal of physical constituents. Cinema borrows light to create and project its images, but the light remains free. We could say that digital media manipulate, while analog media comodulate with, electronic flows, since analog media play with the properties of wavelengths while digital media convert them to numbers. But in fact, digital media are built on an analog base, in which electrons are corralled and cajoled but always have the possibility of escape. Similarly, cinema's supports and colors derive from cosmic forces at the depths and surface of the earth: metals, petrochemicals, and plant materials. Iron and copper lend their volatile stability to media devices.[130] Digital media appropriate the increasingly rare metals needed to support semiconductor miniaturization, which as we know are extracted at untenable cost to the earth and, as documented in the Democratic Republic of Congo, of humanitarian atrocities—all because tantalum, twice as dense as steel, durable, highly ductile, and especially easy to weld, is valued for its ability to smooth the flow of electrons in miniaturized circuits.[131] Usually these metals die with the devices' so-called obsolescence in toxic dumps in poor countries, but they can easily be recycled. The same can't be said of the sad polymers that encase cameras, laptops, and mobile devices.[132] Such disrespect to the fossils of our ancestors!

A great deal of moving-image media is toxic to the planet: proliferating waste, chemicals from film processing, and now the unsustainable carbon

footprint of streaming media. Streaming video is calculated to contribute 1 percent and rising of total annual greenhouse gas emissions, because of the high electricity consumption of the data centers, networks, and devices that support streaming (and the internet at large).[133] There are solutions, however, including sustainable film and television production as modeled by initiatives like Albert in the United Kingdom and, where I live, Reel Green; working with found footage rather than creating new footage; alternatives to high-resolution streaming media, such as streaming in low resolution and watching physical media; and electing politicians with strong environmental agendas.[134]

All media are soul-assemblages. If they comodulate with, rather than attempt to dominate, the cosmic flows that constitute them, they are cosmic soul-assemblages. Earlier I said each entity is doubly connected to the cosmos, inwardly through its soul and outwardly through its skin. We can analyze a soul-assemblage's connections both in terms of its materiality, or its body; and in terms of its view of the cosmos, or its soul.

Consisting of three hours of calming synthesizer music playing over cycling shots of forests, waterfalls, blue skies, and flowers, "Beautiful Relaxing Music for Stress Relief ~ Calming Music ~ Meditation, Relaxation, Sleep, Spa" by Meditation Relax Music has had fifty-eight million views since it was posted in 2018. The video's soul-assemblage includes the musicians and filmmakers, the production company, the YouTube platform, the millions of human souls who have played this movie, the uncountable anxieties and sleepless nights they suffered, the soothing feelings that washed over them as they listened, the dopamine secreted in the listeners' brains. It includes the devices—phones, laptops, TVs—on which the audience streamed "Beautiful Relaxing Music for Stress Relief," the wired and wireless internet connections, the data centers that store YouTube videos, the networks that connect them. It includes engineers, rare metals, and electrons.

YouTube, owned by Alphabet, claims to be a carbon-neutral source and has received an A rating from Greenpeace.[135] In fact this neutrality is achieved in part by cap-and-trade measures, which means an exchange of carbon credits, not an absolute decrease in carbon emissions. Moreover, it does not account for the energy source of the data centers that hold "Beautiful Relaxing Music for Stress Relief" and the networks through which it passes, nor for the carbon emissions resulting from production of the devices, nor their disposal. Bitter irony that a movie made for relaxation from stress makes a substantial contribution to the despoilation of the planet! By my reckoning, "Beautiful Relaxing Music for Stress Relief" is an overall unhealthy soul-assemblage, whose

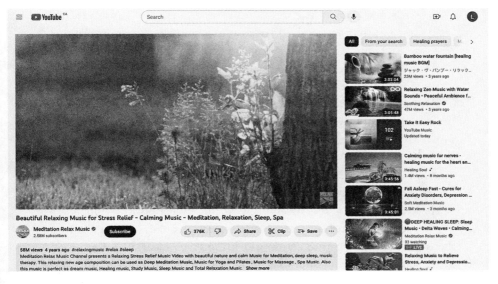

FIGURE 4.4.

benefits for anxious humans are canceled out by the stress its delivery system imposes on the planet. If all those troubled souls were able to download the video once, instead of streaming it every time they craved it, networks would be significantly less stressed, and the planet could breathe more easily.

But some soul-assemblage media, such as the appropriate technologies I discussed above, fold human and cosmic forces together in salubrious ways. The Small File Media Festival, which I founded in 2020, models a paradigm for collapse-informatics art and entertainment and is, if I may say so, a very healthy soul-assemblage.[136] Our purpose is to draw attention, in a relatively enjoyable way, to the carbon footprint of streaming media. Small-file videos, of no more than 1.44 megabytes per minute (about two percent of the size of a 720 × 1080p high-definition video with frame rate of 24 frames per second), show that a movie can be intensively pleasurable without contributing to the internet's expanding carbon footprint. On a tiny but cosmic scale, the Small File Media Festival draws artists, environmental activists, audiences, servers, broadband networks, new and obsolete devices, video compression algorithms, electrons, rare metals, ceremonies, dance parties, awards (such as Lowest Bitrate, Best Porn, and Best Haptic Renunciation), and many other entities into a common fold.[137] Most of the participants in the small-file soul-assemblage, certainly the makers, audiences, and the movies themselves, thrive and expand their amplitudes. In the case of the infrastructure and the

rare metals, they can at least rest a little easier, because they are less bitterly exploited than in standard streaming. Small-file movies are "cool," in Marshall McLuhan's sense that an audience must lean in and use their mind and senses more intensely to get that immersive experience. They give the viewer a healthy perceptual and intellectual workout.

Each 1.44 megabyte-per-minute movie in the festival is a jewel-like microcosm. For example, Christopher Carruth's two-minute, 4.7-megabyte *why wonder* (Canada, 2021), shares a YouTube video of beloved Muppet Kermit the Frog singing "It's Not Easy Being Green." The page shows more than nine million views. The video starts to jitter; JavaScript errors hide Kermit behind blocks of magenta and yellow; his reedy voice echoes and hiccups. *Why wonder* forms a soul-assemblage of the endearing frog puppet, the wistful singing of Jim Henson, green felt, electrons, the YouTube platform, the material infrastructure across which the video has traveled again and again, those millions of visitors, Carruth the artist, the JavaScript program, a compression algorithm, the festival, and the viewers who receive this dense little soul-assemblage. Those are what its body connects to. The soul of *why wonder* perceives a world of gentle humor, nostalgic longing, modest energy consumption, and—unlike most digital media that disavow its material support—a properly modernist observation of the irony that this longing is fed by fossil-fuel-burning ICT infrastructure. It reflects on all the soulful actions that composed it. *Why wonder* is what Mark Betz terms a "roundelay movie," incorporating nine million refrains, nine million unique viewing events.[138] Wittily, *why wonder* concludes that being green is devilishly difficult, but low-impact streaming movies like itself are part of the solution.

Small-file movies do not give viewers the gratification that "hot," high-resolution streams do. But their 1.44-megabytes-per-minute aesthetics challenge viewers to rethink their viewing habits and perhaps lower the streaming resolution of conventional media, purchase movies they want to watch in high resolution, borrow DVDs and Blu-Rays from the library, watch TV instead of streaming, and enjoy the communal immersivity of the movie theater.

All media are soul-assemblages, but many of them are unhealthy assemblages that do damage to the souls enfolded in them. What we might call totalitarian digital media, such as high-resolution streaming and NFT art, depend on the destructive control of electronic flows and on unsustainable energy extraction. But digital media that use appropriate technologies with a light footprint are salubrious soul-assemblages. They comodulate with electrons, whose assertion of their freedom is attested by glitches.[139] They

FIGURE 4.5. Still, Christopher Carruth, *why wonder* (Canada, 2021)

embrace mortality. They acknowledge ICT infrastructure but demand little of it. Small-file media reach "in" to the infinitesimal and "out" to the cosmos. They reflect the cosmos in both body and soul in a salubrious way, such that the makers, the audiences, the infrastructure, and the media themselves can feel good about participating in their soul-assemblage. As my small-file colleague Radek Przedpełski writes, small-file movies "ponder the mystery, at the level of the pixel, of how an extreme compression of timespace can nonetheless engender new vast universes. And, by the same token, these inframedia show how we can make do with less, affirming the image not as a wholesome high-fidelity representation but as operative nothingness, diagnosing the environmental degradation under the Anthropocene."[140]

5

TRAINING PERCEPTION AND AFFECTION

Each of our souls is a microcosm, a tiny pocket of the cosmos. We not only express the cosmos but can also learn to identify the cosmos from the point of view that we occupy. We can train ourselves to detect various kinds of unfolding. It's a bit like the detection of symptoms in psychoanalysis. The difference is that the unfolding is coming from without, not within—from the cosmos, not yourself, or more precisely, from yourself as part of the cosmos. This chapter provides a few ways to train perception, sensation, and affect in order to get a hold of the infinite and strengthen the path from your body to the cosmos, so that you may take part in struggles at all scales.

Unfolding is an aesthetic practice, because experience is embodied and temporal. Training our senses is the human end of a chain of indexical witnessing. Witnessing combines sensing with memory, and we extend these human capacities with nonhuman sensory capacities, techniques of measurement and attestation. Aligning our sensory capacities with those of nonhumans, natural and technological, we gain in an understanding of chains of causality. Plants, minerals, seas, winds, solar radiation, and other cosmic powers bear causal witness, and humans can, rather than dominate

them, align our senses with theirs. Such human-nonhuman sensory collabora-
tions provide the techniques of material witnessing that Susan Schuppli and
the Forensic Architecture team deploy, where seeming objects, like cracked
walls and poisoned leaves, bear witness in their bodies to war crimes. As
Matthew Fuller and Olga Goriunova point out, sensing has a new urgency
in the time of climate catastrophe. Understanding sharpens the urgency to
act, but not necessarily our capacity to act. Enormous, complex, and con-
tradictory soul-assemblages assemble to battle climate catastrophe and the
obscene economic arrangements that underlie it.

Enfolding-unfolding aesthetics can help us experience the flow of being,
enlarge our understanding of the cosmos, and prepare to unfold differently.
Habitual filters block experience of the cosmos, so it can be exciting and
spiritually fulfilling, but also terrifying, to experiment with lifting those fil-
ters. To get ready to join healthy soul-assemblages, we can cultivate our ca-
pacity to affect and be affected. These practices too can be perilous; hence art
is a fairly safe way to experiment or practice with lifting filters.

Which is healthier, to maintain the body's wholeness or to break and remake
the body? The first view, which respects the monad's body's life-preserving
boundary and seeks to maintain its equilibrium, arises in Spinoza, phe-
nomenology, and also cultural traditions such as Buddhist philosophy and
yoga praxis. For example, a number of filmmakers and film scholars relate
cinematic rhythm to breath and propose that a cinema of breath can sup-
port human health. Kalpana Subramanian argues that light in cinema cor-
responds to breath in the body, using yoga and Vipassana philosophy, while
Nathaniel Dorsky and Anand Pandian identify breath with the rhythm of
editing. In both cases, and also in the breath-based cinema theory of Davina
Quinlivan, the body of the film can regulate the body of the viewer.[1] The sec-
ond view, in the minor genealogy from Nietzsche-Artaud-Deleuze/Guattari
to contemporary antihumanism, contends that human life is invaded by in-
stitutions on every level and must be "cruelly" reinvented, as in Artaud's the-
ater of cruelty.[2] Such a view resonates with minoritized, feminist, queer, and
trans feelings that society controls us through our bodies, and with the feel-
ing of probably every person who has endured the sensation that their body
is a stranger to them, such as in adolescence or a life-threatening illness.
As I mentioned earlier, a health check such as that prescribed by Spinozan
feminists is useful to test whether the organism can support such a rupture.

I support both of these understandings of the body, contradictory though
they appear. As I explain in the section below, "Affective Analysis," they operate
at the different scales of affect and embodiment, both of which are relevant.

Training our bodies to be more than human, we toughen our skins to the biopolitical forces that aim to modulate the body. Biopower, Uno Kuniichi writes, transforms the body into a substance that can be analyzed, measured, and normalized, all in the name of the preciousness of human life. "A philosophy of life must say on the contrary, become animal, and you will be life, the body without organs, worthy of life." By seeming to revert to states prior to the human, Uno continues, we can "open [human life] up to the life of the cosmos, to rediscover connections with all the flows of life."[3] Elsewhere Uno characterizes the boundary-defying Butoh performances of Tatsumi Hijikata and Min Tanaka, who, plunging into childhood and into death, train their bodies to eradicate the clichés of humanness. The strange emergent rhythms invite the virtual into the body.[4]

I had the unsettling pleasure to witness a performance by Tanaka at a symposium Uno organized in Tokyo in 2014. Dressed in a patched old robe, his aged and lanky body pure sinew, Tanaka ran around the stage in circles like a worried dog, faster and faster, dipping ever more deeply to the floor, muttering something like "What am I going to do?" Suddenly he swept back the heavy curtain behind the stage, revealing the wintry campus outside, and disappeared. We heard his feet pounding into the distance. Time elapsed and we started to worry that he had abandoned us too-serious academic conferenciers. Finally, Tanaka reemerged on the other side of the window. He fell to his back on the concrete among overturned café chairs, his behind facing us. As he opened his legs wide to the sky, the robe slipped away to reveal his electric-blue underwear. It was like the sun rising!

Tanaka's performance taught me that discovering a more ancient, prehuman body within your body requires you not to abandon human culture but to remix it. Trained over years to forget and reinvent, his muscles, joints, and organs discovered new internal rhythms. With skillful showmanship Tanaka *included* us, the attending audience, in his discovery of what a body can do, activating in us new rhythms of shock, elation, and profoundest silliness.

Artworks Connect the Body to the Cosmos

An artwork is not (only) an allegory for the monad, it is a monad, an enclosed soul that perceives and expresses the cosmos from its singular point of view. An artwork is a disquiet monad, applying differential relations to unfold certain microperceptions; as Simon O'Sullivan explains, probably the disturbing or "remarkable" elements that are bothering it. It folds these with its own style (or manner of unfolding) to create its world, actualizing virtualities and

realizing possibilities.[5] One of O'Sullivan's examples is Gerhard Richter's color-chart paintings, whose colored rectangles grow from endless recombinations of red, blue, yellow, and white. They are "immanent utopias" performing the infinity of possible colors. Selectively framing and intensifying chaos, artworks make soul-assemblages that bring new sensations into actuality. Artworks are also great places to test fabulations, monads that model worlds incompossible with ours and invite us to inhabit them in relative safety.

Recall that affections, those singular points of actualization, have the potential to turn the individual inside out and link it to the cosmos.[6] The human microcosm can discover the cosmos within itself not only through older methods such as meditation and hallucinogens but also through cosmic cinemas. What I call "talisman-images" are artworks that comodulate with the cosmos by aligning human and cosmic powers.[7] Pisters proposes that in the past couple of decades, partly made possible by growing public understanding of neuroscience, a new cinema has joined Deleuze's movement-image and time-image: the neuro-image. In the neuro-image, bodies, brains, screens, and worlds are intimately interfolded. The neuro-image, Pisters argues, is uniquely equipped to explore the cosmos from the embodied position of the microcosm, in what she calls an "intense cosmic cinema."[8]

Embodied Methods

The human body, with its embodied mind, is the interface to the infinite. To develop this interface, we cultivate, refine, and redesign our bodily and sensory capacities. Body and mind are partners in an aesthetic team. (We can also use enfolding-unfolding aesthetics to study the aesthetic experience of a tree, or a planet, or an electron, through careful empathic research.)

When I am writing or speaking, I frequently check in with my body to make sure I am saying what I mean. Braced shoulders suggest that I'm writing out of resentment. A prickling on my upper lip indicates I'm saying something I no longer believe. I pause to investigate the source of this feeling and try to resolve it. This body check is a simple method, not infallible, but pretty good, to ensure a higher degree of truth by appealing to "my" nondiscursive knowledge. I read other writers for the feelings embodied in their language.

An aesthetics, in its simplest and most old-fashioned guise, is simply an account of how we engage with the perceptible world. This is a phenomenological aesthetics, not a system for judging what is beautiful. Thus, what I propose falls in the minor tradition linking the pre-Kantian, pro-Leibnizian aesthetics of Alexander Baumgarten (1714–1762) with Peirce's analysis of

sensation, Maurice Merleau-Ponty's phenomenology of perception, and contemporary embodied aesthetics—as well as, I must note, a tension with phenomenology in the antihumanist tradition of Nietzsche, Artaud, and Deleuze. Baumgarten defines aesthetics as a *scientia cognitionis sensitivae*, "science of sensuous cognition": a sensory connection rather than a transcendental judgment.[9] In his aesthetics, sensory knowledge, including the subtlest of microperceptions, has a synthetic immediacy that cognitive knowledge lacks.[10] Enfolding-unfolding aesthetics, in Baumgarten's spirit, honors sensory knowledge and postpones cognition and theorization.

While Spinoza was most concerned with the health and power of the body, Deleuze and Guattari, writing for our time when capitalism penetrates the most fundamental levels of embodied being, recognized that health required first breaking down and opening up the body and the self: schizo health.[11] Affect touches our bodies and, if we take it seriously, turns our selves inside out.[12] As we've seen, affect is what allows us to enter a soul-assemblage.

Installed in the humanities for a generation, affect theory has come to constitute a complex discourse with application across many fields, much internal debate, some degree of calcification, and, interestingly for my purposes, a recent formalist turn.[13] Sophisticated analyses of the concept remain crucial.[14] As I do in this book, many scholars have worked on how affect might avail tools in the struggle against information capitalism's colonization of the body.[15]

Rather than hypostatize affect, my method of affective analysis puts it into a structured, triadic flow. It suggests ways to hone our bodies' affective capacities as analytical tools alongside, not instead of, perception and thought. We need to begin analysis with the thing that makes us most vulnerable: feeling. Yet it's important to stay sharp while feeling, for as we've seen, affects are singularities: points that may be grasped in order to draw out an enfolded field. An affective response may be your cue to seize the moment and unfold differently. Affective analysis, therefore, is one of the central methods to construct that line from your body to the cosmos.

Affective Analysis

A Method

Over the years I have developed a simple method for analyzing movies, artworks, and other phenomena by working through affective, perceptual, and conceptual responses. Affective analysis is an aesthetic analysis that begins

FIGURE 5.1. Still, McG, *Charlie's Angels* (US, 2000)

by analyzing affective and embodied responses. It begins by acknowledging that starting with concepts can be reactive. Conceptual analysis tends to respond to representation. In the academy we're under pressure to sound smart, but if we adopt the wrong concepts in haste we miss an opportunity to really think. Formal analysis of the perceptible qualities of a work comes closer to the experience but can also be reactive. Perception is, of course, shaped by history and culture. It does not give complete access to the world; in fact, as Bergson pointed out, perception *protects* us from the world by focusing on survival. As I show in "The Information Fold," technologies that inform how it is possible to perceive make perception even more reactive.

Affective analysis draws both thought and perception back to the body, forcing us to generate new thoughts, or to face the fact that we do not yet have thoughts. It works as a reality check to slow intellectual responses and to guarantee that, when we arrive at them, they will be well grounded and relatively free of ideology. It may generate what Spinoza terms adequate ideas, or ideas that align the powers of the body with the capacities of the mind in a given situation. This Spinozist turn in the theory of affect draws on the thought of Deleuzian feminists Rosi Braidotti, Elizabeth Grosz, Patricia Pisters, and Mai Al-Nakib, who seek to identify practices that can increase joyful affects and develop adequate ideas.[16] I use affective analysis in encounters with a film or artwork, in studio visits to artists, when reading, when conversing, and in everyday situations. Over the years I have taught affective analysis to many students in classes and workshops, and it works well in itself, or as the basis for further research.

FIGURE 5.2.

I first realized the need for this method years ago when I was watching *Charlie's Angels* (McG, US, 2000). There's a scene where the brave Dylan, Drew Barrymore's character, is betrayed by her erstwhile lover moments after they have had sex. After he and his sidekick explain the conspiracy, the sidekick shoots at Dylan. She throws up her arms and falls dramatically backward through the plate-glass window of the high hotel room. Presumably she falls to her death. The film cuts to another scene and then returns to explain, in slow motion, what happened: The bullet strikes not Dylan but the window behind her. She falls back, in a cascade of shattered glass. The bedsheet catches on the window ledge, saving her life. And there she hangs, grasping the sheet, now completely naked, as the conspirators leave the hotel room.

During these scenes I noticed, to my dismay, that I got goose bumps and felt aroused! Even though the film was about "empowered," sexy, fighting women, my joyful affective response arose not from these representations but from an image of a woman menaced and vulnerable (though managing to survive). This startling response showed me that if I analyzed only the conceptual or narrative content of the film, I would entirely miss what it was doing.

As Elena del Rio explains, often artworks and other cultural phenomena operate differently at the molar and molecular levels, and our responses at these levels differ as well. That is what was going on in *Charlie's Angels*. The molar level deals with bodies as a whole; it supports identity politics, struggles against constraints and struggles for representation.[17] The molecular level deals with energies that are not yet captured by these discourses of identity. It provides a source of energy for molar-scale struggles. Because Deleuze and

FIGURE 5.3.

Guattari diagnose the body to be overcoded by ideology, they privilege the molecular nature of these encounters over the larger, molar scale at which meaning, narrative, thought and even emotion take place. As they argue, following Spinoza, energies operating at the molecular level are creative in themselves before they are captured and pressed into meaning at the molar level. This shift of emphasis to the molecular informs the influential argument of Brian Massumi that the activities of affect are best detected at the level of the autonomic nervous system.[18] Doing affective analysis, we are working to identify our responses along continua from the molecular to the molar, from the non-discursive to the discursive; from those parts of experience that seem free of culture and ideology to those that are clearly cultural and ideological.

Affective analysis accounts for the experience within individual sensation of forces that come from without. Guattari describes aesthetic encounters as "blocks of mutant percepts and affects, half-object half-subject, already there in sensation and outside themselves in fields of the possible." Paradoxically, as he points out, affects that come from beyond are catalyzed by representations.[19] A cognitive response stimulates an affective reaction. Thus, we usually experience affect, perception, and concept all at once, balled up, as it were: a ball of singular sensations, inextricable from one another and barely extricable from the world in which they emerged at that moment.[20] Affective analysis draws this ball of responses into a line. Doing this might feel rather artificial, but it helps to slow the path from affect to percept to concept, which makes it possible to produce well-grounded concepts.

Affective analysis is a slowed-down description that aims to get at how experience usually arrive to us as an assemblage, of which we are part. This method shares much with Kathleen Stewart's method of ordinary affects, including its cultivation of empathy.[21] One difference is that Stewart's evocative writing describes that ball of sensations all at once, while I attempt, painfully and unnaturally, to draw them out. Later, when actually producing a description of the movie, artwork, or other event that precipitated the experience, I put them together again. Another difference is that my method exercises and amplifies the researcher's embodied capacities, while the empathy of Stewart's method, similar to Jane Bennett's vital materialism, is a more diffuse feeling of being-with the other entities in the experience.

Affective analysis takes place in the body of a specific beholder, but it strives to be impersonal, insofar as affect happens to us from the outside. I contend that the results of affective analysis are objective, because it identifies empirical data that arise in the aesthetic encounter. We are using our bodies to do philosophy.

Affective analysis relates Deleuze and Guattari's three analytical categories of affect, percept, and concept to Peirce's triadic logic.[22] Peirce's Firstness is a possibility, "a mere may-be," as redness is a possibility before it is embodied in something red.[23] This is the level of affect. Peirce's Secondness is the realm of actuality, in which one thing is constrained by another or two things struggle with each other: I identify this with perceptibles.[24] In Thirdness, a third element enters to carry out a relation between two things, as in comparison, judgment, prediction, and interpretation. This is the level of concept. My method consists simply of comparing the affect and percept that arise together at a specific moment in order to create a concept that adequately explains how what we perceived gave rise to, or occurred simultaneously with, that affective response. For example, why did the image of naked, suffering Drew Barrymore thrill and arouse me? That should generate a useful concept that can direct further research. When there is no noticeable affective response, we can carry out the analysis by accounting for other kinds of embodied response, as I will explain.

Peirce's three types of interpretant have their own Firstness, Secondness, and Thirdness, namely affective, energetic, and representational.[25] Occurring a beat apart, these correspond to different moments in affective analysis. For example, at a certain point in a slasher film my affective interpretant might be revulsion; my energetic interpretant, flinching and covering my ears; my representational interpretant, "That's horrible!"[26]

Moving backward then. *Before concept, perception.* In the encounter with a work of art (and indeed many life situations), critics are often under pres-

sure to quickly come up with concepts. However, conceptual analysis tends to respond to an artwork as a representation. The first analysis might sound smart, but it is likely glib, reactive, and unable to account for what the artwork *does* to the perceiver. That representational reflex, David Raskin argues, can be countered by the "natural, realist position that our conjunctive conceptions and perceptions are enmeshed in an emerging and material world."[27] Accepting for the moment Raskin's realist position, a first step in postponing the conceptual reaction is to focus trustingly on perception: to describe without judging, in the method of phenomenology.

Another reason to focus on perception, as I argue throughout this book, is that contemporary media technologies treat perception as merely an interface to information. Thus, phenomenological methods that enlarge our sensory capacities and skills constitute a strong defense against the cultural-economic tendency to make people information processors.

Before perception, affect. Unfortunately, even our sincerest acts of perception are menaced by habit. "Habit (Peirce), conventional perception (Bergson), and cliché (Deleuze) form the skin that holds an individual together in a predictable attitude."[28] As I noted above, perception is colonized. The reactiveness of perception is exacerbated by technologies that inform how it is possible to perceive. Moreover, while the close bodily senses of touch, taste, and smell may create a temporary private *Umwelt*, even these senses may deliver our body to capital.[29]

Thus, an adequate analysis needs to begin with affect or noncognitive thought: "every mode of thought insofar as it is non-representational."[30] Affect indicates the fold between thought and matter.[31] Affective analysis treats the encounter as capable of opening in two directions, both potentially infinite: "inward" to matter and "outward" to thought.[32]

In Spinoza's two terms often both translated as affect, *affectio* denotes the encounter between bodies, *affectus* the resulting becoming "by which the body's power of acting is increased or diminished, aided or restrained."[33] Doing affective analysis, we focus on the becoming, *affectio*, in order to identify the encounter, *affectus*.

Affect can be the means of transport from your body to the cosmos. It gains in capacity as it spirals through expanding circuits of virtuality, from immediate encounter to emergent capacities to a potential contact with the infinite. Gregory J. Seigworth teases out this sense of expansion across Deleuze and Guattari's conceptions of affect: "The affect goes beyond affections [*affectio*] no less than the percept goes beyond perceptions. The affect is not the passage from one lived state to another [that is, *affectus*] but man's non-

human becoming [*affect as expressive world*]."[34] *Affectio* is an actualization of the virtual relations between bodies, implying a relation of power (*pouvoir*, power over another). *Affectus* is the lived intensity of variations in the capacity to become (*puissance*, power as potential). And finally affect as pure immanence, where the plane of immanence is a life, Deleuze writes: "complete power, complete bliss," composed of "virtualities, events, singularities."[35]

For Deleuze, gaining access to the infinite entails abandoning actualization for virtuality, leaving the self behind, and becoming a vessel for pure immanence. What I aim to do in affective analysis needs to remain more grounded in lived experience. It aims to expand the lure of the singular, that twinkle of the virtual, on the individual, us reactive people caught up in our personal histories.[36] The impersonal state of pure immanence glimmers in the initial affective encounter; it draws the becoming like a lodestar; it is something to aspire to. But affective analysis works first to figure out, "What just happened to me?," and thus to convert *pouvoir* to *puissance*. That's why the method includes existential phenomenology, which is somewhat disparaged by Deleuzians for sticking too close to the human scale.

Before affect, culture. Autonomic responses such as goose bumps, arousal, blushing yield valuable data in affective analysis. However, these and other autonomic responses can encode cultural ideologies. Deleuze and Guattari noted that Romantic music can pull downward, appealing to history, soil, and identity and creating closure. Or it can pull outward, toward a people to come, creating openness.[37] That's a heavy burden—revolution or fascism latent in the same sounds! You can perhaps distinguish the ways these responses of closure and openness feel in your own embodied response to music or, say, taking part in a political demonstration. Moreover, contemporary media increasingly bypass perception to mobilize affect with unprecedented skill. As we've seen, many argue that social media, computer games, and other surveillant entertainments instrumentalize humans' very synapses and contribute to the production of what Väliaho calls the "neoliberal brain."[38] For these reasons, we cannot assume that our affective responses yield adequate ideas. Therefore, we need to use critical precision to identify the relations that occur between affect, percept, and concept—as well as the extra categories I suggest below of embodied response and feeling—in a given situation. Affective analysis works case by case.

Here's how to do it:

Choose a particular moment in your experience of a movie, an artwork, or anything you wish to analyze that seems especially dense, like that ball of affect-percept-concept that I mentioned, or that especially pleases, excites, or troubles

you. You and it, and other participants, constitute a soul-assemblage, and you want to learn what it can do. Note and set aside any initial concepts you have about it. You will be making a triadic analysis, following Peirce's logic: in which affect is First, percept is Second, and concept is Third: Affect—Percept—Concept.

Affect

1. Identify the affective responses or noncognitive thoughts that you experience at that moment.

 1.1. First, you might have the good luck to experience autonomic nervous system responses. Shivering, goose bumps, or hardened nipples; arousal; blushing; a rush of adrenaline; twitching of the forehead or upper lip; and other responses over which you have no control all constitute precious data. These responses come from something like the animal in you. However, as I noted above, even at the autonomic level our bodies are informed by culture.

 1.2. Here in the realm of Firstness, you may be experiencing what Daniel Stern terms "amodal perception": perceptions that do not yet grasp their object. You may feel little becomings that occur in microtemporal periods, or vitality affects.[39] As you assemble souls with it, you may find you feel a bodily empathy with the thing you are experiencing. Are you becoming like it in any way, taking its shape or its rhythm, participating in its energy? Do you, like early twentieth-century painter Clementina Anstruther-Thomson, feel your lungs expanding, your symmetry confirmed, or not?[40] Here research on mirror neurons, and its extensions into film and art theory, come into play.[41] Mirror-touch synaesthesia, in which one's body responds to visual images, is a common condition, but you don't need to push it if this is not happening.[42] It's impossible to grasp these things without changing their character, but you can practice noticing the embodied qualities that arise, perhaps recording them in a gesture, a vocalization, or a drawing and later translating that into words.

 1.3. It may be that you experience none of these. Thus, the next step is to identify embodied responses that are more likely learned and culturally grounded. Are there tears in your eyes? Is your throat constricted? Notice what else your face—that surface that gathers

micromovements but is unable to act, to move away, protect itself, or fight—is doing.[43]

For example, there are many kinds of smiles—a grin, a smirk, a rictus: Which one is happening on your face? Similarly, there are many kinds of laughter, such as a belly laugh, snort, giggle, or embarrassed laugh. (Embarrassment is very useful data!) As you notice your bodily state, turn your attention to the definition of *affectus* as a movement to a greater or lesser power of action. Cringing, grimacing, agitation; elation, a "bursting" feeling; calm; feeling yourself open up or close down: these embodied responses are examples of Spinozan affects. Do you feel tickled? Slapped around? Such responses also call up Vivian Sobchack's point, drawing on the research of George Lakoff and Mark Johnson, that metaphors are not arbitrary but based in embodied experience.[44]

Pay attention to boredom, irritation, and other grumpy feelings. Writing in 1903, Vernon Lee vividly captures the various kinds of irritation that her encounters with art provoke, and they yield valuable data for analysis. It is only bad statues whose eyes we notice first, she writes. A painting by Ignoto Toscano at the Uffizi is "singularly *out of time*, the eyes violently squinting in all directions." She is "distinctly annoyed by the forward action of the three very bad *Tyrannicides*. They keep catching my attention and not keeping it; it is like having one's name called repeatedly."[45] Often these moments of impatience indicate that the work or experience in question is trying too hard to signify.

1.4. If there are people in the image or phenomenon you're observing, try to imitate their posture and gesture. How does it feel?

1.5. In this method I try to avoid the category of emotion, so often the result of manipulation. However, my students' sensitive accounts of their feelings in response to a movie or artwork taught me that feeling is a useful category to include in the expanded notion of affective response. Some of them deploy categories of feeling in their writing that do not reduce to emotion but diffuse around the scene that gives rise to them, similar to the circulation of *qi* or vital energy.[46] Feeling detects an atmosphere in a way that is not necessarily subjective.[47] I use the term *feeling* in an underdetermined way to indicate responses that fall somewhere between embodied response and emotion. Feelings such as wistfulness, elation, longing, dismay, and (again) embarrassment correspond closely to Spinoza's terms and can still fall short of the more coded emotions telegraphed by the work under study.

Now you have at least one and perhaps a clutch of affective responses to analyze.

Percept

2.1. As you accept the Secondness of your experience, amodal perception settles into modal perception, and things take form. Here, describe impartially all that you perceive with all your senses. This is similar to formal analysis. Strive to be as precise as possible, for it is likely the singularity of a color, a rhythm, a shape, a scent, or another perceptible that gave rise to the affective response. At this point, a sophisticated phenomenology kicks in: one that attends to what the body becomes in the act of perception. Here we have to acknowledge that perception, as Helen Fielding notes, requires us to "make assumptions about the world according to the systems that have already been given, according to a world that [precedes us], that is given by others."[48] Perception is blurred by convention, but it is rich with singular data nonetheless. The longer you postpone recognition of what is before your senses, the richer and more precise your description will be.

2.2. Recognition. Finally, at this point you can acknowledge the cultural signs that likely were apparent to you immediately, but that this exercise has asked you to repress so far. What is being represented here? Good old Saussurean and Barthesian semiotics of denotation and connotation kick in here. More subtly, what cultural filters have you learned to embody as natural? If possible, step outside your perception to identify the information-filters that have shaped it, for example in framing your visual field as though it were a photograph.[49]

Concept

3. Compare the affects and percepts that arose at the moment you have chosen for analysis to move toward a concept tailored to that encounter. What did you perceive, or what happened, that gave rise to these affective responses? What did the soul-assemblage of your encounter do? The well-formed concept might prove to be a Spinozan adequate idea, in that it matches the powers of the body and the capacities of the mind in a given situation.[50] In this case, affective response will give rise to an adequate idea that increases understanding.

But sometimes you reach no concept, no new understanding, just the painful resonance of the affects you experienced. At such an unresolved point you are stuck in paradoxical experience, as Jon Roffe explains: "the experience of something which cannot be thought, but which thereby engenders a capacity in thought—assuming it is not, however, excessive to the point of the destruction of the thinker."[51] Day-to-day life is full of this kind of frustrated passion, since many ideas are not adequate.[52] Something is germinating within you. The point is not to despair but, if possible, to cultivate that germination: to grow a faculty to think. You need to carefully assess whether you can handle this new capacity. This feeling of disquiet may also, as we'll see in "The Feelings of Fabulation," develop into a collective capacity to act.

Here's how affective analysis works on my *Charlie's Angels* example. My affective response occurred at the autonomic level: arousal and goose bumps. I described what happened narratively in the scene, but what I perceived that gave rise to those responses were the painful crash as Dylan/Drew's body smashes backward through the window, the glittering shards flying as the window shattered, and, later, the gleam of her smooth naked body as she clings to the sheet, suspended from the window ledge on a toothlike fragment of glass. These were the moments that displayed her greatest vulnerability, made me feel it, and simultaneously made me enjoy it. Comparing my affective response with what I perceived, I conclude that I was not simply sexually attracted to her naked body, but aroused by a spectacularly sadistic image of a woman in peril. This response dismays me, to say the least, because it suggests that I share my society's general misogyny at a fundamental level—one that, in a Spinozan sense, decreases my capacity to live and increase my powers.

Now I can analyze *Charlie's Angels* as a movie that propounds a "positive" image of women in its representations but draws its power from affects of gleeful misogyny, in the molecular-molar opposition that del Rio identifies. That's the concept: how misogyny manages to endure in a bait-and-switch between empowering representation and salacious affect. An irritatingly large number of movies work this way. Racist and other kinds of hateful cultural artifacts operate similarly: advertising a positive image while perpetrating sad and sickly affects. Thus my affective analysis draws to a disappointing close. Yet such depressing concepts can lead to adequate ideas, such as how to make movies whose affects complicate and support their percepts.

In other cases the affective analysis exercise generates more salutary concepts. We can admire an artwork for the subtle ways it interweaves af-

fects and percepts. We can analyze a conversation in terms of how molecular events of gesture, intonation, vocal music, and allusion add texture and subtlety to the molar-scale event. As we'll see, it may be the initial step of fabulation, collective imaginal action.

To complete affective analysis we need to distinguish our conclusion (or lack of one) from any initial concepts we had before beginning the exercise. Our initial concepts might be supported and enriched by the affective analysis, in which case, bravo! But if the affective analysis does not support the initial concept, most likely it was not our own concept but a habit of thought. For example, we may get affective responses not to the perceptible image but to an idea that it stimulates. Similarly, we might have responded affectively not to the perceptual event itself but to personal memories and associations to which it gave rise. Both of these are noteworthy responses, but on their own they will not give rise to a strong concept. It helps to take note of these responses, set them aside for later research, and begin the process anew.

However, sometimes what we arrive at in comparing affect and percept may be, if we are honest with ourselves, nothing. This result echoes Deleuze's observation, "Not that the body thinks, but, obstinate and stubborn, it forces us to think, and forces us to think what is concealed from thought, life."[53] At the conclusion of the careful process of affective analysis, an incapacity to think, to bring together what we perceived and what we felt, can function as a painful marker for a thought yet to come.

Here's another example of how affective analysis can proceed.[54]

"Can Anyone Really Register Trauma?"

Mounira Al Solh made *Now Eat My Script* (2014) in Lebanon as refugees from the Syrian civil war began to pour into the country. In the first years after the Syrian civil war began in 2011, reporters and documentarists deployed many strategies to try to inform audiences about the Syrian government's inconceivable brutality against its own citizens. They struggled to activate that knowledge into empathy, and empathy into action, despite the well-known phenomenon of compassion fatigue. In contrast, Al Solh's *Now Eat My Script* steps back from political representation and adopts the strategy of suspending emotional response. She soberly, deliberately asks what documentary can do, while exposing herself and the viewer to glimpses of unthinkable things.

The artist narrates that her aunt is visiting from Damascus with the lamb she has slaughtered to celebrate her son's successful Canadian citizenship

test. Most of the video's visual field is occupied by a very slow overhead pan of the parts of the slaughtered animal, laid out on pristine white paper like precious artifacts: the glistening heart, the accusing eyeballs, muscle and bone obscenely exposed. Meanwhile Al Solh's text enumerates a series of traumas that must be documented, chiefly from the genocidal Syrian war. "Can anyone really register trauma?" she asks.

Now Eat My Script works carefully on levels of affection, perception, and concept, all coolly laid out and observed. It tests the idea that truth in representation requires including the representer, as well as feelings that appear trivial or "merely" personal. As it begins, a text explains paradoxically that the writer of the video, who is pregnant, does not have a script for this video. It describes the arrival of Syrian refugees in the writer's neighborhood, looking for parking. The text recalls how, comparably, the writer's family left Lebanon for the safety of Damascus in 1989 at a dangerous period in the Lebanese civil war, and how they as refugees tried to retain their bourgeois status. The soft sounds, whispers, and echoes of Nadim Mishlawi's sound design susurrate, opening up a space in which an audience can consider what it might be like to have to flee: not in the immiserated "bare life" of an imagined refugee, but as the deliberate decision to pack up what's important, make financial provisions, soothe children, and hasten to hoped-for safety. The camera slowly pans the contents of a heavily packed car—a heap of bags tied onto the roof, jars of food, cabbages—as the text recalls the Beirut-Damascus taxi driver who charmed the checkpoint guards back in 1989. It's the cabbages that grip my heart—smooth and dense, long-lasting, nutritious; I can imagine someone hefting them and placing them in the back seat of the car.

The text explains that the writer is trying to write a dissertation on what it is like to be "pregnant, penetrated, and feminist" and that the video is concerned with the task of witnessing trauma. Her pregnancy recurs as the reason she is unable to focus on the subject. As the camera contemplates the lamb's testicles, smooth and pearly, filigreed with red veins, the text notes that there are jokes about people who try to commit suicide from Beirut's landmark Pigeon Rock and fail. "It's mostly a male figure in those jokes." Because text and image retain the restrained tone of objective documentation, a gap is created. Now the task falls to the viewer to bring to mind those hapless would-be suicides who trip as they throw themselves from the rock formation, and who now must deal with humiliation on top of the bankruptcy or broken heart that made them choose death. If you let yourself go there, the burden of empathy is unbearable.

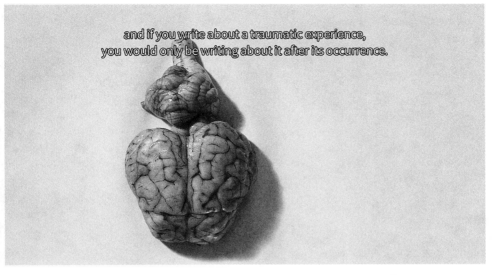

and if you write about a traumatic experience, you would only be writing about it after its occurrence.

FIGURE 5.4. Still, Mounira Al Solh, *Now Eat My Script* (Lebanon, 2014)

Just as drily, the text relates a story of Syrian fighter who ate the heart of a man he killed. "The writer read a text aloud: 'Get rid of meaning, your mind is a nightmare that has been eating you: now eat your mind.'"

While eating the barbecued lamb ribs, the artist's family learns from the radio of the Syrian government's chemical attack on civilians in Ghouta that killed hundreds, dating this barbecue to August 11, 2013. "'What does it mean to slaughter?' asked one as we chewed on ribs." Once again refusing judgment and sentimentality, the video continues to pass on to the viewer the question of how to respond. Sounds fizz, crackle, and sussurate, widening the gap in which we the audience might attempt to grieve the massacre at Ghouta, since nobody else is. Disquiet amplifies to a roar. As the lamb's now-useless jaw and brain are presented to us—what use is it to think or talk?—the text argues that trauma can't be shown. Writing always comes after trauma. The writer's most difficult and important task is to report. Now Al Solh's eyes face us gravely as she holds up two written notes to the camera: "I/she read these thoughts and my second mind thought, 'I'm hungry.'"

Now Eat My Script could have expressed the emotions that Al Solh's stories might elicit—grief, rage, horror—and thus compressed the viewer's volatile responses into an easy-to-swallow cathartic pill. Instead she encourages us to linger in feedback loops of less righteous, more complex feelings that start

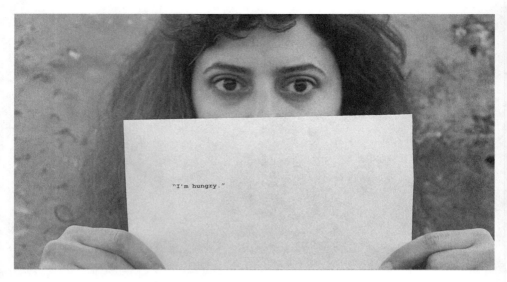

FIGURE 5.5.

with the body. By bypassing any kind of catharsis, using the "excuse" of her pregnancy, Al Solh gives over to the viewer the impossible responsibility of bearing witness to the suffering of others, of empathizing with massacred Syrian civilians and the others whose heartbreaking stories the video relates in a seemingly offhand way.

At the conclusion of my affective analysis, *Now Eat My Script* leaves the attentive viewer in an untenable state. I am left quivering with feelings that can't be resolved. I feel compelled to compare my bodily capacities to the slaughtered lamb's. Is my brain capable of comprehending this genocide by Bashar al-Assad's government of its own citizens, or even a single painful death? Are my eyes capable of witnessing? My mouth of speech that would make a difference? What strength do I have in my muscles that could fight this injustice? Can my sexual organs support a conatus, a will to thrive, that would strengthen my resolve to act? If not, am I dead too?

Now Eat My Script precisely addresses the (in)capacity of art to register trauma and makes an ethical demand on the viewer that may be impossible to meet. My monad experiences this disquiet as a stretching of its amplitude, its capacities to know and to feel. Like Al Solh, it soberly tests its capacity for witnessing while protecting its body, the source of life for me at least, from the harm of borrowed trauma. Maybe it is not necessary to register trauma in order to act ethically. Muting empathy and quieting emotion do not translate

into stilling speech and action, which take shape around the penumbra of the unthinkable.

Affective analysis is especially useful with those experiences and cultural texts that seem opaque or illegible but that stick with you uncomfortably for a long time. The method stays with the discomfort, not forcing it into a Procrustes' bed of discursive or ideological meaning but allowing discourse to emerge from a careful and gradual process. Affective analysis can begin in the body's feelings of discomfort and gradually shape into an understanding of how a movie—or any experience—creates thought precisely by beginning where thought is most difficult. As I noted above, sometimes affective analysis concludes not with a new concept but with painful disquiet, which may be the witness to an emerging capacity for thinking.

6

THE FEELINGS OF FABULATION

A lot of people fed up with trying to appeal for justice in this world are resorting to science fiction: to bring about justice for the present by importing it from the future. Science-fiction movements are arising in places where, at first glance, science fiction does not seem to be an important fictional tradition: global Indigenous peoples, the Arab world, sub-Saharan Africa, and South Asia. However, these regions have profound traditions of using storytelling and indigenous technologies to devise utopias and alternative futures. As Yazan al-Saadi writes, "The most iconic example of proto-science fiction tales are recounted within *One Thousand and One Nights* that include fantastical journeys through the cosmos, brass robots, and an adventure undersea to a community governed by a primitive form of communism."[1]

When Sun Ra said in 1980, "We hold this myth to be potential. They hold their truths to be self-evident. Our myth is not self-evident because it is a mystery," he hints at an alternative heritage for the descendants of enslaved Africans that is historically enfolded or yet to come.[2] For one of fabulation's greatest powers is to fold the past together with the future. Afrofuturism, African diasporan artists' rejection of existing reality and fabulation of alternate realities, may be

the most significant artistic movement of our time, to which I pay homage in other chapters, in studies of the Otolith Collective's *INFINITY Minus Infinity* and Black Audio Film Collective's *The Last Angel of History.*

Here in Kanata, Indigenous futurism and fabulation blossom like bitter-root in the Osoyoos Desert. Since the early 1990s the oeuvre of Zacharias Kunuk (Inuit) and others at Isuma Productions has often featured fabulative time travel, from the 1995 video series *Nunavut (Our Land)* to detailed historical dramas like *Atanarjuat: The Fast Runner* (2001), set over five centuries in the past, and *Maliglutit (Searchers)*, set in 1913. Helen Haig-Brown's (Tsilhqot'in) mesmerizing *?E?anx/The Cave* (2009) presses together two incompossible times. A cowboy-hatted Tsilhqot'in hunter, tracking a bear, ties his horse and crawls into the small opening of a cave. When he exits on the other side, the dusty colors have given way to saturated greens and blues, a hint that we are in a different place-time. The hunter finds himself in the ethereal parallel reality of a never-colonized Tsilhqot'in group. The air around these figures clothed in skins vibrates, and bubbles rise in the air around them. Like the superior beings from the future in Chris Marker's *La Jetée*, they communicate telepathically with the hunter. They warn him to turn back; he is not ready. Returning to his present, he finds his horse has become a skeleton. The folded narrative hints that either the Tsilhqot'in people are in a future where they have survived settler colonialism, which has now vanished, or they are in a parallel reality in which settler colonialism never happened. Lisa Jackson's (Ojibwe) virtual-reality work *Biidaaban: First Light* (2018) is set in a postapocalyptic Toronto that is being reclaimed by Indigenous people. As in *?E?anx/The Cave*, it is as though the apocalypse has come and gone, wiping out settler-capitalist civilization.

Haida animator Christopher Auchter's *The Mountain of sGaana* (2017) models a complexly interfolded cosmos from Indigenous storytelling. Auchter's shapely hand-drawn forms and fluid transformations suggest a cosmic stretchiness. *The Mountain of sGaana* folds time as the relative temporality of a linear narrative is overtaken by the absolute temporality of Haida legend.[3] To fold space, Auchter translates traditional Haida arts into cinematic devices. Simultaneous frames of action nest side by side in curvilinear designs like Haida painting, showing human, animal, and spirit points of view. A young fishing-boat navigator, distracted by his smartphone, is surprised by Mouse Woman jumping from his tea mug to knit him a story. Zooming into the pictures knitted into the fabric, a legend unfolds of a young man kidnapped by an enamored orca spirit and taken to the bottom of the sea. Plunging from her canoe, his lover uses her singing and negotiating skills

FIGURE 6.1. Still, Christopher Auchter (Haida), *The Mountain of sɢaana* (Canada, 2017)

to rescue him from the spirit world. When they surface again, eons have passed. They're in the present time of the young fisherman—yet the jilted orca spirit is still in pursuit! As relative and absolute time fold together, the navigator must save his own ancestors.

These and other Indigenous futurist films accomplish a cosmic folding that reaches into Indigenous tradition to gather resources for a survivable future. Sometimes, as in *Biidaaban* and *?E?anx/The Cave*, they literally enfold settler colonialism, removing it from the larger historical narrative.[4] The incompossible universes that intersect in some of these movies resonate with multiverse theory; however, as Grace Dillon emphasizes, past, present, and future, as well as natural and spirit worlds, interfold fluidly in many Indigenous worldviews.[5]

Fabulation movements are inseparable from decolonization and the attempt to extricate from neo-imperial economies. They pull folds from the past to identify resources that may have been forgotten, and from these they unfold a future better able to survive the indignities of the present. South Asian Futurism is building momentum, for example in the oeuvre of Raqs Media Collective; the Otolith Group's science-fiction works like *Otolith II* (2007) and *Otolith III* (2009), which revisits Satyajit Ray's unmade science-fiction film *The Alien*; and Hetain Patel's fabulative performances.[6]

Plate 1. Still by Tali Yankelevich
from *Meu Querido Supermercado*
(São Paulo, Brazil, 2019).

Plate 2. (*Left.*) Natalie Sorenson, *Quantum Solutions for Everyday Problems*. Watercolor, 2019.

Plate 3. (*Below.*) Still, Otolith Collective, *infinity minus Infinity* (UK, 2019)

Plate 4. (*Below.*) Still, Christopher Auchter (Haida), *The Mountain of SGaana* (Canada, 2017) .

Plate 5. (*Right.*) Still, Basel Abbas and Ruanne Abou Rahme, *Only the Beloved Keeps Our Secrets* (Palestine, 2018).

Plate 6. (*Left.*) Still, John Akomfrah, The Last Angel of History (UK, 1996)

Plate 7. (*Below.*) Still, Ephraim Asili, *The Inheritance* (US, 2020).

Plate 8. María Angélica Madero,
Camouflage for anti-facial recogni-
tion for quarantine surveillance
(Colombia, 2020).

A Gulf Futurism movement has emerged to confront the coming demise of oil-based economies, the sturdy local shapes of neo-imperialism, over-sanguine investment in desert "smart cities," and oddly filtered conservative Islam and Bedouin tradition. Kuwaiti artist Monira al Qadiri and Saudi-American writer Sophia Al-Maria coined the term Gulf Futurism to char-acterize "our dizzying collective arrival in a future no one was ready for."[7] This movement begins with archaeology, an attempt to peel back the wreck-age of the near future and see what might grow there. A sometimes despair-ing, sometimes darkly humorous futurism colors practices in less wealthy Arabic-speaking countries too, as well as in diaspora.[8]

The most important recent fabulation arising from the Arabic-speaking world is the media of the 2010–2012 uprisings in Cairo, Damascus, and Tu-nisia. Thoughtfully discussed by many, these urgent videos, such as those posted by the Mosireen Collective during the Tahrir uprising in Cairo, now constitute a living archive online whose source materials are secretly cached outside of Egypt for safety. In the blur, noise, and anonymous voices of these urgently recorded movies, a collective embodiment comes into being. As Peter Snowdon movingly contends, these videos are not simple documents but aesthetically complex, devotional, multisensorial performances. They are preparing individual bodies to join a collective that is created *"at the mo-ment when they are uploaded to the Internet."*[9] Fabulation begins by prepar-ing a collective to come.

Fabulating a Plant-Based Future

A delicate strand in Arab Futurism that interests me circles around plant life. The 2016 Sharjah Biennale, curated by Christine Tohme, had a focus on regional ecosystems, crops, and culinary practices. In tours, meals, and workshops, participants learned by listening and making, tasting, smell-ing, and eating. Homa Al Hashimi led a tour through the supermarket and spice souk and shared recipes for traditional remedies. At Sharjah's Islamic Botanical Garden people met the healing and nutritious local plants men-tioned in the Qur'an and enjoyed a meal incorporating them. Laura Allais-Maré, founder of Slow Food Dubai, led a seed exchange, and participants brought potluck dishes containing herbs and greens local to the Emirates. Local children learned to identify edible plants, grew plants from kitchen scraps, made art with plants, and wrote stories and poems about the materi-als. The children built habitats for fish, calling to mind the graceful Umwelt that the mangrove tree, which lives in the salt water of the Gulf, creates for

the young fish that shelter within the weave of its roots. All these activities instilled knowledge about indigenous plants not only through instruction but through the senses and the imagination. Doing so, they planted seeds of fabulation, for a future UAE that might exit the extraction economy and live sustainably in the ancient and vivid ecosystem of the region.

A fabulative work that embraces plants while refolding the information fold is Jawa El Khash's haunting virtual-reality work *The Upper Side of the Sky* (Canada, 2020). It fabulates a future in the Syrian Desert that is dystopian from a human point of view but healthy for the ecosystem of flowers and butterflies. *The Upper Side of the Sky* elegantly exemplifies unfolding differently, using its minimal means to point at the infinite while also critiquing an imperialist manner of unfolding. The VR work reconstructs parts of the ancient oasis city of Palmyra, located in Syria's Homs Province. In the first centuries of the Christian calendar, Palmyra's wealth and sophistication reflected its position at a trade crossroads. As a succession of empires besieged, flattened, and reconstructed the city, it acquired many layers of languages and religions. Palmyra was just a village when the French directorate evicted the remaining Palmyreans in order to preserve the city's ancient architecture. In 2015, ISIS yahoos demolished large areas of Palmyra and knocked the faces off statues.[10]

In 2018, the Oxford-based Institute for Digital Archaeology, in cooperation with UNESCO, fabricated a 3D-printed 30-percent-scale replica of Palmyra's fifteen-meter Arch of Triumph. It was displayed in London's Trafalgar Square and traveled to Luxembourg, Bern, Geneva, and other Western cities. The replica looks a bit ridiculous in these contexts with dignitaries posing in front of it, feeling good about "giving hope to the Syrian people." It calls to mind the minuscule Stonehenge concert prop in *This Is Spinal Tap*. Given the devastation of Syria by the unfinished civil war, the replica, in Toufic's term, is a zombie unfolding of an irrevocably lost culture.

In contrast, El Khash used the open-source virtual reconstruction of Palmyra painstakingly produced by Syrian software engineer Bassil Khartabil. Khartabil was an outspoken internet-rights activist who led a hackerspace in Damascus and created open-source software. Made anxious by the free information movement he led, Syrian authorities detained Khartabil without trial in 2012 and executed him in 2015. Subsequently group of activists released Khartabil's NewPalmyra software.

Unlike the IDA's decontextualized, grotesquely material reproduction, *The Upper Side of the Sky* is ethereal and dreamlike, yet full of life. You can hear high-pitched cries like unseen birds. High above the horizon, distant butterflies twinkle like stars. This world is rendered in shades of gray, most

FIGURE 6.2. Screen grab, Jawa El Khash, *The Upper Side of the Sky*, virtual reality work (Canada, 2020)

of the colors drained away, the shadows of monumental columns and leaf tracery seeming as real as the objects that caused them. The music, a high, sparkling piano upheld by a steady, cyclical melody like the slow beating of wings, evokes the contentment of a feeding butterfly.

All these creative decisions suggest that El Khash was not interested in resurrecting historic Palmyra intact, but in turning it upside down to privilege the nonhuman life of the region. She creates for the visitor a Palmyra fantastical in its timeless serenity, its harmonious ecology. The first space you encounter is a majestic arcade, populated by dignitaries not human but vegetal. Handsome pots hold olive trees and a fantastical cotton plant, its flowers opaque black, its leaves of delicate blue-and-white ceramic. Sparkling white butterflies populate the space. A lacy tower of clematis vine climbs into the sky. In the spacious courtyard too, each arch frames not a human statue but a plant: wild parsnip, what look like corn and pepper, a plant with hairy seeds, all ghostly like ancestral daguerreotypes.

Two towering crystalline poppies guard the temple of Al-Lat. Inside towers a single flower, a five-petaled lily, languidly moving its petals. Al-Lat is one

FIGURE 6.3.

of the goddesses worshipped by Arab peoples before Mohammed destroyed the idols at Mecca.[11] Each of the lily's orb-like anthers, glowing against the black petals, is a wire-frame map of the starry sky. If you traveled into this lily, you would be traveling out to the farthest stars. Like the fecund motifs on some floral carpets, this marvelous flower encloses the entire cosmos!

Is the world of *The Upper Side of the Sky* ancient or still to come? The artwork hints at a world takeover by "the 80%," aka the plants, who hold 80 percent of the carbon stored in the Earth's living creatures.[12] It imagines an expansive future phytoremediation of the damage humans have done, plant life rebelling against millennia of servitude. El Khash reveals in her research that her grandfather, Mohamed N. El-Khash, studied the survival of cotton and other agricultural plants as director of the Arab Center for the Studies of Arid Zones and Dry Lands. I am reminded of the angry farmers in Syrian documentarist Omar Amiralay's documentary *Daily Life of a Syrian Village* (1974), whose land became desiccated after the construction of the Euphrates Dam.[13] I am reminded too that drought caused by global warming is one of the reasons behind the Syrian civil war, as farmers had to move to the cities when their land ceased to yield.

Yet *The Upper Side of the Sky* feels more elegiac than postapocalyptic. The human cultures visible in this virtual world already adored flowers and plants—the lovingly observed floral motifs, the stylized leaves topping the stone columns, the attentive botanical drawings, and the devoted work, by

Mohamed El-Khash and others, to encourage plants to grow in dry soil. Rather than use digital tools to resurrect a dead monument, *The Upper Side of the Sky* invites us to an inversion of perspective, reimagining humans' role not to subjugate nature but to nurture it, if it is not too late.

Cinema of Folds

The monad, packed tightly together with other monads, feels the world before it perceives it. Affection is the soul's differential sensation of contact; it is the fold between matter and soul. "The infinite fold separates or moves between matter and soul, the façade and the closed room, the outside and the inside," Deleuze writes. "Because it is a virtuality that never stops dividing itself, the line of inflection is actualized in the soul and realized in matter."[14]

Many contemporary cinema and media experiences are adequate to the baroque nature of our contemporary time: fractal image and sound searches; YouTube remixes; memes that transform in their travels like resourceful refugees; and movies that fold together matter and spirit. For a generation cinema scholars have been identifying how the medium enfolds the world like a luxurious fabric with the two-sidedness of the Baroque—thought on one side, body on the other. In Pethö's intermedial argument, the moving image cinema folds outside into inside, illusion into reality, and haptic into optical, as well as enfolding other media. Bruno's Deleuzian work focuses on the texture of the fold as an interweaving of spirit and matter, in cinema, architecture, and fashion. Saige Walton relates the Baroque to Merleau-Ponty's concept of the chiasm, and thence to cinema, to demonstrate that thought is immanent to densely folded, expressive surfaces. Fabrics express unspoken desires in the queer melodramatics that Joe McElhaney identifies in the films of Luchino Visconti and Sergei Eisenstein.[15]

Some of us perceive an algorithmic matrix at work in cinema's folded world-surface. Timothy Murray pursues the intimate relation between folding and possession and the paradox of incompossibility in some of the earliest works of digital media art. Cubitt characterizes the plot of a neobaroque film as a "knot garden, a spatial orchestration of events whose specific attraction is its elaboration of narrative premise into pattern, its reorganization of time as space." Angela Ndalianis, similarly to Cubitt, identifies a fascistic neobaroque in the infinitely folding, exit-less spaces of digital blockbusters. I take up Cubitt's knot-garden analogy, relating Steven Soderbergh's much-loved caper film *Ocean's 11* (US, 2001) to infinitely patterned Persian carpets: algorithmic universes of baffling complexity, augmented with lush tactility.[16]

Into this infinitely folded surface of which movies are a part, Pisters includes the folds in the spectator, right down to the folds in our brains, in a new ontology of cinema in which bodies, brains, screens, and worlds complexly interfold. In Pisters' pleasing analogy, in the Deleuzian movement-image, stories are like bricks. In the time-image, the bricks shift and break, creating gaps through which the virtual seeps. In the neuro-image, the whole house has fallen apart, but each fragment is a microcosm of the whole.[17]

An archive—in which I include even mean-spirited databases of stolen metadata—reveals only the tips of folds. There is so much that might be unfolded if one has the means. Remixing (as we will see in "Monad, Database, Remix") pulls together folds from the past in order to prepare for the future. It dives into the audiovisual archive and folds it differently. Pisters' example is the formidable archival unfolder John Akomfrah, who unfolds other worlds from 1960s instrumental documentary films of Black migrants to England. This kind of unfolding differently occurs wherever the audiovisual archive is hateful or nearly mute about one's people, as when filmmakers from colonized lands have to unfold their own history from racist and colonial images.[18]

Fabulation pulls out the deepest folds of all, folds so distant in space and time or so lost to memory that they might seem to come from another world. Affect operates like a dowser to identify their subterranean patterns. Grasping an affective flash, fabulation assembles a coalition of the film's subjects, the filmmakers, and the audience to multiply its power as it tugs out the once-unthinkable new plane. At the same time, it minimizes the present, dominant surface by enfolding it, or falsifying it.

Powers of the False

Futurist artists like the ones I mentioned above have no interest in truth. They reject truth as the banal prison of the same. As Nietzsche wrote, truth is an act by which the "regularly valid and obligatory designation of things is invented."[19] Truth allows powers to impose languages, conventions, and laws that seem natural to them (to us) because they serve their (our) interests. "The truthful man in the end wants nothing other than to judge life," Deleuze writes; "he holds up a superior value, the good, in the name of which he will be able to judge."[20] The powers of the false replace judgment from above with ethics from within, ethics that begin with the impersonal resonance of affect. "Affect as immanent evaluation, instead of judgment as transcendent value: 'I love or I hate' instead of 'I judge.'"[21] Fabulation is not interested in trying to change minds by expressing the "truth" of people's experience.[22] It *falsifies* commonly accepted truth, and puts in its place not another truth but an infectious creative power.[23]

In documentary cinema, powers of the false begin to gather when the impulse to educate is discarded; when the goal is not truth but expression. This is part of the turn from the discourse of sobriety analyzed by Bill Nichols.[24] As Rangan notes, documentary has "embraced pleasure, sobriety's nemesis, in the form of the performative, the emotional, the erotic, and the personal, ushering in a new era of 'anti-documentary' exhibitionism, entertainment, intimacy, and play."[25] Ilona Hongisto extends the Spinozan thesis to the soul of documentary cinema, defining documentary according to what it is capable of doing. Documentary's power, she argues, lies in capture or creative framing: the selection of certain aspects of the real to actualize, which I call unfolding. Hongisto's study focuses on the three operations of imagination, fabulation, and affection, which capture and express the processes of actualization of subjects and objects. As experimentations, Hongisto emphasizes, these operations have an ethical responsibility in terms of the reality they help bring into being.[26]

As we've seen in chapter 2, folds are granular, composed of numerous individual unfoldings. Fabulation is the topological act of first identifying singularities, then drawing out the unimagined fold that they inhabit—like a magician producing a parachute from her vest pocket. As I discussed in "Style in Manners of Unfolding" in that chapter, relevance, not truth, is the criterion for unfolding differently: creating the more capacious and expressive fold. Fabulation unfolds differently not by excavating the historical past but by inventing a new fold, by pulling together singular points, including incompossible points, from different sheets of past. Given that it creates such a fold from apparent discontinuity, fabulation is a manner of unfolding that is especially acute in its deft grasp of fleeting points. The surfaces over which it operates call to mind the firelike flows of Heraclitus, the flickering atomism of Hume and Al-Ghazālī, and the fleeting *dharmas* of Buddhism.[27] It lies in wait for difference, in the manner of *festina lente*, making haste slowly.

This tactic is especially useful when an existing information fold is so obdurate that its internal granularities don't manage to bend it out of shape. For example, the "heartbreaking" popular story of Princess Diana has been unfolded many times in fine-grained detail, reinforcing the information fold with the unhelpful sad affects of a victim narrative, accruing profit on every cycle. Revolving stories of her betrayal by the royal family, her bulimia, even her brief happiness with Dodi Al-Fayed burnish an existing "truthful" fold. Pablo Larrain's *Spencer* (US, 2021), by contrast, frees Diana Spencer from yet more documentation and, more important, frees audiences to use imagination rather than pruriently reinforcing the existent. Formally, as Steven Rybin

notes, the film does not invite intrusive empathy with Diana but holds the viewer alongside her.[28] This psychological distance creates space for fabulation to occur. *Spencer* imagines parallel lives for the ostracized princess that form crystal-images with the historical accounts. At yet another punishing formal dinner, the fat pearls from her necklace (an unwanted gift from her husband) drop into the pale-green cream soup, and she spoons them into her mouth. Wandering freely on the estate, she encounters the warning ghost of Anne Boleyn. The film fabulates for Diana a real friend—a crystal-image/hallucination of Diana's sympathetic lady's maid. A succession of Dianas dance in a montage, set to Johnny Greenwood's ethereal score, her dresses no longer imprisoning uniforms for public appearances but dream-materials that swirl around her as she moves. And in a gratifying act of rebellion, she liberates her sons from the sacrificial ritual of a pheasant shoot with Prince Charles, wearing the faded bomber jacket of her father—the grounding Spencer of the title—like an amulet. In such ways *Spencer* rejects the suffocating patterns of even a sympathetic retelling, instead choosing to liberate the deceased princess and us, the spectators, into breathing, imaginative unfoldings.

Sometimes people find movies like these irresponsible—they are not representing properly, they have no regard for difference between fiction and fact, they are in danger of confusing audiences with "fake news." Fabulative strategies stimulate imaginations otherwise, in ways as enjoyable as Instagram face filters and as empowering as *Black Panther* (Ryan Coogler, US, 2018). Inspiring for all who have fallen out of the dominant folds of information capitalism, fabulation jerry-rigs a new reality from parts, not brand-new platforms. Like metallurgy, fabulation reaches into history for scraps that it smelts, alloys, and burnishes, bringing new assemblages into existence.[29] When fabulation succeeds, it sets history in a new direction. Future archaeologists of the United States of Africa, Kodwo Eshun writes, will have been "touched by the seriousness of those founding mothers and fathers of Afrofuturism, by the responsibility they showed towards the not-yet, towards becoming."[30]

Fabulation

A Method

So how does one cultivate a feeling for fabulation, a way of responding to events that is sensitive to emergent energies and may extend into action? In my domain of moving-image media, the movies that yield such ener-

gies may well appear apolitical at the level of representation. However, they have an important *prepolitical* power of assembling forces for future action.[31] In some cases, these energies can leap over representation to achieve fabulation.

This method builds on the previous chapters' analyses and exercises in unfolding differently and enlarging perceptual and affective capacities, to explore how you can tell that a fabulation is occurring and what you can do to hasten its emergence. Arising from a dimly sensed disquiet, fabulation is *felt* before, often long before, it occurs. The feeling of fabulation can be gentle as a breeze on the back of your neck, as piercing as a dagger. It can be that twinge in your navel where a tug from the cosmos signals an inversion to come. Affective analysis can sometimes detect the initial step of fabulation, collective imaginal action.

In the section "Style in Manners of Unfolding" in chapter 2, I compared skillful unfolding to a martial art. Fabulation requires a refined sense of timing and rhythm, dancerly precision, nimble sleight of hand, a delicacy that belies great effective force, and either saintlike wisdom or astonishing luck. That's why it is virtually impossible to fabulate alone: no one being has all those capacities.

The method incorporates and expands my method of affective analysis introduced in the previous chapter. Some people vigorously detest this method, and the very notion of prepolitical practice; they argue instead that the responsibility of the artwork is to represent reality and stimulate thought. Obviously, if that is your view, this method—even though thinking is one of its steps—is not for you.

Affective analysis, the method of comparing affect and percept to arrive at a triadic concept, already prepares the ways for this step, in the cases when you arrive at not a concept but a painful marker that you are not yet able to think.

1. Don't Worry about Representation

The first step is to put aside the idea that the main thing an artwork—or any entity—does is represent. At the level of representation, a "political" image is already captured. Quelling the interpretation that follows representation is a first step in allowing affects to multiply.

At its heart, representation is judgment: the judgment that this image properly represents its object. It leads perception to hesitate, asking "Is this image correct? Is it significant (that is, does it already have a place

on a dominant fold)?" As we saw, the powers of the false replace judgment with responsiveness: not "Is it good or bad?" but "What does it do to me?"

2. Cultivate Passivity, at First

In *Hanan al-Cinema* (2015) I argued that perhaps surprisingly, given the constant state of political emergency that prevails in many Arabic-speaking countries, many experimental works by Arab makers operate at a kind of prepolitical stage. In turning away from politics at the discursive level, they generate the energy necessary for political action. "With a slight shift of energy, apathy converts into play, possessing a speculative lightness that might survive where more earnest attempts get bogged down under the weight of good intentions and ideology."[32]

I based this idea on Deleuze's concept of the time-image, or an image that creates within a gap between perception and action, drawn in turn from Bergson. In Bergson's theory of perception, an organism, such as us humans, is usually able to move quickly from perception to affection (or feeling) to action, for example when receiving a light electric shock. Usually this speedy cycle is necessary and fine, but sometimes it indicates a reactive or habitual response. But when we choose not to move on from perception to action, or something prevents us from acting, we find ourselves suspended in a widening gap. We perceive very well the problem that affects us, or the recent condition we desired to achieve—in fact we perceive it better and better in this state of suspension—but we are unable to resolve the situation. So the feeling or affection intensifies. We are stuck in the affection-image, perceiving and feeling with increasing intensity. Affection, passion, intense feelings of passivity: Spinoza argued we need to get over them, while Deleuze cultivates them. This is a painful state, but it can be the foundation of creative activity.[33]

An efflorescence of creativity in a given country or region often results from such a coincidence of political frustration and reasonable access to means of the medium. The explosions of creative production among Palestinian, Lebanese, Syrian, Moroccan, and Egyptian artists and intellectuals that I studied in *Hanan al-Cinema* (2015) occurred when being ideologically disabused and coincided, crucially, with having access to the means of production and (usually) distribution.

Writing about movies, I try to cultivate embodied responses in myself and the reader, so that we may accompany them on their creative passage

through the body. We feel the moment of emergence, sometimes as a physical release: the affect of unfolding.

3. Train Senses and Body

A theory of the affection-image helps identify these emergent powers by using one's own body as a diagnostic. Here we can use the method of affective analysis. Affective analysis, as we've seen, is an empirical method to compare affective and perceptual responses in order to arrive at a concept or analysis. A method to account for prediscursive effects must include becoming aware of *affectio* (encounters between bodies) and *affectus* (variations in bodily capacity; both from Spinoza). It detects molecular energies not yet captured by meaning or narrative. If your senses are well trained to perceive slight differences, and your affective capacity honed to detect what occurs in those distances, you are better able to identify those molecular forces.

I uphold Deleuze and Guattari's conception of an artwork as not a communication but a bloc of sensations in itself. It is just there, vibrating with energies, ready to be met by a perceiver. The affection-image takes place in the body's encounter with the work as it actualizes some of those energies. Other energies remain virtual, though someone else may be able to actualize them—hence, again, the usefulness of collective experience.

4. Intensification

As we saw in the last chapter, sometimes affective analysis concludes with a painful suspension, and that's the point. Affects put us in touch with the outside and express molecular powers, but they do not give them new shape. However, revealing the limits of the seeable and sayable is already a political act. Disquiet indicates what cannot be unfolded.

The organism puts its needs first; lingering in the passive state of affect is a luxury at best and dangerous at worst. Yet in terms of soul-assemblage politics, lingering at the level of affection is a healthy thing to do, if one has the time and stamina. It feels like not scratching an itch or like holding a position for a little longer than your muscles can bear. Lingering here you attend to the disquiet, drawing out connections that were unknown or unconscious. Usually, we Deleuzians aim to postpone resolution as long as possible, for fear that it will neutralize those nascent energies. Doing this can feel unbearable, but it widens the virtual field and nourishes a sense of future without giving it a form.

Sometimes, when we are lucky, the energies that gather in that painful gap come to cohere at a larger scale that maintains their force. Movies and storytelling artifacts may witness the collective passage to a greater capacity. In these, fabulation falsifies, bypasses the clichéd ways that molecular energies are captured in the molar. Fabulation palpates the plane of immanence. Usually this happens collectively, in the emergence of a soul-assemblage that to a greater or lesser degree includes you, the audience.

Fabulation doesn't have to be difficult! It can happen with grace and ease when the time and place are right. We have many examples of graceful fabulations in movies where people collaborate with filmmakers to storytell themselves out of seeming dead ends into new and expansive life.

My favorite example of fabulation is not cinematic but a life-changing performance by a JetBlue flight attendant, summarized in the laconic prose style of Wikipedia.

> The JetBlue flight attendant incident occurred after Flight 1052, from Pittsburgh to New York City on August 9, 2010, had landed at John F. Kennedy International Airport. Steven Slater, a veteran flight attendant, announced over the plane's public address system that he had been abused by a passenger and was quitting his job. He then grabbed two beers and exited the plane by deploying the evacuation slide and sliding down it. Slater claimed to have been injured by a passenger when he instructed her to sit down.[34]

Apparently, the passenger stood up to remove her bag from the overhead bin while the plane was still moving, whacked Slater in the head with it, and refused to apologize. As the overworked, underpaid human buffer zones between airlines' profit margins and frustrated, anxious passengers, flight attendants are required to absorb pressure from both sides while remaining smiling and professional. But Slater, suddenly seizing other points to unfold (including the two beers), grasped the moment to falsify this degrading capitalist narrative, in a timely and elegant unfolding. Slater was enacting a refusal of the entire system that dehumanizes flight attendants, passengers, airlines, and stockholders too. His fabulation did not bring a new plane into existence—the Wikipedia entry goes on to diagnose, judge, and blame him—but it contributes to a groundswell of refusal.

There is one more step to this method.

Affective analysis's three subdivided steps move backward from what is most discursive and easiest to identify to what is least so: from affect to percept to concept. Step one, affect, gets your body in touch with outside forces: it is Peirce's First and Spinoza's *affectio*. Fabulation adds a "zeroeth" step: getting in touch with outside forces from far away. It makes connections to the beyond, whether that is unimaginably far in time or space, incompossible with the space-time in which we seem to live, or deeply virtual within oneself. This step zero is the most difficult of all, but it can be practiced, exercised like a muscle, alone and with others.

Fabulation does not only change minds; it establishes its reality in bodies. Your own body can detect a successful fabulation. We can feel things emerging before we can name them. Doing fabulative analysis, I test this emergence on my own body and share my findings. If they resonate with others, that is satisfying. If not, other people with different knowledge and capacities can carry out the experiment. When that encounter with emergence happens, one feels the transformation, the bootstrapping quality of a successful fabulation. Or one may feel, in a breathless leap and lurch, the failed launch of an fabulation that lacks sufficient propulsion.

Earlier I asked, who can say whether we're unfolding something deeply virtual in this universe or issuing from another universe? Fabulation holds that question open.

Real-Time Fabulation

Catherine Deneuve is asleep, her iconic face reflected in the windshield, beyond which a little road rises through brilliant green hills. In Joana Hadjithomas and Khalil Joreige's 2008 film *Je veux voir* the French megastar plays herself, visiting Lebanon for the first time in 2006, as the country was reeling from the Israeli-Hizbollah war. Lebanese critics rejected this film as inaccurate, prey to Western neo-liberalist individualism, and politically suspect from a variety of angles. Yet *Je veux voir* does the most beautiful things we can hope of a fabulation, a necessary fiction invented by real characters. Fabulation, the forging of stories, has become an essential tool in the practice of artists from countries formerly colonized or in the grip of neo-imperialism, who can only tell the stories of their nations by falsifying narratives that manage, categorize, and commodify their experience.

To the filmmakers' amazement, Deneuve accepted to participate in the film, unpaid, and without a script. As the incarnation of fiction cinema, Deneuve comes as a witness—"Je veux voir," she says; she wants to see for herself the destructive outcome of the war—and with great dignity allows herself to be made a passive recipient of the day's events. She meets the Lebanese actor and artist Rabih Mroué and he drives with her, first to the southern suburbs of Beirut shattered by Israeli bombardment in the war, and then to the south of Lebanon, where the worst devastation occurred, including in his ancestral town of Bint Jbeil.

In July 2006, world news was briefly awash in images of the destruction of Lebanon, the bodies of the dead, and the suffering of displaced people. *Je veux voir* re-enfolds those images, or as Toufic would say, withdraws them, refusing to render up a representation that would serve as more sophisticated victim porn.[35]

Je veux voir is neither documentary nor fiction, but what Hadjithomas calls "a chemical experiment for the cinema. To bring together two bodies— Catherine Deneuve, the body of fiction cinema; Rabih, representing the artistic history of Lebanon. Artists who interrogate the cinema and the archive. Put these two bodies together in a car and see what happens between them, and between them and us, the directors, camera, and crew."[36]

Deneuve seems strangely calm throughout the trip. She does not react with horror to the devastation by Israeli bombardments in the southern suburbs of Beirut. They chat quietly. Mroué performs for her translation of her lines in *Belle de jour* (Luis Buñuel, France, 1967) in formal Arabic, correcting for gender, and they laugh over the lovely leap the words make to a different language. Deneuve seems obsessed with her seat belt. Now and then she sleeps, dozing through the green and hilly landscape as well as through some of the scenes of destruction the car traverses.

As they drive further south, sunlight glitters on the car's windows, and reflections of trees further obscure the camera's view of the car's interior, creating a sense that the vehicle is a capsule for the travelers within that protects them even from the film crew's documentation. Of another artist's car on another highway, Deleuze writes that the car is a monad, with its privileged zone that captures what passes outside. The monad's enclosure of the outside world is perfect, because the asphalt outside the car has nothing to do with the asphalt reflected on the windshield.[37] The car-monad assembles souls— Mroué, Deneuve, the histories they embody of Lebanon, war, art, and cinema; the speed of unimpeded movement; conversation, silence, and sleep.

FIGURE 6.4. Still, Joana Hadjithomas and Khalil Joreige, *Je veux voir* (Lebanon, 2008)

Protecting its precious contents, the car-monad intensifies the internal relations among them.

When they reach Bint Jbeil, half the village has been destroyed by the Israeli bombardment. Mroué walks hesitantly up a path between the remains of buildings to search for his old family home, leaving Deneuve standing bewildered among the rubble, her brief dispossession contradicting the image cultivated in all her films as aloof and self-controlled. "Rabih, Rabih!", she calls. We know she is not in danger, because the film crew is present, but the moment generates a tweak of tender alarm. He quickly returns, also shaken, having been unable to identify the house. It feels as though the intimacy that has begun to develop within Mroué's car has been broken prematurely, like an undercooked egg, and neither party feels solid enough to stand alone.

Deneuve's slumber in the car is perhaps her greatest gift to Lebanon. Sleep, writes Haytham al-Wardany, is the necessary acceptance of disaster as a precursor to recovery. After a disaster, a new start "is not generated by managing the disaster or ameliorating its impact but rather by acceptance, of permitting the collapse it occasions to run its full course. And this is sleep's function, to take us to the very bottom, without touching which we are unable to rise back up to the surface. Sleep . . . is the labour pains that come

at the moment of the struggle's transformation."[38] Sleeping trustfully in the safe space of the car, Deneuve creates a space for the disaster of the war to play itself out without being prematurely captured in earnest witnessing and brave words. She is sleeping, in a way, on behalf of Lebanon. The car-monad becomes a mobile alchemical experiment in friendship, a soul-assemblage that generates energy for future action.

Je veux voir premiered in Lebanon in September 2008 after a warm reception at Cannes and elsewhere. The next day the papers were full of negative reviews, and the filmmakers were roundly denounced. Lebanese critics were irritated that the film could not be aligned with a political program. They were angry that Deneuve does not express horror at the destruction she witnesses, so that she could be a more effective ambassador for Lebanon, and particularly offended that she sleeps during the drive. They insinuated collaboration with both Israel and Hizbollah.[39] "People reacted to the fact that the film resisted appropriation: none of the multiple parties could take it to their side. So they were very angry at us," Hadjithomas writes.[40]

In the lurching dynamic between the moment people are creative and the moment their creativity is recognized and seized upon, many movies become muffled, deformed, and forced to represent. The severest critique of representation seems always to come from local audiences trying to anticipate (often quite astutely) how Western audiences will interpret the works. As Samir Kassir writes, "When you are thrown off course by the Other's gaze, or by the comparison to the Other, self-awareness is not a great help. The Arab sense of self has become so undermined that the slightest thing is enough to distort it."[41]

Hadjithomas and Joreige appeal not to truth but to the powers of the false. The desire for truth in Lebanon can never be satisfied, partly because of that ricocheting of gazes whereby every event is judged according to how it will appear in the eyes of others, that is, of the West. *Je veux voir* refuses to affirm a truth, such as "Hizbollah heroically defended Lebanon during the July War," or "Innocent Lebanese suffered because Hizbollah dragged Lebanon into a war with Israel," or even a truth that nobody can doubt, "The Lebanese people suffered terribly as a result of this war." Instead, the film concocts a new reality, potentially more powerful than truth, in the laboratory where fiction reacts with reportage.

In this experiment, things happen that could not occur in either fiction or documentary. When the two performers and the film crew reach the frontier

FIGURE 6.5.

between Lebanon and Israel, they are prevented by Lebanese, Hizbollah, UN, and Israeli authorities from filming. Then they spot a little road in the narrow unclaimed area between the two borders. The filmmakers emphasize that it was because of the French movie star (who graciously poses for a photo with the UN peacekeepers) that they were granted permission to place their tripod and film Mroué and Deneuve walking down this little road toward the border with Israel.[42] As journalists they could not have filmed it, but the spirit of cinema permitted a walk in no-man's-land.

Upon returning to Beirut, Deneuve is sucked back in to the VIP world, attending a gala dinner organized by the French Embassy. "We do this to show our support to the Lebanese," the ambassador tells her rather pompously. Deneuve takes to the role of celebrated guest of honor with the same dignified reserve she showed during most of the road trip, suggesting that she has had a great deal of practice "playing" Catherine Deneuve. But when (in an ambiguous eyeline match) she sees Mroué across the room, her dark eyes glimmer with tears.

As Deneuve told Jim Quilty, film journalist for the Lebanese *Daily Star*, "This film is being seen through me, but Joana and Khalil are making the film. So it's their eye. I'm their eye. . . . It's just my character to be used this

way for this project. I suppose it's in my nature. I've always viewed actors as instruments, you know. And more than ever I accept to be this instrument."[43] The great actor avows that she is a crystal-image, lending her character to the undecidability between virtual and actual—both of which expand as Mroué's little car tootles along the Lebanese roads.

Fabulation Begins at Home

Fabulation begins at home, in Glissant's observation that the wandering thinker commences to unfold the entire world by "[plunging] into the opacities of that part of the world to which he has access."[44] Like all folding, fabulation occurs from a point of view. Certainly the people (and other beings) best capable of a large-scale fabulation are those whose presence is most diminished by dominant folds, as in the Indigenous futurist, Afrofuturist, and counter-imperial works I have mentioned. The most expansive fabulations are attempted, and sometimes achieved, by the people who have the least to lose in this world and the most to gain in another. But as I suggested, it is not appropriate to demand of those who are most oppressed that they fabulate a world for the rest of us. Everyone can start unfolding differently from the point of view they inhabit, for from every point of view there are singularities to be discovered and nurtured.

To create *La Maison du bonheur* (Canada, 2020), Sofia Bohdanowicz packed thirty rolls of 16mm film and traveled to Paris to spend a month with Juliane Sellam, the seventy-seven-year-old mother of a friend, who lives in a third-floor apartment in a fine old building in Montmartre. A widow of some means and a working astrologer, Juliane welcomes Sofia warmly. Her balconies are abloom with geraniums, roses, and hydrangeas. In the mornings when she waters them, a drift of petals pools on the pavement below. Juliane's flutelike voice always seems to have a smile in it. "Flowers require a lot of patience, just like men!"

It seems Juliane's life is constructed around cultivating and sharing beauty and pleasure. In the recordings that accompany the images, she avows to Sofia that she chooses to divulge no dark part of her life, only the good things that she wishes to share. Proud never to have had a facelift, as we hear her tell Sofia, Juliane applies face cream and makeup with care. "It's nice to show the world a cheerful face." She delights in getting a pedicure. For thirty years she has been getting her hair done at Manouk's, who she praises warmly for his kindness, sociability, and good humor despite his difficulties, adding "It's very rare to find people like that." While we see Juliane admiring her fresh

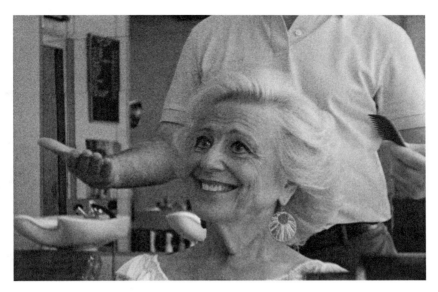

FIGURE 6.6. Still, Sofia Bohdanowicz, *La Maison du bonheur* (Canada, 2020)

blonde coif in the salon mirror, she describes the social atmosphere at the salon, which we understand her presence has cultivated. The other ladies like to come when she is there, somebody brings a cake they made, they drink coffee and chat. "At Manouk's you enter hideous and leave looking like a star!"

The knowledgeable enjoyment of cooking and eating is central to the film. Juliane bakes two loaves of challah bread, explaining how she gauges the suppleness of the dough. At dinner with her sister and brother-in-law, the conversation focuses on the subtle distinctions between the four patés they are eating. One evening when Sofia returns to the flat, Juliane is away, but she has left Sofia *un petit café* and a little heap of beignets. This act of kindness tenderizes my heart.

At one point Sofia confides, her voice hovering over black leader, that six days into her Paris trip, she still hadn't tasted a pastry that was really delicious. So she bought an éclair with great expectation; but it was another disappointment. Juliane, she says, seems to have heard her recording this, for the next day she sets it right, taking Sofia to a proper patisserie. The camera then captures not Sofia's enjoyment but Juliane's, from several angles and in real time, as sitting at the waxcloth-covered kitchen table she slowly, deliberately delectates the pastry from a pretty china plate.

Toward the end of the film, on a drab afternoon, Sofia takes the long train trip to Deauville and studies the mute architecture of her old high school. Rain begins to fall on the pitted concrete. She waits in a bus shelter. "I didn't feel like being there anymore." She seems to have no happy memories of this period, and we sense that Sofia is not yet a resident of *La maison du bonheur*, the house of happiness.

At the film's deepest point, Juliane bakes Sofia a birthday cake, her efficient gestures suggesting an athlete's seasoned skill. As she separates the eggs, and whips the egg whites in the electric mixer, turning the bowl upside down to determine the meringue's stiffness, and expertly folds it into the blended wet ingredients, we hear her explaining her young visitor's astrological chart. "It was amusing to hear you talk about yourself, because in fact you don't know yourself. No one really knows themselves." Sofia assents with a little groan. "You are astonishingly sensitive," Juliane pursues. "Your vice is that you think too much." And, as a result of Pluto in her ascending sign, she is too hard on herself. But, she reassures Sofia, she can rely on her honesty and her strong intuition. The cake rises perfectly, and as the camera examines its rough golden surface, Juliane's hands cuts it into rough, fragrant slices. Sofia has received the gift of how to overcome the uncertainty she feels and come into her own being—just as, one feels, practice makes the perfect cake.

When I first saw *La Maison du bonheur*, I was transported with delight. I left the theater on wingèd feet, smiling at everybody. But soon habits of thought of judgment and guilt made me question my response. What a silly, lightweight story of a privileged Parisian lady, all flowers and pastries! Moral justifications came to mind. In terms of the politics of representation, the film smacks down clichés of elderly women as lonely, bitter, and invisible. Furthermore, Juliane is Jewish, a descendant of survivors enjoying a deserved *douceur de vivre*. A little more satisfyingly came a structural justification. These moments from the weeks of Sofia's visit are captured on the few film rolls—the colors of the soft grain and the occasional lens flare attest to their materiality—imposing a rigorous limit on this movie of gentle enjoyments. The shooting ratio of 1.5 to 1 ensures that what we witness is very close to what Bohdanowicz chose to record: they attest to the rarity of these moments of unfolding.

Yet ultimately, I needed to jettison "the model of truth which penetrates" reality,[45] killing it with joyless justifications. Gradually I recognized what seems to be a gentle fabulation unfolding in flower petals and kind ges-

tures. The boundless, unquestioning hospitality of Juliane models not love but kindness; not Derrida's power-infected hospitality but a mentorship in how to take a shared pleasure in the world and, so doing, to become more grounded, more complete, and more capable of combining healthily with others, be they pastries or high-school bullies. To give beauty and pleasure to others, one must know how to receive them oneself. Juliane seems like the point of a fold from a kinder world, pulled out by the film into the pliable sheet of a good life. A bourgeoise bodhisattva, she teaches Sofia, and us in the audience, to individuate in a more beautiful way.

As Grosz brilliantly demonstrates, individuation arises from experimentation for the sake of beauty and pleasure. This is according to Darwin's category of sexual selection, which has been much less remarked than natural selection.[46] Picking up Bergson's point in *Creative Evolution* that we humans inherit all the creative solutions of other creatures from whom we differentiated at some point in evolution, Grosz rereads Darwin to argue that survival be construed in the broadest sense possible.[47] Where natural selection would seem to postpone pleasure until after the fittest have survived and settled down to procreate, sexual selection promotes the fascination and delight that lead to procreation in the first place. Among our animal and vegetal cousins, the desire to seduce gives rise to all kinds of genetic inventiveness and experimentation, engendering beauty that is useless from the point of view of natural selection but essential for sexual selection.[48] The mature male stickleback fish becomes "beautiful beyond description" during mating season, Darwin writes: colorful, translucent, and iridescent.[49] The bowerbird gathers colorful objects to decorate a stage for its courtship dance. To attract pollinators, flowers color their petals yellow and rose and emit entrancing scents.

Once we understand that evolution arises not only from natural selection but also from sexual selection, a universe of necessary beauty, seduction, and pleasure unfolds for us. Juliane's cultivation of beauty, easily despised as frivolous from the masculinist point of view of natural selection, is just the kind of individuation nature favors for us organic beings.

Fabulation begins at home. The intensification of enjoyment hones our instruments of perceiving and feeling, aspiring to a Leibnizian perfectibility of the soul. It increases our Spinozan power to be affected so that we can enter into soul-assemblage with others.

Feeling Fabulation

Apichatpong Weerasethakul is beloved as a filmmaker of fabulation, unfolding legendary monsters into contemporary Thai life. *Mysterious Object at Noon* (Thailand, 2015) brings together the road-trip genre and the Surrealist game of exquisite corpse to provoke fabulation from the film's collective subject. Apichatpong and his crew travel through Thailand's Isaan region, inviting the people they encounter to contribute a piece of a story that connects to the end of the previous one. As in the Surrealist game, fantasies and seeming silliness divert the story in unanticipated directions.

David Teh explains the weight of this connective performance. The people of this region have been historically marginalized in Thailand, caught between Khmer, Lao, and Siamese powers. The Thai language was imposed on Lao workers who resettled there. In the 1960s the state brutally repressed a Communist insurgency. Isaan people retain animistic folk culture despite official Thai Buddhism.[50] It would do violence to attempt to represent people from this region "objectively" or, worse, to ask them to tell their authentic stories in order to more properly represent them. Instead, the filmmakers' unserious prompts elicit playful tales, which they weave into light audiovisual refrains. Linking the storytellers with traveling shots from the filmmakers' car or from trains, the film establishes a lilting momentum.

The film crew encounters a woman selling fish from a truck, who unprompted tells them the terrible story that her father sold her when she was a child. Apichatpong interrupts her tears and asks her to tell them something else. "It can be real or fiction." Perhaps shocked out of the groove of grief she has carved for herself, the woman initiates the story of Dogfahr, the teacher of a paraplegic child in a wheelchair, who, she emphasizes, loves the child very much. Subsequent storytellers adopt a stranger direction. When Dogfahr stands to go to the toilet, the boy notices something falling out of her skirt. An older woman standing at the door of her cottage determines that the mysterious object fell from the heavens and transformed into a child; it was star shaped.

Each new twist of the tale fulfils some wish on behalf of the tellers. In the most elaborate scene, a group of traditional Thai musicians and performers enact the next steps of the story. Two performers in identical costumes play the real and the fake Dogfahr that previous storytellers have established. The fake one enunciates her evil intentions. "I was just studying quietly, suddenly there were two teachers," the boy says, a bike cart standing in for the wheelchair. The other performers urgently crowd around him and urge him to choose the correct Dogfahr. He does, and they gleefully drive the other

one away. Later, two girls continue the story in sign language, smiling at each other encouragingly. As they relate that a man took Dogfahr and the boys to perform in a bar, the film cuts to documentary shots of singers in glittery gowns and pole dancers. "She sang and danced beautifully. He brought her flowers to comfort her."

At one point Dogfahr and a neighbor have apparently kidnapped the two boys and are trying to sell them in Bangkok. Approaching a man washing dishes, the neighbor proposes to give him a boy for free. The man sends him away. As he wanders out of the spacious, light-filled scene and a woman wanders in, we hear a fictional radio interruption declaring the end of the Asia-Pacific War. The government has declared laws that the Thai people must honor the Americans, buy American products, and send their youngsters to the US for their education, and nightclubs must give American men a 25 percent discount. A nationalistic song plays: "The people, no matter where they come from, are united in respect for each other."

Here is a hint of the national and geopolitical folds that *Mysterious Object* hopes to wrinkle with this rangy collective fable, to displace it not with another tale but with the enjoyment of storytelling: the nervous excitement as a new segment is improvised, the participants watching and listening carefully as their friends step into the unknown. Toni Pape notes the sense of "aimless joy" that holds the film together, writing that it is a "series of affirmative acts of "yes and," "each of which brings out the joyful suspense of the relay."[51] But there is too the sense of a steamy telenovela in the plot twists of jealousy and murder, and of science fiction with this boy who falls to earth. Near the end a group of schoolchildren bring the story to a spectacular crash ending packed with tigers, swords, and aliens, and immediately commence a new story. Documentary, fiction, and archival footage refract one another, germinating crystals in which the fabulated stories take shape. As Deleuze notes, most movies ensure that the camera's point of view is objective, the characters' point of view subjective. Objectivity is on the side of the camera, reinforcing a given regime of truth and its judgments. But in what Pier Paolo Pasolini terms *free indirect discourse*, the camera itself takes a subjective viewpoint. *Mysterious Object at Noon* abolishes objective space. The characters are emprismed in the crystalline space of actuality and imagination, and, thanks to the archival footage, in a temporality that floats uncertainly. The film seems to delight in the possibilities latent in each of these, even those that do not spill into the story, such as a quite long scene on a crowded train in which a couple dispute at length because he forgot to pack her eyedrops. Could they be performing too?

FIGURE 6.7. Still, Apichatpong Weerasethakul, *Mysterious Object at Noon* (Thailand, 2015)

An atmosphere of play nurtures the film to its final shot. Three little children are squatting in the yard playing with a metal car. When their mother calls them in for lunch, they tie the car to the dog's leash and laugh as it runs, trailing the clattering toy, scaring the chickens.

The feeling of fabulation in *Mysterious Object at Noon* is, for some of the real characters and for me, a woozy, rubber-kneed sense of liberation. It's like stepping out of a cave into the light, the dazzlement of possibility.

Some fabulations take shape in the viewer's body with especial insistence. Ramallah-based artists Basel Abbas and Ruanne Abou Rahme's video and sound installation *Only the Beloved Keeps Our Secrets* (Palestine, 2018) draws from an archive of Palestinian found images that pile upon one another, each partly obscuring the last, so that events appear not as reportage but as legends. The images' poor quality invites us to cherish them even more: soft videos of women and men dancing in the spiral of the *dabke*; an exultant sea of raised hands clapping at a nighttime rally. This archive might be a compost heap, so much are the images cradled by plant life: fields and close-ups of grasses, thistles, and golden flowers twitching in the breeze, as though the living land itself enfolds the joyous and terrible events the work witnesses. In the foreground of one shot pink blooms bob in a garden; in the background, the horrible proboscis of a demolition tractor is destroying a two-story con-

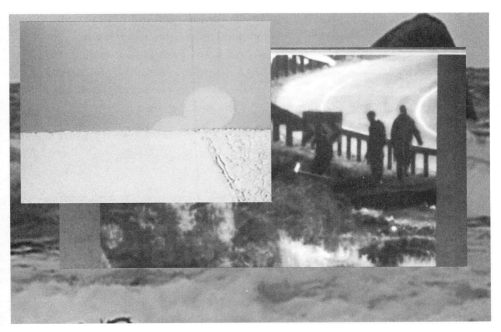

FIGURE 6.8. Still, Basel Abbas and Ruanne Abou Rahme, *Only the Beloved Keeps Our Secrets* (Palestine, 2018)

crete house. "SEND MY LOVE / TO THE LAND / THAT RAISED ME," a text commands. The beloved that keeps our secrets is the land itself. Shots of the moon and the setting sun suggest that the earthly longing for justice for Palestinians is witnessed by the heavenly bodies.

Darker footage from an Israeli surveillance camera explains why wild plants frame *Only the Beloved*. A youth walks off the road into a field. Israeli soldiers follow him off camera, and shortly later return, carrying his limp dead body. This youth was Yusuf Shawamreh, who stepped through the Israeli separation wall crossing his family's land on March 19, 2014, to gather *akub*, a spiny-leaved plant that Palestinians harvest in its brief flowering period to cook as a delicacy.[52]

Like the images but more insistently, the work's sounds and layered images inspire alert perception without resolving into meaning. Deep rolling bass, high piercing tones, scraping and scratching activate listening responsiveness, pushed into your viscera by the subwoofer. Palpable sound and rhythm demand that the audience witness. Bypassing documentation, *Only the Beloved Keeps Our Secrets* links bodily feelings of intensity with human

collectives—the dancers, the protesting crowds—and more distant powers. Refusing to be captured in geopolitical truth claims about Palestine, the work enacts a great refusal, leaping instead to an emergent form of existence. Abbas and Abou Rahme are fabulating a longed-for Palestine to come. Feeling the act of fabulation, viewers may take this heightened capacity into their bodies, form a soul-assemblage with it and partake in actions that will increase its reality.

Fabulation and the Great Refusal

Fabulation can unfold something so deeply enfolded that common wisdom holds that it does not exist. This is the great refusal we encountered at the end of chapter 2, in which the soul-assemblage ignores local data of experience, departs from its habitual path, and instead draws out the deepest folds of all. Fabulation may unfold incompossible points from different cosmoi, where, as we saw, monads that in one cosmos are squashed, miserable, and damned can in another cosmos expand their amplitudes and thrive. Similarly, what appeared to be evil, in Whitehead's term—the point that has no company on the present fold—turns out to belong to an enfolded crowd. The evil and the damned, then, are peaks of subcosmic folds, monads that link to other places and times. Fabulation embraces the evil and the damned, anomalies on the hostile planes where they appear, as peaks of generous folds elsewhere.

With elegance and rhythm, fabulation grasps those damned points and follows along their folds. It becomes a collective act, by necessity, because you'll be forming a soul-assemblage with the erstwhile evil monad and its company. The luckiest fabulation draws on the most unlikely sources and yet has the power to sustain itself and to crystallize further unfoldings. In the great refusal, an entity rejects its local circumstances in favor of remotely distant possibilities. Focusing its becoming on them is risky and almost doomed to fail. "But the advance, when it does arrive," Whitehead writes, "will be richer in content, more fully conditioned, and more stable."[53] The great leap, the apparently unsustainable "break," makes contact with a reality that is more true than the present actuality. The waywardness that Hartman advocates is such a great refusal: "Waywardness is the refusal to be governed. It is the next phase of the general strike, the flight from the plantation and refusal of slavery and the demeaning conditions of work, this time it happens in the slum. It is a social experiment and an effort to elaborate new forms of existence."[54]

Hartman's tactic of waywardness makes a bold rejoinder to Kassir's gloomy diagnosis of powerlessness. Her statement points to the fact that fab-

ulation entails not only drawing out deeply enfolded regions but pushing in the most stultifying of dominant folds. Elaborating new forms of existence: this is fabulation, pulling together energies to make a great leap over current patterns of power. Fabulation grasps as real an image that is not of this world, pulling out the most distant, most unlikely fold.

Questions of truthful representation imply a binary relationship between an image and a historical event that preceded it and that it represents. The image is always judged to be inferior to the event it depicts, for it leaves out nuances, it sees the event from a particular angle ("bias"), and so forth.[55] This suspicion of images, the legacy of Plato, shows up all through the history of Western thought, writ broadly: in Byzantine, conservative Islamic, and Protestant iconoclasm and in the twentieth-century culture of media critique. The Platonic legacy grips us tightly still.

I conclude this chapter by shifting the question of whether or not images are truthful away from the Platonic legacy and a little farther to the east. Thinking beyond dualistic epistemologies that consider the relationships between matter and mind, or sensible and intelligible worlds, thinkers in the eastern Islamic world and the Sufi intellectual tradition include a third realm, the imaginal. Perceptible but intangible, more real than material reality, the imaginal is an intermediate realm between the sensible and the intelligible, between physical reality and rational thought. I propose that the concept of the imaginal realm releases artists from the pressure to represent. It creates a healthy environment for image-making, and for images that are not demanded to represent the truth. The concept of the imaginal realm develops ways to unfold the unthinkable, what has been put outside of language.[56] No image can comprehend the virtual or the infinite, but the imaginal relates to the virtual and the infinite asymptotically, expressing some sense of them in images and sounds. Thus, incomprehension does not obviate images but multiplies them, as in the beautiful refractive images we have encountered in this chapter: not reflections of reality but images snatched from imagination and made real.[57]

7

MONAD, DATABASE, REMIX

Manners of Unfolding in The Last Angel of History

There's something enduringly seductive, thrilling, enigmatic about John Akomfrah and Black Audio Film Collective's *The Last Angel of History* (UK, 1996). Dimly felt ideas take form. Images flash over your retinas too quickly to grasp mentally, so you feel them: in goose bumps, in fixed attention. You feel your capacities enlarge. Maybe you feel afraid, for things you thought you knew are coming undone. It's tempting to try to master this smart movie by being just as smart as it is—to use a couple of recurring characters from Parliament Funkadelic, by being the Sir Nose D'void of Funk to the film's Star Child. But I found that briefly renouncing the academic Sir Nose approach so as to pay attention to the feeling of my hairs standing on end alerted me to the moments when *Last Angel* was performing something particularly deft. These performances constitute *The Last Angel of History*'s manners of unfolding.

This chapter accounts for some of *Last Angel*'s manners of unfolding: methods and skills of both the artifact (here, the movie) and the recipient (the viewer) that actualize virtual and latent events as knowledge. I move from the lightest to the largest acts of unfolding: unfolding with the body;

unfolding urgently from layers of ruin; refraining from unfolding, out of respect for what is enfolded; unfolding not from images but from information; unfolding from monads, as montage reveals the folds that connect them; a Foucauldian counterdiscursive unfolding. Facing the devastating loss of African knowledge in the diaspora, *Last Angel* invents even more manners of unfolding, including remix and fabulation.

The movie is one of the first documents of the artistic and intellectual movements of Afrofuturism, in which Black musicians, writers, and artists argue that since the great rupture of the Middle Passage, African diaspora people have been doing science fiction.[1] People who have lived the legacy of slavery are time travelers. As Greg Tate, Ishmael Reed, Kodwo Eshun, and numerous others argue in the film, ever since Africans were kidnapped, forced onto slave-ship holds and plantations, and forbidden to use their languages, their descendants have survived and created in this alienated, dislocated state. They have done so by assembling futures from fragments of the past, preferring to disdain the present that accords them less than human status or, at best, offers "inclusion" in a humanity not of their design, and using technology and art to invent when historical research fails to yield anything useful.

Akomfrah and Edward George picked up on critic John Corbett's observation of the uncanny similarity between Sun Ra, Lee Scratch Perry, and George Clinton, African-diaspora masters respectively in jazz, reggae, and funk: all of whom, while unaware of one another's practices, deploy the captivating discovery that they came to Earth from another planet on a spaceship.[2] As Clinton says in the film, "Space for Black people is not something new. I really believe we've been there, we're returning to there, and the consciousness of Black people, of all mankind, is striving to return. Whether somebody gave us our intellect genetically by cloning, or that we're descended from the stars." Hieroglyphs, diagrams of insects, and an ultrasound of mysterious tissue accompany his words, skimming the field of vision a bit too fast to scry.

Black science fiction invents manners of unfolding—that is, forms of historiography that would make sense of perceptible artifacts. One manner of unfolding that *Last Angel* decisively abandons is a belief that the present arises continuously from the past and that the past is fully available—a luxurious falsehood that some people who occupy global positions of power still indulge, and an ideology that lulls dominated people, too. Instead, African-diaspora science fiction unpacks fragmentary artifacts that indicate a buried past, fabulating history by modeling it on imaginations of the future. It mourns pasts that can never be recollected and incorporates unknowns when facts do not serve. *The Last Angel of History* is thrilling not only because of the

Afrofuturist topic but also because the artists of Black Audio Film Collective have devised manners of unfolding that match its driven creative energy. A scintillating essay by George explores the interweaving of philosophy, historical research, and embodiment that shaped the film.[3] George performs the film's errant guiding figure, a Glissantian wanderer called the Data Thief.

Unfolding New Embodiments

The contagious rhythms and enveloping bass tones of the Black techno musics featured in George's soundtrack for *Last Angel* make their arguments by making you dance. They demand that your body discover new feelings to go with the new sounds. Derrick May's juicy bleeps and wasplike synth snares make me vibrate in blissful forgetfulness. Juan Atkins's crystalline, satiny chords expand me while his micropercussions introduce shocks, as though pointing out joints in my body I never knew I possessed. This embodied antinaturalism is what Alexander Weheliye values in Black phonography: the inextricability of sound and writing in recorded music.[4] Eshun describes the way breakbeat music redesigns the body through "impacts at levels barely explicable in the normal languages of sensation," with sounds that create intensities that are received not by the mind but by the nervous system, the "brain distributed across the entire surface of the body."[5] This of course is a shout-out to Deleuze's concept of the Figural, an emergent image that does not draw on preexisting knowledge but makes the body anew, through rhythm.[6] Parliament's greasy funk, the elastic reggae grooves of Perry, Burning Spear, and others, John Coltrane and Alice Coltrane's Artaudian embodiments, and Sun Ra's voyages from body to cosmos too are among *Last Angel's* musics that invert and reshape your body.

In the 1970s, disco replaced the soulful sounds of R&B and the self-righteous transcendentalism of prog-rock music with mechanical beats. As Richard Dyer wrote in 1979, rock used percussion in a thrusting, phallic way, while disco released rhythms that caressed the whole body into dancing. In 1978 in Mississauga, the grungy jewel of Canada's multiculturalism policy in that era, my nerdy adolescent self, up to then troubled that I just wasn't serious enough to appreciate rock music, felt liberated moving to the easy, seductive, mechanical beats of disco and Parliament's booty-bending "Aquaboogie" and doing Chic's Le Freak in a multihuman snake around the darkened high school cafeteria.

Transcendence offered a good solution to people who didn't want to dance, or felt they couldn't dance or shouldn't dance, like Funkadelic's Sir

Nose, who wails, "Aw, I can't dance, don't make me dance," only later to moan "Oh it feels good, oh it feels good!"[7] Disco abandoned transcendence. Dyer puts a novel spin on the shallow glamour of disco that somehow condemned it as more commercial than "serious" rock: "Disco's celebration of materiality is only a celebration of the world we are necessarily and always immersed in—and disco's materiality, in technological modernity, is resolutely historical and cultural—it can never be, as most art claims for itself, an 'emanation' outside of history and of human production."[8] If enjoying disco entailed a fall from grace in relation to the masculine transcendentalism of rock music, that fall grounded my teenage boogying body in the immanent erotics of class-precarious, immigrant-led, style-hyperconscious high school life.

Later, Detroit techno in its turn abandoned God, soulfulness, and "keeping it real." "Techno . . . says nothing to the Lord, but speaks volumes on the dance floor," Stuart Cosgrove noted in 1988. "Derrick May's revolutionary backtracking on the Technics decks and Santonio's Yamaha drums are stripped of any sense of emotion: they just percuss you out."[9] So from the start, though *Last Angel* has serious arguments to make, it catches a viewer out with new vibrations, new embodiments. These musics have since spawned generations of dancers who understand from the inside out how to make themselves new bodies with new organs.

Unfolding from Ruins

The Last Angel of History is composed around ruins and palimpsests. These qualities indicate another manner of unfolding: a view that history is almost entirely lost to us, unless one can seize on the briefest of clues as they flash in the rubble. As I noted in chapters 2 and 3, this manner of unfolding requires that the unfolder distinguish singular points from ordinary points and demands the enigmatic action that Perniola describes.[10] One of the first things you notice about the film—from the first shots of the Data Thief surveying a flooded landscape—is that it is composed around ruins. This scene of devastation returns several times: some shacks and a mobile home all knee-deep in water, abandoned, in an image saturated with an eerie bronze light.[11] The other scene of ruin is Detroit, once-grand buildings empty and painted with graffiti. The Data Thief explores these ruins in search of clues, the voice-over (also George's) tells us. Sometimes the Data Thief carries a dowser, an instrument of cosmic montage that pulls signals from the earth. The film takes up the motif of the ruin by creating ruined images: palimpsests layered so that parts of each layer are revealed, parts obscured. Striking among these layers

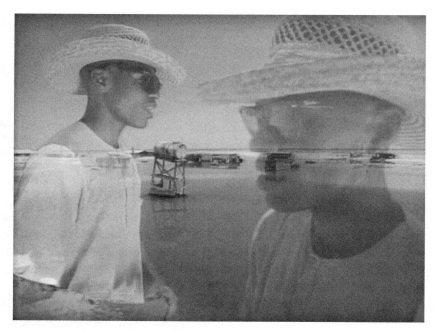

FIGURE 7.1. Still, John Akomfrah, *The Last Angel of History* (UK, 1996)

is an image roughly in the shape of the African continent that appears to be a large piece of rust.

In this introduction the Data Thief (never facing the camera but presenting in profile, which preserves the impression that he is of another space-time from the places he visits) relates the story of musician Robert Johnson, who sold his soul to the devil at a crossroads in exchange for a "secret technology": the blues. We receive the first clue that the characters in this movie are time travelers and that time does not stretch forward and backward smoothly but is fractured and discontinuous and folds up to permit certain characters to travel in time. The Data Thief says: "Rumour has it that before Robert Johnson made his deal with the devil at the crossroads, he couldn't play to save his life. He sold his soul, in return he got the secret. Our thief from the future gives up the right to belong in his time—in order to come to our time, to find the Mothership connection. The thief becomes an angel— an angel of history."

The filmmakers evoke Walter Benjamin's heartbreaking meditation, from "Theses on the Philosophy of History," on Paul Klee's *Angelus Novus* (1920), a big-headed, snaggle-toothed angel rendered in Klee's scratchy line with

many curlicues, its useless wings rising like surprised hands. Benjamin pro-
poses that this angel is powerless to intercede and can only be blown back-
ward into the future, farther away from Paradise. "Where we perceive a
chain of events, he sees one single catastrophe which keeps piling wreckage
and hurls it in front of his feet."[12] Here is a manner of unfolding, crushing
to contemplate, that says history constitutes no progress but only devasta-
tion. Benjamin kills any Hegelian virus that still infects Marx's historical
materialism, to which the theses elsewhere devote themselves. The im-
mobilized angel recognizes that human "progress" consists of catastrophe.
That is the correct perspective on the mass-scale abduction, enslavement,
murder, and knowledge theft by Euro-Americans of African peoples in
order to capitalize on growing global markets for sugar, cotton, tobacco,
coffee, and indigo.

Benjamin's well-known sixth thesis states, in part: "To articulate the past
historically does not mean to recognize it 'the way it really was' (Ranke). It
means to seize hold of a memory as it flashes up at a moment of danger."
This oft-quoted invocation continues, less familiarly, to state that both the
content of tradition and the people who receive it are in danger of becoming
tools of conformism and of the ruling class. "Only that historian will have the
gift of fanning the spark of hope in the past who is firmly convinced that *even
the dead* will not be safe from the enemy if he wins. And this enemy has not
ceased to be victorious" (Benjamin's emphasis).[13] Mining the past for flashes
is a fraught and essential exercise. The past might not be rediscovered at all.
Or, Benjamin warns, it might be homogenized into a dominant narrative of
history that serves the ruling class—a dominant fold. This warning remains
entirely relevant and is echoed in Toufic's diagnosis that culture is withdrawn
from colonized peoples after a surpassing disaster, while the colonizers can
continue to enrich themselves with that culture, unaware that it is a zombie.
Deftness, surprise, *festina lente*, and the ability not just to reveal but also to
conceal their findings will be crucial if Akomfrah and his colleagues are to
enact a Black science fiction that refuses to be incorporated into any trium-
phalist or otherwise linear narrative.

Refusing to Unfold

Given the concerted effort of slavers in the United States to eradicate the
culture of enslaved Africans, to hope for some kind of African communal
memory seems like a desecration of the dead. As Samuel Delany, who is in-
terviewed in *Last Angel*, writes:

Every effort conceivable was made to destroy all vestiges of what might endure as African social consciousness. When, indeed, we say that this country was founded on slavery, we must remember that we mean, specifically, that it was founded on the systematic, conscientious, and massive destruction of cultural remnants. That some musical rhythms have endured, that certain religious attitudes and structures seem to have persisted, is quite astonishing, when you study the efforts of the white, slave-importing machinery to wipe them out.[14]

Aniconism, or the avoidance of figurative image-making, is yet another manner of unfolding that operates in *Last Angel of History*: a strategy of denying images (and sounds) altogether, causing them to remain entirely enfolded. Aniconism protects what it hides, as an oyster shell does a pearl. It seems in many ways to be the most appropriate response both to the lost knowledges of descendants of Africans and to the drawn-out calamity of slavery that precipitated the loss. To try to soothe the wound with holistic fictions, according to aniconic thinking, would do violence all over again. *The Last Angel of History* makes wounds, that is for sure. A question for the aniconic strategies of *The Last Angel of History* is: Do the wounds make a place where knowledge might enter later? Has the Data Thief come from the future to wound African-diaspora peoples so that he can graft their lost knowledge back into them? Are these unseeable images compressed like pills, to expand only after they are ingested? To protect them, meanwhile, from merely curious eyes? Aniconism is at work in this as in many of BAFC's films: refusing to show the image, concealing it as though in a deep fold that the film stretches open for 1/24 of a second.

An ontological kind of question arises: Are these images concealed inside folds, as I just suggested, or by fissures? These sound like metaphors but they yield different ways of thinking about history, different manners of enfoldment. A folded universe, like that described by Leibniz, is fundamentally connected, and someone with perfect knowledge—a God—would be able to unfold it all and see how each part connects to every other. In such a universe there are not disconnected fragments but peaks of folds. But a fissured universe, or more rightly a fissured history of the world, like that described by Foucault, sees earthquakes, the formation of sedimentary layers, tsunamis of destruction that utterly bury and disconnect its parts. In this kind of universe, the fragment surfaces, if it ever does, quite alone.

This second ontology seems to more properly describe the universe the Data Thief travels in and explains his necessity. While this book maintains

FIGURE 7.2.

the Leibnizian position regarding fundamental continuity, that doesn't contradict the fact that fragments rarely get reconnected to the plane where they make sense. Only a hard-working time traveler might be able to fit the parts together.

Speaking of aniconism, this is a good point to mention that many of the musicians the film presents as protagonists of Afrofuturism interviewed in the film are hard to see. Black Audio's characteristic stylized framing and lighting for interviews sculpt the speakers in chiaroscuro, giving them authority and beauty without exposing them. Atkins, majordomo of Detroit techno, looks a bit ill at ease. British jungle musician Goldie, framed at the right of the image, looks in that direction as if he'd like to flee. A Guy Called Gerald appears rather forlorn—though he patiently explains, in a cross-cut to an annoyed May, the origin of the term "jungle" (figure 7.2). A smiling Keith Tucker does a cartwheel on a Detroit lawn and literally vanishes. Their enfoldedness suggests that electronic musicians much prefer to be known through their sounds.

In the generations since *Last Angel* introduced these aniconic strategies, new tendencies of figuration have begun to animate African-diasporic art and cinema (as we see in the next chapter).[15] These richly peopled works play with fabulation as much as with realistic unfolding of newly available Black histories.

Unfolding from a Database

The reason we cannot really see the images in *Last Angel*'s subliminal montages is that the film is not really showing us images: it is showing a database. The clicking sound we hear as the images flash by suggests a future researcher clicking through a mass of information that takes the shape of a database: an organized ruin. It is as though the Data Thief knows no history, neither the official version of progressive history nor the fractious alternatives, and so can only patiently scroll through the archive. The Data Thief is collecting *all* possibly relevant fragments into a vast database, of which we perceive only a very few entries. He begins to seem like a Benjaminian redeemer, armed with a megacomputer and, we can imagine, algorithms for sorting and extrapolation. Here *Last Angel*'s aniconism takes an additional significance. It doesn't show images, or "content," but the means for managing content: databases and algorithms. Thus, the images fold up and recede away into a database that, the film makes us hope, someone may be able to interpret. (Who and where is this tech-savvy redeemer? We can't count on the Data Thief to do everything.)

In this way *Last Angel* in 1996 expresses a truth of contemporary power that most cinema caught on to only later: namely, that power operates not by manipulating individuals and representations but by modulating them algorithmically.[16] BAFC was one of the first to reject the critique of representation at a time, the mid-1980s, when many minoritized filmmakers were enthusiastically and sometimes sophisticatedly elaborating it. Akomfrah points out that in the 1980s BAFC "did not have the luxury" to be hostile to identity politics.[17] Instead they developed a layered, fractured concept of identity that transformed the image into an archive (or database). BAFC knew that manipulating representation was an old power game, and for filmmakers of color to engage in it would be to waste in skirmishes energies needed for an imminent war. Now, in the light of revelations that governments and private companies in many countries use illegally obtained information about citizens, it is abundantly clear that power can do perfectly fine without "content." It only needs to track the metadata. Images in databases are usually only raw material for operations.

Eshun addresses this issue in his 2003 essay "Further Considerations on Afrofuturism": "In the colonial era of the early to middle twentieth century," he summarizes, "avant-gardists from Walter Benjamin to Frantz Fanon revolted in the name of the future against a power structure that relied on control and representation of the historical archive. Today, the situation is

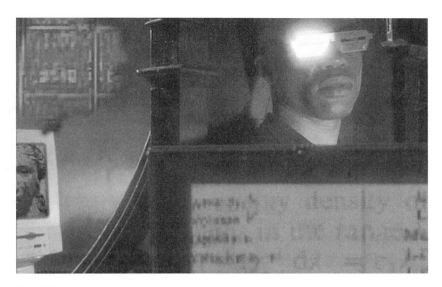

FIGURE 7.3.

reversed. The powerful employ futurists and draw power from the futures they endorse, thereby condemning the disempowered to live in the past."[18]

Those futurists shape the present quite literally. They are no longer employees either, as we saw in "The Information Fold," but megacomputers owned by financial investors, insurance companies, giant online stores, social-media networks, search engines, and intelligence agencies that, as reluctant futurist Lanier points out, calculate actions on behalf of their owners that reduce risks and increase wealth and influence.[19]

Nonetheless, if we accept that those entities that own the most powerful computers are going to win absolutely, that is, economically; that tricksterism and brilliant critique will not save the multitude (that is, the majority of people in the world who do not hold shares in those companies); and that—as Eshun points out and as African debts to China's Belt and Road program make clear—the futurologists have targeted Africa to suffer the most in the coming economic, medical, and environmental disasters, we can only fall into despair. "These powerful descriptions of the future demoralize us; they command us to bury our heads in our hands, to groan with sadness."[20]

In "The Information Fold," I mentioned some practical responses to the death-grip that information capitalism holds on the majority, such as true-cost accounting, breaking up monopolies, and regulating addictive content. The most radical strategy I proposed, after Glissant, Eglash, and Beller, is

nonextractive unfolding, an unfolding that lives on the surface of the infinite and cannot be translated into information capital.

Another, perhaps naive, strategy is to completely monetize the information economy, which would involve an unlikely strike. Databases and algorithms are products of human labor. Most of the contents of databases are scraped from unwitting human providers. And algorithms are trained on the unwitting behavior of consumers. People are getting wise to the theft that undergirds the sharing economy and the diminishing returns of the long-tail economy for artists and influencers. What if those humans who are not properly remunerated ceased to generate content? Profits would fall, and companies would need to find a way to pay unwitting content providers—software writers, composers, filmmakers, thumbs-uppers, tiny dancers, tweeters, people who pose unwittingly for security cameras, and so forth—every time their content is viewed, recirculated, or otherwise used.[21] This idealistic-sounding scheme to monetize the information economy, which Lanier proposes and which I find very appealing, will return later in this essay in the content of music remixing.

Eshun urges people to be smart about futurism. Science fiction is concerned with "engineering feedback between its preferred future and its becoming present" as much as the financial analysts are.[22] African and African-diaspora artists intervene in those smug futurisms by disturbing temporal linearities of progress, and also of inevitable decline.

Unfolding from Monads

Montage

Watching *Last Angel* in real time, the unseeable archival photographs sting, they startle, you feel them as a wound or a shock. Does this bodily response elicit embodied knowledge or some other communal memory?

The true picture of the past flits by. Memory flashes up at a moment of danger. If you don't catch those pictures deftly, you may lose them forever; and if you fail to catch them, the enemy will blend them into a bland, psychologizing homily or a mediocre pop tune. *Last Angel* draws inspiration from Sergei Eisenstein and from others who practice Eisensteinan montage, including Ousmane Sembène, who perfected the dialectical montage he had studied on scholarship at VGIK in Moscow. Eisenstein and Sembène did not trust cinema to produce truth even by observing the world long and patiently, but argued that it must *cut into* the observable world. These ideas inspire

the filmmakers to elicit those moments of flashing, where an unbidden artifact cuts into the present. That is montage, a skeptical manner of unfolding. Montage should produce contrasts—between shots, between image and sound, and within a shot—whose rhythm releases an energy that the spectator's body absorbs.[23]

Last Angel uses montage in two distinct ways. One is montage within the frame, especially in stationary shots that contain multiple contrasting images. These occur on the screens of the Data Thief's three boxy computers and in the slits of his sunglasses, a different image fleeting across each eye. In an interview with Kass Banning, Akomfrah defers Arthur Jafa Jr.'s suggestion that the essence of Black cinema resides in rhythm, or the cut, and posits that it may reside instead in the frame.[24] Montage within the frame holds contrasts together like the points of multiple folds, inviting the viewer to unfold the surface that they might constitute, even if these be points from incompossible worlds.[25]

The other is the recurrent strategy of a barely cognitive montage, in which worlds of images speed by too fast to comprehend. Watching *Last Angel* in real time, you don't see these sequences as much as feel them bypassing your brain to go straight to the nervous system, in intense streams that raise your energy a quantum. I experienced this nervous flow in viewings over numerous years, and began to distinguish some patterns. Then I finally used the pause button to try to scrutinize these sequences frame by frame, with limited success. Here are some of them:

The Data Thief instructs himself to find the crossroads where Robert Johnson sold his soul for the blues. Flashing on one of the computers: ancient religious deities? A multilimbed figure—Hindu? A wide-browed, naturalistic figure, possibly Persian or Armenian. An Egyptian relief carving. A phallus-headed entity. An African female figure. Another female figure, vulva dilated, giving birth. A winged creature cupping her breasts—Babylonian? (Note the uncomforting fecundity of these beings.) A big-eyed Greek-looking head. These give way to a rotating vortex that spins out into text (hard to read, but it looks like critical race theory). The Data Thief concludes this research with a clue—the phrase "Mothership Connection"—that leads him to George Clinton.

Later: the Data Thief is, as he says, "surfing the Internet of Black culture." Old photographs flit by, scanning views of each intercut with others. There's a poster advertising Beulah Poynter performing at Havlins Theater; a group of Asian women in uniform; Black sailors; four smiling Black soldiers, one on a bicycle; a group of Indigenous people posing outside a tent; some well-dressed

FIGURE 7.4.

people c. 1900 scrambling over the rubble of ruined buildings; a group of Black men taking a rest on the porch of a 1930s gas station, the white proprietor seeming to share a joke with them. There occur the figure of an eagle, composed, it seems, of hundreds of people standing in formation—a ceremony for Kwame Nkrumah?; Richard Nixon, gesturing palms down; a teeming Klan rally. There are funeral wreaths. Plump-cheeked women wearing babushkas. Black soldiers carry a missile inscribed with some message to Adolf Hitler. A Black man holding his child, who is pointing with fascination at something off-frame. White soldiers in fancy uniforms doing acrobatics. Dozens of oil wells. From the 1940s, six pretty Black women, all lipstick and gams. Schoolchildren at their desks. This is no stereotypical archive of Black culture, though there's a strong emphasis on African American military service. Something more is going on.

At another point, May explains, "Detroit techno came from Juan Atkins's idea to infiltrate the music industry as a Black artist doing electronic music. Nobody was doing it." Atkins says, over outer-space sound effects, "I wanted to land a UFO on the track." Flashing on one of the computers: anatomical drawings of insects; an animal that looks like a primitive rhinoceros; Chinese text; an astrolabe; cosmic diagrams labeled in Arabic. These pictures, streaming by too fast to really see (especially by 1996 standards), aren't illustrating what May and Atkins say. What are they doing?

These subliminal montages do not confirm what the speaker is saying. They take it in another direction, dig into the strata. We get a sense that

the Data Thief's computers are mining and mixing universal knowledge, unearthing fragments that may turn out to be connected.

Montage turns up a monad. Weheliye, in an inspired comparison of Ralph Ellison's *Invisible Man* and Benjamin's theses on history, notes that in both, "the past monadically flares up, . . . which opens a different series of doorways to the crinkle of the past while suggesting a nondogmatic and elastic arrangement of temporal confluence." Note the folded surface that facilitates time travel. The term *monad* is used in Benjamin's sense: the historical materialist "only approaches a historical entity when it confronts him in the form of a monad": a breach in the seemingly inevitable progression of time.[26] These monads, Weheliye proposes, can also be considered opacities, in Glissant's sense, and as folds in Deleuze's sense.

As we know, Leibniz's monad is a soul that perceives the entire universe from its point of view, some parts clearly, some indistinctly. In contrast, Benjamin considers the monad to be an interruption, clearly departing from Leibniz's embracing totality in which each monad knows its place and reverentially discloses the (closed) universe as well as it is able. The Benjaminian monad interrupts the totality and grasps the researcher's attention. "The historical materialist approaches a historical object *only* where it confronts him as a monad."[27] In contrast to progressivist history, this conception of monad indicates that history is discontinuous and rhythmic. Benjamin's monad is an infinitesimal microcosm, rendered immanent from Leibniz's divine origin, much like the other monads that populate this book.[28]

Unfolding Counterdiscursive Fragments

Another manner of unfolding that *The Last Angel of History* engages is Foucauldian historiography. Akomfrah often emphasizes that BAFC was interested in Foucault's concept of countermemory, a memory that opposes official memory but is, necessarily, fissured with gaps. "You could not present the fullness of memory; you had to evoke the interruptions and those interruptions spoke as eloquently as the speech, the silences became as important as the voices."[29] BAFC's archaeology of the image considers the archive to be not only partial but also constructed in the available terms of the discourse of its time. Thus, to excavate a countermemory it's necessary to look for what the archive is unable to show.[30]

Last Angel presents us with images from actual photographic archives: national archives, archives of media companies, university archives. Through these pictures (that flash by almost too quickly to see) the montage hints at

all manner of enfolded histories. More than the Benjaminian mood of danger and disaster, a Foucauldian archaeology invites us to roll up our sleeves and do research, to follow the clues left by BAFC's researchers themselves—Eshun, Edward George, and Floyd Webb—from their journeys in these actual archives.

In another of those subliminal montages that touches on labor in the early twentieth-century United States, you might recognize those pictures of a child working in a textile mill and workers hauling bananas from another film of countermemory, *The Wobblies* (Deborah Shaffer and Stewart Bird, 1979). That film unearthed the history of the International Workers of the World, who in the early twentieth century fought for the rights of temporary, "unskilled," and non-white workers, whom the American Federation of Labor would not represent. These images of exploited laborers make it clear that *Last Angel* is not a documentary of "inclusion," a cheering assurance that Black people and immigrants are integral to building the American Dream. They counter two of *Last Angel's* rather awkward interviews with famous African Americans who have a science-fiction connection. The astronaut Bernard A. Harris Jr., a sweet fellow who avows being "an original Trekkie," recalls partying a lot in college to Parliament's *The Mothership Connection*. Elegant and earnest, Nichelle Nichols, who played Lieutenant Uhuru from Star Trek, describes an inspiring visit to a newly multicultural NASA. It's great to hear from them and to know that Harris flew a composite flag of African nations on the moon, but you get the feeling *Last Angel's* heart is not in these interviews. As Octavia Butler's critical words elsewhere in the film suggest, if inclusion means being part of the military-industrial complex, angels would prefer to be excluded from this particular history.

Mulling over those pictures of the White House and the Lincoln Memorial under construction, I receive another gift from the archive. Benjamin Banneker (1731–1806), the African American mathematician, astronomer, surveyor, and antislavery activist who lived in Maryland, was the self-taught son of freed slaves. Banneker worked on the land survey for the construction of Washington, DC in 1791. During that time, he wrote the first of several almanacs for the coming year based on his independent astronomical observations. The first of these, which corrected errors in two existing almanacs, he sent to Thomas Jefferson, secretary of state under George Washington. In the accompanying letter Banneker denounced the reliance on slavery in a country where all men were created equal, but "detain[s] by fraud and violence so numerous a part of my brethren, under groaning captivity and cruel oppression."[31]

FIGURE 7.5.

Unfolding Banneker's eloquent archival artifacts, we can celebrate his achievements and influence with positivistic ease. In a mood of variantology, after Siegfried Zielinski, we can also read with pleasure the observations in his almanac about the seventeen-year locusts and enjoy his mathematical puzzles. Certainly, this kind of fruitful archival unfolding from fragments, slightly expanding the monadic field in which they resonate, is one of the greatest pleasures of unfolding. However, Banneker has been selectively unfolded and incorporated into the information fold of US history, his history and this letter appearing in school curricula and online essay-cheating sites detached, as Ellen E. Swartz warns, from the larger African-diaspora fold that shaped him.[32] Banneker will return to this essay soon as the protagonist of yet another manner of unfolding.

Inventing Folds

Fabulation

Sometimes, as we saw in chapter 6, the lack of images and total loss of the past lead to another manner of unfolding: fabulation, collectively making up folds, in particular a future fold that pulls the past in a different direction.[33] *Last Angel's* account is a fabulation more relevant than historical record, for

it relates the reality about the African diaspora, testified by multiple witnesses, that people who have been abducted and genetically altered, denied their rights, and belonging in the present, have privileged access to knowledge of a future time.

The appeal of an outer-space origin allows African-diaspora people, as George writes, "To finally have done with this God. To finally abandon the search for a place in this world. To become something other than human, here and now, while also hailing from some far away land, from ancient Egypt, Africa before the slave trade, and from somewhere out there too, from deep in the harsh winds of Saturn."[34] (Saturn is the origin Sun Ra privileges over his terrestrial birthplace of Birmingham, Alabama.) Afrofuturism asks: What's so great about being human? Humanism defines the liberal subject as sovereign, free from the will of others. It means less to people who, during the golden age of humanism, were considered animals or possessions by Euro-American colonizers—yet who, as Glissant observes, possess a knowledge of the totality inaccessible to their "owners." As Weheliye argues, too, technological mediation poses no threat to the humanity of people considered not quite human anyway. Phonography, he proposes, is an appropriate model for African American historiography, a way to make Black people appear in history that otherwise erases them. Hence the ease with which Black people have adopted and transformed recording technologies.

Even a reversal of humanism that claims African and African-diaspora people are *more* human than other earthlings falls claim to an earnest essentialism. Eshun, at his most vividly withering, puts it thus, in a quote I visited earlier:

> Today's cyborgs are too busy manufacturing themselves across timespace to disintensify themselves with all the Turing Tests for transatlantic, transeuropean and transafrican consciousness: affirmation, keeping it real, representing, staying true to the game, respect due, staying black. Alien Music today deliberately fails all these Tests, these putrid corpses of petrified moralism; it treats them with utter indifference; it replaces them with nothing whatsoever.[35]

Fabulation, then, rejects a humanist notion that it is possible to tell stories truthfully, that if you're real enough you will receive justice. It has done with judgments of truth that insert you into the status quo. It seeks not truth and reconciliation but powers of the false that may generate ungovernable—wayward, in Hartman's term—new forms of life.

A further step of fabulation is the moving and enigmatic myth of the Black Atlantis. In 1997, a year after *Last Angel*, the Detroit techno band Drexciya, in the liner notes to their CD *The Quest*, speculated that African peoples may have survived the Middle Passage to construct an underwater civilization. Maybe the pregnant women who the slavers threw overboard during that harrowing journey did not perish but gave birth—to children with gills, who can live underwater and swim to other galaxies. This mythological island under the sea features in Parliament's song "Deep," where Clinton sings, "We need to raise Atlantis from the bottom of the sea, dancing 'til we bring it to the top."

Drexciya's aquatic civilization inspired the most aniconic film dealing with the unspeakable disaster of the Middle Passage, the Otolith Group's *Hydra Decapita* (UK, 2010). The sublime dream of a watery civilization descended from murdered slaves could make a ripping science-fiction movie. But *Hydra Decapita* shows almost nothing but the view of sand and sky from within a cave; the dawn over a shoreline; and the surface of dark waves. White light picks out ripples on the water; in freeze-frame, they suggest hieroglyphs, signals floated up from the deep. Recalling the Data Thief, a researcher from the future, typing in an awkward interface, seems to be trying to make sense of these fragments. A voice speculates that an extraterrestrial civilization might have populated Earth in interplanetary liquid flows. Antiauratic close-ups of reproductions of J. M. W. Turner's *Slavers Throwing Overboard the Dead and Dying—Typhoon Coming On* of 1840 give glimpses of the dangerously listing ship, the dark choppy sea, and tiny figures undramatically falling into the water, barely recognizable in Turner's miasma of paint strokes. We hear the terrible story of this event in a triply-mediated way: John Ruskin's description of Turner's painting, sung in Anjalika Sagar's beautiful, throaty voice uninflected by sentiment. The sound of this voice is as close as *Hydra Decapita* gets to any kind of redemption.

Gabrielle Tesfaye's *The Water Will Carry Us Home* (US, 2018) uses stop-motion paper animation and prayer to fabulate a Black Atlantis. Surrounded by powerful objects and accompanied by a song to Mami Wata, Tesfaye enacts a ritual to invoke a Yoruba magician: a jointed, top-hatted paper man with eyes on his hands who lights a cigar and unlocks a door to reveal a slave ship riding on watercolor waves. People are packed in the hold, pictured in an old print, and Tesfaye sends a simple paper figure to briefly embrace them. We hear splashes as women plunge lifeless into the blue water, babies like pearls inside their bellies. Accompanied by sweet singing (a slightly incongruous song

FIGURE 7.6. Still, The Otolith Group, *Hydra Decapita* (UK, 2010)

by Kenn C), mermaids, their faces and limbs decorated with henna-like dots, release the babies from shells and they swim out, birthed as mer-people. On the shore Tesfaye waits, listening through conch-shell headphones. What makes this film so moving to me is the stiff but infinitely tender movements of the figures, which seem capable of only limited magic but are imbued with powers beyond their papery creation.

Seventeen years after *Last Angel* appeared, Martine Syms roundly rejects fabulative daydreams in her "Mundane Afrofuturist Manifesto." "We recognize . . . the chastening but hopefully enlivening effect of imagining a world without fantasy bolt-holes: no portals to the Egyptian kingdoms, no deep dives to Drexciya, no flying Africans to whisk us off to the Promised Land." Instead Syms looks for "the possibilities of a new focus on black humanity: our science, technology, culture, politics, religions, individuality, needs, dreams, hopes, and failings."[36] Syms is urging that the collective energies that take shape in fabulation would be better realized in earthly projects, even in a revival of the Black humanity that *Last Angel* abjures. Yet the fabulative impulse of *Last Angel* and other Afrofuturist projects, including the glorious *Black Panther*, give impetus to the worldly acts of unfolding differently that Syms conjures.

FIGURE 7.7. Still, Gabrielle Tesfaye, *The Water Will Carry Us Home* (US, 2018)

Unfolding Deep Time

More images on the Data Thief's computer: typewritten equations and spare diagrams, geometric and curvilinear. Drawings of strange animals, as though described to a medieval visitor to some foreign land; astrolabes inscribed in Arabic; splendidly ornate North African mosques; Chinese text. I recognize no sub-Saharan African artifacts, but still the montage gives a sense of ancient technologies and cultural sharing. As the images compress down to text and diagrams, I get a sense of knowledges compressing as they travel through history. Recall the concept of logical depth, the amount of calculating time implicit in a message, that relieves its receiver from having to repeat.[37] *Last Angel*, by flashing all these images at us, is suggesting that contemporary math, science, and technology have deep, and deeply implicit, cultural roots.

Not long ago, the idea that modern science, math, and technology had roots in Chinese, Indian, African, and other non-Western cultures provoked howls of consternation. Some of this is summarized in the debate over *Black Athena*, the title of Martin Bernal's three-volume work (1987–2006), which argued that much of the Greek mythology that Europeans claimed as their cultural heritage arose in Africa. Bernal showed that the myth of Greek origins for European culture dates to the late eighteenth century, before which

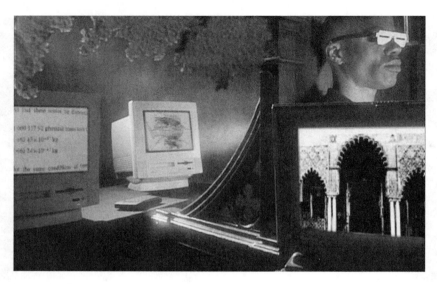

FIGURE 7.8.

time Europeans commonly acknowledged the Greek debt to Egyptian culture.[38] These ideas arose quite a bit earlier than Bernal's work: in Frederick Douglass's research on the Upper Egyptian and Nubian origins of predynastic Egyptian culture, for example, or in Sigmund Freud's suggestion that Moses was an Egyptian and adapted his monotheism from the worship of Akhenaton, or in W. E. B. DuBois's research on the earliest world civilizations along the Nile Delta. Islamicate philosophy also gives precedence to an African origin over the much later Greek one. It was Thales (c. 640–c.–546 BCE), Ṣadrā asserts, philosophizing in Egypt and then migrating to Miletus, who introduced philosophy to Greece.[39] Now that the acrimonious confrontation between Euro- and Afrocentrists has settled down somewhat, solid scholarship proliferates.

Still, a sting of resentment characterizes these scholarly struggles over the African origins of Western civilization. This resentment speaks to the very purpose of historiography. What kind of unfolding is it? Let us consider specifically the history of science and technology. Insofar as the search for origins seeks to insert forgotten ancestors into a linear and causal model of history, it is beholden to the Enlightenment progress narratives that have justified oppression and slavery. Conversely, we can value other knowledge systems that may or may not get pulled into dominant or royal science, value minor

science for its own local relevance, and develop its nonlinear and sometimes fabulated connections as resources for present concerns.[40]

In these flickering pictures of ancient technologies, *Last Angel* is beginning to unfold those histories of work whose elision constitutes logical depth. Let us suspend questions like "but what does African mathematics signify *now*?," which demand that we prove the influence of ancient African knowledge on contemporary thought. Instead we can cultivate curiosity about the inventions Africans made in the past without having to justify them in terms of the present. Zielinski calls such a generous, curious attitude toward the history of technologies "variantology," for it seeks not trends but variations. Zielinski criticizes linear, survival-of-the-fittest historical narratives, such as those that see past technologies as "anticipating" present ones. This manner of Foucauldian archaeology searches into history in order to release creative energies from past key moments.[41] Similarly, Stengers refocuses attention not to the results of experimentation but to the proliferation of experimental practices.[42] The past is richer than the present. It is full of virtualities that someone may be able to actualize. This is another way to describe *Last Angel*'s manner of unfolding.

For example, in its provocative flashes of ancient technologies on the Data Thief's computers, the film invites a variantology of the history of computing. Here is a variant that is satisfying to explore: the African history of binary mathematics, which ethnomathematician Ron Eglash succinctly summarizes. Geomancy is a form of divination calculated in base two and using sixteen figures that was popular in Renaissance Europe. It is usually attributed an Arabic origin, which Arabic-speaking mathematicians and magicians in turn learned from traders returning from East Asia, reflecting its deep Chinese origin.[43] However, Eglash points out that while most world mathematics calculate in base ten, base-two calculation is an ancient and ubiquitous practice in Africa. Eglash studied the base-two divination practiced by the Bamana people of Senegal that, through a series of iterations made using shells or marks in the sand, results in sixteen divination symbols.[44]

This binary mathematics became one of the many syncretic North African Muslim practices, termed in Arabic *'ilm al-raml*, science of the sand. The translator Hugo of Santalla introduced binary divination in Spain in the twelfth century, apparently in a translation of a work by an "unknown Tripolitan" referred to as Alatrabuculus.[45] Geomancy was quickly taken up by alchemists, hermeticists, Rosicrucians, and others. The thirteenth-century Franciscan missionary, translator, and writer Ramón Llull adapted Arabic

FIGURE 7.9. From Ron Eglash, "The African Heritage of Benjamin Banneker." Courtesy of Ron Eglash.

Design for Leather Neck Bag

Prayer Mat

Floor Tiles

Balcony

Bus Grille

Toolbox Decoration

cryptography to create a combinatorial logic that would influence many Renaissance thinkers. Deep-time scholars have been excavating Arabic and Jewish sources of Llull's combinatorics.[46] A little more research might shed light on the pre-Islamic African roots of the process of transmission that Eglash suggests.

Folds within folds. Geomancy was taken up as an occult art in the Renaissance and its origins were effaced. Nevertheless, Llull's binary mathematics returned to legitimacy (and got whitewashed of any Arabic, let alone African, sources) in their influence on Leibniz's binary logic in the *Dissertation de arte combinatorial*.[47] Leibniz is usually credited for the invention of the binary language of Boolean algebra, on which the logic gates of computer circuits are based. In short, computers' binary logic finds one of its origins in the widespread African practices of geomancy.

In a more open fold in the African roots of computational culture, Banneker composed mathematical puzzle-poems, which Eglash notes revolved around base-two calculations. Eglash postulates that Banneker's inventions arose not only from his innate intelligence but from his African ancestry. Banneker's father, Robert, came from an area of West Africa (termed only

"Guinea") in which people cultivated binary numerology. Banneker's grand-father "Banneky" was of royal Wolof origin. He may have been the one who taught Banneker about the quincunx, a cruciform geometric design widely used in Senegal that grafts Islamic and animist images of power radiating in all directions. It returns to Banneker in a dream:

> On the night of the fifth of December 1791, Being in a deep Sleep, I dreamed that I was in a public Company, one of them demanded of me the limits Rasannah Crandolph's Soul had to display itself in, after it departed from her body and taken its flight.... When I returned I found the Company together and was able to Solve their Doubts by giving them the following answer: Quincunx.[48]

This astonishing passage indicates that Banneker's unconscious modeled the soul's movement in the afterlife as a geometric dispersion of power into the universe.

On the Middle Passage some enslaved West Africans managed to carry talismanic pouches in a variety of African cultural traditions: *nkisi, gris-gris,* Qur'anic textual amulets, and the quincunx. The Bambara people made land in Louisiana, where these practices would become the origin of voodoo.[49] These connections suggest that African mathematical knowledge, deeply en-folded in binary logic and unfolded as spiritual practice, was remembered and practiced in the diaspora.

Unfolding as Remix

As Rinaldo Walcott points out, *Last Angel* is structured in a cut-and-mix form appropriate to diaspora aesthetics.[50] Remix constitutes methods of aesthetics, epistemology, and historiography: a manner of unfolding that snatches up fragments from whatever stratum it wants and crashes them together with fissile power. In the film Paul Miller and Goldie celebrate the freedom digital remixing gives composers to take sounds from wherever they want. That's true of many early sampling musicians, and DJs before them. The legendary DJ Grandmaster Flash mixed "white boy music like the Steve Miller Band and Spooky Tooth, Jeff Beck and Steely Dan . . . talk about righteous beats! Crazy beats from the Philippines and India with sounds I didn't know a human being could make."[51] In their landmark 1988 and 1990 albums, Public Enemy collaged dozens of samples into a cognitive sonic rapture, before licensing laws made such music financially impossible for most musicians.[52]

In *Last Angel* Goldie says, "Time is irrelevant, cuz we can take music from any era," and Greg Tate calls sampling "digitized race memory," allowing people without formal musical training to access musics from all places and times, if these have been recorded. (This remark is accompanied by shots of the Data Thief fiddling in bewilderment with the innards of a discarded computer.) From a majoritarian point of view, the idea of remixing history sounds capricious and irresponsible; but not so for Afrofuturists. The remix manner of unfolding releases granular folds from the dominant fold. It takes a point of view from the underside of majoritarian history and releases energy from hitherto unimagined connections.

Appropriation and deracination were issues at the time *Last Angel* was made. The ease of electronic sampling got people worried that recorded sounds would be separated even further from their sources (in the psychological condition R. Murray Schafer called schizophonia, hearing sounds from another space and time embedded in one's own[53]) and that the original would not be credited. Aesthetically, remix differs from plagiarism in that it refers to its history in the recognizability of its sources, as Eduardo Navas notes.[54] Yet as we know, much of the history of modern popular music consists of white appropriation of African American innovations. Black techno music, like its predecessor R&B (as well as jazz and disco, though these never lost their African American associations), was adopted by white musicians who reached large white audiences, to the point where its Black origins became effaced and forgotten. Beverly May recounts how this happened with the techno music invented by Black musicians in Detroit. In the early 1990s, Detroit techno got taken up by European audiences at the same time that the Detroit scene faded, partly because of the rising popularity of hip-hop, declining radio support, and the loss of its major venue in the city, the Music Institute. For a while a network of independent record labels thrived, especially on the "Detroit-Berlin axis" of techno music. Techno fed the European and North American rave culture. Unlike the reportedly drug- and alcohol-free Detroit techno scene, raves were indissociable from drugs and liable to police raids on the illegal venues where they were held—especially dangerous for Black ravers.

May relates that the increasingly white, suburban crowd and the faster, colder sounds that ravers wanted alienated a lot of African American musicians and audiences. Techno's Black origins got sucked up by the increasingly commercial alt-techno vortex. She asked Derrick May if he still characterized techno as "Kraftwerk and George Clinton stuck in an elevator." He replied gnomically: "Kraftwerk got off on the third floor and now George Clinton's got

Napalm Death in there with him. The elevator's stalled between the pharmacy and the athletic wear store."[55]

Giving credit and getting paid remain concerns for the session musicians and backup singers whose infectious hooks and sublime vocalizations often *make* the song. When musicians sample Clyde Stubblefield's performances on James Brown's *Funky Drummer* and *Cold Sweat*, the licensing fees go to James Brown's record label. Merry Clayton's vocal improvisation drove home the sublime terror of the Rolling Stones' *Gimme Shelter*, but no royalties go to her.[56]

Remixing is a sonic, not visual, theory of montage, and thus especially sensitive to the way montage is received and realized in the body. So, if we give a little more credit to the audience, we can respect how they complete the creativity of the remix, as they follow samples, hooks, styles, remakes, and remixes back to their sources and unfold them while listening, dancing, and reading. Returning to Lanier's proposal to monetize the information economy, we can also imagine a way that at least some creators can continue to be rewarded for their creations as they recirculate. A remix manner of unfolding authorizes the historian to play DJ.

So let us enjoy inventions, as May invites us to in *Last Angel* with his disarmingly simple recipe for remix: "You just take a little salt, a little pepper, mix it up and you've got a nice piece of soup."

This chapter has unfolded just a few of the shimmering monads in *The Last Angel of History*. There remain many more that likely lead to all kinds of unforeseeable connections. I ask my fellow admirers of this film, John Akomfrah, and Black Audio Film Collective to abstain from being scholarly Sir Noses and be Star Childs instead. Instead of interviewing Akomfrah yet again to ask him what the movie is about, let us feel it for ourselves, do a little homework, and unfold accordingly.

8

THE MONAD NEXT DOOR

Everyone needs privacy, somewhere to go where they won't be bothered, a place to withdraw to. Somewhere they can think their own thoughts; be opaque to others; undergo their creative process in private. Yet we all have to have neighbors.

Monads are neighbors, packed together infinitesimally close, each of our bodies a hammock suspended in the plenum. Yet in a marvelous harmony that might be described by calculus, each one of us enfolds the cosmos differently. Leibniz explains that monads—minds or souls—are "simples," dimensionless and irreducible entities, while our bodies are changeable composites of monads. The monad's soul expresses the universe all the way to infinity, for the most part confusedly. Similarly, its body feels the universe all the way to infinity, but only feels distinctly what's most immediate or pressing. As we've seen, in the best of all possible worlds, this arrangement leads to harmony, Leibniz argues, not for individual monads but for the whole.

The monad proper resides on the second floor of its body, observing the neighborhood and the universe beyond from its windowless room. Its neighbors perceive it as it represents its body to them, giving information about

what it's composed of, what it's connected to (its neighbors), and how it's changing. But they don't perceive what it does, in privacy.

Most monads' bodies, those comfy hammocks I'm evoking, are composites of innumerable other monads, whose bodies in turn enfold other monads—our organs, our cells, all the way down to our atoms—in the vinculum I discussed in "Soul-Assemblages." A soul's body, then, is composed of innumerable other souls, converging and dispersing (to switch metaphors) like soap bubbles on the water's surface. Bodies are soul-assemblages. They shift shape and get bigger and smaller as their constitutive monads come and go, as we incorporate and shed body parts—hair, skin cells, blood vessels, possibly a limb or an organ—and when we finally die. As souls we are simple, but as bodies we are collective. It is these collectives, these shape-shifting soul-assemblages, that our neighbors perceive when they encounter us.

The difference between the monad's experience and its body's experience is like the difference between sound and vibration. As anyone who lives in a wooden building knows, we *hear* acoustic sounds—conversations, the music we play—but we *feel* the vibrations of our neighbors' activity. The body feels, while the monad perceives and sometimes thinks. (For example, for a monad with a minimalist world like Jacob von Uexküll's tick, the body would be successfully sunk in the warm flesh of an animal and the monad would be thinking, "Life is good!") We can map Leibniz's dualist distinction onto the gradualist triad of affective analysis that I have described. Feeling or affect is selectively filtered into perception. Some perceptions and feelings, in us higher monads, give rise to thought, if we are not too busy surviving and too distracted by information folds to think. There is an aspirational quality in the monad's thought, then: not necessarily a disavowal of its immediate surroundings, but a desire to distill the big picture.

Considering the health of the monad-body relationship, it seems to me that when the body is sick, tired, or dying, it distracts the monad from the view upstairs and pulls its attention toward the other monads that erstwhile compose it—as anyone knows who's ever had major surgery or food poisoning. But also, an overly healthy body, bouncy with musculation, tugs on the monad, pulling attention away from what it's thinking.

I suggest that everything else that we appropriate to ourselves in order to thrive—clothing, furniture, plant and animal life, technologies, food, drink; all the things we enfold—also composes our bodies. This raises the question, where does one's body end? The answer, strictly, is nowhere, as our bodies extend to infinity. Practically, it ends where we don't recognize it as part of ourselves.

When, this chapter asks, do our bodies extend to our space, our home, our neighborhood? I look at recent movies that, each with their own manners of unfolding and enfolding, tell stories about neighborhoods. Neighborhoods are nested monads, ever reorganizing and mingling, that reveal the process of the cosmos and the interdependency of humans, animals, infrastructure, atmosphere, and information. In this chapter I take Leibniz at his word as far as possible, occasionally resorting to deconstructions of the *Monadology*, Deleuze's and my own.

Movies too are monads, representing the cosmos from their interested point of view, some parts distinct, some dimly perceived, some not at all. This occurs not just in the narrative but in point of view, point of audition, generally the ways the movie creates a sensory center or centers. Some impose the mind on the body strictly, constructed so that all the parts align to support a single vision, as in Alfred Hitchcock or Stanley Kubrick. Others are loose and rangy, not too concerned about where their borders end, as in Alice Rohrwacher and Mohamed Soueid. Movies that are very involved in their bodies, such as through special effects, elaborate mise-en-scène, or showy editing, may distract from the movie's idea, while movies that are too idea-driven eschew the support of the many organs that compose their bodies.

Answers for Monado-Skeptics

Why stick with Leibniz at all, you might ask, whose thought is so old-fashioned, so dualistic, so closed? In whose cosmology the soul and body live on separate parallel paths, the whole universe subsumed to a God assumed to know what is the best of all possible worlds? Because—once philosophy stops bothering that God—Leibniz's statement that every monad, from its unique perspective, is "a perpetual living mirror of the universe" rings true to me.[1] The same goes for his argument that every body is connected to every other, like folds in a fabric or ripples on the sea. Believing these improves my life, for to understand that every entity expresses something about the whole universe invites me to value and appreciate each one of them. To conceive of all of us as physically interconnected, from my spleen to a distant star, nurtures respect and wonder and amusement. To live in a cosmos conceived in this way is fun and never boring. It's worth the effort of getting in there with a wrench and trying to retrofit Leibniz's untenable and objectionable arguments, even at the risk of the whole jalopy collapsing.

And why do a monadological analysis instead of a Marxist or class analysis? In a Marxist analysis the bourgeoisie are ignorant about the material

basis of their lives and of their dependency on the working class. They suffer from false consciousness, believing they are the masters of their destiny, when in fact they are completely reliant on the value that they extract from other people and from the planet itself. We saw in "Soul-Assemblages" that Marxist false consciousness describes remarkably well the experience of the dominant monad, which binds together a soul-assemblage of dominated monads to support it. An organic body depends on its organs; a person depends on all the human and nonhuman entities whose labor allows her to survive, often to the extent of exploitation. Unlike Marxist analysis, a monadological analysis does not dismiss anyone's view of the world as false consciousness. It accepts that this is their point of view on the world, based on their position, and as such it is real. Also, in my extension of the theory, a monadological analysis respects that every entity is a monad, even those that appear to others as invisible or just furniture. As the analysis shifts among their points of view, it builds an ever-richer picture of the cosmos. I revised the concept in chapter 1 to elevate (practically) every entity to the level of a soul, a tinkering to which this chapter will need to return. I suggest that the seemingly old-school Leibnizian approach, with a few tweaks, accommodates a more expansive and more accurate understanding of what the world is like and how relationships construct it.

Dragging our perspective from the nineteenth century into the twentieth and later, why attempt a monadological analysis instead of a materialist or new-materialist analysis? My answer is that even a rich materialism has little to say about irredeemably immaterial things like soul, feeling, and thought, unless it can reconfigure it as something quasi-material such as affect. I suggest, however, that we don't need to contort seemingly immaterial things in order to fit them into acceptable conceptual paradigms. In the monist approach I outlined in chapter 1, material and immaterial are a matter of perspective. Seen from outside, a being appears as matter, while from within it appears as soul. Given this, monadology 2.0 harmonizes well with new materialism. Thus, a monadological analysis inhabits each being in the situation (which may be a soul-assemblage) and explores the interconnections from its perspective. It is not a "flat ontology," however, but an interested one, focusing on the monads in the neighborhood and following their folds to tease out their interrelationships.

Recall from "Soul-Assemblages" that, in order to make Leibniz's cosmology palatable for modern thinking, it becomes necessary to open Leibniz's closed cosmos in order to recognize the freedom of each monad, even at the risk of disharmony. That modification involves banning a transcendental

God and accepting instead that monads compose the infinite for one an-other. In Carr's words: "Each monad is within the other's perspective, but in coming into another's perspective the included monad leaves nothing of itself outside. There is absolutely no transcendence."[2] It further implies that sufficient reason, the causal link to the entire cosmos, be found within each monad: indeed, this book's most pressing and pleasurable project. We saw that this can be achieved if we replace sufficient cause with self-causation or autopoiesis. To do so places a Spinozan ethical burden on the individual monad, as Juarrero points out, that can be quite daunting.[3] But it means choosing your relations: identifying the souls with which you assemble, rather than having them chosen for you. The next step is to deal with mind-body dualism, a step that we can identify in the *Monadology*'s own elegant solution of the fold. Thus, we can enjoy the benefits of the monadic cosmos without its unfreedoms and tiresome calls for harmony.

The more "aware" a being is of what it enfolds, the more it may become passive, suffering, a mass of quivering affects, exhibiting the effects of all the things that act on it. Translating affects into immediate action—like, say, em-bedding a sleeping pill in a piece of meat and throwing it to the dog whose barking is driving you crazy—is satisfying in the short term, but it may cre-ate larger problems or shove our problems onto someone or something else. What if those painful feelings of connectedness can multiply and extend to the whole world or the whole cosmos? In this chapter, I seek some an-swers to these questions of microcosm, passivity, and action locally, in the neighborhood.

The Monad Enfolds the Cosmos

There is no cinephilic pleasure greater than sharing the point of view of a cinematic monad as she perceives a changing and expanding universe. I say she because I am thinking of the eponymous heroine of Alain Gomis's *Fé-licité* (Senegal, 2017). The first half of the film is constant movement. The film begins with a fluid long-duration shot at the nightclub where Félicité (Véro Tshanda Beya Mputu) sings. The camera, seeming a little tipsy it-self, moves in toward the clustered faces of the habitués drinking, arguing, flirting, dancing, absorbed in the sound of her raspy, powerful voice and the raucous elation of the Kasaï Allstars' music. All is relational movement. Félicité, professional and in full possession of her vocal instrument, is like an island to which the others return and recede like waves.

Félicité's humble Kinshasa neighborhood is dense with relations too, people helping each other out in simple ways. In the daytime we see that her neighbors all keep their eyes on each other, and electrical cables strung from house to house also suggest a necessary intertwinement in a neighborhood where resources are scarce. Félicité, though, keeps herself apart, carving a territory with room for only two. Strongly built and indomitable, she works ceaselessly for her and her son Sama's survival. She makes the rounds of the neighborhood grimly collecting debts. She argues sharply with her neighbors, defending her territory. When the cheerful electrician Tabu returns to repair the small refrigerator that she is proud to be able to afford, she rebuffs his friendliness. After Sama has been in a motorcycle accident, she hustles desperately to try to raise money for his surgery, debasing herself to beg. But when she finally raises the money it is too late, and her son's leg must be amputated.

In a classic shift from movement-image to time-image, Félicité becomes a seer when all her resources are depleted and her hope to save Sama's leg dashed. She undergoes an exterior and interior voyage, accompanied by incompossible guests. She walks the length of the city at night, seeing as though for the first time: lights on the river; a group of youths pushing a pickup truck; the beauty, suffering, and togetherness of her neighborhood. In a dim, dreamlike night scene, Félicité, in a white nightgown, wanders in a forest. A gentle zebra comes to her and she caresses it. Gomis introduces documentary passages of the Orchestre Symphonique Kimbanguiste, assembled on a simple stage, performing works by Arvo Pärt—music that tests the soul's capacity to grow and furnishes it strength to do so. Stretched over the image, the music brings Félicité's soul-destroying and ordinary problem into contact with the world, where the majority of people face predicaments similar to hers, and to the cosmos.

Félicité has been rightfully skeptical regarding Tabu's amorous intentions. But as her vigil of walking ends at dawn, she knocks at his little shack. He opens, she lies on his bed, and he lies on top of her. We wait, for long apprehensive seconds, for some kind of sexual consummation. But then with exquisite tenderness, rather than kiss her, Tabu gently pulls Félicité's shawl around her to warm her shoulders. The tension of waiting releases, for now she and we know that this is a man she can trust to be open to.

The shift in Félicité's island-like manner is gradual. Flora Yang carefully analyzes the transition over the seven scenes in the nightclub. In the first, the movement always returns to Félicité on stage, her performance holding

FIGURE 8.1. Still, Alain Gomis, *Félicité* (Senegal, 2017)

the lively evening together. The next time, after Sama's accident, the rhythm slows and her smile is laborious. Her bandmates raise a little collection for her. In the third scene, once she knows Sama will lose his leg despite her efforts, the slow movement of camera and editing accompany Félicité's resignation to her fate. Renunciation marks the next two scenes in the bar, as she quietly sits, does not sing, and recedes from Tabu's drunken altercation that captures the camera's saccadic movement. In the final nightclub scene, the rhythms are buoyant again as Félicité sings and moves with a new full-throated joy.[4] These club scenes elegantly diagram how the character cautiously softens her boundaries and accepts the relations in which she and her son are entwined.

Talk is sparing in *Félicité*, and much of the story implicit, giving the film room to breathe. The film has the intermittence of life itself, as Nathaniel Dorsky advocates. "Its montage should be sparing enough, and at the same time poignant enough, to allow the viewer's most basic sense of existence to 'fill in the blanks.'" Shots give empathy, Dorsky suggests, as camera and filmmaker are "selflessly present" with the subject matter, and this occurs in Félicité's clear-eyed observations. Cuts "are the clarity that continually awakens the view."[5] *Félicité* breathes well, going out toward the world with each shot, then in the edit backing away to reflect. This rhythm maintains in every scene as the film's registers expand, drawing in more of the world, as though drawing ever deeper breaths. Félicité herself enters a rhythm of expanding

FIGURE 8.2.

ever further into her world, selectively enclosing it, and bringing it back as part of herself. Finally, an earned and playful grace enters the film when Tabu joins Félicité and Sama to make a triad. In a sweet scene the man and the youth goof off and play a drinking game on Félicité's sofa while she feigns disapproval, concealing a smile. As Olivier Barlet writes, "The constellation of the three characters is essential; one does not exist without the other. Félicité is of course almost always present on the screen, but her character does not exhaust itself in this presence; it constantly refers us to this relational trinity, but also to what surpasses it, to the problem that it poses everyone."[6] Now Félicité can accept the expansion of her borders to include selected others, and from this careful expansion she can relax into relationality, even with all its unknowns, and, as Glissant writes, "fit into the chaotic drive of totality that is at work."[7] In the course of *Félicité* its breathing has deepened to encompass these characters, the neighborhood, the city, and the world.

The Soul's Reading Room

The reason I am most committed to maintaining a concept of the monad, or soul, is that upper floor, a private space from which the soul enfolds the cosmos selectively, which we visited in "Soul-Assemblages." This private space is where creativity happens. Recall that soul, in Leibniz's definition and my redefinition, is not a transcendental spirit that survives the body, as in religious

conceptions, but the monad, turned inward to contemplate. Enveloped by a cosmic fold, the monad feels the pressures of the world outside—the outer surface of its fold—and perceives the world inside, what it has chosen to include. The monad lives on the windowless upper floor of its body, its private reading room, where it can synthesize the data it has received from the world. There it is free to turn its attention away from the other bodies that tug on it and toward the things that interest it. In Leibniz, those things are divine truths. For me as for Deleuze, they are whatever the monad encloses, seen from the inside. To bring Whitehead into the mix, the actual entity (or monad) has a relatively private space in which to chew over that piece of the cosmos that it has bitten off. The actual entity concresces until it is satisfied: it synthesizes every portion of the cosmos that it has prehended and decides whether and how to include it in its being.[8] This private enfolding and synthesis of a selected portion of the cosmos constitutes the soul's activity.

The upper floor is expressed literally in this chapter's focus on movies about homes and neighborhoods. I fend off the Marxist critique of false consciousness by saying that sometimes a monad needs a private space to reflect and synthesize. This is especially the case when the monad's body is beleaguered and endangered. The perfect movie to demonstrate the importance of a private reading room is Ephraim Asili's *The Inheritance* (US, 2020). It's the fictional tale of a group of young African Americans who come together to live communally in a West Philadelphia house that Julian has inherited from his aunt. The film takes place almost entirely inside this spacious house. Its windows are covered with colorful African textiles, replacing the view to the exterior with a view to cultural history. Julian and his partner Gwen bring into being the House of Ubuntu: a safe space in which they, and the friends with a variety of interests and skills who join them, can educate themselves and each other. Being recorded on 16mm augments the film's sense of looking inward and valuing its small cache of materials.

Julian also inherited his aunt's collection of Black liberation books and pamphlets. She had been a member of MOVE, the visionary African American political organization based in this same Philadelphia neighborhood. Led by John Africa and all taking the last name Africa, MOVE members practiced a self-reliant, Afrocentric form of communal living. They home-schooled the children, grew their own food, supported animal rights, and espoused natural law over state law.[9] But MOVE is best known for the day the Philadelphia police leveled their community with shocking violence. On May 13, 1985, hundreds of police ambushed the MOVE home, the FBI dropped a bomb on

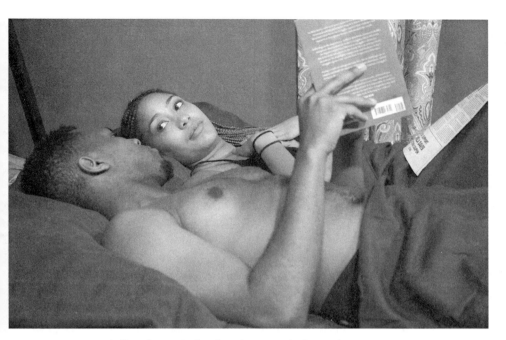

FIGURE 8.3. Still, Ephraim Asili, *The Inheritance* (US, 2020)

the house and allowed the fire to spread until it destroyed an entire block, and the police shot at people attempting to flee. The attack killed eleven people.

Thus, the film's endeavor to imagine a new MOVE-like utopia grows from literally scorched earth. The books and records that Julian's aunt carefully stored two generations prior are radioactive fossils of an unfinished lesson in Afrocentric, utopian world creation. Malcolm X is here, Julius K. Nyerere, Angela Davis, and rarer books and pamphlets. "Frequently featured in portrait-style shots, almost as if receiving their own reverent close-ups," as Esmé Hogeveen notes, the books and albums are essential members of this carefully curated soul-assemblage.[10] Their music too is from that era and played on its technologies. There are many beautiful scenes in *The Inheritance* when the householders quietly read together, welcoming back knowledge that has yet to be consummated. Reciting, writing on a blackboard, arguing, and discussing the distribution of chores—a deal-breaker for many communal living situations—they raise the House of Ubuntu's consciousness. The pedagogy and primary colors pay homage to some films by Godard but are, to my taste, less irritating.

Historical footage is welcomed into the film too—important speeches by Shirley Chisholm and other political leaders of the time, powerful brief moments of dreadlocked MOVE children playing in the safety of a backyard. But no radio, no television, and nary a digital device interrupts the group. The House of Ubuntu becomes a carefully curated microcosm, excluding what is predatory and unhealthy—that is, the great majority of US society and culture. It is a protected reading room for serious intellectual and spiritual nurture. As the film concludes, new life begins to sprout, as though to finally consummate what the visionaries of MOVE strove for almost forty years prior.

Disquiet

The Monad's Body

I live on the fourth floor of a six-story apartment building constructed, quite sturdily, of pine wood in 1914. Music floats and blares from our windows. We smell everything our neighbors are cooking and smoking. From the laundry room in the basement, the stench of fabric softener drifts chokingly into my open window. The old wooden floors creak, and depending on how your upstairs neighbors walk, toe-to-heel or heel-to-toe, the vibrations can awaken you at night.

This captivity to the sounds of neighbors used to drive me crazy. Once when I lived in an even noisier building, my friend Janine Debanné tried to cheer me up:

> I once moved out of an apartment after one night there, totally freaked by sounds. I have always found my first nights in a new place very distressing: new sounds that I think will bother me. In the end though, you make friends with the sounds. The neighbor's steps sounds become comforting. Try to think of it as "I am surrounded, not all alone in a suburb far from human life." In this building I can hear neighbors peeing, above me, beside me. I really love it. We're in sync, all of us chumps getting ready for work in the morning, and for bed at night. I kind of get into it.[11]

Janine—an architect who studies life patterns in urban public housing—managed to expand her monad to include her neighbors' bodily functions and the gurgling building itself.[12] I am not as generous a soul as Janine is, but I find that when I know my neighbors their sounds and smells bother me less. Now when I hear sounds upstairs I can say to myself, "Elaine is stepping to the

bathroom. Elaine is putting a kangaroo into a box." It is somewhat soothing. It's about redefining one's boundaries so that the neighbors are not a toxic threat to the amoebic borders of ourselves but are lightly incorporated as relations.

Neighbors test the monad. The monad's mind sometimes includes its neighbors, but the monad's body always includes its neighbors. That's why it is easier to love the moon than to love your next-door neighbor. As I noted in chapter 3, because everything one perceives relates to one's position, the monad's point of view enfolds secrets that are imperceptible to others. Anamorphosis is an unfolding available to only one point of view. What is clear to my neighbor may appear as no more than a smudge to me, unless I were able to align myself exactly with their position. This is why it's easy to get paranoid about your neighbors. Around the world, neighborliness varies greatly with culture and economic status. In well-to-do neighborhoods, neighbors rarely enter the monad's perception. It's so well insulated that it can turn its attention to other things, like poetry or politics or televised sports or online quizzes. In well-to-do neighborhoods, neighbors only constitute the monad's body, as disturbing vibrations. While in anxious neighborhoods, where your well-being relies on the well-being of your neighborhood, neighbors loom high on the monad's radar. In my downtown Vancouver apartment building, as in most buildings in wealthy parts of cities, most of my neighbors ignore my friendly hellos in favor of the world present on their mobile devices. My neighbors are not rude; rather, my neighborly presence has no prominence in their world. However, when I have lived in middling neighborhoods in Beirut, where safety and status are perennial concerns (and this was before the financial crash of 2019), my neighbors knew all about me. Once on a November day I washed my windows, which turns out to be a foolish thing to do in November because the rains will just muddy them again. A couple of days later, when I visited a friend two blocks away, she said, "I heard you were washing your windows." My ignorant foreignness was worth noticing: it gave my neighbors a chuckle and indicated a change in the neighborhood worth keeping tabs on.

Because for most people our bodies extend to include the spaces we occupy and the relations they mediate, traveling is a disorienting experience. When I am in an unfamiliar place, my sense of self diminishes. My monad's body shrinks, yet I bump into things. I miss the familiar beings that speak to me of our history together, like my houseplants and the gentle clack of the electric bus passing outside. For a person living on the street, the arrangement of a few possessions creates a temporary territory into which their monad can expand slightly.

Expressing these neighborly feelings in Leibniz's terms, occasionally the monad feels a tug from the lower floor, its body. A feeling of disquietude ensues: those microperceptions we encountered earlier in this book. Like the dog that shrinks from the stick once used to beat it, I feel that if this thing is connected to me, I cannot be safe. Living in a neighborhood, this question becomes political. When the dim awareness of a neighbor twitching my folds becomes a conscious perception, or what Leibniz calls an apperception, how can I respond? What is part of me, what do I reject? What aspect of those twitching folds does not form part of the picture I show to the world? "And because this body expresses the whole universe through interconnection in the plenum, the soul also represents the whole universe by representing this body."[13] We all have to repress some of the relations that constitute us in order to appear coherent to ourselves and others.[14] In Vancouver where I live, the fundamental disquiet consists of the fact that all the homes are built on stolen land: traditional Indigenous territories that were never ceded to the Canadian state.

The monad's borders extend to the home as a soul-assemblage, whose internal constituents shift and transform. Let's test extending the outline of that body to things whose belonging we might question. Does a monad's body include its apartment, house, tent, or other dwelling? Does it include the electricity, water, steam heat, television, and internet that attach to those dwellings by snaky pipes and invisible rays? Does it include the people who support those dwellings and connect it to the outside world—the plumber, the mail carrier, the internet service provider's call-center representative? What about the media that assail the home: flung newspapers, possibly, and cables and Wi-Fi bringing calls and texts and news and porn and social media and "Baby Shark Dance"?

The physical infrastructure of homes and neighborhoods functions as those folds that connect soul to body to world: walls, windows and doors, indoor plumbing, heating and cooling, insulation, upholstery, pictures (the monad's views of the world), and telephone, cable, and internet connections. Comfortable homes are designed to disguise the labor of their infrastructure. But they never do it thoroughly enough, especially when the infrastructure breaks down. Underground and overhead, pipes and cables, suffering depredations of weather and nibbling animals, leak. In the Levant, *khamseen* winds blow sand through the slimmest crevices. Wood rots. HVAC breaks down. Ceilings leak. Sofas burst their springs, mattresses flatten, sleek-looking IKEA furniture sheds its laminate. Unwanted creatures make their homes in the domicile—silverfish, mice, other human beings. You can sweep

out the fine sand, putty the holes, and stuff the crannies with steel wool yourself. Or you can hire workers to reinforce your home's infrastructure, so that they too become part of it.

Plants also test where the monad-house's body ends. Vines gradually break down the bricks; roots buckle the foundation. On my bike ride I pass a house whose inhabitants decided to let the yard grow wild, entering into a more equitable exchange with the local plant life and in turn the critters and fungi that thrive in it. Morning glory vines stretch their greedy tendrils, dandelions go to seed, rusty-looking dockweed shoots up, all in a tangled profusion. Evidently this decision caused some kerfuffle with the neighbors, for posted in front of the wild-yard house is stationed a rather plaintive, hand-lettered sign giving a definition of goodness as that which supports the greatest amount of life. I slow down to study the next-door neighbors' response: a deep ditch dug along the property boundary, resentfully lined with gray stones. Cables, vines, and neighbors: all the things that connect your home to the world also threaten to pull it apart.

A home seems to constitute a decision regarding what's inside and what's outside: but in fact, the resident often has little choice but to incorporate unhealthy elements into its soul-assemblage. Appadurai, writing on films about housing in Mumbai, characterizes such mutable extensions of the body into the neighborhood as actants, including "cameras, billboards, cash, cement, construction equipment, water pipes, and electricity lines," as well as human mediants such as filmmakers, audiences, developers, real-estate brokers, and politicians.[15] In the United States they also include subprime mortgages, which transform a person's home into an investor's toxic wager. Because mortgages mediate homes into assets, and in turn financial derivatives mediate mortgages into tradable debts, "the home—as a material fact—does not exist in our highly financialized world apart from its availability to the mediation of the derivative form," Appadurai writes.[16] Living in a dangerously mortgaged home gives the most sickening sensation that not only do your borders not belong to you but that they are swept into the merciless fold of information capitalism.

Upstairs and Downstairs

A soul or monad is only dimly aware of the forces that impinge on it, unless they suddenly command the soul's attention. It is similar to how bourgeoisie can ignore the oppressed (human and nonhuman) classes that support them until something goes wrong, such as a strike, a power outage, or slow

bandwidth. Then their dependent connectivity hits them in the face. If we map the *Monadology* onto a Marxist analysis, the soul, supported by the body and dimly aware of the latter's connections to the world, compares to the upper class, disavowing its reliance on the working and underclasses. "Upstairs-downstairs"-type fictions, as in the 1970s British TV series of that title and *Downton Abbey* in the 2010s, literalize the monad experience, with the toffs upstairs mostly unaware of the servants' bustle downstairs, without which they could not survive.

As I argued in "Soul-Assemblages," the slavery economic system puts these relations into deepest disavowal. Leibniz modeled his world-seeing monad during the height of European imperialism and slave trade. The wealth that the bourgeoisie extracted from Indigenous territories and the labor of enslaved and indentured workers supported bourgeois intellectual life. As long as these relations were disavowed, mind could appear to be separate from body—or in Leibniz' solution, one monad could dominate other monads that supported and constituted it.

Yet an uneasy twitching at the edges of the monad's consciousness informs it of its body's efforts in the world. Bong Joon-ho's *Parasite* (Korea, 2019) is an upstairs-downstairs movie par excellence. The Kim family manage one by one to inveigle themselves into service at the wealthy Park family's home, only to discover that another family has already ensconced itself in the bowels of the house. Jordan Peele's *Us* (US, 2019) shows that the secret people underground control, but are also controlled by, their mirror images above, their bodies jerking cruelly as their counterparts move with apparent easy mastery above. Both are horror films: the horror for the wealthy of discovering that the thinnest of convoluted membranes separates them from the destitute people they exploit, and the horror for the poor people of being contorted in the folds of those membranes.

Steven Soderbergh's enjoyable *Logan Lucky* (US, 2017) is also an upstairs-downstairs movie, where it's the down-on-their-luck, unemployed working-class folk who devise an ingenious heist that involves a tunnel under the Charlotte Motor Speedway. As in other upstairs-downstairs monad movies, the working-class people's upper floors do not contain the deceiving pictures that decorate the mind-rooms of the upper classes. Clyde, Jimmy, Mellie, and their colleagues' lives are relatively analog, free of the amusements and deceptions proliferated by the digital media, and therefore also free of the surveillance that interconnects other humans. Clyde can't afford a data plan. Conversations are face to face. The speedway's concession stands use an ingenious old-tech pneumatic tube system to inhale cash and release it into

FIGURE 8.4. Still, Steven Soderbergh, *Logan Lucky* (US, 2017)

bins underground. Mellie, a nail aesthetician, shellacs cockroaches with nail polish of different colors, and the team releases the insects into the pneumatic tube system to determine the paths taken by the cash drops. Sam and Fish explode the generator that supports the credit card system, so that customers have to pay cash at the concessions. These and other adorably clever analog devices, coupled with the solidarity and upstandingness of the team, lead to success, as a volley of bills descends on the plucky subterranean conspirators. A near-perfect heist movie, *Logan Lucky*, released in the middle of Donald Trump's presidency, twinkles just a little too ardently with the desire to enfold the American working class into a "progressive" worldview, by showing that the understanding of how the world works lies with the working class.

The Monad's Guts

Some movies give the sense of navigating the interior of a body. Surfaces close in on all sides, it's impossible to see the outside, and every twist and turn leads to another enclosure. It's like swimming inside the guts of a giant creature. This is especially the case with movies that remain in interiors, often in mimicry of the theater, slightly suffocating movies where the air feels dense and humid. *Birdman or (The Unexpected Virtue of Ignorance)* (US, 2014) by Alejandro González Iñárritu is the quintessence of what I would call an intestinal movie. A movie like *Birdman*, whose insistent cinematography and few cuts give the impression of a single-shot film, traps the viewer in an almost smothering empathy. It takes place almost entirely in the cramped backstage

FIGURE 8.5. Still, Alejandro González Iñárritu, *Birdman or (The Unexpected Virtue of Ignorance)* (US, 2014)

interiors of a Broadway theater, gut-pink walls pressing close and ancient pipes dangling overhead. The small number of long-duration, complex tracking shots that conduct us through the space of this movie like an endoscopic camera confine us within its body, never permitting the moments of breath and perspective that are granted by editing.

All single-shot films, even those with plenty of outdoor views, have this interior, intestinal quality. We are inside the entrails of filmmaking, uncomfortably aware of mechanics that usually are gracefully concealed by editing, the *how* of mise-en-scène and cinematography trumping the *why* of the plot. The camera cannot freely travel to where the action is; instead, action converges on the camera, as in Sebastian Schipper's *Victoria* (Germany, 2015). *Rope* (US, 1948) is the most compressive, inverted film in the cerebral oeuvre of Hitchcock. Aleksandr Sokurov's ethereal *Russian Ark* (Russia, 2002) propels its phalanxes of characters through spaces both airy and confined, the way food passes through ever-narrower channels as it is being digested. Yes: the single-shot film yields the point of view of a turd.

Monads and Their Bodies in *Neighboring Sounds*

Intermediality, Pethö argues, is neither textual (like intertextuality) nor conceptual, but sensational. She refers to Jacques Rancière's observation that in cinema sensible and intelligible are undifferentiated, "captured in the same texture."[17] Intermediality works on us physically; it is something we feel, and

FIGURE 8.6. Still, Kleber Mendonça Filho, *Neighboring Sounds* (Brazil, 2012)

to analyze intermediality requires an embodied spectator.[18] Referring to my terms enfolding and unfolding, Pethö argues that cinema enfolds and unfolds other media: "the mediality of the moving pictures becomes perceivable ('unfolded') through interactions between the senses and between media."[19]

In Kleber Mendonça Filho's *Neighboring Sounds* (Brazil, 2012), the architectural space of the neighborhood is illegible, imposed, and divisive. *Neighboring Sounds* disorients the viewer by playing optical against haptic experiences of the space, so we cannot establish ourselves in an objective (optical) point of view. To the haptic-optical dynamic that Pethö observes in Antonioni, I would add a proprioceptive sense, that woozy gut feeling I described above.[20]

Neighboring Sounds, set in a wealthy neighborhood of recently erected luxury condominiums in Recife, Brazil, shares the intestinal quality of the single-shot films mentioned above, because so many of its scenes are compressed within the narrow confines of the buildings. The condos themselves are difficult to see: sheer white-tiled walls face the street, and the inhabitants are confined to a cramped, barely legible mise-en-scène of courtyards, lobbies, passageways, staircases, and elevators, which reach apartments whose windows open onto their neighbors' homes just a few feet away. In the film's very first scene, two cosseted children cycle and skateboard not on the street but in the compressed space of the condominium's indoor parking lot. Their privilege, the sequence indicates, results in confinement. When they pop out into a public basketball court, the children are a little bit undone; their privilege and safety come into question.

Four historical power structures are layered in the film, corresponding to feudal, sovereign, disciplinary, and control societies.[21] We are reminded frequently that much of the property belongs to Francisco Oliveira (referred to by all as Seu Francisco), also a plantation owner, and that the condos replaced modest single-family dwellings such as appear in the opening shots. Seu Francisco's son João sells real estate in the neighborhood. Property and security are front of mind for these owners, and with these comes surveillance. Security-camera videos constitute another set of cramped interior passages in the film. A group of condo owners meet in the building's blindingly clean common room to discuss how to get rid of their elderly concierge without the expense of severance pay, with the excuse that he has been sleeping on the job. Qualifying their concerns, the concierge watches João and his girlfriend Sophia embrace on the security cameras.

Neighboring Sounds' monad and its body map maps onto the class stratification of the film. The film's stultified point-of-view shots reflect its wealthy protagonists' paralyzing ignorance with regard to class power relationships. They are hemmed in by high walls and security systems; their visitors are escorted in and out like prisoners in a courthouse. The gleaming steel-walled elevators groan and rattle. The movie suggests that the condo residents' freedom and sovereignty lie in inverse proportion to their real-estate holdings.

In one scene that seems emblematic of this ignorance, a woman and her daughter are examining a prospective apartment in the condominium. A boy's soccer ball lands on a balcony and, seeing the girl peering over the railing above, he calls up to her to throw it back. She gives him a helpless shrug, not troubling to explain to him that the ball landed on the balcony below her and so she cannnot help him. The boy finally leaves in frustration. At another orifice of the complex, a plump woman carrying boutique shopping bags squeezes through a whitewashed and leafy but narrow passageway. She spurns the help of the casual concièrge—"No, I've already paid your friend"— and flicks him away with her hand, as though he were an insect, as she continues to chatter on the phone. Stunned by this dismissal, he takes revenge by key-scratching her car while his colleague is settling her into it. But what strikes me most about this scene is the way the woman must squeeze, turd-like, through the passageway.

These condo-dwelling monads receive views only from the rooftops, where João retreats between sales meetings. Seu Francisco, the ultrapatriarch, expands to fill the tastefully furnished condominium that confirms his self-view as master of the neighborhood, yet he is blind to whatever escapes his considerable penumbra. In her own reading room Bia, *Neighboring Sounds*'

FIGURE 8.7.

FIGURE 8.8.

most likeable character, gets high to numb the sensations of the neighbor-bodies that disquiet her. Her bodily universe is entirely filled by the constantly barking dog next door, the sound of security at the expense of peace. In the middle of the night she throws a steak, into which she has inserted a sleeping pill, over the fence to the dog. The next day she examines the animal's unconscious form from her window. It is only steps away, but Bia uses binoculars to peer through the slatted blinds, which underscores the gut-like membranes that barely separate neighboring properties.

Bia's and her neighbor's bodies are intimately connected by the densely folded architecture, but their minds are miles apart in their separate reading rooms. As Patricia Sequeira Brás points out, Bia and her family represent

an emergent Brazil social class "whose aspirations are converted into commodities."[22] Struggles about appliances occupy most of Bia's time that is not occupied with the barking dog and getting high. Her children are studying English and Chinese, fixed on academic and financial success that will maintain the family's position. With an eye to survive in the power-by-modulation of neoliberal capitalism, they are translating themselves into the terms of the information fold.

Only the security team who negotiate passages into and from the neighborhood have a sensory and epistemic grasp of the space as a whole. Their leader Clodoaldo inveigles himself into the neighborhood with smooth assurances to some of the condo owners. Militia-style, they occupy the street. The team takes on the task of monitoring the flow of working-class and undesirable people to the neighborhood—the music seller with his cart, the water deliveryman who also sells weed, the barefoot boy from the favela, the well-dressed couple who park so the woman can vomit. The security team becomes a new vinculum, encircling the neighborhood. Yet Clodoaldo and his brother embody and possess the knowledge of historical colonial violence that the wealthy inhabitants repress, but that will explode in the film's last minutes. This uneasy knowledge is sensed, rather than stated, throughout the film's queasy and cramped duration.[23]

The Monad's Mortgage

Leibniz argues that the dominating monad necessarily has clearer perceptions than the dominated monads, and thus has greater perfection. To understand this, we must examine Leibniz's conception of causality, which is quite queer to modern eyes. A dominating monad, such as a human mind, doesn't actually *cause* its dominated monads to do anything—in the example Lloyd Strickland gives, to walk to the refrigerator, open it, and get a cool drink. Rather, the dominated monads are *included* in the dominating monad's predication. To Leibniz's thinking, this is the perfection of the universe at work: the dominating monad, with a clear perception of its desire, summons the dominated monads, who perceive the reason for their actions only confusedly. God, Leibniz argues, has organized the universe so perfectly that every monad is accommodated to every other, so that when I want a cool drink, all my dominated monads—legs, arms, blood vessels, and so forth—cooperate to get it for me. Or, in the wonderfully perverse sequence in the opening credits of *Downton Abbey*, the wealthy nobility in their upstairs salon press buttons that activate bells in the servants' quarters below, sum-

moning a servant to come do their bidding. The people upstairs understand the reasons for their summoning—to bring refreshments that will facilitate a land purchase, say—but the workers downstairs don't. It's the dominating monad that has the clearest perception.

Needless to say, Leibniz's confidence in the rightness of the dominating monad's actions is one of the elements that get binned when we open up his closed cosmology. Now, as I argued in "Soul-Assemblages," the vinculum that assigns possession of some monads to others is always up for question. Yet the neighborhood studies in this chapter show that it is enormously difficult for one monad to extricate itself from the assemblages of which it forms a part and create alternative ones. In a queasily earthy iteration of the soul-assemblage, we are stuck together like folds in an intestine, our skins shared with the skins of others, who turn out to be parts of us, living a few bends away.

In very few cases the relationships are harmonious and healthy for all. Sometimes it is a question of rearranging one's position in a soul-assemblage in order to enjoy a more nourishing flow of giving and receiving with the other souls in your assemblage, as in *Félicité*. Sometimes the dominated monads devise clever ways to turn their domination inside out, as in *Logan Lucky*. In *Neighboring Sounds*, vengeance for unforgotten violent exploitation turns the vinculum inside out. And in the rare and beautiful case of *The Inheritance*, a group of people and their nonhuman allies enfold themselves in a vinculum of their own careful design, creating a safe enclosed microcosm in which to nurture collective action.

But what about those monads who both suffer and benefit from their connections to others? Here a class analysis returns, as well as the questions of human domination of nonhuman beings. This question brings back Appadurai's point, which I mentioned in "Soul-Assemblages," that human mediants mediate the force of other members in an assemblage. The health or sickness of an assemblage points to the role of its human mediants. Real estate agents, financial traders, and old-style patriarchs like Seu Francisco are such mediants, maintaining conservative soul-assemblages that extract resources from other human and nonhuman souls that they dominate. Skillful interlopers like Clodoaldo and the heist team of *Logan Lucky* are mediants in soul-assemblages that deterritorialize, tearing open the old vinculum.

Neighbors who own the mortgaged homes they live in, like Bia and me, have only small degrees of room to maneuver in the compromised soul-assemblage of the neighborhood we live in. We exploit and are exploited, reinforce our bodily boundaries and endure the incursions on them. It may

be healthier to retain a light hold on one's neighborhood and be ready to join soul-assemblages that are more maneuverable—after my friend Janine, all-of-us-chumps soul-assemblages.

Jennifer Fay points out that the protagonists in film noir tend to be renters. They exempt themselves from the system of property ownership, but they know their neighborhoods intimately. "As renters, as people who nimbly navigate the urban world (so often they run through streets and dark alleys) and suffer its bad air and corrupt environment, they have a decidedly ecological relationship to the city. They dwell in the city's logic and understand its infrastructure, living and dying intimately connected to the quirky space." Fay connects this light hold on property to Michel Serres's concept of *cosmocracy*, in which humans treat the Earth in terms not of ownership but of tenancy, as a Hotel for Humanity.[24] Living ethically in our cosmic neighborhood, we would invite the vines to twine and the critters to thrive. Nobody and everybody would be an interloper. Human and nonhuman refugees would be welcomed into flexible soul-assemblages. Adapting the slogan of the migrant justice movement, no one would be illegal.

I embrace the beautiful goal of cosmocracy. It aligns gracefully with the aspiration of the cosmic soul-assemblage that I've described: a soul-assemblage that comodulates with, rather than dominates, the cosmos and maximizes the thriving of each of its ensouled bodies.

Still, concluding this chapter about living tightly bound in material, social, financial, and information folds not of our choosing, I have to tell you another of my favorite soul-assemblage genres is the one where people fake their deaths, disappear, and begin a new life somewhere else, free of all the connections that held them.

Recognizing Other Edges

The simple cosmology proposed by this book has suggested that our cosmos consists of a single, infinitely folded and internally differentiating surface. What appear to be separate points are the peaks of folds. Those peaks, I've argued, are what Leibniz called monads: connected souls bordered by bodies. Each of them lives on a continuum: souls on the inside of the fold, bodies on the outside. Monads thus doubly connect to the cosmos. I go to some trouble to argue that almost every entity, human and nonhuman, organic and inorganic, even ideas and processes, is bounded and therefore living. I revive the old term soul, not to suggest a transcendent spirit but to emphasize that each monad is a temporary, private enclosure of the cosmos. All of these ensouled bodies are connected on the cosmic fold, but I propose the concept of soul-assemblage to describe strong connections: groups of monads that gather to do things. Soul-assemblages, functioning as single monads, may conserve existing orders, willfully or willy-nilly, or they may break from the dominant folds, in local ways or cosmically.

In the ceaseless process of cosmic unfolding, things get complicated by the additional foldings performed by information, as my three-ply model of unfolding from the infinite demonstrates. I've suggested ways to detect folds and manners of unfolding and to perform acts of unfolding and enfolding. Enfolding is an important strategy for protecting the temporary enclosure from hostile or premature unfolding, including the capitalist unfolding that translates experience into fungible value. Here aesthetics steps in, as I propose we humans can train our bodies and senses to detect, resist, and create alternatives to the ways information prefolds experience. Information technologies ever more efficiently capture pieces of the infinite, for mostly

rapacious purposes. As I explained, I am less worried than some about the ways information capitalism preempts perception, but very concerned about the destructive environmental effects of information technologies.

In the first chapter of this book I demonstrated that the virtual is not an amorphous blob but is immanently structured, along the lines of Bohm's implicate order. What seems indistinct is not formlessness but virtuality, points of folds that hint at immanent connectivity. This is why it's important to develop capacities to detect moments of actualization and align with them, that is, unfold them. It may be some form of affect that gets you there; it may be perception; it may require cultivating empathy; it may take research. In every case unfolding requires rhythm and a sense of timing: in other words, style.

The Fold has offered a number of practical methods for doing philosophy that begin with the body: enfolding-unfolding aesthetics, affective analysis, fabulation, and manners of unfolding and enfolding. I've argued that it is possible to align our soul-assemblages with the cosmos, in a modest and healthy way of living within the Earth's carrying capacity rather than seek unsustainably (and in the long run, impossibly) to dominate the cosmos. Several chapters, animated with stories and movies, demonstrate practical ways to feel along with nonhuman entities, deploy folding as a research strategy, detect toxic folds, and unfold differently. I hope you have enjoyed them and felt inspired to incorporate some of these methods and concepts into your own practice.

I conclude with some thoughts on contours, edge-recognition software, and the politics of figure-ground distinction. Boundaries are temporary folds in the continuum. Rather than argue that all is open flux, I've argued that boundaries are important, for they constitute the interior of a monad, its private reading room where it selectively takes in the world, ruminates, and prepares to act. The monad is a microcosm, a curated unfolding of the cosmos to a point of view.

Lately in Vancouver, as in many places around the world, it's been hard to see clearly in the summers because of the smoke blowing south and west from terrible wildfires. The thick air hurts our eyes and travels uncomfortably into our lungs. Our planet is in pain, and so are we. At a meeting in September 2020 called "Light in Dark Times," hosted in San Francisco during the devastating California wildfires but held over videoconference, Abby Chen related that an artist she knew had characterized this thick, smoky air as the new light. We talked, Abby, my friend Tarek Elhaik, and others, each of us from our little box with different amounts of brown haze in the background, about the connection between smoke, *sfumato*, and intimacy. *Sfumato*, smo-

kiness, is that hazy contourlessness that suggests forms but asks the beholder to complete them.[1] It makes perceptible the fact that beings are not separate. Sfumato and similar techniques "encourage the ripening of the semi-visible image in the observer."[2] They are techniques of haptic visuality, with all its disturbing qualities of drawing beholders close and questioning where their edges end and others' begin. Another technique is the proliferation of detail: when there are so many entities in the visual field that your eyes cannot choose one but continue to restlessly explore. This proliferation occurs in networked algorithmic media too: as they travel and gain connections, their detectable surfaces scumble.[3]

Edge Recognition

Anne Rutherford beautifully invokes how the invisible animates the visible. She asks where, in the figure-ground distinction, does figure end and space begin. In certain artistic forms like sfumato and haptic cinema the difference is blurred. Cinematic mise-en scène, Rutherford writes, is "dynamic, material and embodied," and the films that interest her "all move in and out of scenes in which spatial composition, mobile camera, cinematography and/or cutting work to maximize the dynamic integration of space and body, figure and ground."[4] Her wonderful descriptions include a rainy fight scene in Wong Kar-Wai's *The Grandmaster* (Hong Kong, 2013). Filming in high-frame-rate slow motion results in "raindrops elongated into a moving thatch of white streaks, pools shimmering with an uncanny movement and crystalline splashes that capture the precise trajectory of water across the frame." Wong's visual practice, Rutherford suggests, builds on a long tradition in East Asian cinema of animating the air, expressing *qi*. "Qi becomes a haptic register of dynamic energy flow given material form, rendered visible through the confluence of water, light, and movement."[5] *Qi* is one name for the immanent infinite, an implicate order that is invisible as such but active and ever-moving. Even in the absence of such edge-blurring techniques, the beholder's embodied attention can unfold some of that invisible implicit structure.

Feminine glamour in movies is often a Trojan horse for the diminution of figure-ground distinctions. Rhinestones, satin, marabou feathers, and other feminine accoutrements dazzle the eyes, blur boundaries, and render figures fugitive. Images that oscillate between haptic and optical have a disarming fascination; they are the essence of glamour. Think of Marlene Dietrich in *Shanghai Express* (Josef von Sternberg, US, 1932), her face veiled

in mesh, a feathered stole hovering around her; or Asmahan, her beautiful face encircled by cloudlike wisps of cigarette smoke. Shimmer, texture, flutter, and dazzle create a haptic-optical dance of revealing and concealing that pulls a viewer close only to rebuff them.

Glamour replaces stasis with process, as Fiona Matthews, a dancer, describes in a famous dance sequence from *Top Hat* (Mark Sandrich, US, 1935):

> Rogers' gown is practically drowning in delicate ostrich plumes as Astaire sweeps her around the soundstage. The plumes loft up around Rogers with only the slightest of drafts, making visible what otherwise would be imperceptible. They sensuously, angelically wrap themselves between Astaire's legs as the two waltz around their private arena. Most compellingly, the feathers are perpetually one moment behind Rogers' movements, blurring the images of where she was and where she is. Isolating any one frame from this number, one would see a record of Rogers' physical orientation in that given moment, as well as a record of the overall kinetic pathways of the action, thanks to these feathers. In this way, the material nature of the feathers "gives body" to the air, just as [in Rutherford's account of *The Grandmaster*] Wong's raindrops did, and even begins to give body to a kinetic history.[6]

Glamour blurs the difference between where Rogers begins and where she ends, where she was and where she's going.

At the risk of introducing a new concept in the very last pages of the book, I'd like to suggest that glamour, in its dazzlement of enfolding and unfolding, is apotropaic: it wards off evil. In many cultures, a way to keep away devils is to distract them with a complex knot or complicated pattern. The devils (or other malfeasants) pause to try to figure out the pattern while you run to safety. Comparably, Alfred Gell argues that complicated patterns on Trobriand war canoes are intended to stymie the enemy's cognitive capacities.[7] Patterns that are a little bit too hard to understand, Gell argues, are "sticky": we become attached to them and cannot stop gazing at them. Bedazzlement toys with visual mastery, sometimes in a magical dynamic between optical and haptic, mastering and disarming.

Given that our faces and their varying moods are increasingly subject to instant recognition both online and in places equipped with surveillance cameras, it is great that face masks are in fashion again. Designs by Hussein Chalayan, Alexander McQueen, Gareth Pugh, and others, as well as style tips from our *niqab*-wearing sisters, suggest elegant ways to disguise our identities and expressions. Taking a page from cinematic glamour to evade

FIGURE C.1. María Angélica Madero, *Camouflage for anti-facial recognition for quarantine surveillance* (Colombia, 2020)

capture, light-emitting eyeglasses, Adam Harvey's cv dazzle and Hyperface techniques, and numerous other anti-surveillance designs effectively confuse facial recognition algorithms when their wearers use camera-equipped devices or sally forth in surveillant RL.[8] María Angélica Madero's camouflage filter parries prying social media algorithms.

An informatic opacity, in Zach Blas's term, resists the information fold's practices of capture.[9] This magic is not only visual but cognitive: it's the semblance of encryption that fascinates. Glamour, then, is a manner of unfolding that unfolds partially to bind the receiver's attention and draw the receiver disarmingly into its play of unfolding and enfolding.

Contours may be not outlines of a figure but records of acts of perception, like an artist's rendering of a dancer or a cloud. A contour is like the membrane that holds a soul together. A contour marks the site where an object disappears from view: it is both decisive and melancholy. It records a decision about where the boundary exists, the extraction of an edge.

As I emphasized in chapter 4, information's selection from the infinite loses the connective tissue between things. Even before algorithms, the information fold filters the perceptible world through conventions and clichés, making it more difficult to receive the infinite to perception. Perception quickly gives way to cognition, and cultural connotations become soft-wired into perception.

Optical technologies of edge recognition are one of the ways information preempts unfolding. Many compression algorithms, such as those used to

shrink the file size of streaming media, privilege edges. They are based on wagers that if the borders of figures are sharp, viewers won't be too bothered by the paucity of detail elsewhere. Recognizing edges is also important to surveillance and facial-recognition software. Edge-recognition programs automate the optical visuality that I have critiqued, in an argument that Rutherford amplifies powerfully here.

Those sawtooth haloes of gradated hues in a compressed video, termed ringing or the Gibbs phenomenon, replace a color field with a set of nested outlines. Ringing results from Fourier analysis, a descendant of Leibniz's calculus, which represents a discontinuity with a finite number of coefficients. Marek Jancovic writes that Fourier analysis' "uncanny ability to refract the world into its components and extract rhythm and periodicity from chaos had serious cosmological consequences," making the infinite graspable by quantifying it.[10] It is moving to find that that these and other compression artifacts arise from the discrepancy between calculus' assumption of infinity and the physical finitude of signals. This enfolding of cosmic quantification into the video signal, I note with a sigh, reduces streaming videos to a healthier file size.

Image-recognition algorithms create operational images. In the case of video compression, they create images intended not for contemplation but as pieces in a transaction, such as an internet service provider agreement. In the case of surveillance, they diagnose opportunities and threats and draw lines around them, in images legible to other machines. In either case, what appear to be figures are information folds: they unfold not from the infinite but from information. Demarcating things allows their commodification: if you can draw a line around it, you can sell it. "Of interest to Facebook are the so-called edges, the interactions between users that indicate affective distances between objects" and thus enable the algorithmic commodification of a user.[11] But it is possible, both perceptually and more abstractly, to unfold the infinite around and despite those conventions. Mirror-touch synaesthetes are able to get in touch with a larger piece of the infinite by completely responding to the perceptible with their bodies.[12] Folks who do not have this neurological capacity can cultivate embodied empathy in practiced acts of perceptually staying with the infinite.

Edge-recognition programs and human perceptual conventions mistake the visible field for the surface of the infinite. They unfold not singular points but ordinary points, to bring back the terms of topology theory. They miss the invisible energies and immanent structures. Lingering below the threshold are the most important boundaries: the ones that assemble souls. (Or if, at this late stage in the book, you still don't like the soul concept, boundaries that

temporarily enclose a heterogeneous group of beings that come together to do something.) With enfolding-unfolding aesthetics it's possible to peer around the edges of the information fold and discover the infinite at work.

Small-file movies taught me that compression can be soulful. They use compression algorithms artfully, whether to render the visible as clutches of soft and approximate images or crisp patches of pixel blocks or to build up edges so laughably thick that they become figures of their own, galumphing across the screen. Tactfully apologizing for their optical inadequacy, small-file movies also point proudly to the infrastructure that supports them. They acknowledge, as I wrote earlier, all the souls involved in their creation and their transport to the beholder's eyes, including artists, networks, energy sources, and the compression software itself. Leaning in, the audience becomes part of the assemblage. Small-file movies are healthy microcosms, and contemplating them is practice for discovering the infinite in the seemingly limited.

This book has celebrated a line that strives for freedom: the skein of the deterritorializing soul-assemblage, heading for the stars. Elsewhere I propose that contemplating abstract lines in art can train a viewer to embody this kind of freedom.[13] Both kinds of line depart from known territory to follow a vector of thriving. One is visible, the other is the ontological contour of a fold.

Many of us put our hopes on the line. Tim Ingold proposes that lines not only instrumentally connect points but also trace the path of an uncontained life. Cubitt suggests that a free line, open to the future, can model democracy and ward off fascism. I've suggested that abstract lines can channel forces of individuation.[14] This is a lot of pressure to put on a line or a space. "Never believe that a smooth space can save us," as Deleuze and Guattari write;[15] nor an abstract line. There's a long and treacherous history of linking form to ethics.

And yet—to practice with one's body breaking down closed-down meanings, regimented forms, and oppressive laws constitutes a temporary respite, a truce between powers of liberation and powers of control. It releases energies for new struggles. In the realm of perception abstract line and haptic space model manners of unfolding in opposition to dominant folds. They can train our bodies, help us become better grounded, and prepare us to unfold differently. Aesthetics can model ontology, as my funny diagrams suggest. It can point a way toward ethics.

A haptic image is not formless but populated: it is a field of folds. One of the main findings of this book is that a field that appears homogeneous turns out, when you look, listen, feel, or think closer, to be composed of a throng

of individual entities, monads of all sorts. If you draw near you can figure out which ones to unfold. I've suggested that even the obdurate large-scale folds of culture and ideology, which I've called information folds, are aggregations of many unique unfoldings. They are enfolded or implicate in the larger field. They are virtual from certain points of view and actual from others.

Enfoldedness is what gives shimmer to the virtual: the attractive twinkle of countless enfolded points gleaming on the surface of the infinite, each of them a microcosm. Respecting the opacity of these shimmering points, it's important to determine whether they are yours (singular or collective) to unfold, and when is the propitious time to do it. Sometimes it's more appropriate to honor the haze.

Visually and sonically, that haziness has the effect of haptic space and haptic sound: a proliferation of individual elements composes a whole that doesn't resolve into a figure but keeps moving and transforming. Those individual entities throng, coalesce, and diverge, forming soul-assemblages that may reaffirm or contest dominant folds. If you accept that each of those monads incorporates all the others—selectively, in its own way—then you see that each point in the teeming field is a microcosm, a condensation of the whole event. As each of those smoky particles in my lungs condenses the burning trees, the animals consumed by the fire, and the many causes of the heat and dryness that include the world's reliance on fossil fuels, the Canadian government's ruinous subsidies of the fossil-fuel economy, the energy corporations, the individual shareholders who make money from them, the pension funds that invest in them, and the individual pensioners who retire more comfortably because of that money. The forest fire soul-assemblage contains a multitude of souls, some of which both benefit and suffer from the harm. No wonder our smarting eyes fill with tears.

As Appadurai's concept of mediant reminds us, it is possible to identify the human agents of sick-unto-death assemblages. And it is possible for some of the souls in that assemblage to extricate themselves and form healthier soul-assemblages. A large proportion of Canadian investments is held by pension funds. Overall, in the last ten years Canadian pension funds massively divested from fossil-fuel holdings; and yet fossil-fuel investments actually increased since Canada signed the Paris Climate Accord in 2016.[16] One of the regulations necessary to make divestment meaningful would be for the federal government to redefine the fiduciary duty of pension plan managers to take into account the externalities of climate science and Indigenous rights.[17] Such true-cost accounting would only happen under the pressure of a diverse activist soul-assemblage. Pension plan managers are

mediants whose decisions determine how easily we pensioners can rest on our burning mattresses. If they're required to divest from companies that are toxic to the Earth and the Indigenous peoples who understand it best, then our collective health stands a greater chance.

The edges of soul-assemblages that matter politically are often drawn by corporate, government, and imperial interests. But those edges are always shifting according to the restlessness of the enclosed elements. I don't mean this to sound too cheery but to point once again to the ways soul-assemblages can deterritorialize existing folds. Activist soul-assemblages strive to create their collective boundary in a way that makes them effective as an assemblage—in the case of climate activism, a cosmic soul-assemblage—and good for expanding the soul-capacities of all their monad-members.

The unity of the cosmos is rarely beautiful, certainly not static, but ever inflecting anew as each restless soul uniquely embodies it. The political act is to recognize the effects of the soul-assemblages to which we belong and to take part in unfolding differently.

CHAPTER 1. LIVING IN A FOLDED COSMOS

1 A cosmic image I first introduced in *Touch*, ix. I was inspired by the baker's transformation in mathematics, mentioned in Deleuze, "Mediators," 124.

2 Walid El Khachab, presentation to Substantial Motion Research Network, April 30, 2022. El Khachab is taking up an argument I made long ago in "Video Haptics and Erotics."

3 Deleuze and Guattari, *A Thousand Plateaus*. Spinozan Marxist A. Kiarina Kordela proposes that capitalist modernity constitutes the plane of immanence we occupy now, and that its immanent process converts substance into value. Kordela, *Epistemontology in Spinoza-Marx-Freud-Lacan*.

4 Bohm and Hiley, *The Undivided Universe*, 58.

5 Leibniz, *The Monadology*, §56, in Strickland, *Leibniz's Monadology*, 119.

6 "The actual image and its virtual image . . . constitute the smallest internal circuit, ultimately a peak or point." Deleuze, *Cinema 2*, 73.

7 Deleuze, *The Fold*, 58.

8 Deleuze has been unfairly criticized for the seeming Platonism of the concept of univocity of being. He would have been helped by the argument of Ṣadr al-Dīn al-Shīrāzī (1571–1640), who posited that existence is a process of systematic ambiguity or modulation (*tashkīk al-wujūd*, the modulation of being), and being is predicated by modulation, not univocity. Ṣadr al-Dīn al-Shīrāzī, *Asfār*, edited by M. Riḍā al-Muẓaffar (Tehran, 1378), I:433, in Rizvi, *Mullā Ṣadrā and Metaphysics*. I relate Ṣadrā's modulation of being to Deleuze's disjunctive synthesis in Marks, "Lively Up Your Ontology."

9 See, for example, Marks, *Enfoldment and Infinity*; "A Deleuzian Ijtihad"; and "'We Will Exchange Your Likeness.'"

10 Fuller and Goriunova, "Devastation."

11 Peirce, "Man's Glassy Essence," *Collected Papers*, 6.268.

12 Carr, *A Theory of Monads*, 22.

13 Ruyer terms this self-proximity or auto-affection. See Grosz's survey of Ruyer in *The Incorporeal*, chapter 6.

14 *Synechism* is Peirce's term for this indexical interconnection among all entities: in his case, the interconnection among all signs, in a cosmos composed only of signs.

15 Pandian, "Love," in *Reel World*, 93.

16 See, for example, Leibniz, *The Monadology*, §31–39, in Strickland, *Liebniz's Monadology*, 20–21. Deleuze, "Sufficient Reason," *The Fold*, 41–58. Similarly, for Whitehead, when an entity gets prehended, its grasp of the universe may potentially be prehended.

17 This respect for the interior infinity of objects sounds similar to object-oriented ontology but is quite distinct. While OOO respects the autonomy of objects as separate, I interpret their autonomy as the maintenance of connectivity in a state of latency.

18 MacCormack, "Becoming-Vulva," 99.

19 Whitehead, *Process and Reality*, 41, 88.

20 Deleuze, *Expressionism in Philosophy*, 11.

21 I undertake a similar exercise in an investigative love letter to a certain rock. It is an example of how research—here in geologic history—and experimentation can unfold monads and learn about the cosmos from their point of view. Marks, "Object Lesson: My Rock," 503–5.

22 Braidotti, "A Theoretical Framework for the Critical Posthumanities," 32–33.

23 Peirce, "The Law of Mind," *Collected Papers* 6:158.

24 Rescher, *Process Metaphysics*.

25 Bohm, *Wholeness and the Implicate Order*, 14.

26 Bohm, *Wholeness and the Implicate Order*, 67.

27 Bohm, *Wholeness and the Implicate Order*, 181. Bohm emphasizes that both relativity and quantum theory are provisional accounts that will have to evolve.

28 Grosz, *The Incorporeal*.

29 Deleuze, "Bergson, 1859–1941," 31.

30 Friedman and Schäffner, *On Folding*, 23.

31 Friedman and Schäffner, *On Folding*, 20–23. In 1996, Murray Gell-Mann proposed *plectics* as a name for the interdisciplinary science of complexity, in "Let's Call It Plectics."

32 Deleuze's paraphrase of Duns Scotus in *Difference and Repetition*, 36.

33 Deleuze, *Difference and Repetition*, 37.

34 As Steven Shaviro notes, there is a tension in Deleuze and Guattari's work over how the process of actualization happens. Is it the result of conatus (from Spinoza) or autopoiesis (as in Varela), which emphasize how entities endure as they interact with their environment? Or is it individuation, from Simondon and Whitehead, which emphasizes novelty over endurance? Shaviro, *Without Criteria*, 112n7.

35 Simondon, "The Genesis of the Individual."

36 Simondon, "The Genesis of the Individual," 310; emphasis in original.

37 Braidotti, "Conclusion."

38 Iqbal, *The Reconstruction of Religious Thought in Islam*, 12.

39 Nail, *Theory of the Earth*.

40 Leibniz gives this definition in the *Corpus hominis*. Arthur points out that he derives the concept of conatus from Hobbes. Arthur, *Monads, Composition, and Force*, 174.

41 Hongisto, *Soul of the Documentary*, 35 and 141n35, referring to Aristotle, *De anima*, books 2.1 and 2.2. I will challenge the Aristotelian contention that matter does not have soul.

42 Arthur, *Monads, Composition, and Force*, 127.

43 Leibniz, *Sämtliche Schriften und Briefe*, cited in Arthur, *Monads, Composition, and Force*, 165.

44 Smith, "Genesis and Difference," 142.

45 Leibniz, *Discourse on Metaphysics and Other Essays*, §9, 9.

46 Arthur, 117. The first quotation is from Arthur, the second from Leibniz, *Sämtliche Schriften und Briefe*, series II, volume 1, 113.

47 This is the case with Bergson and Whitehead too. There is a point of view so inextricable to a thing, Deleuze writes, that "the thing is constantly being transformed in a becoming identical to point of view." Deleuze, *Cinema 2*, 146.

48 Viveiros de Castro, "Cosmological Deixis and Amerindian Perspectivism."

49 Strickland, *Leibniz's Monadology*, 92–93. This concept is rooted in Avicenna's argument, transmitted via Thomas Aquinas, that the whole series of contingent entities must depend on an ultimate noncontingent entity, namely God. Fakhry, "The Ontological Argument in the Arabic Tradition," 8–9.

50 Leibniz, *The Monadology* §61, in Strickland, *Leibniz's Monadology*, 127.

51 Leibniz, *The Monadology* §60, in Strickland, *Leibniz's Monadology*, 125.

52 Arthur, *Monads, Composition, and Force*, 138.

53 Deleuze, *The Fold*, 120.

54 Leibniz, "Philosophical Essays," 207 cited in Look, "Leibniz's Metaphysics," 104.

55 Leibniz, *The Monadology* §29, §30, in Strickland, *Leibniz's Monadology*, 82–83.

56 Russell's critical study of Leibniz supplied all the ingredients that Whitehead would take up some years later. One of his solutions to make a monadic cosmos immanent, not transcendent, was to argue that relations are not ideal, subsisting in the divine mind, but real. See Bertrand Russell, *The Philosophy of Leibniz*; and Basile, *Leibniz, Whitehead and the Metaphysics of Causation*, 27.

57 Basile, "Herbert Wildon Carr," 383–84.

58 Like all histories, the history of philosophy is mostly enfolded. Why certain thinkers continue to be acknowledged, or get rediscovered, likely owes a lot to arbitrariness, politics, and laziness. When I chanced upon Carr's book in the philosophy section of Powell's Bookstore in Portland, a mecca for secondhand books, in April 2019, I took it as a clear signal. Inspired by Bergson, Leibniz, and the new discoveries of physics, Carr looked to be my fellow traveler— especially when he declares in the first few pages that all substance consists of experience, in fact infinite numbers of ever-changing experiences. I would

grab the book and see how his findings paralleled those of thinkers who survived the next hundred years, such as William James and Alfred Whitehead. But Carr's contribution has been forgotten. Carr was no underdog. He translated Leibniz, published eighteen books of philosophy, and taught at King's College, London and at the University of Southern California. He was a public intellectual, too, publishing sheaves of reviews of books, art, and performances. Yet Wikipedia doubts that he is notable enough to include. Carr's ideas are now quite enfolded—not gone but become very small. This copy of *A Theory of Monads*, published in 1922, is being avidly prehended by mildew. A thousand mildew-monads make me sneeze. I understood my encounter with this now-forgotten philosopher as a *memento mori*.

Yet it is no melancholy exercise to unfold the community of scholars who engaged with Carr's work. As a fellow member of the Aristotelian Society, Carr would have been Whitehead's interlocutor in their shared interest in Leibniz and Bergson. Whitehead adopted Carr's term "solidarity" to characterize the universe as a solidarity of actual entities (*Process and Reality*, 40). Another is the Indian philosopher C. T. K. Chari (1909–1993), who argued for links between quantum theory and psi phenomena. And another is Carr's contemporary Hilda Oakley (1867–1950), who also anticipated Whitehead in her argument that the world is constituted by cumulative acts of creative memory.

59 (Nor do monads float like bubbles in Francisca da Silva's mop bucket, though it remains a beautiful metaphor.) Carr, *A Theory of Monads*, 46. See also Basile, "Herbert Wildon Carr."

60 Carr, *A Theory of Monads*, 52–53, 55.

61 Carr, *A Theory of Monads*, 57.

62 D. H. Lawrence evidently absorbed his British contemporaries' theories that the monad encompasses the entire world. In the steep Italian hillside town of San Tommaso, near which he lived in 1912–1913, he encounters a woman spinning yarn on the church terrace. From her incurious responses to his questions, Lawrence gains the impression that "She was herself the core and centre to the world, the sun, and the single firmament. She knew that I was an inhabitant of lands which she had never seen. But what of that! . . . The lands which she had not seen were corporate parts of her own living body, the knowledge she had not attained was only the hidden knowledge of her own self. She was the substance of the knowledge, whether she had the knowledge in her mind or not. There was nothing which was not herself, ultimately." Lawrence, *D. H. Lawrence and Italy*, 24–25. I thank Rick Coccia for reading this passage to me.

63 Carr, *A Theory of Monads*, 252.

64 Geoffrey C. Bowker also makes this Leibniz-Bohm connection in "A Plea for Pleats," 125.

65 Arthur, *Monads, Composition, and Force*, 296.

66 Bohm, *Wholeness and the Implicate Order*, 188; emphasis in original. Pylkkänen construes Bohm to argue that each entity enfolds not the universe

but information about the universe, as light waves enfold information that is unfolded by the eye. Pylkkänen, *Mind, Matter, and the Implicate Order*, 19.

67 Bohm, *Wholeness and the Implicate Order*, 189. This example inspired my earliest iteration of enfolding-unfolding aesthetics in Marks, "Nonorganic Subjectivity."

68 Bohm and Hiley, *The Undivided Universe*, 31–32. The reason the quantum potential does not change, they explain, is that the quantum field, ψ, occurs in both the numerator and the denominator of its equation.

69 Bohr, *Atomic Physics and Human Knowledge*, 17–19. Faye and Jackstad explore further whether Bohr held a realist attitude in "Barad, Bohr, and Quantum Mechanics," 8231–55.

70 Bohm and Hiley, *The Undivided Universe*, 39.

71 Bohm and Hiley, *The Undivided Universe*, 24.

72 Bohm and Hiley, *The Undivided Universe*, 41.

73 Bohm and Hiley, *The Undivided Universe*, 25–26.

74 Bohm and Hiley, *The Undivided Universe*, 36. As mentioned, Bohm and Hiley's concept of information, which they call "active information," derives not from the information theory associated with Claude Shannon but from the Aristotelean idea of something that gives form, as form in-forms matter. However, this is not Aristotelean hylomorphism, where matter is mute and passive until form shapes it.

75 Bohm and Hiley, *The Undivided Universe*, 37.

76 Bohm and Hiley, *The Undivided Universe*, 39.

77 Gell-Mann, "Let's Call It Plectics," 96. The term has had some traction in art and architecture theory.

78 Bohm and Hiley, *The Undivided Universe*, 339–41, on Gell-Mann and Hartle, "Quantum Mechanics in the Light of Quantum Cosmology," 321–43.

79 Bohm and Hiley, *The Undivided Universe*, 38.

80 Another was Louis de Broglie, whose pilot-wave theory was brusquely rejected in 1927 by Pauli at the famous Solvay Conference. In 1952, Bohm revived it and provided a response to Pauli. Strikingly, at that point twenty-five years later, de Broglie recommenced work on the pilot-wave theory. Bohm and Hiley, *The Undivided Universe*, 39.

81 Wing, "Translator's Introduction," xii.

82 Glissant, *Poetics of Relation*, 78.

83 Glissant, *Poetics of Relation*, 78.

84 See, for example, Marks, *Enfoldment and Infinity*, chapters 3–5; and Belting, *Florence and Baghdad*. Tarek Elhaik finds this enfolded heritage of Islamicate plastic arts and philosophy in the beautiful walking cogitation "Ibn Rushd/Averroës in Mexico City's Kiosko Morisco."

85 Gell, *Art and Agency*, 80–82.

86 Curiel, "Leather Trunk," 161. An art historian might demur that the foliate forms are simply performing their traditional duty of space filling, or that the animals are eating them, and not speaking them.

87 Glissant, *Poetics of Relation*, 79.

88 Wing, "Translator's Introduction," xiv.

89 Glissant, *Poetics of Relation*, 124–25.

90 Glissant, *Poetics of Relation*, 123, 124.

91 Bohm, *Wholeness and the Implicate Order*, 62; Ṣadrā, *The Book of Metaphysical Penetrations*, 37.

92 Bohm and Hiley, *The Undivided Universe*, 326.

93 Barad, *Meeting the Universe Halfway*. Barad looks to Niels Bohr, I to Bohm, for problems and solutions in quantum physics that can be generalized. Barad adapts Bohr's majority position in quantum physics, according to which positions of particles at the quantum level are indeterminable. I adapt Bohm's minority argument that these positions are determinable according to an implicate order, as we've seen. Nail, in *Theory of the Earth*, terms our present era the kinocene because these foldings have accelerated, and with them environmental devastation. Ivakhiv, *Shadowing the Anthropocene*.

94 Deleuze, *Difference and Repetition*, xxi.

95 Nail, *Theory of the Image*, 53.

96 In physics, most systems behave independently, not only in the classical limit, but also in most quantum situations. The equation for the quantum potential can be expressed as the sum of two (or more) terms, proving that the two (or more) systems behave independently. Even though the universe is a whole system, we can usually analyze its parts separately. Not everything is subject to the butterfly effect. Bohm and Hiley, *The Undivided Universe*, 58–62.

97 Other case studies of enfolding-unfolding aesthetics include Marks, "Experience—Information—Image," "Noise in Enfolding-Unfolding Aesthetics," and *Enfoldment and Infinity*, and my 2019 film with Azadeh Emadi *Gerard Caris: Unfolding from Pentagons*.

CHAPTER 2. SOUL-ASSEMBLAGES

1 Hoffmeyer, *Biosemiotics*. On cell membranes see also Nail, *Theory of the Earth*, 140–46.

2 Deely, "Building a Scaffold."

3 Withdrawal is a shout-out to object-oriented ontology, opacity to Glissant. The private constitution of the soul is comparable to the process of concrescence that Whitehead describes, in which an actual entity undergoes a private meditation, or subjectivation, in the course of selectively prehending its corner of the universe.

4 Ivakhiv, *Shadowing the Anthropocene*, 63.

5 Leibniz, *The Monadology*, §67–68, in Strickland, *Leibniz's Monadology*, 133.

6 See Halperin's beautiful essay on body stones, "Physical Geology/The Library," 79–84.

7 Kimmerer, *Braiding Sweetgrass,* 55. I thank Denise Oleksijczuk for this connection.

8 Organism, in Whitehead's term. Deleuze, *The Fold,* 78–79.

9 Deleuze, *The Fold,* 98.

10 Kimmerer, *Braiding Sweetgrass,* 54.

11 That is why it takes so long to finish writing a book: each idea unfolds others, which unfold others. Schwebel, "Intensive Infinity," 604n40.

12 Hongisto, *Soul of the Documentary.*

13 Deleuze and Guattari, *A Thousand Plateaus*; Wise, "Assemblage," 91–102.

14 Deleuze, "What Is a Dispositif?" in *Two Regimes of Madness.* I am grateful to John Roberts for pointing out this connection.

15 Deleuze, "On Philosophy," in *Negotiations,* 150.

16 Szerszynski, "How to Dismantle a Bus."

17 Whitehead, *Modes of Thought,* 31.

18 Juarrero, "Downward Causation," 4–15.

19 This exercise, which resonates with the encounter described below by Juan Goytisolo, is inspired by Somayeh Khakshoor's project to make a dictionary in which the definition of every word would be (a divine) You.

20 Emadi, "Reconsidering the Substance of Digital Video from a Sadrian Perspective," 75–80.

21 Latour, "Why Has Critique Run Out of Steam?"

22 Eshun, "Further Considerations on Afrofuturism"; Keeling, *Queer Times, Black Futures*; Esi Eshun, remarks on the panel "Department of Xenogenesis: Hostile Environment: Environmental Hostility," LUX London, July 1, 2020.

23 Angela Sterritt, CBC Radio, March 3, 2021.

24 Cubitt, *Finite Media,* 155.

25 Bennett, "Logical Depth and Computational Complexity."

26 Cited in Hui, *On the Existence of Digital Objects,* 14.

27 Simondon, "The Genesis of the Individual"; Rizvi, *Mulla Ṣadrā and Metaphysics.*

28 Nail, "What Is an Assemblage?"

29 Arjun Appadurai, "Mediants, Materiality, Normativity," 232.

30 Goytisolo, *The Garden of Secrets,* 26.

31 Deleuze and Guattari, *A Thousand Plateaus,* 249.

32 Leibniz, *The Monadology* §14. As Lloyd Strickland notes, this, with Spinoza, was one of the earliest proposals of the unconscious, a subject not widely taken up until the nineteenth century. Strickland, *Leibniz's Monadology,* 67.

33 Deleuze, *The Fold,* 129–30.

34 Whitehead, *Process and Reality,* 43.

35 This screen in *The Fold* operates similarly to Deleuze and Guattari's plane of consistency in *A Thousand Plateaus.* A slight difference in emphasis focuses on actualization according to points of view: monads in Leibniz, actual entities/occasions in Whitehead.

36 Deleuze, *Difference and Repetition,* 170; Jones, "Solomon Maimon," 104.

37 Deleuze, *The Fold*, 89; Jones, "Solomon Maimon." Maimon deployed these ideas to critique Kant's *cogito*, arguing that the integration of perceptions precedes, and indeed causes, the subject of perception.

38 Deleuze, *Difference and Repetition*, 47; Jones, "Solomon Maimon," 109.

39 Deleuze, *Difference and Repetition*, 209.

40 As Ṣadrā writes: "That which is experienced is being but that which is understood is quiddity," or discursive experience. Ṣadrā, *Al-Asfār* (*The Four Journeys*), 1:3.

41 Grosz expands this concept to explain how art liberates qualities of objects and events in order to make them available to sensation, in *Chaos, Territory, Art*, 9–18.

42 Leibniz, The *Monadology*, §48; Arthur, *Monads, Composition, and Force*, 258; Strickland, *Leibniz's Monadology*, 109–111.

43 Deleuze, *The Fold*, 68.

44 Deleuze, *The Fold*, 74.

45 Deleuze, *The Fold*, 130–31. Leibniz writes: "Whoever dies malcontent dies a hater of God." After the person dies, the soul, deprived of sensory experience, amplifies those miserable last thoughts in a sort of feedback loop. Leibniz, *Confessio Philosophi*, 91; Strickland, *Leibniz's Monadology*, 156.

46 In Leibniz's doctrine of *transformationism*, "death is merely a transformation of the organism in such a way that the domain of influence of its dominant monad shrinks to a physical point." Arthur, *Monads, Composition, and Force*, 146, 179n38.

47 Deleuze, *The Fold*, 111; Look, "Leibniz and the '*Vinculum Substantiale*.'"

48 Basile, *Leibniz, Whitehead and the Metaphysics of Causation*, 54.

49 Deleuze, *The Fold*, 110.

50 See Mbembe, *Critique of Black Reason*, 12–15.

51 Hartman's study shows that after Emancipation, freed slaves were required to adopt the responsibilities of the liberal individual, "displac[ing] the nation's responsibility for providing and ensuring the rights and privileges conferred by the Reconstruction Amendments and shift[ing] the burden of duty onto the freed." Hartman, *Scenes of Subjection*, 118.

52 Balibar, "Subjection and Subjectivation," 9.

53 Hartman, *Scenes of Subjection*, 123.

54 Juan Castrillón, email to the author, March 19, 2020. Castrillón is a member of the Substantial Motion Research Network.

55 "Under every vinculum infinities of 'dominated' monads begin to group into clusters that can organize material aggregates," which can move from one vinculum to another. Deleuze, *The Fold*, 135.

56 Ward argues that dominant monads integrate the nonconscious experiences of dominated ones into a conscious whole. Basile, *Leibniz, Whitehead and the Metaphysics of Causation*, 54.

57 Peirce, "Man's Glassy Essence," *Collected Papers* 6.268.

58 Moten and Harney, *The Undercommons*.

59 Moten, *In the Break*, 9–12. Moten is writing about a "commodity" that screams: Frederick Douglass's account of his aunt Hester, screaming as her owner whips her.

60 Deleuze, *Difference and Repetition*, 256.

61 Deleuze, *Difference and Repetition*, 256, 120.

62 Moten, *In the Break*, 263n1.

63 Eshun, "Operating System for the Redesign of Sonic Reality."

64 Glissant, "The Open Boat," in *Poetics of Relation*, 8.

65 Glissant, "Closed Place, Open World," in *Poetics of Relation*, 74.

66 Yusoff, *A Billion Black Anthropocenes or None*.

67 Stengers, "Breaking the Circle of Sufficient Reason," in *Power and Invention*, 21–32.

68 Pesic, "Leibniz and the Leaves: Beyond Identity." I disagree with Pesic's contention that Leibniz would be proven wrong nowadays because "electrons altogether lack the individuality that Leibniz argued was an essential attribute of a substance." Electrons possess individuality!

69 Glissant, *Poetics of Relation*, 190.

70 Deleuze, *Difference and Repetition*, 213. Microperceptions, distinct *and* obscure, contrast with most perception, which is confused *and* clear: the clear awareness of what has been unfolded, the ignorance of how it got there.

71 Deleuze, "Plato and the Simulacrum." In *Logic of Sense*, 52; DeLanda, *Intensive Science and Virtual Philosophy*, chapter 1; Smith, "G. W. F. Leibniz," 61.

72 Deleuze and Guattari, *A Thousand Plateaus*, 485–86. Bernhard Riemann's mathematics is deeply implicit in Deleuze's thought, given Bergson's debt to Riemann for the concept of multiplicity.

73 DeLanda, *Intensive Science and Virtual Philosophy*, 14, referring to Poincaré.

74 DeLanda, *Intensive Science and Virtual Philosophy*, 61; see also DeLanda, "Emergence, Causality, and Realism," 391–92.

75 Negri, *Reflections on Empire*.

76 Monticelli, "Prefiguration: Between Anarchism and Marxism."

77 Sha, *Poiesis and Enchantment in Topological Matter*.

78 For a rigorous yet wildly creative application of nonlinear dynamics, topology, and morphogenesis, see Noble, "Anthrotopology."

79 DeLanda, *A Thousand Years of Nonlinear History*.

80 Deleuze and Guattari, *A Thousand Plateaus*, 408–9.

81 Focillon, "Forms in the Realm of Matter," *The Life of Forms in Art*, 95–103.

82 Stengers, "Wondering about Materialism," 378.

83 Deleuze, *Difference and Repetition*, 190.

84 Deleuze, seminar at Paris VIII Vincennes and Vincennes St.-Dénis, quoted in van Tuinen and McDonnell, "Introduction," *Deleuze and* The Fold, 6.

85 Whitehead, *Process and Reality*, 47.

86 Carr, *A Theory of Monads*, 55, 112–13.

87 Deleuze, *The Fold*, 81.

88 Deleuze, *The Fold*, 70.

89 Deleuze, *Difference and Repetition*, 256.

90 Deleuze, *Difference and Repetition*, 47.

91 As when Deleuze considers whether to go out to a nightclub or stay home and write, weighing the sensations of each divergent path; or Adam contemplates whether to accept the apple from Eve, stimulated by the fruit's fragrance and Eve's encouragements.

92 Deleuze, *Difference and Repetition*, 45.

93 Whitehead, *Process and Reality*, 190.

94 Deleuze, *The Fold*, 78–79.

95 Juarrero, "Complexity and Chaos," 390. I thank Dave Biddle for introducing me to Juarrero.

96 Basile, *Leibniz, Whitehead and the Metaphysics of Causation*.

97 Braidotti, "Sustainable Ethics and the Body in Pain," *Nomadic Theory*; Al-Nakib, "Disjunctive Synthesis."

98 Duffy, "Leibniz, Mathematics, and the Monad," 104–10.

99 "It could be said that the monad, astraddle over several worlds, is kept half open as if by a pair of pliers." Deleuze, *The Fold*, 137.

100 Deleuze, *The Fold*, 81, and *Difference and Repetition*, 123.

101 A many-worlds interpretation is only necessary if you assume that since particles collapse in relation to the position of the observer (after Schrödinger), there must be a different world for each potential position of a particle following a quantum transition: what is termed a "Hilbert space." There is no need for many worlds in Bohm and Hiley's ontological interpretation, in which the position of the particle is an expression of the guiding field, and in which, moreover, most systems can be adequately described by classical physics. (It's also unnecessary in Bohr's theory, which treats the wave function not as real but as a mathematical tool.) See Bohm and Hiley, *The Undivided Universe*, 296–318, and Pylkkänen, *Mind, Matter and the Implicate Order*, 160–63.

102 Syms, "The Mundane Afrofuturist Manifesto"; Pisters, "Temporal Explorations in Cosmic Consciousness."

103 Ligia Lewis, conversation with the author, moderated by Rizvana Bradley, International Tanzmesse, Köln, September 3, 2022 (by videoconference), and email to the author, September 7, 2022.

104 Deleuze, *The Fold*, 73.

105 Adamson and Monani, "Cosmovisions, Ecocriticism, and Indigenous Studies."

106 Yellowhorn and Lowinger, *Sky Wolf's Call*.

107 Deleuze, *Cinema 2*, 150.

108 Braidotti, "A Theoretical Framework for the Critical Posthumanities," 49.

109 Tuck and Yang, "Decolonization Is Not a Metaphor"; Arias, "Indigenous Knowledges and Sites of Indigenous Memory."

110 Glissant, *Poetics of Relation*, 20.

111 https://lux.org.uk/event/department-of-xenogenesis-the-equation-of-value-eshun-and-sagar/. Accessed August 28, 2020.

112 For analyses of the imbrication of the speculative economy in the slave trade, see Keeling, "Financial Derivatives and the Afterlife of Slavery," in *Queer Times, Black Futures*, 25–32, and Beller, *The Message Is Murder*.

113 Ferreira da Silva, "1 (life) ÷ 0 (blackness) = ∞ − ∞ or ∞ / ∞." Ferreira da Silva traces the logic of separation that subtends Euro-American economy, aesthetics, and philosophy to Kant, Descartes, Francis Bacon, and Aristotle. Her equation regarding the infinite employs not the Leibnizian infinitesimal, 1/∞, but "1 (life) / 0 (blackness) = ∞ − ∞," where the infinite is a formlessness that disables determinacy.

114 Eshun, remarks on the panel "Department of Xenogenesis."

115 Paul, *Whitewashing Britain*.

116 Eshun, remarks on the panel "Department of Xenogenesis."

117 Pethö, "The Garden of Intermedial Delights," 474.

118 Here Nathaniel Dorsky's Buddhist-inflected ideal that cinema improve the metabolism of the viewer, in *Devotional Cinema*, confronts Antonin Artaud's theater of cruelty that should tear the audience out of their habitual bodies. Kuniichi Uno revises this into a cinema of cruelty in "Variations on Cruelty," in *The Genesis of an Unknown Body*, 40.

119 Katie Christing, "Demanding Dysmorphia," essay in my class Art and the Moving Image, Simon Fraser University, fall 2021.

120 Deleuze, *Difference and Repetition*, 42.

121 See Klein, *The Shock Doctrine*.

122 Burrows and O'Sullivan, *Fictioning*; Simondon, "Technical Mentality," 15.

123 Dogon metallurgy, via the anthropological research of Marcel Griaule, is the source of *A Thousand Plateaus*' references to metallurgy. The anthropologist probably coached his informants to oversophisticate their astronomical knowledge. Adams, "African Observers of the Universe"; Van Beek et al., "Dogon Restudied."

124 Collier, *Media Primitivism*.

125 Nail, *Theory of the Earth*, 136.

126 Deleuze and Guattari, *A Thousand Plateaus*, 242.

127 See, for example, Federici and Linebaugh, *Re-Enchanting the World*.

128 Keeling, *Queer Times, Black Futures*, 15–16; Glissant, *Poetics of Relation*.

129 Whitehead, *Process and Reality*, 223.

130 On accepting death as a form of reorganization, see Braidotti (who refers to death as "our becoming-imperceptible"), "The Residual Spirituality in Critical Theory"; Fuller and Goriunova, *Bleak Joys*; Nail, *Theory of the Earth*; and Bennett, *Vibrant Matter*. Following Povinelli's *Geontologies*, we might accept that many ways of being are quiet. Not dead, just quiet.

131 Deleuze and Guattari, *A Thousand Plateaus*, 325–26.

132 Deleuze and Guattari, *A Thousand Plateaus*, 326. Quoting Jacques Cousteau.

133 Guattari, *Chaosmosis*, 81–82.

134 A lot of luck and skill. "No one, not even God," can say where the line of flight will pass or whether it will succeed. Deleuze and Guattari, *A Thousand Plateaus*, 250.

1 Grusin, "Radical Mediation," 129.

2 Noble, "Anthrotopology," 23.

3 Deleuze, "Doubts about the Imaginary," 65.

4 My argument that signs develop relationally in a changing environment draws mainly on Bergson, Peirce, Whitehead, and Leibniz. James Williams develops a comparable approach by innovatively bridging Whitehead, Wittgenstein, and evolutionary biology in *A Process Philosophy of Signs*.

5 See Ivakhiv, *Shadowing the Anthropocene* and *Ecologies of the Moving Image*; Nail, *Theory of the Earth*; Kember and Zylinska, *Life after New Media*; Peters, *The Marvelous Clouds*; and Furihata, "Of Dragons and Geo-Engineering."

6 Parks, *Cultures in Orbit*.

7 5G uses much more electricity than previous generations, increasing the drain on the planet's finite resources. See, for example, Koziol, "5G's Waveform Is a Battery Vampire." 5G's pervasive radiofrequency electromagnetic fields almost certainly damage cells and decrease immunity in the creatures they pass through. See, for example, Di Caulo, "Towards 5G Communication Systems."

8 Collier, *Media Primitivism*.

9 For a study of universal semiosis as "envirocognition," see Noble, "Anthrotopology."

10 Deleuze, *Cinema 1: The Movement-Image*, 59.

11 I use the term *signs* sparsely to avoid confusion with Saussurean semiotics, which only accounts for human culture.

12 Rangan, *Immediations*, 178. See also Marks, "Images in Motion, from Haptic Vision to Networked Space," in *Hanan al-Cinema*, 275–98.

13 Marks, "Nonorganic Subjectivity"; see also Marks, "Invisible Media," 33–46, and "Noise in Enfolding-Unfolding Aesthetics," 101–14.

14 Past occurrences are no longer actual, but they continue to exist in a virtual state. Ivakhiv argues that past virtualities, those that were never actualized, are gone forever. I used to think so too, but now I think that past virtualities may still sometimes precipitate in the present.

15 Deleuze, *Nietzsche and Philosophy*, 3.

16 Deleuze, *Cinema 1: The Movement-Image*.

17 Cubitt et al., "Ambient Images," in Lund, "Questionnaire," 72.

18 Weizman and Fuller, *Investigative Aesthetics*.

19 Eyal Weizman in conversation with Lund, "Inhabiting the Hyper-Aesthetic Image," in Lund, "Questionnaire," 22.

20 Schuppli, *Material Witness*, 37.

21 Zylinska, *AI Art*.

22 Priest, *Earworm and Event*.

23 Adrian Ivakhiv's visualization of the universe is remarkably similar to view 21 of my diagram, with the point of view located on the edge. It too takes the shape of a sphere that is carved into a torus-like form by constant processes of unfolding and enfolding: unfolding in the process of actualization and enfolding as

actualized entities become part of the infinite (die and become objective, in Whitehead's terms). Ivakhiv, *Shadowing the Anthropocene*, 71–73.

24 On the term *dividual* see Deleuze, "Postscript on the Societies of Control."

25 Lefebvre, "Peirce's Esthetics."

26 Peirce, *Collected Papers* 6.307, 1893.

27 See, for example, Grusin, "Radical Mediation"; Ivakhiv, *Ecologies of the Moving Image*; and Marks, "Immigrant Semiosis."

28 See DeLanda, *Intensive Science and Virtual Philosophy*, 171, 181.

29 Deleuze, *Difference and Repetition*, 181.

30 Deleuze, *Difference and Repetition*, 179.

31 Deleuze, *Difference and Repetition*, 181. Smith is more cautious, referring to calculus as "a symbolism for the exploration of existence," in "The Deleuzian Revolution," 41.

32 DeLanda, *Intensive Science and Virtual Philosophy*, 181.

33 Bailey, "Mammalian Mathematicians," 322.

34 Wiratama, et al., "Pornography Object Detection Using Viola-Jones Algorithm and Skin Detection," 29–34.

35 Braidotti, "A Theoretical Framework for the Critical Posthumanities," 37.

36 MacCormack, "Becoming-Vulva," 106.

37 Perniola, "Secrets, Folds, and Enigmas," in *Enigmas*, 7–8.

38 Bruno explores the inextricability of clothing from being itself in "Pleats of Matter, Folds of the Soul."

39 Deleuze, "Mediators," in *Negotiations*, 124.

40 I survey more manners of unfolding in *Enfoldment and Infinity*, "Experience—Information—Image," "Radical Gestures of Unfolding," and "Arab Cinema Unfolds," in *Hanan al-Cinema*, 69–82.

41 Perniola, "Secrets, Folds, and Enigmas," in *Enigmas*, 10; emphasis in original.

42 Deleuze, *The Fold*, 22.

43 Doane, "Indexicality," 2; Peirce, "Genuine and Degenerate Indices," *Collected Papers*, vol. 2, book 2, chapter 3, §4.

44 Baltrušaitis and Strachan, *Anamorphic Art*.

45 Walton (quoting Christine Buci-Glucksmann), *Cinema's Baroque Flesh*, 68.

46 On Neo-Baroque conspiracy movies see Cubitt, "NeoBaroque Film," in *The Cinema Effect*, 217–44; and Marks, *Enfoldment and Infinity*, chapter 6.

47 As Zarathustra is unformed, asubjective, less and more than a person: just speeds and slownesses. Grosz, *The Incorporeal*, 141; Deleuze and Guattari, *A Thousand Plateaus*, 269.

48 Schwebel, "Intensive Infinity."

49 Matthew 10:16.

50 Fuller and Goriunova, "Devastation," xxiii, 14. "Wise cunning" is termed *metis*, after the Greek goddess who exemplified it.

51 Allen, *Striking Beauty*, 7–10.

52 Perniola, "Secrets, Folds, and Enigmas," in *Enigmas*, 18–21.

53 Critchley, *On Humour*.

54 And the author of Davies, *System Change Not Climate Change*.
55 Deleuze, *The Fold*, 41–58.
56 Deleuze, *Difference and Repetition*, 176.
57 DeLanda, *Intensive Science and Virtual Philosophy*, 7.
58 Over the decades of doing activism, I've always noticed, with some resent-
 ment, that the ones on the Right have more unified messages than the ones on
 the Left. I've finally figured out why, in terms of sufficient reason.
59 Glissant, *Poetics of Relation*, 193, 190.
60 Keeling, *Queer Times, Black Futures*, 31, quoting Brian and Rafferty, "Finan-
 cial Derivatives and the Theory of Money." Also see Birchall, "Introduction to
 'Secrecy and Transparency,'" 7–25.
61 Deleuze, *Difference and Repetition*, 256.
62 Glissant, *Poetics of Relation*, 190.
63 Toufic, "Credits Included."
64 The Arabic word *bātin* refers to interior meaning and to the body's internal
 organs.
65 Deger, *Shimmering Screens*.
66 Marks, *Enfoldment and Infinity*, 48–53.
67 Crow, "Imam Ja'far al-Sadiq," 64–65.
68 See Marks, "I Feel Like an Abstract Line."

CHAPTER 4. THE INFORMATION FOLD

 1 Deleuze, "Postscript on the Societies of Control."
 2 Marks, "Immanence Online," in *Touch*. In many ways this chapter is an expan-
 sion of that chapter's early observations.
 3 Hilbert and López, "The World's Technological Capacity to Store, Communi-
 cate, and Compute Information."
 4 On true-cost accounting of media see Cubitt, *Finite Media*; and Vaughan, *Hol-
 lywood's Dirtiest Secret*.
 5 Marks, *Enfoldment and Infinity*, 19–20.
 6 Ian Johnson, "Thirty Years After Tiananmen: Someone Always Remembers,"
 New York Times, June 3, 2019.
 7 Associated Press, "Kremlin Crackdown Silences War Protests, from Benign to
 Bold," *The Globe and Mail*, April 14, 2022.
 8 Deleuze, *The Fold*, 76–82.
 9 Mackenzie, *Machine Learners*, 7.
10 Mattern, *Code and Clay, Data and Dirt*, 105–7.
11 Simondon, "The Genesis of the Individual," 311.
12 Simondon, "The Genesis of the Individual," 299. In this definition of informa-
 tion, we can hear the echo of Bergson's *Creative Evolution*: entities individuate
 in relation to the potentials in their environment in ways that are necessarily
 unique.
13 Deleuze, *Foucault*, 131.

14 Munster, *Materializing New Media*, 35–38.

15 Stalder, "Information Economy," 110.

16 Citton, "Automatic Endo-Attention, Creative Exo-Attention."

17 Smith, *Iconomy*.

18 Citton, "Automatic Endo-Attention, Creative Exo-Attention."

19 Jonathan Beller, *The Message Is Murder*, 80–82; Cubitt, *Finite Media*, 8–9. The International Energy Agency's influential "Sustainable Development Scenario" tricks investors into believing that continuing to exploit fossil fuels, in the hopes that fantastical "negative emissions" technologies will be realized, is less costly than converting quickly to renewable energy (Oil Change International and Greenpeace UK, "The International Energy Agency and the Paris Goals: Q&A for Investors," 2019).

20 Beller, *The World Computer*, 119–20.

21 Fuller and Goffey, *Evil Media*, 57.

22 Kockelman, "The Complexity of Discourse."

23 Kockelman, "Information Is the Enclosure of Meaning," 117.

24 Every year Roach sends the festival another hilarious experiment in hyper-low-bitrate video.

25 hooks, "The Oppositional Gaze," in *Black Looks*.

26 Parks and Starosielski, "Introduction," in *Signal Traffic*, 1–27.

27 Goriunova, "Digital Subjects."

28 MacKenzie, *Machine Learners*, 14.

29 Peirce, "Logic as Semiotic," in *Philosophical Writings*, 115–19.

30 Sterne, MP3.

31 Beller, *The World Computer*, 259.

32 James Elkins's category of *informational images* denotes images "principally intended . . . to convey information": they include graphs, charts, maps, some money, technical drawings, scientific images, and "pictographic or ideographic elements in writing." Informational images, Elkins notes, rely on interpretive skills more than representational images do. Elkins, "Art History and Images."

33 On this perceptual freedom available in cross-cultural situations, see Marks, "Immigrant Semiosis."

34 Hayles, *How We Became Posthuman*.

35 Stiegler, *Technique and Time* 2, 134; emphasis in original.

36 Flusser, "The Technical Image," in *Towards a Philosophy of Photography*; Beller, *The Message Is Murder*; Genosko, "A-Signifying Semiotics."

37 MacKenzie and Munster, "Platform Seeing."

38 Farocki, "Phantom Images."

39 Genosko, "A-Signifying Semiotics."

40 Fan, *Cinema Approaching Reality*.

41 Hoel, "Image Agents"; Lund, "Questionnaire." I'm grateful to Jacob Lund for publishing this valuable survey just as I was completing this book.

42 Grusin, *Premediation*.

43 Munster, *An Aesthesia of Networks*, 42.

44 Massumi, *Ontopower*.

45 Amoore, "Doubt and the Algorithm."

46 From a table of top competitions posted by the data-science platform Kaggle in MacKenzie, *Machine Learners*, 204.

47 "Introducing WaveNet," https://www.deepmind.com/research/highlighted -research/wavenet. Accessed May 3, 2022.

48 Fuller and Goffey, *Evil Media*, 99.

49 Lanier, *Who Owns the Future?*

50 MacKenzie, *Machine Learning*, 205–6.

51 Eshun, "Further Considerations on Afrofuturism," 289.

52 Haykal, "nusantara pessimism," 52, 53.

53 Steyerl, "A Sea of Data," in *Duty Free Art*.

54 Cubitt, *The Practice of Light*, 250.

55 Steyerl identifies this phenomenon as "corporate animism," a justified paranoia in which it turns out the world really is watching you.

56 Väliaho, *Biopolitical Screens*.

57 Parisi and Goodman, "Mnemonic Control."

58 Shaviro, "Post-Cinematic Affect;" Gallagher, "Eliciting Euphoria Online."

59 Crary, *24/7*; Väliaho, *Biopolitical Screens*.

60 Lanier, *Who Owns the Future?*, cited in MacKenzie, *Machine Learners*, 11.

61 Fuller and Goffey, *Evil Media*.

62 I thank Sarah Joyce, director of the New Media Gallery in New Westminster, BC, for bringing Monaghan's work, as well as her many other insightfully curated exhibitions.

63 In French those buttons are referred to as *points de capiton*, an upholstery term Jacques Lacan employed to indicate the points in the unconscious where signified and signifier cohere despite slippage elsewhere.

64 Latour, "Why Has Critique Run Out of Steam?"

65 Ekbia and Nardi, *Heteromation and Other Stories of Computing and Capitalism*.

66 Irani, "Difference and Dependence among Digital Workers."

67 Citton, "Automatic Endo-Attention, Creative Exo-Attention," 108–9.

68 Irani, "The Cultural Work of Microwork"; Irani, "Difference and Dependence among Digital Workers."

69 I distinguish between immaculate information-food and noisy infinite-food in "Noise in Enfolding-Unfolding Aesthetics."

70 Sherman, "I Get Tired," 120.

71 Haber, Voss, and Wall, "Upgraded Google Glass Helps Autistic Kids."

72 As for content moderation and censorship, when people perform algorithms, context disappears and the world looks too clean, too "likeable." In *The Cleaners*, one moderator deletes the famous Vietnam War photograph of a little girl running with napalm burns because it shows an unclothed minor, and activists' documents of the brutal Syrian war are deleted as too disturbing.

73 On haptic images and haptic visuality see Marks, "Video Haptics and Erotics" and *The Skin of the Film*.

74 Elahi, "You Want to Track Me? Here You Go, F.B.I."

75 Robert Brandl and Josep Garcia, "The world's most surveilled citizens," *Tool-Tester*, July 25, 2022.

76 Bucher, "The Algorithmic Imaginary," 30–44. See also Amoore, "Thinking with Algorithms."

77 Perry, "Spotify Algorithm."

78 Jennings, *Net, Blogs and Rock 'n' Roll.*

79 Seaver, "Seeing Like an Infrastructure," 71.

80 Seaver, "Captivating Algorithms," 432.

81 Chun, "Queerying Homophily."

82 William Latham, email to the author, July 10, 2022.

83 al-Gitani, *Zayni Barakat.*

84 al-Nimr, "A Three-Step Guide to Becoming a Model Facebook Citizen in Egypt." https://madamasr.com/en/2019/12/30/feature/society/a-three-step -guide-to-becoming-a-model-facebook-citizen-in-egypt/. *Mada Masr*, an on-line publication, has been blocked in Egypt since 2017. Its editors now publish via social media and a proxy link to the site.

85 Hintemann, "Efficiency Gains Are Not Enough."

86 Strubell, Ganesh, and McCallum, "Energy and Policy Considerations for Deep Learning in NLP."

87 See, for example, Belkhir and Elmeligi, "Assessing ICT Global Emissions Footprint," 448–63, and Bordage, "The Environmental Footprint of the Digital World."

88 Gossart, "Rebound Effects and ICT."

89 Halfhill, "The Mythology of Moore's Law."

90 "EIA Projects Accelerating Renewable Consumption and Steady Liquid Fuels Growth to 2050," US Energy Information Administration, October 6, 2021. https://www.eia.gov/todayinenergy/detail.php?id=49856.

91 Reuters, "China approves biggest expansion in new coal power plants since 2015." February 27, 2023.

92 Chernicoff, "How Data Centers Pay for Renewable Energy."

93 O'Doherty and Hyland, "Fossil Fuel Burning Plants to Be Used in Emergency." Thanks to Radek Przedpełski for this reference.

94 Marks, "Collapse Informatics and the Environmental Impact of Information and Communication Technologies."

95 Hilty, "Computing Efficiency, Sufficiency, and Self-Sufficiency."

96 See Hansen, *Cinema and Experience.*

97 Pad.ma, "10 Theses on the Archive"; Amad, *Counter Archive.* These attitudes are like those of Benjamin and Siegfried Kracauer: keep everything, because its significance might become apparent later. See Hansen, *Cinema and Experience.*

98 Pisters, "Temporal Explorations in Cosmic Consciousness"; and "Expressions of Creation," in *The Neuro-Image.*

99 Blanchette, "A Material History of Bits," 1046.

100 I was using dictation software to relieve my tendinitis. I have since ceased because this AI-enabled device is not only insulting but surveillant, in most cases, and uses a lot of electricity, and also my tendonitis is better.

101 Steyerl, "In Defense of the Poor Image," in *The Wretched of the Screen*, 31–45.

102 Lialina and Espenschied, *Digital Folklore.*

103 Goriunova, "New Media Idiocy."

104 Price, *How to Disappear in America.*

105 Leidig and Teeuw, "Quantifying and Mapping Global Data Poverty."

106 Pisters, *The Neuro-Image*; Rødje, *Images of Blood in American Cinema*, 85–103.

107 de Certeau, *The History of Everyday Life*; Citton, "Automatic Endo-Attention"; Crary, *24/7*; Marks, "Immanence Online," in *Touch.*

108 Glissant, *Poetics of Relation*, 126. For an introduction to Amin's work see Amin, *Samir Amin, Pioneer of the Rise of the South.*

109 de Rivera, Eglash, and Gray, "An Introduction to Generative Justice," 363.

110 Beller, *The World Computer*, 193.

111 Hansen, *Cinema and Experience*, 135. Jean-Louis Comolli, a key author of 1970s apparatus theory, diagnoses contemporary media's expanded capacity to colonize cognition in *Cinema against Spectacle.*

112 Fossati, *From Grain to Pixel*, 14; Gunning, "Re-Newing Old Technologies."

113 Nardi et al., "Computing Within Limits," 87.

114 Tomlinson et al., "Collapse Informatics and Practice."

115 Lambert et al., "Post-Peak ICT."

116 DeDecker, "Keeping Some of the Lights On."

117 Marks, "Collapse Informatics."

118 Eglash, "Oppositional Technophilia."

119 Lobato and Thomas, *The Informal Media Economy*; Liang, "Beyond Representation"; Pad.ma., "10 Theses on the Archive."

120 Marks, "Poor Images, Ad Hoc Archives, Artists' Rights," 3899–3916. The article offers case studies of oppositional technophilia (in Eglash's term) in Beirut, Cairo, and Gaza. See also Larkin, "The Politics and Poetics of Infrastructure."

121 Goriunova, *Art Platforms and Cultural Production on the Internet*; Marks, "Arab Glitch."

122 Lobato and Thomas, *Informal Media Economy*; Rai, *Jugaad Time.*

123 Hjorth, Pink, and Sharp, *Screen Ecologies*; Parikka and Hertz, "Zombie Media."

124 See, for example, Patrignani and Whitehouse, *Slow Tech and ICT.*

125 Preist, Schien, and Blevis, "Understanding and Mitigating the Effects of Device and Cloud Service Design Decisions," 1332.

126 Marks, "Small-File Movies"; Marks and Przedpełski, "The Carbon Footprint of Streaming Media"; Kong and Marks, "'You can't look into my eyes.'"

127 Rødje, "Blood Assemblages," in *Images of Blood in American Cinema*, 85–103.

128 Herzog, "Assemblage, Constellation, Image," 220.

129 Martin, *Mise-en-Scène and Film Style*, 179.

130 Parikka, *A Geology of Media*; Pisters, "The Filmmaker as Metallurgist." For a metallurgical media genealogy see Przedpełski, "Steppe C(ha)osmotechnics" and "Becoming-Sarmatian, Becoming-Steppe."

131 Thiebaud et al., "Where Do Our Resources Go?"

132 Wäger, Hischier, and Widmer, "The Material Basis of ICT"; and Böni, Schluep, and Widmer, "Recycling of ICT Equipment in Industrialized and Developing Countries."

133 See, for example, The Shift Project, "Climate Crisis: The Unsustainable Use of Online Video," https://theshiftproject.org/en/article/unsustainable-use-online-video/, and Belkhir and Elmeligi, "Assessing ICT Global Emissions Footprint," 448–63. My research team Tackling the Carbon Footprint of Streaming Media surveyed the engineering literature to interrogate this figure, first calculated by the French think tank The Shift Project. Our publications include Makonin, Marks, ElMallah, Rodriguez-Silva, and Przedpełski, "A Holistic End-To-End Model to Calculate the Carbon Footprint of Streaming Media"; Marks, "A Survey of ICT Engineering Research Confirms Streaming Media's Carbon Footprint," *Media + Environment*; and Marks and Przedpełski, "The Carbon Footprint of Streaming Media."

134 See https://wearealbert.org/, https://creativebc.com/reel-green/, and the best practices outlined at "Tackling the Carbon Footprint of Streaming Media," https://www.sfu.ca/sca/projects—-activities/streaming-carbon-footprint.html.

135 Greenpeace, "Clicking Clean: Who Is Winning the Race to Build a Green Internet?"; greenpeace.org.

136 https://smallfile.ca.

137 According to The Shift Project, 27 percent of all streaming video is porn; thus it's urgent to create satisfying small-file alternatives.

138 Betz, "At Random, By Design."

139 Marks, "Algorithm, Encryption, Glitch," in *Hanan al-Cinema*, 239–73; Zinman, "Getting Messy."

140 Marks and Przedpełski, "Bandwidth Imperialism and Small-File Media."

CHAPTER 5. TRAINING PERCEPTION AND AFFECTION

1 Dorsky, *Devotional Cinema*; Pandian, "Rhythm," in *Reel World*, 205–18; Subramanian, "Breath: A Yogic Genealogy of Embodiment in Cinema"; Quinlivan, *The Place of Breath in Cinema*.

2 Uno, "Variations on Cruelty," in *The Genesis of an Unknown Body*, 41.

3 Uno, "Vitalism and Biopolitics," 124–25.

4 Uno, "Body-Genesis or Catastrophic Time—Around Tanaka Min, Hijikata and Artaud," in *The Genesis of an Unknown Body*, 55–67."

5 O'Sullivan, "From Possible Worlds to Future Folds," in *Art Encounters*, 121–43.

6 Deleuze and Guattari, *A Thousand Plateaus*, 248.

7 Marks, "Talisman-Images."

8 The neuro-image aligns with Deleuze's third synthesis of time in *Difference and Repetition*: "The present, the past and the future are proposed as three different ways of synthesising time: past, present and future can be synthesised from the foundation of the present (first synthesis), from the grounds of the co-existent layers of the past (second synthesis), or from open-ended future (third synthesis)." Pisters, "Temporal Explorations in Cosmic Consciousness," 127.

9 Welsch, "Aesthetics Beyond Aesthetics," 178. The priority to which Baumgarten gave sense experience was eclipsed by Kant's aesthetics as the transcendental study of the objective conditions for judgments regarding the beautiful. Nicholas Davey writes that Baumgarten was "one of the first moderns to defend the autonomy not only of aesthetics but also of immediate experience against the encroachments of theory, while his suggestion that sensuous experience is art's proper terrain opens a line of thinking which leads to Nietzsche, Heidegger, and Gadamer." Davey, "Baumgarten, Alexander G(ottlieb) (1714–1762)," 163. See also Barnouw, "The Beginnings of 'Aesthetics.'"

10 Baumgarten wittily termed the sensuously perceived realm *campus confusionis*, "field of confusion," where con-fusion denotes convergence and synthesis. Davey, "Baumgarten," 163.

11 Deleuze and Guattari, *Anti-Oedipus*; Davis, *The Desiring-Image*.

12 Deleuze and Guattari, *A Thousand Plateaus*, 240.

13 Amon, review, *How to Do Things with Affects*, 93–96.

14 See, for example, Smith, "Ethics," in *Essays on Deleuze*; and Nail, "The Fold of Affect," in *Theory of the Image*.

15 See, for example, Massumi, *Ontopower*.

16 See Braidotti, "Sustainable Ethics and the Body in Pain," in *Nomadic Theory*, 299–324; Grosz, *Chaos, Territory, Art*; Al-Nakib, "Disjunctive Synthesis."; Pisters, "Logic of Sensations in Becoming-Animal," in *The Matrix of Visual Culture*, 141–74, and "Surveillance Screens and Powers of Affect," in *The Neuro-Image*, 98–124; and Massumi, "The Power to Affect," in *Ontopower*, 171–205; see also Marks, "What Can a Body Do?" in *Hanan al-Cinema*, 307–44.

17 del Rio, *Deleuze and the Cinemas of Performance*, 27, 114–16.

18 Massumi, "The Autonomy of Affect," in *Parables for the Virtual*.

19 Félix Guattari, *Chaosmosis*, 92–93.

20 Firstness and Secondness, or in Stern's terms, *amodal* and *modal* perception, occur simultaneously: the emergent process of perception and the distinguishing of objects and relations. See Hongisto, *Soul of the Documentary*, 115–16.

21 Stewart, *Ordinary Affects*.

22 Deleuze and Guattari, *What Is Philosophy?*

23 Peirce, "The Principles of Phenomenology," in *Philosophical Writings*, 81.

24 Here my categorization diverges from Deleuze's in *Cinema 1*, which identifies perception as a degree zero, affection as First, action as Second, and reflection as Third.

25 These three lead to what Peirce called "ultimate interpretants," in which we change our dispositions: always feeling revolted by slasher films; always preparing to flinch; believing that all slasher movies will be that way. See Kockelman, "Information Is the Enclosure of Meaning."

26 Peirce, "Pragmatism in Retrospect: A Last Formulation," in *Philosophical Writings*, 269–89; Kockelman, "Information Is the Enclosure of Meaning," 121.

27 Raskin, "The Dogma of Conviction," in *Rediscovering Aesthetics*, 69.

28 Marks, *Enfoldment and Infinity*, 17.

29 As I argue in chapter 4 of *The Skin of the Film*.

30 Deleuze, "Lecture Transcripts on Spinoza's Concept of *Affect*."

31 As we've seen, Leibniz treated these as the inside and outside surfaces of folded substance. Spinoza argued thought and matter are the same thing, considered according to different attributes. Spinoza, *The Ethics*, part 2, prop. 7.

32 Marks, "Thinking Multisensory Culture."

33 Spinoza, *The Ethics*, part 3, prop. 1.

34 Seigworth, "From Affection to Soul," in *Gilles Deleuze: Key Concepts*, 190: Seigworth's interpolation of Deleuze and Guattari, *What Is Philosophy?*, 173; emphasis in original.

35 Deleuze, "Immanence," in *Pure Immanence*, 27, 31.

36 Deleuze, "Immanence."

37 Williams, "Distributed Affects and the Necessity of Expression," 18.

38 Väliaho, *Biopolitical Screens*.

39 See Stern, *Forms of Vitality*; and Bertelsen and Murphie, "An Ethics of Everyday Infinities and Powers," 138–60.

40 Anstruther-Thomson, *Art and Man*.

41 See, for example, Gallese, "Motor Abstraction."

42 See Martin and Cleghorn, *Mirror-Touch Synaesthesia*, and Marks, "I Feel Like an Abstract Line."

43 Deleuze, *Cinema 1*, 87–88.

44 Sobchack, "What My Fingers Knew," in *Carnal Thoughts*, 53–84.

45 Lee, *The Psychology of an Art Writer*, 68, 87, 57.

46 On *qi* in cinema see Duan, "Thinking, Feeling, and Experiencing," and Rutherford, "What Is Body, What Is Space?"

47 Griffero, *Atmospheres*, 4–5.

48 Fielding, "Maurice Merleau-Ponty," 84.

49 Lewis, "Technological Gaze."

50 Deleuze, *Spinoza*, 74, 85.

51 Roffe, "David Hume," 78.

52 As Yani Kong points out in an email to the author, May 15, 2022.

53 Deleuze, *Cinema 2*, 189.

54 For other exercises in affective analysis see Marks, "What Can a Body Do?," in *Hanan al-Cinema*, 307–44, and "Workshopping for Ideas."

1 Al-Saadi, "Arabic Science Fiction: A Journey into the Unknown." Al-Saadi alludes to the marvelous thirteenth-century automata that Ibn al-Razzaz Al-Jazarī designed for the Artuqid ruler of Diyarbakır, present-day southeastern Turkey.

2 Sun Ra, in Rollefson, "The 'Robot Voodoo Power' Thesis," 96.

3 *Relative* and *absolute time* are Dorsky's terms in *Devotional Cinema*.

4 See Dillon, *Walking the Clouds*. Comparable movies include Lisa Jackson's (Ojibwa) short animation *The Visit* (2009), Amanda Strong's (Anishnabe) stop-motion animation *Biidaaban* (2018), and Danis Goulet's (Cree-Métis) dark futurist *Night Raiders* (2021).

5 Dillon, *Walking the Clouds*.

6 Alina Khakoo, "Raqs Media Collective and the Powers and Textures of the False," essay for my course "A Deep History of Arts of the Secret" at Harvard in fall 2018. On *Otolith II* see Marks, "Radical Gestures of Unfolding in Films by Mohamed Soueid and the Otolith Group," 69–88.

7 Al-Qadiri and al-Maria, "Al-Qadiri and Al-Maria on Gulf Futurism."

8 See Muller, *Lost Futurities*; İşcen, "The Geopolitical Aesthetic of Computational Media"; and Parikka, "The Middle East and Other Futurisms."

9 Snowdon, *The People Are Not an Image*; emphasis in original.

10 This discussion is abridged from Marks, "A World Where Flowers Reign."

11 Al-lat is "the god" in Arabic in feminine form, while Allah is "the god" in masculine form, and in monotheism, *the* God.

12 Pennisi, "Plants Outweigh All Other Life on Earth."

13 The film was banned in Syria, and Amiralay went into permanent exile in France.

14 Deleuze, *The Fold*, 35.

15 Bruno, "Pleats of Matter, Folds of the Soul"; Pethö, *Cinema and Intermediality* and "The Garden of Intermedial Delights"; Walton, *Cinema's Baroque Flesh*; McElhaney, *Luchino Visconti and the Fabric of Cinema*.

16 Murray, *Digital Baroque*; Cubitt, "Neobaroque Cinema," *The Cinema Effect*, 217–44; Ndalianis, *Neo-Baroque Aesthetics*; Marks, "Baroque Fascination in Persian Carpets and Casino Movies," *Enfoldment and Infinity*, 176–88.

17 Pisters, *The Neuro-Image*, 211. On neuro-aesthetics also see Rajchman, *The Deleuze Connections*, chapter 6.

18 Marks, "Archival Romances," in *Hanan al-Cinema*, 171–214.

19 Nietzsche, "Truth and Falsity in an Extra-Moral Sense."

20 Deleuze, *Cinema 2*, 137.

21 Deleuze, "The Powers of the False," in *Cinema 2*, 126–55.

22 Rangan, "For a Critique of the Documentary Logic of Sobriety."

23 Deleuze, "The Powers of the False," in *Cinema 2: The Time-Image*, 126–55. Also see Mullarkey, *Refractions of Reality*; Bogue, *Deleuzian Fabulation and the Scars of History*; and Flaxman, *Gilles Deleuze and the Fabulation of Philosophy*.

24 Nichols, *Representing Reality.*

25 Rangan, "For a Critique of the Documentary Logic of Sobriety," 2.

26 Hongisto, *Soul of the Documentary.*

27 Mullik writes, "In contrast to Heraclitus's famous saying that 'you do not step into the same river twice,' the Buddhists, because of their belief in reality being constituted of only momentarily existing *dharmas*, would perhaps like to say 'you do not step into the same river even once.'" Mullik, *Explorations in Cinema through Classical Indian Theories*, 85.

28 Rybin, "Hidden Fire."

29 See Deleuze and Guattari, *A Thousand Plateaus*, 404–15; Pisters, "The Filmmaker as Metallurgist,"; Collier, *Media Primitivism*; and the exhibition "LA Blacksmith," curated by Jill Moniz, California African American Museum, September 12, 2019–February 16, 2020.

30 Eshun, "Further Considerations on Afrofuturism," 289.

31 See Monticelli, "Prefiguration."

32 Marks, *Hanan al-Cinema*, 7.

33 Marks, *The Skin of the Film.*

34 "JetBlue Flight Attendant Incident," Wikipedia, https://en.wikipedia.org/wiki/JetBlue_flight_attendant_incident. Accessed February 7, 2023.

35 See Marks, "Archival Romances," in *Hanan al-Cinema*, 173–216; Toufic, "Credits Included."

36 Interview with Joana Hadjithomas, June 16, 2012.

37 Deleuze, *Le pli*, 168n4, referring to Tony Smith's 1951 night drive on the unopened New Jersey Turnpike.

38 Al-Wardany, "The Hanging Garden of Sleep," 73.

39 These summaries are from Joana Hadjithomas, email to the author, February 13, 2012.

40 Hadjithomas, email to the author, February 13, 2012, and interview with the author, June 16, 2012.

41 Kassir, *Being Arab*, 3.

42 In interview with the author and in *Cahiers du Cinéma* no. 626, summer 2007, supplement titled "Carnet de Cinéastes."

43 Jim Quilty, "'Memories fade away, but images remain' . . . as a reminder of bleak moments," *The Daily Star*, October 29, 2008.

44 Glissant, *Poetics of Relation*, 20.

45 Deleuze, *Cinema 2*, 150.

46 Grosz, *Chaos, Territory, Art.*

47 Bergson, *Creative Evolution*, xii.

48 Grosz, *Chaos, Territory, Art*, 66.

49 Darwin, *The Descent of Man, and Selection in Relation to Sex*, quoted in Grosz.

50 Teh, "Itinerant Cinema"; Lim, *"Mysterious Object at Noon."*

51 Pape, "The Vitality of Fabulation," 27.

52 Stanley Heller, "The bitter anniversary of Yusuf Shawamreh's death." *Mondoweiss*, March 19, 2015. https://mondoweiss.net/2015/03/bitter-anniversary-shawamrehs/.

53 Whitehead, *Process and Reality*, 223.

54 Saidiya V. Hartman, quoted at "Make a Way Out of No Way," event at Arika, Glasgow, September 2014. http://arika.org.uk/events/episode-6-make-way -out-no-way. See also Hartman, *Wayward Lives*. Hartman's method of critical fabulation follows not Deleuze but Bal's narrative method in *Narratology*: See Hartman, "Venus in Two Acts."

55 Deleuze, "Plato and the Simulacrum."

56 Arkoun, "Rethinking Islam Today."

57 On the imaginal realm in cinema see Marks, "Real Images Flow" and Kazemi, "A Cinematic Cosmos in Motion."

CHAPTER 7. MONAD, DATABASE, REMIX

1 *Afrofuturism*, a term attributed to Mark Dery, took form as a movement on a listserv founded by Alondra Nelson in 1998, a couple of years after *The Last Angel of History* was released.

2 Corbett, *Extended Play*.

3 George, "Last Angel of History."

4 Weheliye, "Reading Sonic Afro-Modernity," in *Phonographies*.

5 Eshun, "Virtualize the Breakbeat," in *More Brilliant than the Sun*, 71.

6 Deleuze, "Painting and Sensation," in *Francis Bacon*, 31–38.

7 Less smooth than disco and even more infectious, Parliament's music, Eshun writes, switches the roles and functions of brain and booty. "The ass, the brain, and the spine all change places. The ass emerges from its status as sensory untouchable to become the motor-booty, the psychomotor driving you to dance." Eshun, "Mixadelic Universe," in *More Brilliant than the Sun*, 138–53.

8 Dyer, "In Defence of Disco," 526.

9 Cosgrove, "Seventh City Techno," 679–80.

10 Perniola, "Secrets, Folds, and Enigmas," in *Enigmas*, 18–21.

11 The credits say that it is filmed in the southern United States. The scene hearkens forward to Hurricane Katrina of 2005, which revealed southern state governments' criminal disregard for their poorest populations, overwhelmingly Black, and to subsequent calamities that demonstrate how white supremacy is built into government policy.

12 Benjamin, "Theses on the Philosophy of History," in *Illuminations*, 257; referring to the historian Leopold von Ranke.

13 Benjamin, "Theses on the Philosophy of History," in *Illuminations*, 255.

14 Quoted in Mayer, *Artificial Africas*, 242n71.

15 I thank Yani Kong for this observation.

16 Deleuze, "Postscript on the Societies of Control."

17 Akomfrah and Eshun, "An Absence of Ruins: John Akomfrah in Conversation with Kodwo Eshun," in *The Ghosts of Songs*," 132.

18 Eshun, "Further Considerations on Afrofuturism," 289.

19 Lanier, *Who Owns the Future?*

20 Eshun, "Further Considerations," 292.

21 Lanier, *Who Owns the Future?*

22 Eshun, "Further Considerations," 290.

23 Eisenstein, "A Dialectic Approach to Film Form," in *Film Form*, 45–63.

24 Banning, "Feeding off the Dead."

25 Deleuze, "Peaks of Present and Sheets of Past," in *Cinema 2*, 98–125. Also see Jean Fisher's discussion in "In Living Memory . . . Archive and Testimony in the Films of the Black Audio Film Collective," in Eshun and Sagar, *The Ghosts of Songs*, 24.

26 Cited in Weheliye, 79.

27 Benjamin, "On the Concept of History," in *Selected Writings*, vol. 4, 396.

28 For more on how Benjamin constituted the concept of the monad see Schwebel, "Intensive Infinity."

29 Akomfrah and Eshun, "An Absence of Ruins: John Akomfrah in Conversation with Kodwo Eshun," in *The Ghosts of Songs*, 131; see also George, "Last Angel of History."

30 See chapter 1 of Marks, *The Skin of the Film* for a discussion of Foucauldian archaeologies in the films of BAFC, including Akomfrah's *Handsworth Songs* (1986), *Seven Songs for Malcolm X* (1993), and *Who Needs a Heart?* (1991) and Reece Auguiste's *Mysteries of July* (1991). To Foucault's categories of "seeable" and "sayable" I add the "sensible," for an archaeology of sense memory.

31 Banneker, *Memoir of Benjamin Banneker, . . .* , 15–16. Jefferson responded cordially and told Banneker that he had forwarded his almanac to the Marquis de Condorcet of the Academy of Sciences in Paris, but did not budge in his stance on slavery.

32 Swartz, "Removing the Master Script," 31–49.

33 Deleuze, *Cinema 2*, 149.

34 George, "(ghost the signal)," in Eshun and Sagar, *The Ghosts of Songs*, 205.

35 Eshun, "Operating System for the Redesign of Sonic Reality."

36 Syms, "The Mundane Afrofuturist Manifesto."

37 Bennett, "Logical Depth and Computational Complexity."

38 Bernal, *Black Athena*, vol. 1, *The Fabrication of Ancient Greece, 1785–1995*; vol. 2, *The Archaeological and Documentary Evidence*; vol. 3, *The Linguistic Evidence*.

39 Ṣadrā, *On the Incipience of the Cosmos*, cited in Rizvi, "Mulla Sadra," *The Stanford Encyclopedia of Philosophy*.

40 This is what we do in the Substantial Motion Research Network (SMRN): unfold and, when necessary, fabulate a-Western origins for contemporary philosophy and media technologies. A number of SMRN members appear in these pages, including Juan Castrillón, Delinda Collier, Azadeh Emadi, Tarek Elhaik, Walid El Khachab, Somayeh Khakshoor, and Radek Przedpełski.

41 Zielinski, *Deep Time of the Media*. See also the edited volumes of *Variantology* published by Walther König.

42 Stengers, "Making History," in *The Invention of Modern Science*, 89–107.

43 See Burnett, *Magic and Divination in the Middle Ages.*

44 Eglash, "Bamana Sand Divination." See also Ogunnaike, "Ayodeji Ogunnaike on the Dynamic Spread of Geomancy in Africa."

45 Eglash, *African Fractals,* 99–100; Haskins, *Studies in the History of Mediaeval Science,* 77–78.

46 Zielinski, *Deep Time of the Media,* 79–83, 118–120: Cramer, *Words Made Flesh*; David Link, "Scrambling T-R-U-T-H."

47 Eglash, *African Fractals,* 101; Uckleman, "Computation in Medieval Western Europe." See also Bascom, *Sixteen Cowries*; Peek, *African Divination Systems*; and the large bibliography on ethnomathematics.

48 Silvio Bedini, *The Life of Benjamin Banneker,* cited in Eglash, "The African Heritage of Benjamin Banneker."

49 See Hazzard-Donald, *Mojo Workin'.*

50 Walcott, "The Sight of Sound," 167–71.

51 Grandmaster Flash, quoted in McLeod and DiCola, *Creative License,* 55.

52 Grandmaster Flash, quoted in McLeod and DiCola, *Creative License,* 22–26.

53 Schafer, *The Soundscape.*

54 Navas, *Remix Theory,* 67–68.

55 May, "Techno," 342–48. The interview with Derrick May is undated but took place sometime between 1995 and 2000.

56 Merry Clayton, interview in Morgan Neville's film *20 Feet from Stardom* (US, 2013).

CHAPTER 8. THE MONAD NEXT DOOR

1 Leibniz, *The Monadology,* §56, in Strickland, *Leibniz's Monadology,* 119.

2 Carr, *A Theory of Monads,* 52–53.

3 Deferring to *Reductress* again, I note this quiz, "Are You Overthinking or Are You the Most Perceptive Person Alive?" One of the questions seems to be a spoof of Bergson's widening circle of consciousness:

> Do you tend to think in the same loop, over and over?
>
> 1 I move on pretty easily.
>
> 2 Yes, and it's stressing me the fuck out!
>
> 3 Yes, because each time I think about something, I learn even more, and I become more aware of myself and everything else in the universe. The answers simply lie within me.
>
> https://reductress.com/post/quiz-are-youoverthinking-or-are-you-the -most-perceptive-person-alive/.

Sometimes I spend a few blessed moments in answer number 3, but answer number 2 is more typical of my day-to-day mode.

4 Yang, "Dreamlike Editing in *Félicité*," essay for my course Art and the Moving Image, Simon Fraser University, Fall 2020.

5 Dorsky, *Devotional Cinema,* 33, 48–50.

6 Barlet, "*Félicité,*" 306.

7 Glissant, *Poetics of Relation*, 124.
8 Whitehead, *Process and Reality*, 212–14.
9 Shipley and Taylor, "Life as Eutopia."
10 Hogeveen, "A Rich and Revitalizing Legacy," 3.
11 Janine Debanné, email to the author, March 8, 2005.
12 Debanné, "Claiming Lafayette Park as Public Housing."
13 Leibniz, *The Monadology*, §62, in Strickland, *Leibniz's Monadology*, 27.
14 Unlike the Lacanian subject that is ultimately an illusion, the Leibnizian monad has a center that belongs to it alone. It just isn't quite sure where it ends and others begin.
15 Appadurai, "Mediants, Materiality, Normativity," 228.
16 Appadurai, 231.
17 Rancière, *Film Fables*, 3.
18 Pethö, "Reading the Intermedial," 13.
19 Pethö, "Reading the Intermedial," 12.
20 See Barker, *The Tactile Eye.*
21 The Foucauldian categories to which Deleuze added the societies of control, as Sequeira Brás analyzes in *"O Som Ao Redor."*
22 Sequeira Brás, "O Som Ao Redor," 227.
23 Mendonça's subsequent feature, *Aquarius*, will extend his hold on the real estate horror genre.
24 Fay, *Inhospitable World*, 109.

CONCLUSION. RECOGNIZING OTHER EDGES

1 Quivinger, "Immersed in Sfumato."
2 Lushetich and Fujihata, *"BeHere,"* 149.
3 Lushetich and Fujihata, *"BeHere"*; Steyerl, "In Defense of the Poor Image," in *The Wretched of the Screen*, 31–45; Marks, "Images in Motion: From Haptic Vision to Networked Space," in *Hanan al-Cinema*, 275–98.
4 Rutherford, "What Is Body, What Is Space?," 16.
5 Rutherford, "What Is Body, What Is Space?," 10. Also see Duan, "Thinking, Feeling and Experiencing."
6 Fiona Matthews, response to Rutherford's article in a bibliography for my course Theory and Cinema, Simon Fraser University, Fall 2020.
7 Gell, *Art and Agency.*
8 James Tapper, "Hiding in plain sight: activists don camouflage to beat Met surveillance," *Guardian*, February 1, 2020.
9 Blas, "Informatic Opacity."
10 Jancovic, *A Media Epigraphy of Video Compression*, 124.
11 Charitsis, Zwick, and Bradshaw, "Creating Worlds That Create Audiences."
12 See Martin and Cleghorn, editors, *Mirror-Touch Synaesthesia.*
13 Marks, "I Feel Like an Abstract Line."

14 Ingold, "Up, Across, and Along"; Cubitt, "Line," in *The Practice of Light*; Marks, "I Feel Like an Abstract Line."

15 Deleuze and Guattari, *A Thousand Plateaus*, 500.

16 The apparently contradictory findings of Heaps, Waitzer, and Eaton, "Canadian Pensions Are Retiring Fossil Fuel Investments," and Dempsey et al., "An Insecure Future."

17 Dempsey et al., "An Insecure Future," 7.

Adams, Hunter Havelin III. "African Observers of the Universe: The Sirius Question." In *African Presence in Early America*, 27–46. Edited by Ivan Van Sertima. New Brunswick, NJ: Transaction Publishers, 2007.

Adamson, Joni, and Salma Monani. "Cosmovisions, Ecocriticism, and Indigenous Studies." In *Ecocriticism and Indigenous Studies: Conversations from Earth to Cosmos*, 1–19. Edited by Joni Adamson and Salma Monani. New York: Routledge, 2017.

Allen, Barry. *Striking Beauty: The Dao of Asian Martial Arts.* New York: Columbia University Press, 2015.

Amad, Paula. *Counter Archive: Film, the Everyday, and Albert Kahn's Archives de la Planète.* New York: Columbia University Press, 2010.

Amin, Samir. *Samir Amin, Pioneer of the Rise of the South.* New York: Springer, 2014.

Amon, Stephanie. Review of *How to Do Things with Affects: Affective Triggers in Aesthetic Forms and Cultural Practices*, edited by Ernst van Alphen and Tomáš Jirsa. *Afterimage* 47, no. 2 (2020): 93–96.

Amoore, Louise. "Doubt and the Algorithm: On the Partial Accounts of Machine Learning." *Theory, Culture and Society* 36, no. 2 (2009): 1–23.

Amoore, Louise, ed. "Thinking with Algorithms: Cognition and Computation in the Work of N. Katherine Hayles." *Theory, Culture, and Society* 36, no. 2 (March 2019): 3–16.

Anstruther-Thomson, Clementina. *Art and Man: Essays and Fragments.* Introduction by Vernon Lee. London: John Lane, the Bodley Head, 1924.

Appadurai, Arjun. "Mediants, Materiality, Normativity." *Public Culture* 27, no. 2 (2015): 221–37.

Arias, Arturo. "Indigenous Knowledges and Sites of Indigenous Memory." *Transmodernity: Journal of Peripheral Cultural Production of the Luso-Hispanic World* 7, no. 1 (2017): 1–17.

Aristotle. *De anima*. Edited and translated by R. D. Hicks. Cambridge: Cambridge University Press, 1907.

Arkoun, Mohammed. "Rethinking Islam Today." *Annals of the American Academy of Political and Social Science*, 588 (July 2003): 18–39.

Arthur, Richard T. W. *Monads, Composition, and Force: Ariadnean Threads through Leibniz's Labyrinth*. Oxford: Oxford University Press, 2018.

Bailey, Clark. "Mammalian Mathematicians." In *The Force of the Virtual: Deleuze, Science, and Philosophy*, 301–26. Edited by Peter Gaffney. Minneapolis: University of Minnesota Press, 2010.

Bal, Mieke. *Narratology: Introduction to the Theory of Narrative*. Toronto: University of Toronto Press, 1997.

Balibar, Étienne. "Subjection and Subjectivation." In *Supposing the Subject*, 1–15. Edited by Joan Copjec. London: Verso, 1994.

Baltrušaitis, Jurgis, and W. J. Strachan. *Anamorphic Art*. New York: Harry N. Abrams, 1977.

Banneker, Benjamin. *Memoir of Benjamin Banneker, Read before the Maryland Historical Society, at the Monthly Meeting, May 1, 1845, by John H. B. Latrobe, Esq*. Baltimore: John D. Toy, 1845.

Banning, Kass. "Feeding off the Dead: Necrophilia and the Black Imaginary (An Interview with John Akomfrah)." *Border/Lines*, nos. 29–30 (1993): 28–38.

Barad, Karen. *Meeting the Universe Halfway: Quantum Physics and the Entanglement of Matter and Meaning*. Durham, NC: Duke University Press, 2007.

Barker, Jennifer M. *The Tactile Eye: Touch and the Cinematic Experience*. Berkeley: University of California Press, 2009.

Barlet, Olivier. "*Félicité*: A Lesson in Cinema." Translated by Melissa Thackway. *Black Camera* 9, no. 1 (Fall 2017): 304–6.

Barnouw, Jeffrey. "The Beginnings of 'Aesthetics' and the Leibnizian Conception of Sensation." In *Eighteenth-Century Aesthetics and the Reconstruction of Art*, 52–95. Edited by Paul Mattick Jr. Cambridge: Cambridge University Press, 2011.

Bascom, William Russell. *Sixteen Cowries: Yoruba Divination from Africa to the New World*. Bloomington: Indiana University Press, 1980.

Basile, Pierfrancesco. "Herbert Wildon Carr (1857–1931)." In *Handbook of Whiteheadian Process Thought*, vol. 2, 383–84. Edited by Michel Weber. Frankfurt: Ontos, 2008.

Basile, Pierfrancesco. *Leibniz, Whitehead and the Metaphysics of Causation*. Basingstoke: Palgrave Macmillan, 2009.

Belkhir, Lotfi, and Ahmed Elmeligi. "Assessing ICT Global Emissions Footprint: Trends to 2040 and Recommendations." *Journal of Cleaner Production* 177 (2018): 448–63.

Beller, Jonathan. *The Message Is Murder: Substrates of Computational Capital*. London: Pluto, 2018.

Beller, Jonathan. *The World Computer: Derivative Conditions of Racial Capitalism*. Durham, NC: Duke University Press, 2021.

Belting, Hans. *Florence and Baghdad: Renaissance Art and Arab Science.* Translated by Deborah Lucas Schneider. Cambridge, MA: Harvard University Press, 2011.

Benjamin, Walter. *Illuminations: Essays and Reflections.* Edited by Hannah Arendt. Translated by Harry Zohn. New York: Harcourt, Brace, and World, 1978.

Benjamin, Walter. *Selected Writings.* Edited by Marcus Paul Bullock and Michael W. Jennings. Cambridge, MA: Belknap, 2003.

Bennett, Charles H. "Logical Depth and Computational Complexity." In *The Universal Turing Machine—A Half-Century Survey,* 227–57. Edited by Rolf Herken. Oxford: Oxford University Press, 1988.

Bennett, Jane. *Vibrant Matter: A Political Ecology of Things.* Durham, NC: Duke University Press, 2010.

Bergson, Henri. *Creative Evolution.* Translated by Arthur Mitchell. Mineola, NY: Dover, 1998.

Bergson, Henri. *Matter and Memory.* Translated by N. M. Paul and S. Palmer. New York: Zone, 1991.

Bernal, Martin. *Black Athena: The Afroasiatic Roots of Classical Civilization.* 3 vols. New Brunswick, NJ: Rutgers University Press, 1987, 1991, 2006.

Bertelsen, Lone, and Andrew Murphie. "An Ethics of Everyday Infinities and Powers: Félix Guattari on Affect and the Refrain." In *The Affect Theory Reader,* 138–60. Edited by Melissa Gregg and Gregory Seigworth. Durham, NC: Duke University Press, 2010.

Betz, Mark. "At Random, By Design: On Disorderly Affection." Conference in honor of D. N. Rodowick. University of Chicago, May 14, 2022.

Birchall, Clare. "Introduction to 'Secrecy and Transparency': The Politics of Opacity and Openness." *Theory, Culture and Society* 28, nos. 7–8 (December 2011): 7–25.

Blanchette, Jean-François. "A Material History of Bits." *Journal of the American Society for Information Science and Technology* 62, no. 6 (2011): 1042–57.

Blas, Zach. "Informatic Opacity." *Journal of Aesthetics and Protest* 9 (2014). https://www.joaap.org/issue9/zachblas.htm.

Bogue, Ronald. *Deleuzian Fabulation and the Scars of History.* Edinburgh: Edinburgh University Press, 2010.

Bohm, David. *Wholeness and the Implicate Order.* New York: Routledge, 2006.

Bohm, David, and Basil J. Hiley. *The Undivided Universe: An Ontological Interpretation of Quantum Theory.* New York: Routledge, 1993.

Bohr, Niels. *Atomic Physics and Human Knowledge.* New York: Science Editions, 1961.

Böni, Heinz, Mathias Schluep, and Rolf Widmer. "Recycling of ICT Equipment in Industrialized and Developing Countries." In *ICT Innovations for Sustainability,* 223–42. Edited by Lorenz M. Hilty and Bernard Aebischer. Heidelberg: Springer, 2015.

Bordage, Frédéric. "The Environmental Footprint of the Digital World." Report for GreenIT.fr, 2019. https://www.greenit.fr/environmental-footprint-of-the-digital-world/.

Bowker, Geoffrey C. "A Plea for Pleats." In *Deleuzian Intersections: Science, Technology, Anthropology,* 123–38. Edited by Casper Bruun Jensen and Kjetil Rødje. New York: Berghahn Books, 2010.

Bracken, Joseph A. "Whitehead's Rethinking of the Problem of Evil." In *Handbook of Whiteheadian Process Thought,* vol. 1, 549–60. Edited by Michael Weber and Will Desmond. Frankfurt: OntosVerlag, 2008.

Braidotti, Rosi. *Nomadic Theory: The Portable Rosi Braidotti.* New York: Columbia University Press, 2011.

Braidotti, Rosi. "Conclusion: The Residual Spirituality in Critical Theory." In *Transformations of Religion and the Public Sphere: Postsecular Publics,* 249–72. Edited by Rosi Braidotti, Bolette Blaagaard, Tobijn de Graauw, and Eva Midden. London: Palgrave Macmillan, 2014.

Braidotti, Rosi. "A Theoretical Framework for the Critical Posthumanities." *Theory, Culture and Society* 36, no. 6 (2019): 32–33.

Brandl, Robert, and Josep Garcia. "The world's most surveilled citizens." *ToolTester,* July 25, 2022. https://www.tooltester.com/en/blog/the-worlds-most -surveilled-countries/.

Bruno, Giuliana. "Pleats of Matter, Folds of the Soul." In *Afterimages of Gilles Deleuze's Cinema Philosophy,* 213–33. Edited by D. N. Rodowick. Minneapolis: University of Minnesota Press, 2009.

Bucher, Taina. "The Algorithmic Imaginary: Exploring the Ordinary Affects of Facebook Algorithms." *Information, Communication and Society* 20, no. 1 (2017): 130–44.

Burnett, Charles. *Magic and Divination in the Middle Ages.* Brookfield, VT: Ashgate, 2017.

Burrows, David J., and Simon O'Sullivan. *Fictioning: The Myth-Functions of Contemporary Art and Philosophy.* Edinburgh: Edinburgh University Press, 2019.

Carr, H. Wildon. *A Theory of Monads.* London: Macmillan, 1922.

Certeau, Michel de. *The History of Everyday Life.* Translated by Steven Rendell. Los Angeles: University of California Press, 1984.

Charitsis, Vassilis, Detlev Zwick, and Alan Bradshaw. "Creating Worlds That Create Audiences: Theorising Personal Data Markets in the Age of Communicative Capitalism." *tripleC* 16, no. 2 (2018): 820–34.

Chernicoff, David. "How Data Centers Pay for Renewable Energy." *Data Center Dynamics,* 2016. https://www.datacenterdynamics.com/en/analysis/how-data -centers-pay-for-renewable-energy/.

Chun, Wendy Hui Kyong. "Queerying Homophily." In *Pattern Discrimination,* by Clemens Apprich, Wendy Hui Kyong Chun, Florian Cramer, and Hito Steyerl, 59–97. Minneapolis: University of Minnesota Press and Meson Press, 2019.

Citton, Yves. "Automatic Endo-Attention, Creative Exo-Attention: The Egocidal and Ecocidal Logic of Neoliberal Capitalism." *New Formations* 98 (2019): 101–18.

Collier, Delinda. *Media Primitivism: Technological Art in Africa.* Durham, NC: Duke University Press, 2020.

Comolli, Jean-Louis. *Cinema against Spectator: Technique and Ideology Revisited.*
Edited and translated by Daniel Fairfax. Amsterdam: Amsterdam University
Press, 2015.

Corbett, John. *Extended Play: Sounding Off from John Cage to Dr. Funkenstein.*
Durham, NC: Duke University Press, 1994.

Cosgrove, Stuart. "Seventh City Techno." In *The Faber Book of Pop*, edited by Hanif
Kureishi and Jon Savage, 677–80. London: Faber and Faber, 1995.

Cramer, Florian. *Words Made Flesh: Code, Culture, Imagination.* Rotterdam: Piet
Zwarf Institute, 2005.

Crary, Jonathan. *24/7: Late Capitalism and the Ends of Sleep.* New York: Verso,
2013.

Critchley, Simon. *On Humour.* New York: Routledge, 2002.

Crow, Karim Douglas. "Imam Ja'far al-Sadiq." In *The Shi'i World: Pathways in
Tradition and Modernity*, 64–65. Edited by Farhad Daftary, Amyn B. Sajoo, and
Shainol Jiwa. New York: I. B. Tauris, 2015.

Cubitt, Seán. *The Cinema Effect.* Cambridge, MA: MIT Press, 2004.

Cubitt, Seán. *Finite Media: Environmental Implications of Digital Technologies.*
Durham, NC: Duke University Press, 2017.

Cubitt, Seán. *The Practice of Light: A Genealogy of Visual Technologies from Prints
to Pixels.* Cambridge, MA: MIT Press, 2014.

Cubitt, Seán, Celia Lury, Scott McQuire, Nikos Papastergiadis, Daniel Palmer,
Jasmin Pfefferkorn, and Emilie Sunde. "Ambient Images." *Nordic Journal of
Aesthetics* 30, nos. 61–62 (2021): 68–77.

Curiel, Gustavo. "Leather Trunk." In *The Splendor of Viceregal Mexico.* Mexico
City and Houston: Museo Franz Mayer and Houston Museum of Fine Art, 2002.

Darwin, Charles. *The Descent of Man, and Selection in Relation to Sex.* New York:
D. Appleton, 1924.

Davey, Nicholas. "Baumgarten, Alexander G(ottlieb) (1714–1762)." In *A Companion
to Aesthetics*, 162–63. Edited by Stephen Davies, Kathleen Marie Higgins, Robert
Hopkins, Robert Stecker, and David E. Cooper. Malden, MA: Wiley-Blackwell,
2009.

Davies, Thomas. *System Change Not Climate Change.* Vancouver: Battle of Ideas
Press, 2019.

Davis, Nick. *The Desiring-Image: Gilles Deleuze and Contemporary Queer Cinema.*
New York: Oxford University Press, 2013.

Debanné, Janine. "Claiming Lafayette Park as Public Housing." In *Lafayette Park
Detroit*, 67–93. Edited by Charles Waldheim. Munich: Prestel Verlag, 2004.

De Boever, Arne, Alex Murray, Jon Roffe, and Ashley Woodward, editors. *Gilbert
Simondon: Being and Technology.* Edinburgh: Edinburgh University Press, 2012.

DeDecker, Kris. "Keeping Some of the Lights On: Redefining Energy Security." *Demand*, December 13, 2018. http://www.demand.ac.uk/13/12/2018/keeping-some
-of-the-lights-on-redefining-energy-security/.

Deely, John. "Building a Scaffold: Semiosis in Nature and Culture." *Biosemiotics* 8
(2015): 341–60.

Deger, Jennifer. *Shimmering Screens: Making Media in an Aboriginal Community.* Minneapolis: University of Minnesota Press, 2006.

DeLanda, Manuel. "Emergence, Causality, and Realism." In *The Speculative Turn*, 3–16. Edited by Levi Bryant, Nick Smieck, and Graham Harman. Melbourne: re.press, 2011.

DeLanda, Manuel. *Intensive Science and Virtual Philosophy.* New York: Continuum, 2002.

DeLanda, Manuel. *A Thousand Years of Nonlinear History.* New York: Zone, 1997.

Deleuze, Gilles. "Bergson, 1859–1941." In *Desert Islands and Other Texts, 1953–1974*, 21–30. Edited by David Lapoujade. Translated by Michael Taormina. New York: Semiotext(e), 2004.

Deleuze, Gilles. *Cinema 1: The Movement-Image.* Translated by Hugh Tomlinson and Barbara Habberjam. Minneapolis: University of Minnesota Press, 1986.

Deleuze, Gilles. *Cinema 2: The Time-Image.* Translated by Hugh Tomlinson and Robert Galeta. Minneapolis: University of Minnesota Press, 1989.

Deleuze, Gilles. *Difference and Repetition.* Translated by Paul Patton. New York: Columbia University Press, 1994.

Deleuze, Gilles. "Doubts about the Imaginary." In *Negotiations, 1972–1990*, 62–67. Translated by Martin Joughin. New York: Columbia University Press, 1995.

Deleuze, Gilles. *Expressionism in Philosophy: Spinoza.* Translated by Martin Joughin. New York: Zone, 1990.

Deleuze, Gilles. *The Fold: Leibniz and the Baroque.* Translated by Tom Conley. Minneapolis: Minnesota University Press, 1993.

Deleuze, Gilles. *Foucault.* Edited and translated by Seán Hand. Minneapolis: University of Minnesota Press, 1988.

Deleuze, Gilles. *Francis Bacon: The Logic of Sensation.* Translated and with an introduction by Daniel W. Smith. Minneapolis: University of Minnesota Press, 2003.

Deleuze, Gilles. "Lecture Transcripts on Spinoza's Concept of *Affect*." Cours Vincennes, January 24, 1978. https://www.webdeleuze.com/cours/spinoza.

Deleuze, Gilles. "Mediators." In *Negotiations, 1972–1990*, 121–34. Translated by Martin Joughin. New York: Columbia University Press, 1995.

Deleuze, Gilles. *Nietzsche and Philosophy.* Translated by Hugh Tomlinson. New York: Columbia University Press, 2006.

Deleuze, Gilles. "Plato and the Simulacrum." In *The Logic of Sense*, 223–66. Edited by Constantin V. Boundas. Translated by Mark Lester with Charles Stivale. New York: Columbia University Press, 1990.

Deleuze, Gilles. *Le pli: Leibniz et le Baroque.* Paris: Les Éditions de Minuit, 1988.

Deleuze, Gilles. "Postscript on the Societies of Control," *October* 59 (Winter 1992): 3–7.

Deleuze, Gilles. *Pure Immanence: Essays on A Life.* Translated by Anne Boyman. New York: Zone, 2001.

Deleuze, Gilles. *Spinoza: Practical Philosophy.* Translated by Robert Hurley. San Francisco: City Lights, 1988.

Deleuze, Gilles. *The Two Regimes of Madness: Texts and Interviews 1975–1995.* Edited by David Lapoujade. Translated by Ames Hodges and Mike Taormina. New York: Semiotext(e), 2006.

Deleuze, Gilles, and Félix Guattari. *Anti-Oedipus: Capitalism and Schizophrenia.* Translated by Robert Hurley, Mark Seem, and Helen R. Lane. Minneapolis: University of Minnesota Press, 1983.

Deleuze, Gilles, and Félix Guattari. *A Thousand Plateaus: Capitalism and Schizophrenia.* Translated by Brian Massumi. Minneapolis: University of Minnesota Press, 1987.

Deleuze, Gilles, and Félix Guattari. *What Is Philosophy?* Translated by Hugh Tomlinson and Graham Burchell. New York: Columbia University Press, 1994.

del Rio, Elena. *Deleuze and the Cinemas of Performance: Powers of Affection.* Edinburgh: Edinburgh University Press, 2008.

Dempsey, Jessica, James Rowe, Katie Reeder, Jack Vincent, and Zoë Yunker. "An Insecure Future: Canada's Biggest Pensions Are Still Investing in Fossil Fuels." Canadian Centre for Policy Alternatives (August 2021).

de Rivera, Javier, Ron Eglash, and Chris Hables Gray. "An Introduction to Generative Justice." *Revista Teknokultura* 13, no. 2 (2006): 361–67.

Di Caulo, Agostino. "Towards 5G Communication Systems: Are There Health Implications?" *International Journal of Hygiene and Environmental Health* 221 (2018): 365–75.

Dillon, Grace, ed. *Walking the Clouds: An Anthology of Indigenous Science Fiction.* Tucson: University of Arizona Press, 2012.

Doane, Mary Ann. "Indexicality: Trace and Sign." *differences: A Journal of Feminist Cultural Studies*, 18, no. 1 (2007): 1–6.

Dorsky, Nathaniel. *Devotional Cinema.* Revised 3rd ed. Willits and Berkeley: Tuumba, 2005.

Duan, Siying. "Thinking, Feeling and Experiencing the 'Empty Shot' in Cinema." *Film-Philosophy* 25, no. 3 (2021): 346–61.

Duffy, Simon. "Leibniz, Mathematics, and the Monad." In *Deleuze and* The Fold, 104–10. Edited by Sjoerd van Tuinen and Niamh McDonnell. Basingstoke: Palgrave Macmillan, 2020.

Dyer, Richard. "In Defence of Disco." In *The Faber Book of Pop.* Edited by Hanif Kureishi and Jon Savage, 518–26. London: Faber and Faber, 1995.

Eglash, Ron. *African Fractals: Modern Computing and Indigenous Design.* New Brunswick, NJ: Rutgers University Press, 1999.

Eglash, Ron. "The African Heritage of Benjamin Banneker." *Social Studies of Science* 27, no. 2 (April 1997): 307–15.

Eglash, Ron. "Bamana Sand Divination: Recursion in Ethnomathematics." *American Anthropologist*, New Series, 99, no. 1 (March 1997): 112–22.

Eglash, Ron. "Oppositional Technophilia." *Social Epistemology: A Journal of Knowledge, Culture and Policy* 23, no. 1 (2009): 79–86.

Eisenstein, Sergei. *Film Form: Essays in Film Theory.* Translated and edited by Jay Leyda. New York: Harcourt, Brace, 1949.

Ekbia, Hamid, and Bonnie Nardi. *Heteromation and Other Stories of Computing and Capitalism.* Cambridge, MA: MIT Press, 2017.

Elahi, Hasan M. "You Want to Track Me? Here You Go, F.B.I." *New York Times,* October 30, 2011.

Elhaik, Tarek. "Ibn Rushd/Averroës in Mexico City's Kiosko Morisco." In *Philosophy on Fieldwork: Case Studies in Anthropological Analysis,* 302–19. Edited by Nils Bubandt and Thomas Schwarz Wentzer. London: Routledge, 2022.

Elkins, James. "Art History and Images That Are Not Art." *Art Bulletin* 77, no. 4 (December 1995): 553–71.

Emadi, Azadeh. "Reconsidering the Substance of Digital Video from a Sadrian Perspective," *Leonardo* 53, no. 1 (2020): 75–80.

Eshun, Kodwo. "Further Considerations on Afrofuturism." *CR: The New Centennial Review* 3, no. 2 (2003): 287–302.

Eshun, Kodwo. *More Brilliant than the Sun: Adventures in Sonic Fiction.* London: Quartet, 1998.

Eshun, Kodwo. "Operating System for the Redesign of Sonic Reality." In *Audio Culture: Readings in Modern Music,* 157–59. Edited by Christoph Cox and Daniel Warner. New York: Continuum, 2004.

Eshun, Kodwo, and Anjalika Sagar, eds. *The Ghosts of Songs: The Film Art of the Black Audio Film Collective.* Liverpool: Liverpool University Press, 2007.

Fakhry, Majid. "The Ontological Argument in the Arabic Tradition: The Case of al-Fārābī." *Studia Islamica,* 64 (1986): 5–17.

Fan, Victor. *Cinema Approaching Reality: Locating Chinese Film Theory.* Minneapolis: University of Minnesota Press, 2015.

Farocki, Haroun. "Phantom Images." Translated by Brian Poole. *Public* 29 (2004): 13–22.

Faye, Jan, and Rasmus Jackstad. "Barad, Bohr, and Quantum Mechanics." *Synthese* 199 (2021): 8231–55.

Fay, Jennifer. *Inhospitable World: Cinema in the Time of the Anthropocene.* New York: Oxford University Press, 2018.

Federici, Silvia, and Peter Linebaugh. *Re-Enchanting the World: Feminism and the Politics of the Commons.* Oakland: PM Press, 2019.

Ferreira da Silva, Denise. "1 (life) ÷ 0 (blackness) = ∞ − ∞ or ∞ / ∞: On Matter Beyond the Equation of Value." *e-flux journal* 79 (February 2017). https://www.e-flux.com/journal/79/94686/1-life-0-blackness-or-on-matter-beyond-the-equation-of-value/.

Fielding, Helen A. "Maurice Merleau-Ponty." In *Film, Theory, and Philosophy: The Key Thinkers,* 81–90. Edited by Felicity Colman. Durham, UK: Acumen, 2009.

Flaxman, Gregory. *Gilles Deleuze and the Fabulation of Philosophy.* Minneapolis: University of Minnesota Press, 2011.

Flusser, Vilém. *Towards a Philosophy of Photography.* London: Reaktion, 2000.

Focillon, Henri. *The Life of Forms in Art.* Translated by Charles Beecher Hogan and George Kubler. New York: Zone, 1992.

Fossati, Giovanna. *From Grain to Pixel: The Archival Life of Film in Transition.* Amsterdam: Amsterdam University Press, 2009.

Friedman, Michael, and Wolfgang Schäffner, eds. *On Folding: Towards a New Field of Interdisciplinary Research*. Bielefeld, Germany: Transcript Verlag, 2016.

Fuchs, Christian. "Karl Marx & Communication @ 200: Towards a Marxian Theory of Communication." *tripleC* 16, no. 2 (2018): 518–34.

Fuller, Matthew, and Andrew Goffey. *Evil Media*. Cambridge, MA: MIT Press, 2012.

Fuller, Matthew, and Olga Goriunova. *Bleak Joys: Aesthetics of Ecology and Impossibility*. Minneapolis: University of Minnesota Press, 2019.

Fuller, Matthew, and Eyal Weizman. *Investigative Aesthetics: Conflicts and Commons in the Politics of Truth*. London: Verso, 2022.

Furihata, Yuriko. "Of Dragons and Geo-Engineering: Rethinking Elemental Media." *Media and Environment* 1, no. 1 (2019). https://mediaenviron.org/article/10797-of-dragons-and-geoengineering-rethinking-elemental-media.

Gallagher, Rob. "Eliciting Euphoria Online: The Aesthetics of 'ASMR' Video Culture." *Film Criticism* 40, no. 2 (June 2016).

Gallese, Vittorio. "Motor Abstraction: A Neuroscientific Account of How Action Goals and Intentions Are Mapped and Understood." *Psychological Research* 4 (2009): 486–98.

Gell, Alfred. *Art and Agency: An Anthropological Theory*. Oxford: Clarendon, 1998.

Gell-Mann, Murray. "Let's Call It Plectics." *Complexity* 1, no. 5 (1996): 3–5.

Gell-Mann, Murray, and James B. Hartle. "Quantum Mechanics in the Light of Quantum Cosmology," 321–43. *Proceedings of the Third International Symposium on the Foundations of Quantum Physics in the Light of New Technology*. Edited by S. Kobayashi, H. Ezawa, Y. Murayama, and S. Nomura. Tokyo: Physical Society of Japan, 1990.

Genosko, Gary. "A-Signifying Semiotics." *The Public Journal of Semiotics* 2, no. 1 (January 2008): 11–21.

George, Edward. "Last Angel of History: Research, Writing, Performance." *Third Text* 35, no. 2 (2021): 205–26.

al-Gitani, Gamal. *Zayni Barakat*. Translated by Farouk Abdel Wahab. Cairo: American University in Cairo Press, 2004.

Glissant, Édouard. *Poetics of Relation*. Translated by Betsy Wing. Ann Arbor: University of Michigan Press, 2010.

Goriunova, Olga. *Art Platforms and Cultural Production on the Internet*. New York: Routledge, 2012.

Goriunova, Olga. "Digital Subjects: An Introduction." *Subjectivity* 12 (2019): 1–11.

Goriunova, Olga. "New Media Idiocy." *Convergence: The International Journal of Research into New Media Technologies* 19, no. 2 (2012): 223–35.

Gossart, Cédric. "Rebound Effects and ICT: A Review of the Literature." In *ICT Innovations for Sustainability*, 435–48. Edited by Lorenz M. Hilty and Bernard Aebischer. Heidelberg: Springer, 2015.

Goytisolo, Juan. *The Garden of Secrets*. Translated by Peter Bush. London: Serpent's Tail, 2000.

Greenpeace. "Clicking Clean: Who Is Winning the Race to Build a Green Internet?," January 10, 2017. https://www.greenpeace.org/international/publication/6826/clicking-clean-2017/.

Griffero, Tonino. *Atmospheres: Aesthetics of Emotional Spaces.* Translated by Sarah de Sanctis. London: Ashgate, 2010.

Grosz, Elizabeth. *Chaos, Territory, Art: Deleuze and the Framing of the Earth.* New York: Columbia University Press, 2008.

Grosz, Elizabeth. *The Incorporeal: Ontology, Ethics, and the Limits of Materialism.* Durham, NC: Duke University Press, 2020.

Grusin, Richard A. *Premediation: Affect and Mediality after 9/11.* Basingstoke: Palgrave Macmillan, 2010.

Grusin, Richard A. "Radical Mediation." *Critical Inquiry* 42 (Autumn 2015): 124–48.

Guattari, Félix. *Chaosmosis: An Ethico-Aesthetic Paradigm.* Translated by Paul Bains and Julian Pefanis. Sydney: Power Publications, 1995.

Gunning, Tom. "Re-Newing Old Technologies: Astonishment, Second Nature, and the Uncanny in Technology, from the Previous Turn-of-the-Century." In *Rethinking Media Change: The Aesthetics of Transition*, 39–60. Edited by David Thorburn and Henry Jenkins. Cambridge, MA: MIT Press, 2003.

Haber, Nick, Catalin Voss, and Dennis Wall. "Upgraded Google Glass Helps Autistic Kids 'See' Emotions." *IEEE Spectrum*, March 26, 2020.

Halfhill, T. R. "The Mythology of Moore's Law: Why Such a Widely Misunderstood 'Law' Is So Captivating to So Many." *IEEE SSCS Newsletter* (September 2006): 21–25.

Halperin, Ilana. "Physical Geology/The Library." In *Art and the Anthropocene: Encounters Among Aesthetics, Politics, Environments and Epistemologies*, 79–84. Edited by Heather Davis and Etienne Turpin. London: Open Humanities Press, 2015.

Hansen, Miriam Bratu. *Cinema and Experience: Siegfried Kracauer, Walter Benjamin, and Theodor W. Adorno.* Berkeley: University of California Press, 2012.

Hartman, Saidiya V. *Scenes of Subjection: Terror, Slavery, and Self-Making in Nineteenth-Century America.* Oxford: Oxford University Press, 1997.

Hartman, Saidiya V. "Venus in Two Acts." *small axe* 26 (June 2008): 1–14.

Hartman, Saidiya V. *Wayward Lives, Beautiful Experiments.* New York: Norton, 2019.

Haskins, Charles Homer. *Studies in the History of Mediaeval Science.* Cambridge, MA: Harvard University Press, 1924.

Haykal, Bani. "nusantara pessimism / a not-so mani(s)festo." *Millennium Film Journal* 76 (Fall 2022): 48–55.

Hayles, N. Katherine. *How We Became Posthuman: Virtual Bodies in Cybernetics, Literature, and Informatics.* Chicago: University of Chicago Press, 1999.

Hazzard-Donald, Katrina. *Mojo Workin': The Old African American Hoodoo System.* Champaign: University of Illinois Press, 2012.

Heaps, Toby A. A., Ed Waitzer, and Derek Eaton. "Canadian Pensions Are Retiring Fossil Fuel Investments." In *Corporate Knights* (Fall 2021). https://esg-reporting.uwaterloo.ca/catalogue/canadian-pensions-are-retiring-fossil-fuel-investments/.

Herzog, Amy. "Assemblage, Constellation, Image: Reading Filmic Matter." *Discourse* 38, no. 2 (Spring 2016): 2015–34.

Hilbert, Martin, and Priscilla López. "The World's Technological Capacity to Store, Communicate, and Compute Information." *Science* 332 (2011): 60–65.

Hilty, Lorenz M. "Computing Efficiency, Sufficiency, and Self-sufficiency: A Model for Sustainability?" Conference proceedings. LIMITS'15, Irvine, CA, June 15–16, 2015. https://computingwithinlimits.org/2015/papers/limits2015-hilty.pdf.

Hilty, Lorenz M., and Bernard Aebischer, eds. *ICT Innovations for Sustainability.* Heidelberg: Springer, 2015.

Hintemann, Ralph. "Efficiency Gains Are Not Enough: Data Center Energy Consumption Continues to Rise Significantly." Borderstep Institute for Innovation and Sustainability, 2019. https://www.borderstep.de/publikation/hintemann-r-2020-data-centers-2018-efficiency-gains-are-not-enough-data-center-energy-consumption-continues-to-rise-significantly-berlin-borderstep-institute/.

Hjorth, Larissa, Sarah Pink, and Kristen Sharp. *Screen Ecologies: Art, Media, and Environment in the Asia-Pacific Region.* Cambridge, MA: MIT Press, 2016.

Hoel, A. S. Aurora. "Image Agents." *Nordic Journal of Aesthetics* 30, nos. 61–62 (July 2021): 120–25.

Hoffmeyer, Jesper. *Biosemiotics: An Examination into the Signs of Life and the Life of Signs.* Edited by Donald Favareau. Translated by Jesper Hoffmeyer and Donald Favareau. Scranton, PA: University of Scranton Press, 2008.

Hogarth, William. "From *The Analysis of Beauty.*" In *Art in Theory 1648–1815,* 491–501. Edited by Charles Harrison, Paul Wood, and Jason Gaiger. Malden, MA: Blackwell, 2000.

Hogeveen, Esmé. "A Rich and Revitalizing Legacy: Ephraim Asili's *The Inheritance.*" *The Brooklyn Rail* (September 2020).

Hongisto, Ilona. *Soul of the Documentary: Framing, Expression, Ethics.* Amsterdam: Amsterdam University Press, 2015.

hooks, bell. *Black Looks: Race and Representation.* New York: Routledge, 1992.

Hu, Tung-hui. "Wait, Then Give Up: Lethargy and the Reticence of Digital Art." *Journal of Visual Culture* 6, no. 3 (2017): 337–54.

Hui, Yuk. *On the Existence of Digital Objects.* Minneapolis: University of Minnesota Press, 2016.

Ingold, Tim. "Up, Across, and Along." In *Lines: A Brief History,* 72–103. New York: Routledge, 2007.

Iqbal, Muhammad. *The Reconstruction of Religious Thought in Islam.* Stanford, CA: Stanford University Press, 2012.

Irani, Lilly. "The Cultural Work of Microwork." *New Media and Society,* 17, no. 5 (2015): 720–39.

Irani, Lilly. "Difference and Dependence among Digital Workers: The Case of Amazon Mechanical Turk." *South Atlantic Quarterly* 114, no 1 (Winter 2015): 225–34.

Irani, Lilly. Review of *Heteromation and Other Stories of Computing and Capitalism,* by Hamid Ekbia and Bonnie Nardi. *Mind, Culture, and Activity* 28, no. 3 (October 2021): 280–84.

İşcen, Özgün Eylül. "The Geopolitical Aesthetic of Computational Media: Media Arts in the Middle East." PhD diss., Computational Media, Arts and Cultures. Duke University, 2020.

Ivakhiv, Adrian. *Ecologies of the Moving Image: Cinema, Affect, Nature*. Waterloo: Wilfrid Laurier University Press, 2013.

Ivakhiv, Adrian. *Shadowing the Anthropocene: Eco-Realism in Turbulent Times*. Earth, Milky Way [*sic*]: Punctum, 2018.

Jancovic, Marek. *A Media Epigraphy of Video Compression: Reading Traces of Decay*. London: Palgrave Macmillan, 2023.

Jennings, David. *Net, Blogs and Rock 'n' Roll: How Digital Discovery Works and What It Means for Consumers*. London: Nicholas Brealey, 2007.

Johnson, Ian. "Thirty Years After Tiananmen: Someone Always Remembers." *New York Times*, June 3, 2018.

Jones, Graham. "Solomon Maimon." In *Deleuze's Philosophical Lineage*, 104–29. Edited by Graham Jones and Jon Roffe. Edinburgh: Edinburgh University Press, 2009.

Juarrero, Alicia. "Complexity and Chaos." In *Encyclopedia of Science, Technology, and Ethics*, 387–92. Edited by Carl Mitcham. Detroit: Macmillan, 2005.

Juarrero, Alicia. "Downward Causation: Polanyi and Prigogine." *Tradition and Discovery: Polanyi Society Periodical* 40, no. 3 (2013–2014): 4–15.

Kassir, Samir. *Being Arab*. Translated by Will Hobson. London: Verso, 2006.

Kazemi, Farshid. "A Cinematic Cosmos in Motion: Islamicate Philosophy, Hūrqalyā, and Cinema (Theory)." *Techniques*, special issue on "Evil Eye Media." Edited by Farshid Kazemi, Laura U. Marks, and Radek Przedpełski, forthcoming.

Keeling, Kara. *Queer Times, Black Futures*. New York: NYU Press, 2019.

Kember, Sarah, and Joanna Zylinska. *Life after New Media: Mediation as a Vital Process*. Cambridge, MA: MIT Press, 2012.

Kimmerer, Robin Wall. *Braiding Sweetgrass: Indigenous Wisdom, Scientific Knowledge, and the Teachings of Plants*. Minneapolis: Milkweed, 2013.

Klein, Naomi. *The Shock Doctrine: The Rise of Disaster Capitalism*. Toronto: Vintage, 2008.

Kockelman, Paul. "The Complexity of Discourse." *Journal of Quantitative Linguistics* 16, no. 1 (2009): 1–39.

Kockelman, Paul. "Information Is the Enclosure of Meaning: Cybernetics, Semiotics, and Alternative Theories of Information." *Language and Communication* 33 (2013): 115–27.

Kong, Yani, and Laura U. Marks. "'You can't look into my eyes': The Aesthetics of Small-File Cinema." *Unthinking Photography* (May 2022). https://unthinking .photography/articles/you-cant-look-into-my-eyes-the-aesthetics-of-small-file -cinema.

Kordela, A. Kiarina. *Epistemontology in Spinoza-Marx-Freud-Lacan: The (Bio) Power of Structure*. New York: Routledge, 2018.

Koziol, Michael. "5G's Waveform Is a Battery Vampire." *IEEE Spectrum*. July 24, 2019.

Krauss, Rosalind. "Notes on the Index: Seventies Art in America. Part 2." *October* 4 (1977): 58–67.

Lambert, Sofie, Margot Deruyck, Ward Van Heddeghem, Bart Lannoo, Wout Joseph, Didier Colle, Mario Pickavet, and Piet Demeester. "Post-Peak ICT: Graceful Degradation for Communication Networks in an Energy Constrained Future." *IEEE Communications Magazine* 53, no. 11 (November 2015): 166–74.

Lanier, Jaron. *Who Owns the Future?* London: Allen Lane, 2013.

Larkin, Brian. "The Politics and Poetics of Infrastructure." *Annual Review of Anthropology* 42 (2013): 327–43.

Latour, Bruno. "Why Has Critique Run Out of Steam? From Matters of Fact to Matters of Concern." *Critical Inquiry* 30, no. 2 (Winter 2004): 225–48.

Lawrence, D. H. *D. H. Lawrence and Italy*. New York: Penguin, 1972.

Lee, Vernon. *The Psychology of an Art Writer*. Translated by David Nagy. New York: David Zwirner Gallery, 2018.

Lefebvre, Martin. "Peirce's Esthetics: A Taste for Signs in Art." *Transactions of the Charles S. Peirce Society* 43, no. 2 (2007): 319–44.

Leibniz, Gottfried Wilhelm. *Confessio Philosophi. Papers Concerning the Problem of Evil, 1671–1678*. Translated, edited, and with an introduction by Robert C. Sleigh Jr. Additional contributions from Brendan Look and James Stam. New Haven, CT: Yale University Press, 2005.

Leibniz, Gottfried Wilhelm. *Discourse on Metaphysics and Other Essays*. Translated and edited by Daniel Garber and Roger Ariew. Cambridge: Hackett, 1991.

Leibniz, Gottfried Wilhelm. *Sämtliche Schriften und Briefe*, ed. Akademie der Wissenschaften. Darmstadt: O. Reichl, 1923.

Leidig, Mathias, and Richard M. Teeuw. "Quantifying and Mapping Global Data Poverty." *PLOS One* 10, no. 11 (November 2015). https://doi.org/10.1371/journal.pone.0145591.

Lewis, Richard S. "Technological Gaze: Understanding How Technologies Transform Perception." In *Perception and the Inhuman Gaze: Perspectives from Philosophy, Phenomenology, and the Sciences*, 128–42. Edited by Anya Daly, Fred Cummins, James Jardine, and Dermot Moran. New York: Routledge, 2020.

Lialina, Olga, and Dragan Espenschied, eds. *Digital Folklore*. Stuttgart: Merz and Solitude, 2009.

Liang, Lawrence. "Beyond Representation: The Figure of the Pirate." In *Making and Unmaking Intellectual Property: Creative Production in Legal and Cultural Perspective*, 353–75. Edited by Mario Biagioli, Peter Jaszi, and Martha Woodmansee. Chicago: University of Chicago Press, 2011.

Lim, Dennis. "*Mysterious Object at Noon*: Stories That Haunt One Another." *The Criterion Collection*, May 30, 2017. https://www.criterion.com/current/posts/4624-mysterious-object-at-noon-stories-that-haunt-one-another.

Link, David. "Scrambling T-R-U-T-H: Rotating Letters as a Material Form of Thought." In *Variantology 4: On Deep Time Relations of Arts, Sciences and Technologies in the Arabic-Islamic World and Beyond*, 215–66. Edited by Siegfried Zielinski and Eckhard Fürlus. Cologne: Walter König, 2010.

Lobato, Ramon, and Julian Thomas. *The Informal Media Economy*. Malden, MA: Polity, 2015.

Look, Brandon C. "Leibniz and the '*Vinculum Substantiale*.'" *Studia Leibnitiana*, Supplement 30. Stuttgart: Steiner, 1999.

Look, Brandon C. "Leibniz's Metaphysics." In *The Continuum Companion to Leibniz*, 89–109. Edited by Brandon C. Look. London: Continuum, 2011.

Lund, Jacob, ed. "Questionnaire on the Changing Ontology of the Image." *Nordic Journal of Aesthetics*, nos. 61–62 (2021): 120–25.

Lushetich, Natasha, and Masaki Fujihata. "*BeHere*: Prosthetic Memory in the Age of Digital Frottage." In *Big Data: A New Medium?*, 145–59. Edited by Natasha Lushetich. New York: Routledge, 2021.

MacCormack, Patricia. "Becoming-Vulva: Flesh, Fold, Infinity." *New Formations* (June 2009): 93–107.

MacKenzie, Adrian. *Machine Learners: Archaeology of a Data Practice*. Cambridge, MA: MIT Press, 2017.

MacKenzie, Adrian, and Anna Munster. "Platform Seeing: Image Ensembles and Their Invisualities." *Theory, Culture and Society* 36, no. 5 (2019): 3–22.

Makonin, Stephen, Laura U. Marks, Ramy ElMallah, Alejandro Rodriguez-Silva, and Radek Przedpełski. "A Holistic End-To-End Model to Calculate the Carbon Footprint of Streaming Media." Conference proceedings. LIMITS 2022. https://limits.pubpub.org/pub/calc/release/1.

Marks, Laura U. "Arab Glitch." In *Uncommon Grounds: New Media and Critical Practices in North Africa and the Middle East*, 257–71. Edited by Anthony Downey. New York: I. B. Tauris, 2014.

Marks, Laura U. "Collapse Informatics and the Environmental Impact of Information and Communication Technologies." In *Routledge Handbook of Ecomedia Studies*, 115–28. Edited by Antonio Lopez, Adrian Ivakhiv, Stephen Rust, Miriam Tola, Alenda Chang, and Kiu-Wai Chu. New York: Routledge, 2024.

Marks, Laura U. "A Deleuzian *Ijtihad*: Unfolding Deleuze's Islamic Sources Occulted in the Ethnic Cleansing of Spain." In *Deleuze and Race*, 51–72. Edited by Arun Saldhana and Jason Michael Adams. Edinburgh: Edinburgh University Press, 2013.

Marks, Laura U. *Enfoldment and Infinity: An Islamic Genealogy of New Media Art*. Cambridge, MA: MIT Press, 2010.

Marks, Laura U. "Experience—Information—Image: A Historiography of Unfolding, Arab Cinema as Example." *Cultural Studies Review* 16, no. 1 (March 2002): 85–98. Reprinted in *Cinema at the Periphery*, 232–53. Edited by Dīna Iordanova, David Martin-Jones, and Belén Vidal. Detroit: Wayne State University Press, 2007.

Marks, Laura U. *Hanan al-Cinema: Affections for the Moving Image*. Cambridge, MA: MIT Press, 2015.

Marks, Laura U. "I Feel Like an Abstract Line." In *Mirror-Touch Synaesthesia: Thresholds of Empathy with Art*, 151–76. Edited by Daria Martin with Elinor Cleghorn. Oxford: Oxford University Press, 2017.

Marks, Laura U. "Immigrant Semiosis." In *Fluid Screens, Expanded Cinema: Digital Futures*, 284–303. Edited by Susan Lord and Janine Marchessault. Toronto: University of Toronto Press, 2008.

Marks, Laura U. "Invisible Media." In *New Media: Theories and Practices of Digitextuality*, 33–46. Edited by Anna Everett and John T. Caldwell. New York: Routledge, 2003.

Marks, Laura U. "Lively Up Your Ontology: Bringing Deleuze into Ṣadrā's Modulated Universe." *Qui Parle?* 27, no. 2 (December 2018): 321–54.

Marks, Laura U. "Noise in Enfolding-Unfolding Aesthetics." In *The Oxford Handbook of Sound and Image in Digital Media*, 101–14. Edited by Amy Herzog, John Richardson, and Carol Vernallis. Oxford: Oxford University Press, 2014.

Marks, Laura U. "Nonorganic Subjectivity, Or, Our Friend the Electron." *Millennium Film Journal* 34 (Fall 1999): 66–80.

Marks, Laura U. "Object Lesson: My Rock." In *The Object Reader*, 503–5. Edited by Fiona Candlin and Raiford Guins. New York: Routledge, 2009.

Marks, Laura U. "Poor Images, Ad Hoc Archives, Artists' Rights: The Scrappy Beauties of Handmade Digital Culture." *International Journal of Communication*, 11 (2017): 3899–3916.

Marks, Laura U. "Radical Gestures of Unfolding in Films by Mohamed Soueid and the Otolith Group." In *Gestures of Seeing in Film, Video and Drawing*, 51–72. Edited by Asbjørn Grønstad, Henrik Gustafsson, and Øyvind Vågnes. London: Routledge, 2016.

Marks, Laura U. "Real Images Flow: Mullā Sadrā Meets Film-Philosophy." *Film-Philosophy*, 20 (2015), "A World of Cinemas." Edited by David Martin-Jones. 24–46.

Marks, Laura U. *The Skin of the Film: Intercultural Cinema, Embodiment, and the Senses*. Durham, NC: Duke University Press, 2000.

Marks, Laura U. "Small-File Movies: Saving the Planet, One Pixel at a Time." *Millennium Film Journal* 71/72 (Spring/Fall 2020): 94–100.

Marks, Laura U. "A Survey of ICT Engineering Research Confirms Streaming Media's Carbon Footprint." *Media + Environment*, August 3, 2021. https://mediaenviron.org/post/1116-a-survey-of-ict-engineering-research-confirms-streaming-media-s-carbon-footprint-by-laura-u-marks.

Marks, Laura U. "Talisman-Images: From the Cosmos to Your Body." In *Deleuze, Guattari and the Arts of Multiplicity*, 231–59. Edited by Radek Przedpełski and S. E. Wilmer. Edinburgh: Edinburgh University Press, 2020.

Marks, Laura U. "Thinking Multisensory Culture." *Paragraph* 31, no. 2 (July 2008): 123–37.

Marks, Laura U. *Touch: Sensuous Theory and Multisensory Media*. Minneapolis: University of Minnesota Press, 2002.

Marks, Laura U. "Video Haptics and Erotics." *Screen* 39, no. 4 (Winter 1998): 331–48.

Marks, Laura U. "'We Will Exchange Your Likeness and Recreate You in What You Will Not Know': Cinema and Intercultural Process Philosophy." In *The Anthem*

Handbook of Film Theory, 151–76. Edited by Hunter Vaughan and Tom Conley. London: Anthem, 2018.

Marks, Laura U. "Workshopping for Ideas: Jacques Rivette's *Out 1: Noli Me Tangere.*" *The Cine-Files*, 10 (Spring 2016). http://www.thecine-files.com/marks2016/.

Marks, Laura U. "A World Where Flowers Reign." In *The Upper Side of the Sky*. Vancouver: Western Front, 2021. https://archivesweek.ca › content › about › lauramarks_response_2021.pdf.

Marks, Laura U., and Radek Przedpełski. 2021. "Bandwidth Imperialism and Small-File Media." *Post-45*, special issue on "New Filmic Geographies." Edited by Suzanne Enzerink, 2021. https://post45.org/2021/04/bandwidth-imperialism -and-small-file-media/.

Marks, Laura U., and Radek Przedpełski. "The Carbon Footprint of Streaming Media: Problems, Calculations, Solutions." In *Film and TV Production in the Age of Climate Crisis*, 207–34. Edited by Pietari Kääpa and Hunter Vaughan. Basingstoke: Palgrave, 2022.

Martin, Adrian. *Mise-en-Scène and Film Style*. Basingstoke: Palgrave Macmillan, 2014.

Martin, Daria, with Elinor Cleghorn, editors. *Mirror-Touch Synaesthesia: Thresholds of Empathy with Art*. Oxford: Oxford University Press, 2017.

Massumi, Brian. *Parables for the Virtual: Movement, Affect, Sensation*. Durham, NC: Duke University Press, 2002.

Massumi, Brian. *Ontopower: War, Powers, and the State of Perception*. Durham, NC: Duke University Press, 2015.

Mattern, Shannon. *Code and Clay, Data and Dirt: Five Thousand Years of Urban Media*. Minneapolis: University of Minnesota Press, 2017.

May, Beverly. "Techno." In *African-American Music: An Introduction*, 342–48. Edited by Mellonee V. Burnim and Portia K. Maultsby. New York: Routledge, 2006.

Mayer, Ruth. *Artificial Africas: Colonial Images in the Time of Globalization*. Hanover, NH: Dartmouth College Press, 2002.

Mbembe, Achille. *Critique of Black Reason*. Translated and with an introduction by Laurent Dubois. Durham, NC: Duke University Press, 2017.

McElhaney, Joe. *Luchino Visconti and the Fabric of Cinema*. Detroit: Wayne State University Press, 2021.

McLeod, Kembrew, and Peter DiCola. *Creative License: The Law and Culture of DJ Sampling*. Durham, NC: Duke University Press, 2011.

Monticelli, Lara. "Prefiguration: Between Anarchism and Marxism." In *The Future Is Now: An Introduction to Prefigurative Politics*, 32–46. Edited by Lara Monticelli. Bristol, UK: Bristol University Press, 2022.

Moten, Fred. *In the Break: The Aesthetics of the Black Radical Tradition*. Minneapolis: University of Minnesota Press, 2003.

Moten, Fred, and Stefano Harney. *The Undercommons: Fugitive Planning and Black Study*. Wivenhoe/New York: Minor Compositions, 2013.

Mullarkey, John. *Refractions of Reality: Philosophy and the Moving Image*. Basingstoke: Palgrave MacMillan, 2009.

Muller, Nat. *Lost Futurities: Science Fiction in Contemporary Art from the Middle East*. PhD diss., Birmingham UK: City University, 2022.

Mullik, Gopalan. *Explorations in Cinema through Classical Indian Theories*. London: Palgrave Macmillan, 2020.

Munster, Anna. *An Aesthesia of Networks: Conjunctive Experience in Art and Technology*. Cambridge, MA: MIT Press, 2013.

Munster, Anna. *Materializing New Media: Embodiment in Information Aesthetics*. Lebanon, NH: University Press of New England, 2006.

Murray, Timothy. *Digital Baroque: New Media and Contemporary Folds*. Minneapolis: University of Minnesota Press, 2008.

Nail, Thomas. *Theory of the Earth*. Stanford, CA: Stanford University Press, 2021.

Nail, Thomas. *Theory of the Image*. New York: Oxford University Press, 2019.

Nail, Thomas. "What Is an Assemblage?" *SubStance* 46, no. 1 (2017): 21–37.

al-Nakib, Mai. "Disjunctive Synthesis: Deleuze and Arab Feminism." *Signs: A Journal of Women in Culture and Society* 38, no. 2 (Winter 2013): 459–82.

Nardi, Bonnie, Bill Tomlinson, Donald J. Patterson, Jay Chen, Daniel Pargman, Barath Raghavan, and Birgit Penzenstadler. "Computing Within Limits." *Communications of the ACM* [Association for Computing Machinery] 61, no. 10 (October 2018): 86–93.

Navas, Eduardo. *Remix Theory: The Aesthetics of Sampling*. Vienna: Springer-Verlag, 2012.

Ndalianis, Angela. *Neo-Baroque Aesthetics and Contemporary Entertainment*. Cambridge, MA: MIT Press, 2004.

Negri, Antonio. *Reflections on Empire*. With contributions by Michael Hardt and Danilo Zolo. Translated by Ed Emery. Cambridge: Polity, 2008.

Nichols, Bill. *Representing Reality*. Bloomington: Indiana University Press, 1991.

Nietzsche, Friedrich. "Truth and Falsity in an Extra-Moral Sense." Translated by M. A. Mügge. *Et Cetera* 49, no. 1 (Spring 1992): 58–72.

al-Nimr, Samir. 2019. "A Three-Step Guide to Becoming a Model Facebook Citizen in Egypt." *Mada Masr.* December 30.

Noble, Jem. "Anthrotopology: Thirdness, Complexity, and the Poetics of Individualism." PhD diss. Victoria, Australia: Deakin University, 2020.

O'Doherty, Caroline, and Paul Hyland. "Fossil Fuel Burning Plants to Be Used in Emergency, Says Ryan as EirGrid Warns of Major Electricity Outages." *The Independent* (Dublin), September 28, 2021. https://www.independent.ie/irish-news/fossil-fuel-burning-plants-to-be-used-in-emergency-says-ryan-as-eirgrid-warns-of-major-electricity-outages/40899079.html.

Ogunnaike, Ayodeji. "Ayodeji Ogunnaike on the Dynamic Spread of Geomancy in Africa." Islamic Occult Studies on the Rise, October 19, 2021. https://www.islamicoccult.org/ogunnaike.

Oil Change International and Greenpeace United Kingdom. "The International Energy Agency and the Paris Goals: Q&A for Investors." February 7, 2019. https://www.greenpeace.org.uk › wp-content › uploads › 2019 › 07 › 623.1.19-Greenpeace-Investor-QA-v2.1–1.pdf.

O'Sullivan, Simon. *Art Encounters Deleuze and Guattari: Thought Beyond Representation.* Basingstoke: Palgrave Macmillan, 2006.

Pad.ma. "10 Theses on the Archive." 2010. https://pad.ma/texts/padma:10_Theses _on_the_Archive/20.

Pandian, Anand. *Reel World: An Anthropology of Creation.* Durham, NC: Duke University Press, 2015.

Pape, Toni. "The Vitality of Fabulation: Improvisation and Clichés in Mysterious Object at Noon and The Adventure of Iron Pussy." In Érik Bordeleau, Toni Pape, Ronald Rose-Antoinette, and Adam Szymanski, *Nocturnal Fabulations: Ecology, Vitality and Opacity in the Cinema of Apichatpong Weerasethakul.* London: Open Humanities Press, 2017.

Parikka, Jussi. *A Geology of Media.* Minneapolis: University of Minnesota Press, 2015.

Parikka, Jussi. "The Middle East and Other Futurisms: Imaginary Temporalities in Contemporary Art and Visual Culture." *Culture, Theory and Critique* 59, no. 1 (2017): 40–58.

Parikka, Jussi, and Garnet Hertz. "Zombie Media: Circuit Bending Media Archeology into an Art Method." *Leonardo* 45, no. 5 (2012): 425–30.

Parisi, Luciana, and Steve Goodman. "Mnemonic Control." In *Beyond Biopolitics: Essays on the Governance of Life and Death,* 163–76. Edited by Patricia Ticineto Clough and Craig Willse. Durham, NC: Duke University Press, 2011.

Parks, Lisa. *Cultures in Orbit: Satellites and the Televisual.* Durham, NC: Duke University Press, 2005.

Parks, Lisa, and Nicole Starosielski. *Signal Traffic: Critical Studies of Media Infrastructures.* Urbana: University of Illinois Press, 2015.

Patrignani, Norberto, and Diane Whitehouse. *Slow Tech and ICT: A Responsible, Sustainable and Ethical Approach.* Cham: Springer International, 2018.

Paul, Kathleen. *Whitewashing Britain: Race and Citizenship in the Postwar Era.* Ithaca, NY: Cornell University Press, 1997.

Peek, Philip M. *African Divination Systems: Ways of Knowing.* Bloomington: Indiana University Press, 1991.

Peirce, Charles Sanders. *The Collected Papers of Charles Sanders Peirce, Volumes I and II.* Edited by Charles Hartshorne and Paul Weiss. Cambridge, MA: Harvard University Press, 1932.

Peirce, Charles Sanders. *Philosophical Writings of Charles Sanders Peirce.* Edited by Justus Buchler. New York: Dover, 1955.

Pennisi, Elizabeth. "Plants Outweigh All Other Life on Earth." *Science,* May 21, 2018. https://www.science.org/content/article/plants-outweigh-all-other-life -earth.

Perniola, Mario. *Enigmas: The Egyptian Moment in Society and Art.* Translated by Christopher Woddall. London: Verso, 1995.

Perry, Grace. "Spotify Algorithm Totally Nails Lauren's Shitty-as-Fuck Musical Aesthetic." *Reductress,* January 10, 2017. https://reductress.com/post/spotify -algorithm-totally-nails-laurens-shitty-as-fuck-musical-aesthetic/.

Pesic, Peter. "Leibniz and the Leaves: Beyond Identity." *Philosophy Now* 30 (January 2000/2001): 18–21. https://philosophynow.org/issues/30/Leibniz_and_the _Leaves_Beyond_Identity.

Peters, John Durham. *The Marvelous Clouds: Toward a Philosophy of Elemental Media*. Chicago: University of Chicago Press, 2015.

Pethö, Ágnes. *Cinema and Intermediality: The Passion for the In-Between*. Cambridge: Cambridge Scholars Publishing, 2011.

Pethö, Ágnes. "The Garden of Intermedial Delights: Cinematic 'Adaptations' of Bosch, from Modernism to the Postmedia Age." *Screen* 56, no. 4 (Winter 2014): 471–89.

Pisters, Patricia. "The Filmmaker as Metallurgist: Political Cinema and World Memory." *Film-Philosophy* 20 (2016): 149–67.

Pisters, Patricia. *The Matrix of Visual Culture: Working with Deleuze in Film Theory*. Stanford, CA: Stanford University Press, 2003.

Pisters, Patricia. *The Neuro-Image: A Deleuzian Film-Philosophy of Digital Screen Culture*. Stanford, CA: Stanford University Press, 2012.

Pisters, Patricia. "Temporal Explorations in Cosmic Consciousness: Intra-Agential Entanglements and the Neuro-Image." *Cultural Studies Review* 21, no. 2 (September 2015): 120–44.

Povinelli, Elizabeth A. *Geontologies: A Requiem to Late Liberalism*. Durham, NC: Duke University Press, 2016.

Preist, Chris, Daniel Schien, and Eli Blevis. "Understanding and Mitigating the Effects of Device and Cloud Service Design Decisions on the Environmental Footprint of Digital Infrastructure," 1324–37. Proceedings of the 2016 CHI Conference on Human Factors in Computing Systems. Santa Clara, CA: ACM (Association for Computing Machinery), 2016.

Price, Seth. *How to Disappear in America*. New York: Leopard Press, 2008.

Priest, Eldritch. *Earworm and Event*. Durham, NC: Duke University Press, 2022.

Przedpełski, Radek. "Becoming-Sarmatian, Becoming-Steppe: Deleuzoguattarian Multiplicities | Thresholds | Potentialities and the Art-Work of Marek Konieczny." PhD diss. Trinity College, Dublin, 2016.

Przedpełski, Radek. "Steppe C(ha)osmotechnics: Art as Engineering of Forces in Marek Kozniesky and Beyond." In *Deleuze, Guattari and the Arts of Multiplicity*, 113–53. Edited by Radek Przedpełski and S. E. Wilmer. Edinburgh: Edinburgh University Press, 2020.

Pylkkänen, Paavo. *Mind, Matter and the Implicate Order*. Berlin and Heidelberg: Springer-Verlag, 2007.

al-Qadiri, Fatima, and Sophia al-Maria. "Al-Qadiri and Al-Maria on Gulf Futurism." *Dazed*. November 14, 2012.

Quinlivan, Davina. *The Place of Breath in Cinema*. Edinburgh: Edinburgh University Press, 2014.

Quilty, Jim. "'Memories fade away, but images remain' . . . as a reminder of bleak moments." *The Daily Star* (Beirut), October 29, 2008.

Quinlivan, Davina. The Place of Breath in Cinema. Edinburgh: Edinburgh University Press, 2014.

Quivinger, François. "Immersed in Sfumato: Correggio's Sensory Palette and the Immersive Renaissance." *The Senses and Society* 15, no. 1 (2020): 114–17.

Rahman, Fazlur. *The Philosophy of Mullā Ṣadrā (Ṣadr al-Dīn al-Shīrāzī)*. Albany: SUNY Press, 1975.

Rai, Amit S. *Jugaad Time: Ecologies of Everyday Hacking in India*. Durham, NC: Duke University Press, 2019.

Rajchman, John. *The Deleuze Connections*. Cambridge, MA: MIT Press, 2001.

Rancière, Jacques. *Film Fables*. Oxford: Berg, 2006.

Rangan, Pooja. "For a Critique of the Documentary Logic of Sobriety." *World Picture* 9, Special Issue on Seriousness (July 2014).

Rangan, Pooja. *Immediations: The Humanitarian Impulse in Documentary*. Durham, NC: Duke University Press, 2017.

Raskin, David. "The Dogma of Conviction." In *Rediscovering Aesthetics: Transdisciplinary Voices from Art History, Philosophy, and Art Practice*, 68–74. Edited by Francis Halsall, Julia Jansen, and Tony O'Connor. Stanford, CA: Stanford University Press, 2009.

Rescher, Nicholas. *Process Metaphysics: An Introduction to Process Philosophy*. Albany: SUNY Press, 1996.

Reuters. "China approves biggest expansion in new coal power plants since 2015." *Guardian*, February 27, 2023.

Rivero Borrel M. Héctor, Gustavo Curiel, Antonio Rubial Garcia, Juana Gutierrez Haces, and David B. Warren. *The Grandeur of Viceregal Mexico/La Grandeza del Mexico Virreinal: Treasures from the Museo Franz Mayer/Tesoros del Museo Franz Mayer*. Mexico City and Houston, TX: Museo Franz Mayer and Houston Museum of Fine Art, 2002.

Rizvi, Sajjad H. *Mulla Ṣadrā and Metaphysics: Modulation of Being*. London: Routledge, 2009.

Rizvi, Sajjad H. "Mulla Sadra." *The Stanford Encyclopedia of Philosophy*. Edited by Edward N. Zalta. June 9, 2009. http://plato.stanford.edu/archives/sum2009/entries/mulla-sadra/.

Rødje, Kjetil. *Images of Blood in American Cinema: The Tingler to The Wild Bunch*. Farnham: Ashgate, 2015.

Roffe, Jon. "David Hume." In *Deleuze's Philosophical Lineage*, 67–86. Edited by Graham Jones and Jon Roffe. Edinburgh: Edinburgh University Press, 2009.

Rollefson, J. Griffith. "The 'Robot Voodoo Power' Thesis: Afrofuturism and Anti-Anti-Essentialism from Sun Ra to Kool Keith." *Black Music Research Journal* 28, no. 1 (Spring 2008): 83–109.

Russell, Bertrand. *The Philosophy of Leibniz*. 3rd ed. London: Routledge, 1992.

Rutherford, Anne. "What Is Body, What Is Space? Performance and the Cinematic Body in a Non-Anthropocentric Cinema." *Arts* 6, no. 19 (2017).

Rybin, Steven. "Hidden Fire: Four Motifs in Pablo Larrain's *Spencer*." *Film International* 20, no. 1–2 (2022): 127–46.

al-Saadi, Yazan. "Arabic Science Fiction: A Journey into the Unknown." *Al-Akhbar English*. June 3, 2012.

Ṣadr al-Dīn al-Shīrāzī, Muhammad ibn Ibrahīm. *Al-Asfār (The Four Journeys)*. In Fazlur Rahman, *The Philosophy of Mullā Ṣadrā (Ṣadr al-Dīn al-Shīrāzī)*, 114. Albany: SUNY Press, 1975.

Ṣadr al-Dīn al-Shīrāzī, Muhammad ibn Ibrahīm. *The Book of Metaphysical Penetrations*. Edited by Ibrahim Kalin. Translated by Sayyed Hossein Nasr. Provo, UT: Brigham Young University Press, 2014.

Ṣadr al-Dīn al-Shīrāzī, Muhammad ibn Ibrahīm. *Elixir of the Gnostics*. Translation and commentary by William C. Chittick. Provo, UT: Brigham Young University Press, 2003.

Schafer, R. Murray. *The Soundscape: Our Sonic Environment and the Tuning of the World*. Rochester, VT: Destiny Books, 1993.

Schuppli, Susan. *Material Witness: Forensics, Media, Evidence*. Cambridge, MA: MIT Press, 2020.

Schwebel, Paula L. "Intensive Infinity: Walter Benjamin's Reception of Leibniz and Its Sources." *MLN* 127, no. 3 (April 2012): 589–610.

Seaver, Nick. "Captivating Algorithms: Recommender Systems as Traps." *Journal of Material Culture* 24, no. 4 (2018): 421–36.

Seaver, Nick. "Seeing Like an Infrastructure: Avidity and Difference in Algorithmic Recommendation." *Cultural Studies*, 35, nos. 4–5 (2021): 771–91.

Seigworth, Gregory J. "From Affection to Soul." In *Gilles Deleuze: Key Concepts*, 181–91. 2nd ed. Edited by Charles Stivale. Stocksfield, UK: Acumen, 2011.

Sequeira Brás, Patricia. "*O Som Ao Redor*: Aural Space, Surveillance, and Class Struggle." In *Space and Subjectivity in Contemporary Brazilian Cinema*, 221–33. Edited by Antônio Márcio da Silva and Mariana Cunha. Cham: Springer, 2017.

Shannon, Claude, and Warren Weaver. *A Mathematical Theory of Communication*. Urbana: University of Illinois Press, 1949.

Shaviro, Steven. "Post-Cinematic Affect: On Grace Jones, *Boarding Gate* and *Southland Tales*." *Film-Philosophy* 14, no. 1 (2010): 1–64.

Shaviro, Steven. *Without Criteria: Kant, Whitehead, Deleuze, and Aesthetics*. Cambridge, MA: MIT Press, 2009.

Sha, Xin Wei. *Poiesis and Enchantment in Topological Matter*. Cambridge, MA: MIT Press, 2013.

Sherman, Tom. "I Get Tired." In *Information*. Edited by Sarah Cook, 120. London and Cambridge, MA: Whitechapel Gallery and MIT Press, 2016.

The Shift Project. "Climate Crisis: The Unsustainable Use of Online Video—The Practical Case for Digital Sobriety." Report led by Maxime Efoui-Hess for the Think Tank The Shift Project." July 2019. https://theshiftproject.org/wp-content/uploads/2019/07/2019–02.pdf. Consulted January 7, 2020.

Shipley, Morgan, and Jack Taylor. "Life as Eutopia: MOVE's Natural Revolution as a Response to America's Dystopian Reality." *Utopian Studies* 30, no. 1 (2019): 25–44.

Simondon, Gilbert. "The Genesis of the Individual." In *Incorporations*, 296–319. Edited by Jonathan Crary and Sanford Kwinter. Translated by Mark Cohen and Sanford Kwinter. New York: Zone, 1992.

Simondon, Gilbert. *On the Mode of Existence of Technical Objects*. Translated by Ninian Mellamphy. London, ONT: University of Western Ontario, 1980.

Simondon, Gilbert. "Technical Mentality." In *Gilbert Simondon: Being and Technology* 15. Edited by Arne De Boever, Alex Murray, Jon Roffe, and Ashley Woodward. Edinburgh: Edinburgh University Press, 2012.

Smith, Daniel W. "The Deleuzian Revolution: Ten Innovations in *Difference and Repetition*." *Deleuze and Guattari Studies* 14, no. 1 (2020): 34–49.

Smith, Daniel W. *Essays on Deleuze*. Edinburgh: Edinburgh University Press, 2012.

Smith, Daniel W. "Genesis and Difference: Deleuze, Maïmon, and the Post-Kantian Reading of Leibniz." In *Deleuze and The Fold*, 142–54. Edited by Sjoerd van Tuinen and Niamh McDonnell. Basingstoke: Palgrave Macmillan, 2010.

Smith, Daniel W. "G. W. F. Leibniz." In *Deleuze's Philosophical Lineage*, 44–66. Edited by Graham Jones and Jon Roffe. Edinburgh: Edinburgh University Press, 2009.

Smith, Terry. *Iconomy: Towards a Political Economy of Images*. London: Anthem, 2022.

Snowdon, Peter. *The People Are Not an Image: Vernacular Video after the Arab Spring*. London: Verso, 2020.

Sobchack, Vivian. *Carnal Thoughts: Embodiment and Moving Image Culture*. Berkeley: University of California Press, 2004.

Spinoza, Baruch. *The Ethics*. Translated by R. H. M. Elwes. Chapel Hill, NC: Project Gutenberg, 1901.

Stalder, Felix. "Information Economy." In *Information*, 110–12 Edited by Sarah Cook. London and Cambridge, MA: Whitechapel Gallery and MIT Press, 2016.

Stengers, Isabelle. *Power and Invention: Situating Science*. Translated by Paul Bains. Minneapolis: University of Minnesota Press, 1997.

Stengers, Isabelle. *The Invention of Modern Science*. Translated by Daniel W. Smith. Minneapolis: University of Minnesota Press, 2000.

Stengers, Isabelle. "Wondering about Materialism." In *The Speculative Turn: Continental Materialism and Realism*, 368–80. Edited by Levi Bryant, Nick Smieck, and Graham Harman. Melbourne: re.press, 2011.

Stern, Daniel N. *Forms of Vitality: Exploring Dynamic Experience in Psychology, the Arts, Psychotherapy, and Development*. New York: Oxford University Press, 2010.

Sterne, Jonathan. *MP3: The Meaning of a Format*. Durham, NC: Duke University Press, 2012.

Stewart, Kathleen. *Ordinary Affects*. Durham, NC: Duke University Press, 2007.

Steyerl, Hito. *Duty Free Art: Art in the Age of Planetary Civil War*. London: Verso, 2019.

Steyerl, Hito. *The Wretched of the Screen*. Berlin: Sternberg Press, 2012.

Stiegler, Bernard. *Technique and Time 2: Disorientation*. Translated by Stephen Barker. Stanford, CA: Stanford University Press, 2009.

Stivale, Charles, ed. *Gilles Deleuze: Key Concepts*. 2nd ed. Stocksfield, UK: Acumen, 2011.

Strickland, Lloyd. *Leibniz's Monadology: A New Translation and Guide*. Edinburgh: Edinburgh University Press, 2014.

Strubell, Emma, Ananya Ganesh, and Andrew McCallum. "Energy and Policy Considerations for Deep Learning in NLP," 3645–50. Proceedings of the 57th Annual Meeting of the Association for Computational Linguistics, 2019.

Subramanian, Kalpana. "Breath: A Yogic Genealogy of Embodiment in Cinema." *Techniques*, special issue on "Evil Eye Media." Edited by Farshid Kazemi, Laura U. Marks, and Radek Przedpełski, forthcoming.

Swartz, Ellen E. "Removing the Master Script: Benjamin Banneker 'Re-Membered.'" *Journal of Black Studies* 44, no. 1 (2012): 31–49.

Syms, Martine. "The Mundane Afrofuturist Manifesto." *Rhizome*, December 17, 2013. https://rhizome.org/editorial/2013/dec/17/mundane-afrofuturist -manifesto/. Consulted August 15, 2021.

Szerszynski, Bronislaw. "How to Dismantle a Bus: Planetary Mobilities as Method." In *Handbook of Research Methods and Applications for Mobilities*, 398–410. Edited by Nikolaj Grauslund Kristensen, Monika Büscher, Malene Freudendal-Pedersen, and Sven Kesselring. Cheltenham: Edward Elgar Publishing, 2020.

Teh, David. "Itinerant Cinema: The Social Surrealism of Apichatpong Weerasethakul." *Third Text* 25, no. 5 (September 2011): 595–609.

Thiebaud, Esther, Lorenz M. Hilty, Mathias Schluep, Heinz W. Böni, and Martin Faulstich. "Where Do Our Resources Go? Indium, Neodymium, and Gold Flows Connected to the Use of Electronic Equipment in Switzerland." *Sustainability* 10 (2018), 26–58.

Tomlinson, Bill, Eli Blevis, Bonnie Nardi, Donald J. Patterson, M. Six Silberman, and Yue Pan. "Collapse Informatics and Practice: Theory, Method, and Design." *ACM Transactions on Computer-Human Interaction* 20, no. 4 (September 2013): 1–26.

Toufic, Jalal. "Credits Included." *Over-Sensitivity*. Los Angeles: Sun and Moon, 1996.

Toufic, Jalal. *What Was I Thinking?* Berlin: Sternberg Press, 2017.

Tuck, Eve, and K. Wayne Yang. "Decolonization Is Not a Metaphor." *Decolonization: Indigeneity, Education and Society* 1, no. 1 (2012): 1–40.

Uckleman, Sara L. "Computation in Medieval Western Europe." In *Technology and Mathematics: Philosophical and Historical Investigations*, 33–46. Edited by Sven Ove Hansson. Cham: Springer, 2018.

Uno, Kuniichi. *The Genesis of an Unknown Body*. Translated by Melissa McMahon. Helsinki and São Paulo: n-1 Publications, 2012.

Uno, Kuniichi. "Vitalism and Biopolitics." In *Biopolitics, Ethics and Subjectivation*, 67–73. Edited by Alain Brossat, Yuan-Horng Chu, Rada Ivekovic, and Joyce C. H. Liu. Paris: L'Harmattan, 2011.

Väliaho, Pasi. *Biopolitical Screens: Image, Power, and the Neoliberal Brain*. Cambridge, MA: MIT Press, 2014.

Van Beek, Walter E.A., R. M. A. Bedaux, Suzanne Preston Blier, Jacky Bouju, Peter Ian Crawford, Mary Douglas, Paul Lane, and Claude Meillassoux. "Dogon Restudied: A Field Evaluation of the Work of Marcel Griaule [and Comments and Replies]." *Current Anthropology* 32:2 (April 1991): 139–67.

van Tuinen, Sjoerd, and Niamh McDonnell, eds. *Deleuze and* The Fold: *A Critical Reader*. Basingstoke: Palgrave Macmillan, 2010.

Vaughan, Hunter. *Hollywood's Dirtiest Secret: The Hidden Environmental Costs of the Movies*. New York: Columbia University Press, 2019.

Viveiros de Castro, Eduardo. "Cosmological Deixis and Amerindian Perspectivism." *Journal of the Royal Anthropological Institute* 4, no. 3 (September 1998): 469–88.

Wäger, Patrick A., Roland Hischier, and Rolf Widmer. "The Material Basis of ICT." In *ICT Innovations for Sustainability*, 209–22. Edited by Lorenz M. Hilty and Bernard Aebischer. Heidelberg: Springer, 2015.

Walcott, Rinaldo. "The Sight of Sound: *The Last Angel of History*." In *Fluid Screens, Expanded Cinema*, 167–71. Edited by Janine Marchessault and Susan Lord. University of Toronto Press, 2007.

al-Wardany, Haytham. Excerpts from "The Hanging Garden of Sleep." Translated by Robin Moger. In *The Time Is Out of Joint*, vol. 1, 73–77. Edited by Tarek Abou El-Fetouh and Ala' Younis. Sharjah: Sharjah Art Foundation, 2016.

Walton, Saige. *Cinema's Baroque Flesh: Film, Phenomenology and the Art of Entanglement*. Amsterdam: Amsterdam University Press, 2016.

Weheliye, Alexander G. *Phonographies: Grooves in Sonic Afro-Modernity*. Durham, NC: Duke University Press, 2005.

Welsch, Wolfgang. "Aesthetics Beyond Aesthetics." In *Rediscovering Aesthetics: Transdisciplinary Voices from Art History, Philosophy, and Art Practice*, 178–92. Edited by Francis Halsall, Julia Jansen, and Tony O'Connor. Stanford, CA: Stanford University Press, 2009.

Whitehead, Alfred North. *Modes of Thought*. New York: Cambridge University Press, 1956.

Whitehead, Alfred North. *Process and Reality: An Essay in Cosmology*, corrected edition. Edited by David Ray Griffin and Donald W. Sherbourne. New York: The Free Press, 1978.

Williams, James. "Distributed Affects and the Necessity of Expression." In *Deleuze, Guattari and the Arts of Multiplicity*. Edited by Radek Przedpełski and S. E. Wilmer. Edinburgh: Edinburgh University Press, 2022.

Williams, James. *A Process Philosophy of Signs*. Edinburgh: Edinburgh University Press, 2016.

Wing, Betsy. "Translator's Introduction." In Édouard Glissant, *Poetics of Relation*, xi–xx. Translated by Betsy Wing. Ann Arbor: University of Michigan Press, 2010.

Wiratama, Muhammad, Sukmawati N. Endah, Retno Kusumaningrum, and Helmie A. Ribawa. "Pornography Object Detection Using Viola-Jones Algorithm and Skin Detection." Proceedings, First International Conference on Informatics and Computational Sciences, November 15–16, 2017. 29–34. https://doi.org/10.1109/ICICOS.2017.8276333.

Wise, J. Macgregor. "Assemblage." In *Gilles Deleuze: Key Concepts*, 2nd ed., 91–102. Edited by Charles J. Stivale. Stocksfield, UK: Acumen, 2011.

Yakymenko, Igor, Olexandr Tsybulin, Evgeniy Sidorik, Diane Henshel, Olga
 Kyrylenko, and Sergiy Kyrylenko. "Oxidative Mechanisms of Biological Activ-
 ity of Low-Intensity Radiofrequency Radiation." *Electromagnetic Biology and
 Medicine* 19 (2015): 1–16.
Yellowhorn, Eldon, and Kathy Lowinger. *Sky Wolf's Call: The Gift of Indigenous
 Knowledge*. Toronto: Annick Press, 2022.
Yusoff, Kathryn. *A Billion Black Anthropocenes or None*. Minneapolis: University
 of Minnesota Press, 2019.
Zielinski, Siegfried. *Deep Time of the Media: Toward an Archaeology of Hearing
 and Seeing by Technical Means*. Translated by Gloria Custance. Cambridge,
 MA: MIT Press, 2006.
Zinman, Gregory. "Getting Messy: Chance and Glitch in Contemporary Video
 Art." In *Abstract Video: The Moving Image in Contemporary Art*, 254–79. Edited
 by Gabrielle Jennings. Oakland: University of California Press, 2015.
Zylinska, Joanna. *AI Art: Machine Visions and Warped Dreams*. London: Open
 Humanities Press, 2020.

Italicized page numbers indicate figures, illustrations, and photographs.

affect (continued)
144–63; turning self inside out, 148; of unfolding, 6, 57, 94; virtuality and, 48, 153. *See also* affective analysis; affective response; Firstness

affective analysis, 148–63; adequate ideas and, 35, 149, 154, 157–58; affect in, 152, 153–54, 155–56, 160; becoming in, 155; the body in, 149, 152; concept in, 152, 157–59, 160; culture in, 154–56; discomfort and, 163; disquiet in, 162, 177; embodiment and, 147–48; examples, 149–50, 158–62; fabulation and, 175; feeling in, 156; generally, 35–36, 117–18, 148–49, 151–52, 162–63, 177, 179; as impersonal, 152; information-images and, 117; laughter in, 93; method of, 148–59; molecularity and, 150; perception in, 152–53, 157, 160; representation and, 153; rhythm in, 155; Secondness, 84; sensation and, 117–18, 151–52; singularities in, 157; soul-assemblages and, 157; Thirdness, 84

affective response: arousal, 150, 154, 158; described, 194; empathic, 152; goose bumps, 150, 154, 155, 158, 194; joyful, 150; microperceptions and, 48; molarity and, 150; nervous system and, 150; as prompt, 148; sexuality and, 149–50; unfolding differently and, 148, 175, 244

African cinema, 224–227

African culture: European culture's origins in, 213–14; influence in the West, 213–15; perceptions of in the West, 114–15

African-diaspora art, figuration in, 201

African-diaspora cinema, 70–73, 172, 194–219, 228–30

African-diaspora music, 54, 194–219. *See also* music

African-diaspora philosophy, 53. *See also* Balibar, Étienne; Eshun, Kodwo; Ferreira da Silva, Denise; Glissant, Édouard; Hartman, Saidiya; Keeling, Kara; Moten, Fred

Afrocentrism, 229–30

Afrofuturism: as term, 276n1; archaeology and, 174; archives and, 202–3; critiques of, 68, 212; fabulation and, 164–65, 174, 184, 212; histories of, 195, 201; humanism and, 210; manners of unfolding from, 36, 196; "Mundane Afrofuturist Manifesto," 212; politics of folds and, 69; remixing history, 218; soul-assemblages and, 44; unfolding locally, 97. See also *The Last Angel of History*

After Life (Hirokazu), 129

air, 245; as medium, 78

Akomfrah, John, 172, 202, 207, 219. See also Black Audio Film Collective; *The Last Angel of History*

al-Assad, Bashar, 162

Albert (film and television organization), 140

algorithms: attention and, 99; becoming-algorithm, 123; brickmaking, 103, 105; capitalism and, 111, 129; compression, 89, 110, 141, 142, 247–48, 249; "deep belief," 114; detail in, 245; digital participation and, 124; errors, 113, 133, 142; ethics of, 124; facial recognition, 247; the infinite and, 120; labor and, 119–20, 204; machine-learning, 133; media art, 136; noise and, 84; non-extractive, 135, 136; people conforming to, 121–126; perception and, 100, 111; predictive, 113, 116; recommendation algorithms, 124; search, 129; social media, 247; souls of, 128; of standardization, 103; trauma and, 122; unfolding differently, 135–36. *See also* software

The Alien (Ray), 166

alienation, 135–36, 195, 218

Al-Jazarī, Ibn al-Razzaz, 274n1

Allais-Maré, Laura, 167

Almeida, Gustavo, 1–2

Alphabet (company), 114, 116, 127–28, 130, 140

AlphaFold (AI project), 114

al-Saadi, Yazan, 164, 274n1

Amad, Paula, 129

Amazon Mechanical Turk (AMT), 120

Ambassadors (Holbein), 91

Amin, Samir, 134

Amiralay, Omar, 274n13; *Daily Life of a Syrian Village*, 170

amodal perception (Stern), 155, 157, 272n20. *See also* perception

Amoore, Louise, 113
amplitude of soul or monad, 47, 49, 63, 65, 69, 141, 162
the analog, 24, 100, 118, 139, 234–35
anamorphosis, 91, 231
Angelus Novus (Klee), 198–99
aniconism, 36, 97, 200–202, 211
animation, 118–19, 165–66, 211–12
animism, 268n55
Anstruther-Thomson, Clementina, 155
antihumanism and antinaturalism, 54, 145, 148, 196, 210
antivaxxers, 94–95
Antonioni, Michelangelo, 237
apartment living: boundaries and, 230–31, 232, 241–42; in *La Maison du bonheur*, 184; in *Neighboring Sounds*, 237, 238; photographs of, *56*; relations with neighbors, 81, 230–31; vibration and sound in, 221, 230–31
Apichatpong Weerasethakul, *Mysterious Object at Noon*, 188–90, *190*
apotropaic magic, 246–247
Appadurai, Arjun, 45, 233, 241, 250
apparatus theory, 116, 270n111
appropriation, 52, 182, 218
Aquarius (Mendonça), 279n23
Aquinas, Thomas, 255n49
Arab Futurism movement, 167
Arab world: history of mathematics and, 215; uprisings (2010–2012), 167
archaeology, 167, 168, 174, 207, 215
archives: activism in, 208; Afrofuturism and, 202–3; counterarchives, 129; folding differently, 172; found footage, 140, 190; fragments in, 90; living, 167; the ordinary in, 129, 269n97; photography from, 204, 207–8; safety of materials, 167; social media, 112
Aristotle, 103, 257n74
arousal, 150, 154, 158
Artaud, Antonin, 145, 263n118
Arthur, Richard T. W., 22, 24
Artificial intelligence, 113–14, 126, 130–32
artworks: as blocs of sensation, 177; as connecting body and cosmos, 146–47; disquiet and, 146; as monads, 146; representation-based engagement

with, 175; singularities and, 59; as soul-assemblages, 59; souls of, 42; war as message in, 101–2; as ways of being in the world, 59. *See also* names of specific artists and artworks
a-signifying images (Guattari), 112
Asili, Ephraim, *The Inheritance*, 228–30, 229, 241
ASMR, as genre, 117
assemblage: defined, 42; adequate ideas and, 45; audiences in, 139, 249; blood-assemblage (Rødje), 138; bus-assemblage, 42; categories of, 45; for Deleuze and Guattari, 77; examples, 45; failed, 76; film-assemblages (Herzog), 138–39; technologies as, 44–45; territory and, 42, 74–75. *See also* soul-assemblage
astronomy, 69, 75, 191, 208–9, 263n123
asymptote, 66, 193
Atkins, Juan, 201, 206
atomism, 22, 23, 62, 173
attention, 99, 105, 111, 134
Aubry, Gilles, *Stonesound* (with Saouli), 40, *41*
Auchter, Christopher, *The Mountain of sgaana*, 165–66, *166*
audiences: in assemblages, 138–39, 143, 146, 178, 249; enfoldment and, 97; new embodiments, 36; remixing, 219; representational critique, 182; small-file movies and, 142; witnessing, 191
aura (Benjamin), 11–12, 211
autism, 43, 121
auto-affection, 254n13
autocatalysis, 42
automation, 126, 136, 274n1; heteromation (Ekbia, Nardi), 120
autonomic nervous system responses, 88, 150–51, 154, 155, 158. *See also* affective response
autopoiesis, 42, 60, 63, 64, 224, 254n34
Avicenna, 9, 255n49

Bacon, Francis, 20, 263n113
Bailey, Clark, 87
baker's transformation, 90, 253n1. *See also* mathematics
baking, 2, 64, 133, 185, 186

Bohdanowicz, Sofia, *La Maison du bon-heur*, 184–87, *187*

Bohm, David: on active information, 26, 104, 257n74; cosmology of, 24; holographic universe, 24; implicate order, 8, 17, 19, 24–28, 244; information as active, 104; on inner space, 27; on intelligence, 17; (meta)physics, 87; on theory, 32, 254n34. *See also* implicate order; quantum physics

Bohr, Niels, 25, 26, 258n93

Bong, Joon-ho, *Parasite*, 234

Borromini, Francesco, 91

boundaries: apartment living and, 230–31, 232, 241–42; of the body, 146, 221; in Butoh performance, 146; childhood experience and, 42; cosmos and, 38, 102–3; creation of, 45; expanding to others (in *Félicité*), 227; in figure-ground distinctions, 247; in infinity minus Infinity (Otolith Collective), 71–72; of monads, 12, 62, 232; processes as creating, 42; redefining, 231; respecting, 15, 52; safety and, 48, 244; of soul, 39, 248–49; of soul-assemblages, 37, 38–44, 77, 102–3; trauma and, 65

boundedness, 18, 38–42, 187

Braidotti, Rosi, 16, 18, 19, 69, 89–90

branding, 116

breathing, 72, 101, 141; audio recordings, 101; of Eric Garner, 72; of Iyad Hallak, 43; of music, 3, 5; naming, 43; of planet, 141; rhythm of cinema and, 145, 226–27, 236; of rocks, 39–40; of Syrian prisoners, 101

bricks: brickmaking, 103, 105; as pixels, 103; stories as, 172; vines breaking, 233

British Nationality Act, 71

Broglie, Louis de, 257n80

Brown, James, 219

Bruno, Giordano, 171

Bucher, Taina, 123

Buck, Alex, 2

Buddhism, 92, 145, 173, 188

Buñuel, Luis, *Belle de jour*, 180

bus-assemblage (Szernyznski), 42

bus stops, 14–16, 186

Butler, Octavia, 208

Butoh performance, 146

Caché (Haneke), 91

calculus: cosmology and, 8, 21; differential calculus, 87; from essences to infinitesimal, 63; harmony and, 220; imperial expansion and, 51–52; infinitesimal differences (dx) in, 48; infinite points in, 44; metaphysics and, 87; plane of immanence and, 87; singularities in, 57–58; symbolism of, 265n31. *See also* mathematics

cameras: action in camerawork, 236; facial recognition, 121, 247, *247*, 248; movement of, 224, 226; resolution, 121; subjectivity of point of view, 189; surveillance, 5, 121, 191

camouflage, 121, 126, 133, 247, *247*

Camouflage for anti-facial recognition for quarantine surveillance (Madero), 247, *247*

capital, 106–9, 129, 134

capitalism: algorithms and, 111; the Baroque and, 50; biological being and, 116; the body and, 148; cognitive, 116; enfolded in personal histories, 54; history of, 133; images as skin of, 107; information fold and, 104; patterns privileged by, 58; sectarian capitalism, 73; as striation, 12; unfolding under, 243; uniformity under, 56, 58; value under, 106. *See also* information; value

capitalocene, 35, 55, 70, 72

Captcha, 101, 112, 122, 123, 126

captivation metrics, 124

carbon footprint and greenhouse gas emissions, 71, 126–27, 130, 136, 139–40, 141, 271n133

carbon neutrality, 140

Carr, H. Wildon, 10, 22, 23, 62, 173, 224, 255n58

Carruth, Christopher, *why wonder*, 142–43, *143*

cartography (Braidotti), 16.

Castrillón, Juan, 51–52, 277n40

causality: chains of, 144; emergent, 55, 60, 63; flow of signs and, 79; immanence of, 62; in Leibniz, 240; monad and, 21; singularities and, 55; witnessing and, 144–45

censorship, 89, 97, 268n72, 269n84
chaos, 7, 31–32, 33, 80, 147, 227
Chari, C. T. K., 256n58
Charlie's Angels (McG), *149*, 150, *151*, 152, *152*, 158
Chen, Abby, 244
chiasm (Merleau-Ponty), 171
children, 38, 76, 111, 119, 121, 129, 130, 167
China, 101, 123, 127, 203
Chisholm, Shirley, 230
Christing, Katie, 72
Chun, Wendy Hui Kyong, 124
Cillo, André de, 2
cinema: blood-assemblages (Rødje), 138; colors in, 139, 229; of cruelty, 145, 263n118; *dispositif* (Martin), 139; enfolding and unfolding of, 237; of folds, 139, 171–79; granularity and, 139; light in, 139, 145; point of view in, 237–38; post-cinematic affect (Shaviro), 116–17; rhythm of, 145, 205, 226–27, 236; seeing of, 113; soul of (documentary, Hongisto), 173; truth and, 204–5. *See also* film; names of filmmakers and titles of films
citizenship, 71
Citton, Yves, 105, 120
class analysis, 222–23
classical physics, 33
Clayton, Merry, 219
The Cleaners (Block, Riesewieck, documentary), 121–22, *122*, 268n72
clichés: art practices as dispelling, 59; of cultural images, 105, 134; Deleuze on, 153; "everything is connected," 20; fabulation and, 178; of humanness, 146; the information fold and, 247; about women, 186
Climate Convergence (activist group), 93–94
clino (Latin, infinitesimal displacements), 90
Clinton, George, 205, 218–19
code, 82, 112, 142; genetic: 18, 104. *See also* information, software
codecs, 110, 112, 116
coffee, 43, 51, 118, 185, 199
collapse informatics, 35, 137–38, 141

collectives and community: action, 74, 133, 159, 241; African American, 228; ". . . among the peoples" (Peirce), 79; bricklaying and, 103; as chosen not dictated, 224; collective action, 133; collective innervation (Benjamin), 135–36; ". . . to come," 132, 154, 167; embodiment, 167; fabulation and, 175, 212; futurism and, 167; ingroups, 91; innervation, 135–36; intensity and, 191–92; local economies and, 134–35; memory, 112, 129; objects as, 53; organized by singularities, 57; in Peircean semiotics, 79, 86; refolding by, 108; soul-assemblages and, 243; unfolding locally, 97. *See also* neighborhoods and neighbors; soul-assemblage
Collier, Delinda, 75, 79, 277n40
colonialism, 31–32, 69–70, 166, 202, 232, 240; the Baroque and, 28; connectedness disavowed by, 51; fabulation as practice and, 166, 180; *métissage* (colonial hybridization), 28–29
colonization: of perception, 116, 153; of unconscious and pre-discursive thought, 116–17, 154
commodities, 59, 248, 261n59
the Commons, 58, 70, 76, 90, 135. *See also* Undercommons
Communism, 27, 135, 164, 188
community. *See* collectives and community
Comolli, Jean-Louis, 270n111
compassion fatigue, 159
complexity, etymology of, 27
compression algorithms, 89, 110, 141, 142, 247–48, 249
computational perception, 110–13, 116
computational photography, 116
computer-generated animation, 118
computing: binary, 216; critical computing movement, 135, 136; efficiency, 127; history, 215; material impacts, 136; self-sufficiency, 128
Computing within Limits movement, 136
conatus (Spinoza), 20, 42, 162, 254n34, 255n40
concepts: as abstractions, 32; affect to, 157–58; in affective analysis, 152, 157–59, 160; of entities, 11; generation of, 61–62, 158–59; perception to, 157–58; as reactive, 149. *See also* Thirdness

concrescence (Whitehead), 12–13, 79, 258n3
connectedness, 25, 51, 52, 54, 73, 138, 224
connective tissue: of experience, 78, 125, 126, 195, 247; of the infinite, 124, 125; lost in information, 100, 104, 109, 124–26; mediation as, 78
consciousness: as term, 10; consciousness-raising, 229; false consciousness, 54; vs. indexicality, 10; matter and, 16, 52–53; of monad, 234; questions about, 278n3
convergent series, 49, 64, 69. See also best of all possible worlds
Coogler, Ryan, Black Panther, 174
cool media (McLuhan), 142
copies, 124
Corbett, John, 195
corporate animism (Steyerl), 268n55
corporate futurism, 114–15. See also futurism
Cosgrove, Stuart, 197
cosmic soul-assemblages, 74–77. See also soul-assemblage
cosmology: as term, 7; of Bohm, 24; deterministic models of, 9; female sexuality and, 12; floral, 168–71; Indigenous, 40, 69; of infrastructure, 124; models of (list), 32–33; process, 9; thinkers associated with, 7; transcendental models of, 9; of Whitehead, 7, 13, 33, 86
cosmos: artworks connecting body with, 146–47; boundaries and, 38, 102–3; as closed, 51, 118; from closed to open, 62–68, 69, 223–24; comodulating with, 132, 136, 138, 140, 147; as continuum, 20; diagrams of, 39, 39, 66; drawings of, 7; expanding and getting smaller, 10, 80, 86; experience and, 7, 10–11, 145; expression of, 21, 23; finitude of, 10; as folded (see folded cosmos); "from your body to the cosmos," 98, 144, 148, 153, 196; human life and, 146, 147; incompossible, 66–67; as the infinite, 7; the infinitesimal and, 143; as interconnected whole, 9; made of living beings, 38; matter connecting with, 60; media works (materially) and, 139; models of, 10–11; monads and, 243; point of view and, 85; as single infinitely folded surface, 5, 243; soul-assemblages and,

74–77, 102–3, 242; subjecthood and, 109; touch interconnecting the, 79; unfolding from, 144; unity of, 251; vital, 7. See also folded cosmos; infinite; open cosmos
cotton: enslaved people's labor and, 51; Euro-American theft of (epistemologically), 199; labor, 40; market for, 199; naming soul of, 43; realness of, 17; survival of, 170; in The Upper Side of the Sky, 169
counterarchives, 129. See also archives
COVID-19 pandemic, 44, 70, 73; Freedom Convoy, 94–95; soul of vaccine, 44
Crary, Jonathan, 117
creativity: of conception invention, 61–62; enfolding and, 12–13; evolution and, 187; information as dulling, 121; at molecular level, 150–51; new media idiocy (Goriunova) and, 132; of objects, 96; representation and, 182; the virtual and, 89–90
cruelty, theater and cinema of, 145, 263n118
cryptocurrency, 126, 134
cryptography, 91, 216
crystal-images, 174, 184
Cubitt, Seán, 44, 116, 171, 249
cultural images, 105–6
cultural signs, 79, 111, 157. See also information fold
culture: in affective analysis, 154–56; enfoldedness of, 97; folding of, 28–29
Curiel, Gustavo, 29, 257n86
CV dazzle (Harvey), 247

Daily Life of a Syrian Village (Amiralay), 170
damned souls (Leibniz), 49, 52, 65, 66, 67, 192
dance and dancing, 8, 246; brain and body, 276n7; disco music, 196–97; sexual selection and, 187; transcendence as avoiding, 196–97; "Baby Shark Dance," 130, 232; in Félicité, 226; in infinity minus Infinity, 70–71, 72; in Last Angel, 196; in Only the Beloved Keeps Our Secrets, 190, 192
Daoism, 92
Darwin, Charles, 187

data: affect as, 6; extraction from experience, 99, 100, 107, 109, 124; materiality of, 130; metadata, 202; monads and, 228; in monad's prehension and becoming, 7, 12–13, 41, 64, 77, 228; processing, 120; souls of, 128. *See also* autonomic nervous system responses

databases, 202–4

data centers/servers, 79, 100, 109, 111, 114, 117, 127–28, 134, 140, 141

Davey, Nicholas, 272n9

Davies, Thomas, 93

daydreaming, 116, 212

death and dying, 161, 168; belief in God and, 260n45; by execution, 168; jokes about, 160; as living, 97, 98; monads, 76; on the outside, but alive on the inside, 97; in small-file media, 142; soul-assemblages and, 221; transformationism, 260n46; in *After Life* (Hirokazu), 129; in *Now Eat My Script* (Al Solh), 160–62

Debanné, Janine, 230

Debord, Guy, 105, 106

decay, 59, 197–98

DeDecker, Kris, 137

DeepDream (neural network), 116, 134

Deep Mind (tech company), 114

deep time, 36, 213–17. *See also* temporality

Deger, Jennifer, 97

DeLanda, Manuel, 58, 60, 87, 95

Delany, Samuel, 199–200

Deleuze, Gilles: actualization, 254n34; on animals (*involution*), 76; assemblages for, 42, 77; on the baroque, 50; becoming, 6; on the body, 148, 159; on capitalism, 12, 50, 148; centers of envelopment, 53; chaos to perception, 102; on cliché, 153; concept-creation, 61–62; criticisms of, 253n8; difference (metaphysics of), 87; on fiber, 46–47; the Figural, 196; Foucault (Deleuze's), 104; on God, 62; on harmony of universe, 64–65; on images, 78; immanence, 63, 87, 154; on the inessential, 63; influences on, 48, 61; Leibniz (Deleuze's), 18, 22, 41, 47; lines of flight, 77, 263n134; mathematical concepts, 48, 87; minor sciences, 60–61; monad's expressions, 21; movement-images, 79;

147, 172, 225; paradoxical experience, 158; "the people to come," 132, 154; plane of consistency, 49, 259n35; plane of immanence, 87, 154; on point of view, 189; on power of ideas, 61; powers of the false, 172; prehension, 62; on signs, 78; on singularity, 58; smooth space, 12, 58, 249; sources, 263n123; on sufficient reason, 95; synthesis of time, 272n8; time-images, 176; on truth, 172; univocity of being, 9, 18; Whitehead (Deleuze's), 47. *See also* Guattari, Félix; plane of immanence

Deneuve, Catherine, 179–84, *181*, *183*

Den of Wolves (Monaghan), 118–19, *119*

Dery, Mark, 276n1

determinacy and indeterminacy, 71, 113, 263n113

deterritorialization, 45–46, 47, 75, 77, 241, 251

diagrams: of cosmos, 39, *39*, 66; images in, *82*, *85*; the infinite in, *82*, *85*; information in, *82*, *85*; matter in, 39, *39*; of monads, 39, *39*, 66, *67*; of perception, *81*; point of view in, *81*; singularities, *57*; soul in, 39, *39*; time in, *85*; the virtual in, *66*, *85*

dictionaries, 259n13

Dietrich, Marlene, 245–46

difference: in Deleuze's metaphysics, 87; monads as difference engines, 63; rebellious souls and, 53

differential calculus, 87. *See also* calculus

differentiation, 11, 18, 47, 77, 104. *See also* individuation

digital folklore, 132, 138

digital images, 89, 111, 112, 118–19

digital media, 132, 138, 139, 142, 168–71; analog base of, 139. *See also* information-images

Dillon, Grace, 166

discourse, limits of, 5, 177, 207

discursive and nondiscursive experience, 93, 117, 163, 176, 177, 179, 260n40

dispositif, 42, 139. *See also* assemblage

disquiet, 48–49, 51, 146, 162, 177, 232. *See also* microperceptions

dissonant harmony, 65, 73

divergent series, 64, 66, 69

divination, 215

Dogon people and cosmology, 32–33, 75

dominant folds and power relations, 32, 108, 193

Dorsky, Nathaniel, 145, 226, 263n118, 274n3

double-slit experiment, 3, 25, 26

Douglass, Frederick, 214, 261n59

dreams, 116, 168–69, 212, 217

Drexciya, 211, 212

dualism: enfolding-unfolding aesthetics and, 84–85; vs. the imaginal realm, 193; in Leibniz, 40; mind/body, 62, 234; monad/body (Leibniz), 220, 221; representation, 84–85

DuBois, W. E. B., 214

Dyer, Richard, 196, 197

?E?anx/The Cave (Haig), 165, 166

Earth, 7, 72, 78, 95, 118, 139, 170, 197, 211, 251; carrying capacity of, 244; and cosmocracy (Serres), 242; futurism on, 68, 195; Google Earth, 113; as one fold (Nail), 19. *See also* rocks

economies: barter and subsistence, 134–35; circular, 90; of enslaved people, 134; gift-based, 135; of Indigenous people, 135; informal media, 137; local, 134–35; neo-imperial, 166; non-extractive, 134–35; oil-based, 167. *See also* unfolding: non-extractive

edge recognition, 248–49, 251

editing, rhythm of, 145, 226, 236. *See also* rhythm

efficiency, 127

Eglash, Ron, 135, 137, 215–16, *216*, 270n120

Egypt, 125, 126

Eistenstein, Sergei, 171, 204

Ekbia, Hamid, *hetermonation*, 120

Elahi, Hasan M., *Tracking Transience*, 122–23

electricity: circulation of images and, 83; consuming less, 137; consumption statistics, 126, 127; fossil-fuel-powered, 127; hydroelectricity, 70; low-power living and, 137

electronic music, 140, 208, 218

electrons, 25, 27, 104, 139, 261n68; electronic flows in media works, 139

Elhaik, Tarek, 244–45, 257n84, 277n40

Elkins, James, 267n32

Emadi, Azadeh, 43, 277n40

embarrassment, 123, 156

embodied responses, 88, 155–56, 176; breathing and, 72; vs. emotion, 156; examples, 156; methods, 147–48; truth and, 147

embodiment: collective, 167; disco music and, 276n7; of experience, 144; infinity minus Infinity (Otolith Collective) and, 72; intermediality and, 236–37; unfolding new, 196–97. *See also* the body

embroidery, 29

emergence, 42, 55, 60–63, 78, 93, 132, 146, 153, 174–79, 192, 196, 272n20

emojis, 6, 121

emotion, 92, 120, 121, 122, 151, 156–63

empathy: affective response and, 152; empathic responses, 88; the infinite and, 248; intrusive, 174; nonhuman sensing and, 84; practicing, 248; researching, 147; software and, 121

encryption, 91, 98, 101, 247

energy: collapse informatics, 137; consumption statistics, 126–28; in enfolding-unfolding aesthetics, 18–19; information and, 26–27; movement of electrons and, 104; of quantum fields, 26; renewable, 127–28; sound as, *41. See also* small-footprint aesthetics

enfolding: as term, 8; creativity and, 12–13; examples of, 24–25; as future-oriented, 13; history, 200; human error and ingenuity into algorithms, 133; by information, 119; invagination and, 12; manners of, 89; in private, 228; as protective, 96, 243; the unthinkable, 90

enfolding-unfolding aesthetics, 78–98; about, 5, 35; censorship and, 89; dualism and, 84–85; energy in, 18–19; experience and, 7, 145; images in, 80–81, *82*, *83*, 84, 85, *85*, 88; the infinite in, 80–82, *82*, 84–85, *85*, 88; information in, 12, 80, 82–83, *82*, 84, *85*; mediation and, 6; as metaphor and model, 87–88; method, 6, 88–89, 107; realism of, 17; research in, 89; resistance to unfolding, 96; senses in, 83; temporality and, 85, 98. *See also* enfolding; semiotics and semiosis; unfolding

Hadjithomas, Joana, *Je veux voir* (with Joreige), 179–84, *181*, *183*

haecceities, as term, 55. *See also* singularities

Haig-Brown, Helen, *?E?anx/The Cave*, 165, 166

Hallak, Iyad, 43–44

Hanan al-Cinema (Marks), 176

Haneke, Michael, *Caché*, 91

haptic: as field of folds, 249; images, 123, 141, 171, 246; index and, 79; as manner of unfolding, 249–50; relation to history, 98; techniques, 245; visuality, 79, 237

harmony (Leibniz), 63–65, 220; dissonance, 65, 73

Harney, Stefano, 70

Harris, Bernard A., Jr., 208

Hartman, Saidiya, 51, 192–93, 260n51, 276n54

Harvey, Adam, 247

hatred: of God (Leibniz) or Amazon, 49, 77, 122, 160; as transcendent value (Deleuze), 172

Haykal, Bani, 115

Hayles, N. Katherine, 111–12

haziness, 37, 244, 250

HCI (human-computer interface), 120

health: of the body, 145, 148; of boundaries, 187; of monad-body relationship, 221; schizo health (Deleuze and Guattari), 148; of soul-assemblages, 45, 52, 55, 68, 70, 74–75, 117, 128, 136, 140–42, 145, 233, 241–42, 249–51

Heisenberg, Werner, 26

hermeneutics, 90

Herzog, Amy, 138–39

heteromation (Ekbia, Nardi), 120

Hijikata Tatsumi, 146

Hilbert, Martin, 100

Hilbert space, 262n101

Hiley, Basil J., 25, 26, 27, 32, 104, 257n74

Hiley, B. J.

Hilty, Lorenz M., 128

Hirokazu, Kore-Eda, *After Life*, 129

historiography, 207–8, 210, 213–14

history: of Afrofuturism, 195, 201; the Baroque, 28; enfolded, 11, 28–32, 96, 125, 200; fabulation and, 174, 195; haptic

relationship with, 98; natural history, 84; opacity of, 96; of philosophy, 255n58; remixing, 218; sufficient reason and, 95

Hitchcock, Alfred, 222; *Russian Ark*, 236

Hoel, A. S. Aurora, 113

Hoffmeyer, Jesper, 38

Hogeveen, Esmé, 229

Holbein, Hans, *Ambassadors*, 91

holograms (Bohm), 24, 25

homes, 232, 233, 241–42. *See also* apartment living; collectives and community; neighborhoods and neighbors

Hongisto, Ilona, 173

hooks, bell, 108

horror films, 234

hospitality, 187

Hugo of Santalla, 215

human beings, 44; clichés of humanness, 146; cosmos within, 147; vs. non-human actors, 109; as objects, 51–53; as soul-assemblages, 51, 120, 124; souls of matter and, 40. *See also* antihumanism; mediant

human-computer interface (HCI), 101, 117, 120, 121

Hume, David, 173

humor, 93, 108, 142, 167

Hydra Decapita (Otolith Group), 211, *212*

hyper-aesthetics (Fuller, Weizman), 84. *See also* aesthetics

Hyperface (Harvey), 247

icons, as term, 105, 110

ICT (information and communication technologies), 99, 120, 126–28, 136, 137, 138

idealism, 17–18, 68, 109

identity politics, 202

ideology, 108, 110, 149, 151, 154

idiocy, 131–32. *See also* stupidity

images: defined, 6, 78, 79, 81, 113; advertising, 110; affection-image, 176, 177; a-signifying images (Guattari), 112; as capitalism's skin, 107; Captcha, 101, *102*; code and, 112; crystal-images, 174, 184; cultural, 105; in cycle of enfolding-unfolding aesthetics, 79, 80–85, *81*, *82*, *85*, 105–6; Deleuze on, 78; digital, 111; in enfolding-unfolding aesthetics, 80–81, *81*, *82*, 84, 85, *85*, 88; the Figural, 196;

images (continued)

high-resolution, 137, 140; informational images (Elkins), 267n32; interpellation via, 116; low-resolution, 108; vs. memory, 275n43; money translated into, 107; movement-images, 79, 147, 172, 225; neuro-image (Pisters), 81, 130, 147, 172, 272n8; noise unfolded as, 84; operational (Farocki), 112, 113, 248; optical (Benjamin), 113; poor image (Steyerl), 132; programmable (Beller), 112; representation (truthful) and, 193; resistant to unfolding, 89; from ruins (palimpsests), 197–98; suspicion of truthfulness, 193; talisman-images, 147; technical (Flusser), 112; theories of, 79; time-image, 176; unfolding from infinite, 88. *See also* aniconism; information-images; montage

imaginal realm, 193

imagination, 44, 68, 89, 168, 193, 195; algorithmic imaginary (Bucher), 123; archival (Pad.ma), 129; of children, 76; fabulation and, 173, 189

immanence: of affect, 172; of causality, 62; of folded cosmos, 18; of the infinite, 245; plane of, 7, 17, 79, 87, 154, 178, 253n3

immateriality, 41, 119, 126. *See also* materiality

immersion, 137, 138

imperialism, 167, 168

impersonality, 152, 154

implicate order (Bohm), 8, 17, 19, 24–28, 48, 51, 60, 87, 245

In Comparison (Farocki), 103, 105

incompossibility, 66–67, *67*, 165, 166; unfolding from, 90, 192

incompossible worlds, 147

indexes: causality and, 79; vs. consciousness, 10; mediation and, 83; tactile circulation, 79; of technical processes, 112

Indigenous aesthetics, 97, 165–66

Indigenous knowledge, 21, 29, 106

Indigenous land, 232

Indigenous peoples, 51, 69, 93–94, 135

individualism, 51, 179

individuation, 59, 104, 187, 266n12; of electrons, 261n68; of information fold, 107; within technology, 135

industrialization, 71

inequality of present, 54–55

the inessential, 63

the infinite: actualization from, 47; algorithms and, 120; the body and, 21, 147; captured by information technologies, 243–44; as chaos, 80; compression algorithms, 110; connective tissue of, 124, 125; contact with, 120; cosmos as, 7; in diagrams, *82*, *85*; empathy and, 248; in enfolding-unfolding aesthetics, 80–82, *82*, 84–85, *85*, 88; equations for, 65, 263n113; expanding and getting smaller, 10, 80, 86; experience as, 80; experiencing, 49; as formless, 103; images unfolding from, 88; immanence of, 245; information and, 80, 88–89, 121; information as filter for (and part of), 104; information-images and, 86; information's extraction from, 80, 122, 129; information shaping, 102; intensive, 20; lame infinity, 101; in Leibniz's cosmology, 8; living close to, 30–31, 80, 132–33, 204; monad's expression of, 47; pain of, 72; perceiving, 81; quantification, 119; singularities on face of, 55, 58; surface of, 30–31, 32, 80, 96, 105–6, 133, 134, 204, 249, 250; as the unconscious, 47; unfolding from, 88; unfolding from information, 83; unfolding to our point of view, 81. *See also* cosmos

infinitesimal, 63, 90, 138, 143; infinitesimal differences (dx), 48. *See also* microcosm

infinitesimal differences (dx), 48

infinity minus Infinity (Otolith Collective), 35, 70–73, *73*, *74*

information: as term, 99, 103; defined, 83, 108, 266n12; active (Bohm and Hiley), 26–27, 104, 257n74; actualization of, 26–27; always becoming, 104; capital and, 106–9, 129; in diagrams, *82*, *85*; digital images and, 111; as dulling creativity, 121; energy and, 26–27; enfoldedness of, 111; enfolding by, 119–26; in enfolding-unfolding aesthetics, 80, 82–83, *82*, 84, *85*; experience and, 70–71, 99, 101, 125; extractive circulation, 80; as filter, 12, 83, 88–89, 102, 103, 104, 112, 157, 248;

folding, 91, 243, 248; form and, 103; granularity of, 107, 129; history of, 100; human-produced, 100; illegibility and, 132; the infinite and, 80, 82, 88–89, 105, 106, 110, 247–48; life striated by, 133; life vaster than, 100; materiality of, 36, 119, 126–28; monetization of, 204, 219; nodes of, 105; opacity to, 247; patterns of, 58; perception and, 153; politics and, 15; in process, 133; relationality of, 103–4; resistance to unfolding, 249; singularities and, 129; taking the shape of, 121–26; unfolding from, 104–5; unfolds to a point of view, 107–9; volume vs. value, 100. *See also* noise

informational images (Elkins), 267n32

information and communication technologies (ICT). *See* ICT

information capitalism: affect theory and, 148; critiques of, 117; enfolding-unfolding aesthetics and, 12; experience and, 128; fabulation and, 174; the infinite and, 122; mortgages and, 233; resistance strategies, 203–4; vs. the world, 100–101

information economy, 204, 219

information filter, 88–89

information fold, 99–143; capitalism and, 12, 104; clothing and, 106; fabulation and, 173–74; freedom (some) and, 104; granularity of, 129; habits and, 105; historicity of, 107; images circulation through, 82–83; information-images and, 105, 129; manners of unfolding, 109; singularity and, 130; soul-assemblages in, 109

information-images: affective analysis and, 117; computational perception and, 110–13; vs. cultural images, 105–6; information fold and, 105, 129; as language, 111; literature on, 112; as perceptibles, 110; singularity of, 130; stabilization of, 85–86

infrastructure: cosmology of, 124; poverty and, 137; reinforcing, 232–33; small-file movies and, 141–42, 249; soul-assemblages and, 109, 139; as traps, 124. *See also* collapse informatics

Ingold, Tim, 249

The Inheritance (Asili), 228–30, 229, 241

installation art, 118, 190

Institute for Digital Archaeology, 168

intensification: of chaos, 147; of enjoyment, 187; fabulation and, 177; fetishes and, 12; nodes as, 105; time-images and, 176; the virtual and, 31

intensity: collectives and, 191–92; intensive infinity, 20; of small files, 138

interiority: of bodies (feeling of), 235–36, 237, 266n64; boundedness of, 18, 39; infinity of, 11; of monads, 36, 39, 50, 62, 63, 244; movies of, 235–36, 237; of objects, 53–54, 254n17; opacity as gleam of, 57; of soul-assemblages, 62; structure of, 87. *See also* boundaries

intermediality, 71–72, 171, 236–37

International Energy Agency, 267n19

International Workers of the World, 208

internet access, 134, 138, 168

Internet of Things, 128, 134

internet-rights activism, 168

interpellation, 101, 116

intuition, 19, 25, 49, 80, 88, 89, 93, 186

invisibility and visibility, 245

involution, 76

Irani, Lilly, 120

Ireland, 127–28

Irigaray, Luce, 12

Islamic art, 29

Islamic thought, 9, 193, 214, 255n49

Israel, 84, 179, 181, 191

Israeli-Hizbollah war (2006), 179, 181

Isuma Productions, 165. *See also* Kunuk, Zacharias

Ivakhiv, Adrian, 33, 39, 264n14, 264n23

Jackson, Lisa: *Biidaaban: First Light*, 165, 166; *The Visit*, 274n4

Jafa, Arthur, 205

Jankovic, Marek, 248

Jefferson, Thomas, 208, 277n31

JetBlue flight attendant incident, 178–79

La Jetée (Marker), 165

Je veux voir (Hadjithomas, Joreige), 179–84, *181*, *183*

Jevons paradox, 127

Johnson, Mark, 156

Johnson, Robert, 198, 205

May, Beverly, 218–19

May, Derrick, 196, 197, 201, 206, 218–19

McElhaney, Joe, 171

McG, *Charlie's Angels*, 149, 150, *150*, *151*, 152, *152*, 158

McLuhan, Marshall, 142

media: cool vs. hot, 142; as cosmic, 139; distance and, 5–6; environmental footprint of, 136–38; everything is, 78; as mediating, 5–6; soul-assemblages, 138–43

media ecologies, 137

mediant (Appadurai), 45, 50, 241, 250

media soul-assemblages, 138–43. *See also* soul-assemblage

mediation: defined, 78; African knowledges and, 75; by AI, 113; enfolding-unfolding aesthetics and, 6; of labor, 120–21; necessity of, 5; premediation (Gruskin), 86, 113. *See also* enfolding-unfolding aesthetics

meditation, 147

medium: access to, 176; enfolding the world, 6, 171; everything as, 83; immersion in, 138; indexes (Peirce) and, 79, 83; intermediality and, 71; materiality of, 132; soul-assemblages and, 71, 138

membranes: aliveness and, 38, 40; biological processes and, 13; boundedness of, 38, 42; contours as, 247; the outside and, 51; of soul-assemblages, 46–47, 50; in *Parasite*, 234. *See also* vinculum

memes, 25, 130, 132, 138

memory, 101, 275n43; collective, 112, 129; countermemory, 207, 208; seizing hold of (Benjamin), 92; sensing and, 144; technology's inscription, 112; world's memory of souls, 50

Mendonça Filho, Kleber: *Neighboring Sounds*, 36, 237–39, 237, 241; *Aquarius*, 279n23

Merleau-Ponty, Maurice, 148, 171

Meta, 121

metallurgy, 55, 60, 75, 139, 174, 263n123

metaphor, 87–88, 156

methods: affective analysis, 148–59; cartography (Braidotti), 16; enfolding-unfolding aesthetics, 6, 88–89, 107; fabulation as, 36, 159, 174–79; from phenomenology, 153

métissage (colonial hybridization), 28–29

Meu Querido Supermercado (movie, Yankelevich): cosmology in, 3, 4, 5; images from, 2, *3*; "mystery is mystery," 4, 17; obscurity as enfoldedness in, 30; singularities in, 1–2, 55, 60

Micheaux, Dante, 71, 72

microcosm, 1, 9, 13, 20, 27, 41, 67, 72, 77, 92, 118, 144, 207, 224, 230, 244, 250; small-file movies as, 142, 249; soul as, 144. *See also* cosmos

microperceptions, 47, 48; clarity of, 57; vs. perception, 261n70; points of folds and, 57. *See also* perception

Miller, Paul, 217

mind-body dualism, 62, 149, 234

mirror neurons, 155

mirror-touch synaesthesia, 155, 248

Mishlawi, Nadim, 160

model: of cosmos, 10–11, 32–34; of future, 113, 114, 117; vs. metaphor, 87–88

molarity: affective response and, 150–51; of information-images, 111; singularities and, 58–59

molecularity: affective analysis and, 150–51, 159, 177; creativity and, 150–51; perception and, 111

monad: definitions, 10, 20; access to cosmos, 20; amplitude of, 47, 49, 63, 65, 69, 141, 162; artwork as, 146; bodies of, 21, 47, 62, 145, 211, 220, 221, 228, 230–33, 236–39; our body and, 220; boundaries of, 12, 16, 62, 232; car as, 180–81; causality and, 21; consciousness of, 234; cosmos and, 224–27, 243; creating new, 44; data and, 228; death and dying, 76; diagrams of, 39, *40*, *66*, *67*; as difference engines, 63; dominated, 50, 52, 75, 223, 240–41, 260n55, 260n56; encompassing the world, 256n62; experience and, 22–23, 221; expression of cosmos, 20; feeling before perceiving, 171; floor of, 23, 118, 220, 227–28, 232; freedom of, 63–64; God and, 21, 62; ideas as, 41–42; imperfections of, 49; the infinite and, 47, 65; information-monads, 109; interiority of, 36, 62, 63, 227–28, 244; as interruptions (Benjamin), 207; monad-body relation-

ship, 146, 220–21; montage and, 207; movies as, 222; in multiple universes, 66–67; neighbors of, 21, 36, 65, 220–21, 231, 232, 243; organic and inorganic objects in, 50; perception of, 94, 221; perception of world, 21; point of view and, 238–39; political movements as, 95; skepticism about, 222–24; thoughts of, 221; two-floor model, 23; the virtual and, 23; windows of, 23. *See also* Leibniz, Gottfried Wilhelm

Monaghan, Jonathan, 118, 268n62; *Den of Wolves*, 118–19, *119*

Monani, Salma, 69

money, 107, 204, 219

monism, 16–20

montage, 8, 204–7, 213, 219; dialectical, 204

Moore's Law, 127

moralism and morality, 54, 69, 186, 203, 210

Mordvintsev, Alexander, 116

mortgages, 233

Mosireen Collective, 167

Moten, Fred, 53, 70, 261n59

The Mountain of sgaana (Auchter), 165–66, *166*

move (political organization), 228, 230

movement-images, 79, 147, 172, 225

movies as soul-assemblages, 138–39

moving-image media, toxicity of, 139–40

Mroué, Rabih, 180, 181, *181*, *183*

mysticism, 19, 46, 86, 92, 193

Mullā Ṣadrā, 214; on being, 260n40; Bohm's cosmology and, 17; on existence, 253n8

Mullik, Gopalan, 275n27

multiplicity, 46, 58, 261n72

multitude, 66–67

multiverse. *See* many-worlds theory

"Mundane Afrofuturist Manifesto" (Syms), 212. *See also* Afrofuturism

Munster, Anna, 104, 112, 113

Murray, Timothy, 171

museums, 97

music: African-diaspora makers in, 54, 195; apartment living and, 230; beats in, 196; blues, 54, 198; disco, 196–97, 218, 276n7; dissonance, 65; electronic, 140, 208, 218; new genres, 54; open cosmos and, 64–65; recommendation algorithms,

124; refrains, 84; relaxing, 140; rhythm of the infinite, 60; from Romantic period, 154; sampling, 217–19; techno, 196–97, 206, 211, 218–19. *See also* Afrofuturism; songs and singing

Mysterious Object at Noon (Apichatpong), 188–90, *190*

mystery: compression of timespace and, 143; eternity as, 4; in the information fold, 132; of interiority, 57; "mystery is mystery," 4, 17; myth as, 164; of objects, 53; *Mysterious Object at Noon* (Weerasethakul), 188–90

mythology, 164, 211

Nail, Thomas, 19, 33, 45, 258n93

Nardi, Bonnie, *heteromation*, 120, 136

narrative, 189, 215; vs. (molecular) affect, 150–51, 158, 177; falsifying, 180; folded, 165–66; nonlinear, 71, 215

natural selection, 187

Navas, Eduardo, 218

Ndalianis, Angela, 171

Negri, Antonio, 58

neighborhoods and neighbors: in apartment living, 81, 230–31; arguments among, 225, 233; of being, 40; as monads, 222; of monads, 21, 26, 221–23; of plants, 48; relations among, 225, 231, 232, 233, 242; soul-assemblages of, 241–42

Neighboring Sounds (Mendonça), 36, 237–39, *237*, 241

Nelson, Alondra, 276n1

neoliberalism, 154, 179, 239–40

Neoplatonism, 9, 33

Netflix, 124

neural networks, 114, 116

neuro-image (Pisters), 81, 130, 147, 172, 272n8

new materialism, 18, 152, 223

New Media Gallery (British Columbia), 268n62

Nicholas, Nichelle, 208

Nichols, Bill, 173

Nietzsche, Friedrich, 172

Night Raiders (Goulet), 274n4

al-Nimr, Samir, 126

noise, 59, 84, 91, 116, 135. *See also* information

nonhuman entities, 40, 41, 84, 109, 119, 144, 169, 241
nonlinear dynamics, 60, 64
nonlinear structure, 72
non-organic vs. organic, 50
non-representational thought, 153
novelty, 76, 254n34
Now Eat My Script (Al Solh), 159–62, *161*, *162*

Oakley, Hilda, 256n58
objectivity, 95, 152, 160, 188, 189, 237, 272n9
object-oriented ontology, 53–54, 254n17, 258n3. *See also* ontology
objects, 11, 119, 188; as collectives, 53; corporate control of, 119; creativity of, 96; edge recognition, 248; as fetishes, 12; history of, 15, 83; human beings as, 52–54; as indexing, 83; interior infinity of, 254n17; performativity of, 53; as static, 11; as subjects, 52–53; unfolding, 96; witnessing of, 145
occult arts, 215–16
Ocean's 11 (Soderbergh), 171
oil, 40, 93–94, 127, 137, 167, 206, 267n19
oneness, 18
One Thousand and One Nights, 164
Only the Beloved Keeps Our Secrets (Abbas, Abou Rahme), 190–92, *191*
ontology, 16, 87, 223, 249; object-oriented ontology, 53–54, 254n17, 258n3. *See also* Bohm, David; Leibniz, Gottfried Wilhelm; Ṣadr al-Dīn al-Shīrāzī
opacity (Glissant), 15, 31, 39, 54, 70, 96, 97, 250; of history, 96; informatic (Blas), 247; leaving images enfolded, 89; monads and, 207; as mysterious interiority, 57; of non-extractive unfolding, 135; of reification, 12; unfolding and, 96–97, 184. *See also* aniconism
open cosmos, 61–68, 91. *See also* cosmos
operational images (Farocki), 112, 113, 248
optical image (Benjamin), 113
optical vs. haptic, 237
Orchestre Symphonique Kimbanguiste, 225
organic vs. non-organic, 38, 50
organocentrism, 38–39
O'Sullivan, Simon, 146–47

Otolith Collective: fabulation in practice, 72; *Hydra Decapita*, 211, *212*; *Otolith II* and *III*, 166. *See also* infinity minus Infinity
Otolith II and *III* (Otolith), 166
the outside: affect as connecting with, 76, 152, 151, 177, 179; body/matter on, 19, 62, 171, 228, 243; center outside the territory, 77; vs. inside, 10, 11, 16, 52, 223, 231–33; knowledge from outside, 39, 53, 97, 99; noise (from the), 91. *See also* boundaries; vinculum

Pad.ma (archive), 129
painting, 91, 147, 156, 197
Pakistan, 126
Palestine, 190, 191–92. See also *Only the Beloved Keeps Our Secrets*
Palmyra (Syria), 168–69
Pandian, Anand, 11, 145
panopticon, 121
Pape, Toni, 189
paranoia: corporate animism (Steyerl), 268n55; information-images and, 117; in moderation, 35, 100–101, 104, 133–35; about neighbors, 231
Parasite (Joon-ho), 234
pareidolia, 116
Parisi, Luciana, 116
Parks, Lisa, 109
Parliament Funkadelic, 194, 196, 208, 211, 276n7
Pärt, Arvo, 225
particles, 3, 8, 25, 26, 27. *See also* electrons
Pasolini, Pier Paolo, 189
passivity, 23, 176, 224
the past: Benjamin on, 199; in film-assemblages (Herzog), 139; inaccessibility of, 125; photography and, 204; unfolding from, 166, 207; virtuality of, 215, 264
Patel, Hetain, 166
patience, 17, 92–93, 156, 184, 204
patterns, 29, 58, 105, 246; moiré, 105
Peele, Jordan, *Us*, 120, 234
Peirce, Charles Sanders: aesthetics, 147–48; argument, 110; cosmology of, 86; Firstness, 84, 152, 155, 179, 272n20; habit, 16,

42, 86, 153; indexicality, 10; interpretants for, 38, 152, 273n25; on matter, 7, 16; on objects, 10; perception and, 110; Secondness, 84, 152, 155, 157, 179, 272n20; semiotic process, 79, 84, 86; synechism, 79, 254n14; Thirdness, 84, 152, 155

pension plans, 250–51

perceptibles, 6, 110. *See also* Secondness

perception: affect and, 221; in affective analysis, 152–53, 157, 160; algorithms and, 100, 111; amodal (Stern), 155, 157, 272n20; the body and, 157; computational, 113; to concepts, 157–58, 247; as confused and clear, 57; conventions and, 157; diagrams of, *81*; easing up, 116; before feeling, 171; feeling before, 171; habit and, 153; human, 113; of the infinite, 88; of infinitesimals, 48; information and, 106, 153; institutions controlling, 111; machine, 112, 116; vs. microperceptions, 261n70; from microperceptions to clear perceptions, 47; of monads, 94; phenomenology of (Merleau-Ponty), 148; from a point of view, 149; as protective, 149; research to inform, 110; selective, 47; as soul-assemblages, 113; thought and, 17–18; training, 144–63; unconscious, 47; unfolding from infinite, 81, 134. *See also* prehension

perfection, 186; copies as perfect, 124; of dominating monad, 240; of God, 49, 200; imperfection, 13, 49; the infinite and, 13, 14; of monad and the outside, 181; perfectibility, 49; of symmetry, 46; of the universe, 240

Perniola, Mario, 91, 92–93, 96, 118, 197

perspective, 47, 88, 171; of monad, 22–23, 222, 224; Renaissance and Baroque, 91

Pesic, Peter, 261n68

Pethő, Ágnes, 71, 171, 236–37

phonography, 210

photogénie movement, 113

photography: activism and, 268n72; from archives, 204, 207–8; bodily responses from, 204; computational, 116; deletions of, 268n72; seeing of, 113; surveillance and, 123; as technical image, 112; in *Last Angel*, 204, 207–8

physiosemiotics, 38. *See also* Peirce, Charles Sanders; semiotics and semiosis

Pi, Ana, 71

pipelines, 93–94

Pisters, Patricia, 68, 147, 172

pixels, 43, 103, 108

plagiarism, 218

plane of consistency (Deleuze and Guattari), 49, 259n35

plane of immanence, 7, 17, 79, 87, 154, 178, 253n3

plants: *akub*, 191; as cosmic, 75; disquiet of, 48; fabulation and, 167–71; monad's body and, 231, 233; souls of, 55; territorialization and, 77; witnessing of, 144; in *Only the Beloved*, 140, 190

plastic, 42–43, 75

Plato, 193

play, 188, 190

pleats, 19, 27, 30, 90

plenum, 7, 20, 220, 232

Poe, Edgar Allan, 122

poetry, 101, 130–32, 216

Poincaré, Raymond, 66

point of view: antivaxxers unfolding from, 95; in the Baroque, 91; of camera, 237–38; cosmos and, 85, 144; in diagrams, *81*; of digestion, 236; information to a, 107–9; interestedness of, 82; of matter, 40; objective vs. subjective, 189; secret, 91; subjecthood and, 21; unfolding and, 20, 81, *82*, 83, 85, 90, 95, 96, 128–29; uniqueness of, 8. *See also* perspective

police: brutality, 43, 70, 72, 228–29; phone surveillance by, 126

politics: of appropriation, 52; in Egypt, 126; of fabulation, 184; of folds, 69–74; political movements, 75, 95; prepolitical power, 175, 176; of representation, 202; the senses and, 84; of soul-assemblages, 250–51; soul of, 44; of unfolding differently, 107

poor image (Steyerl), 132

pornography, 89, 121, 141, 271n137

possession, 50–51, 171, 210, 241

possible future worlds, corporate media's shaping, 113

post-cinematic affect (Shaviro), 116–17

powerlessness, 182, 192, 199

powers of the false, 36, 172–79, 182, 210

Poynter, Beulah, 205

predicates and predication, 11, 50–51, 63, 240, 253n8

prediction, 9, 26, 104, 111, 113–14, 116, 124, 127, 152, 153; predictive algorithms, 113, 116

preemption (Massumi), 113

prehension, 13, 41, 47, 50, 62, 64, 254n16. *See also* perception

premediation (Grusin), 86, 113

prepolitics, 175, 176

Priest, Eldritch, 84

privacy, 132, 220, 221, 227–28. *See also* monad: interiority of; opacity

privilege, 54, 55, 69–70, 186, 210, 237–38

process: of actualization, 254n34; boundary creation and, 42; cosmology, 9; fetishism as enfoldment of, 12; God replaced by, 62; philosophy, 11, 16–17. *See also* Whitehead, Alfred North

programmable images (Beller), 112

progress narratives, 198–99, 202, 204, 207, 214; cosmos and, 9, 85–86; soul-assemblages and, 45

property ownership, 50, 233m45, 237, 241–42

protests, 93–95

Przedpełski, Radek, 143, 269n93, 277n40

psychoanalysis, 12, 144

Public Enemy, 217

Pylkkänen, Liina, 256n66

al Qadiri, Monira, 167

qi (vital energy), 156, 245

qualisigns (Peirce), 110

quantification, 106–7, 111, 112, 119, 129

quantum entanglement, 25–26, 27, 33–34, 37

quantum field, 19, 25, 26–27, 104, 257

quantum physics, 24, 25–26, 33, 68, 262n101

Quantum Solutions for Everyday Problems (Sorenson), *34*

Rai, Amit, 137

rain, 10–11, 55, 186, 245

Rancière, Jacques, 236–37

Rangan, Pooja, 79, 173

Raqs Media Collective, 166

Raskin, David, 153

Ray, Satyajit, *The Alien*, 166

reactivity, 149, 153, 176

reading room (monad's), 23–24, 36, 227–30, 239, 241, 244

realism of enfolding-unfolding aesthetics, 17

reality: vs. algorithmically produced worlds, 100; "beables" (Bell), 26; cinema's *bizhen*, 113; experience and, 22, 223; images becoming more real, 79; in monism, 17–18; uncertainty principle, 25

reason: and love (Peirce), 86. *See also* sufficient reason

Reductress (magazine), 123, 278n3

Reel Green (sustainability initiative), 140

regulation, corporate and government, 14, 15, 100, 134, 203, 250–51

reification, 12, 108

Relation (Glissant), 30, 54, 69

relational becoming, 53

relevance, 108, 215; in unfolding, 69–70, 95, 173

remarkableness, 94, 146

remix, 90, 129, 172, 217–19. *See also* sampling

renewable energy, 127–28

representation: affective analysis and, 153; conceptual analysis and, 149; creativity and, 182; critique of, 202; dualism, 84–85; fabulation and, 174, 175; imaginal realm and, 193; as judgment, 175; of marginalized cultures, 188; mimesis as, 30; non-representational thought, 153; politics of, 182, 186; truth and, 160, 193; withdrawal of, 180

repression, 31, 51, 69, 94, 115, 119, 157, 188, 232, 240

resistance: to actualization, 89; aesthetics as, 243; to appropriation, 182; creative, 134; information capitalism and, 203–4; to instrumentality of information, 122; to surveillance, 101, 246–47; to unfolding, 89, 96, 248

resolution, 108, 121, 137, 140. *See also* low resolution; Small File Media Festival

respect for fossils (also disrespect), 44, 139
rhemes (Peirce), 110
rhizomes, 61
rhythm, 92, 146, 191; in affective analysis, 155; of body, 145, 146; of breathing, 145; cinema, 145, 205; of dance music, 196; of fabulation, 192; of flows, 92; of history, 207; of the infinite, 60; of montage, 205; of unfolding, 92, 134, 244; in *Last Angel*, 196. *See also* microcosm
Richter, Gerhard, 147
Riemannian theory, 45, 58, 59–60, 87, 130, 261n72
Riesewick, Moritz, *The Cleaners*, 121–22, *122*, 268n72
Rio, Elena del, 150, 158
ritual, 211
Rivera, Javier de, 135
Roach, Andrew, *Expedition Sasquatch*, 108
road-trip genre, 179–84, *181*, *183*, 188–90, *190*
Roberts, John, 259n16
rocks, 40, 41, 55, 254n21
Rødje, Kjetil, 138
Rohrwacher, Alice, 222
ruins, 197–99, 202
Ruskin, John, 211
Russell, Bertrand, 255n56
Russian Ark (Sokurov), 236
Russo-Ukrainian War, 101–2, 127
Rutherford, Anne, 245, 246, 248
Ruyer, Raymond, 10, 254n13
Rybin, Steven, 173–74

al-Ṣādiq, Jaʿfar, 98
Ṣādr al-Dīn al-Shīrāzī, 214; on being, 253n8, 260n40; Bohm's cosmology and, 17
safety: of archival materials, 167; boundaries and, 48; of folds, 90, 96; protective perception, 149, 153; in *The Inheritance*, 228. *See also* aniconism; boundaries; monad: interiority of
Sagar, Anjalika, 211
sampling, 100, 217–18, 219. *See also* remix
Sandrich, Mark, *Top Hat*, 246
Saouli, Abdeljalil, *Stonesound* (with Aubry), 40, *41*
Schafer, R. Murray, 218

Schäffner, Wolfgang, 18
Scheinert, Daniel, *Everything Everywhere All at Once* (Kwan and Scheinert), 67, 68
Schipper, Sebastian, *Victoria*, 236
schizophonia (Schafer), 218
Schrödinger, Erwin, 25, 262n101
Schuppli, Susan, 145; *Material Witness*, 84
Schwebel, Paula, 92
science fiction, 164, 189, 195–96, 204
scientific discourse, 27–28, 61
Seaver, Nick, 124
Secondness (Peirce), 84, 152, 155, 157, 179, 272n20. *See also* actualization
secrets, 91, 101–2, 234
Seigworth, Gregory J., 153–54
self: -actualization, 54; affect turning inside out, 148; -annihilation, 46; Arab sense of, 182; care of, 136; -creation, 60; -organization, 20, 60; -proximity, 254n13; -sufficiency, 128
Sembène, Ousmane, 204
semiotics and semiosis, 38–39, 78, 79, 108, 111, 157. *See also* enfolding-unfolding aesthetics; Peirce, Charles Sanders
sensation, 118, 138, 151, 177, 236–37
senses, 13, 277n30; in affective analysis, 157; apartment living and, 230–31; close (touch, taste, and smell), 83, 110, 153, 167; in enfolding-unfolding aesthetics, 83, 88; fabulation and, 177; information and, 101; nonhuman sensing, 84, 144–45; politics and, 84; vs. proof, 92; training, 144, 177, 243; the virtual and, 6; as world-making, 153. *See also* haptic
September 11 attack, 122–23
Sequeira Brás, Patricia, 239–40
Serres, Michel, 242
servers. *See* data centers/servers
sexuality, 150, 187
Sha, Xin Wei, 59–60
Shaffer, Deborah, *The Wobblies*, 208
Shanghai Express (Sternberg), 245–46
Sharjah Biennale (2016), 167–68
Shaviro, Steven, 116–17, 254n34
Shawamreh, Yusuf, 191
Sherman, Tom, 121
The Shift Project, 271n133, 271n137
shock doctrine (Klein), 73

signification. *See* information; semiotics and semiosis; signs

signs: generally, 78, 264n4, 264n11; a-signifying images (Guattari), 112; cultural signs, 79; Deleuze on, 78; molar, 111; semiosis and, 79, 110, 111, 264n4; Saussurean semiotics, 264n11

Simondon, Gilbert, 19, 27, 45, 104

singularities, 61, 93; defined, 55; actualization of, 57, 58, 60; in affective analysis, 157; art practice and, 59; autopoiesis of, 60; in calculus, 57–58; causality and, 55; collectives organized by, 57; decay and, 59; diagrams, *57*; of events, 56; examples, 55, *56*; fabulation and, 173; humor of, 93; identifying, 35, 56–57, 61; information fold and, 130; molar-scale space and, 58–59; as points of folds, 60, 96; topological theory and, 58, 60; unfolding, 57, 82–83; vs. uniqueness, 132; in infinity minus Infinity (Otolith Collective), 72; in *Meu Querido Supermercado* (Yankelevich), 2

sinsigns (Peirce), 110

siren servers (Lanier), 114

al-Sisi, Abdel Fattah, 126

Slavers Throwing Overboard the Dead and Dying—Typhoon Coming On (Turner), 211

slavery, 51; chattel, 53, 55; denunciations of, 208; the great refusal and, 192; ledgers, 70–71; monadology and, 234. *See also* enslaved people

sleeping, 116, 181–82

small-file media, 137–38, 141–43, 248–49. *See also* Small File Media Festival

Small File Media Festival, 141–42, *143*

small-footprint aesthetics, 137, 138. *See also* aesthetics; Small File Media Festival

smallness: freedom of monads and, 63; of the infinite (increasingly), 10, 80; small folds (drawing out), 90

smiling, 156

Smith, Daniel W., 21, 265n31

Smith, Terry, 105

smoke, 245–46, 250; as new light, 244

smooth space, 12, 58, 249

SMRN (Substantial Motion Research Network), 277n40

Snowdon, Peter, 167

Sobchack, Vivian, 156

social class, 36, 70, 71, 73–74, 199, 222–23, 233–35, 237–38, 239–40, 241

social media, 112, 247

Soderbergh, Steven: *Logan Lucky*, 234–35, *235*, 241; *Ocean's 11*, 171

software, 121, 135, 136, 168; compression, 248; dictation, 130–32; edge-recognition, 248–49; open-source, 136, 168. *See also* algorithms

Al Solh, Mounira, *Now Eat My Script*, 159–62, *161*, *162*

songs and singing, 1, 2, 23, 65, 142, 189. *See also* music

Sorenson, Natalie, *Quantum Solutions for Everyday Problems*, 34

Sorry We Missed You (Loach), 121–22

soul: definitions, 20, 34–35, 39, 227–28, 243; of algorithms, 128; of autopoiesis, 42; bodies of, 221; boundaries of, 39, 41; as capacity of body, 20, 41; of cities, 44; of compression, 249; of the damned, 49; of data, 128; in diagrams, 39, *39*; of documentary cinema (Hongisto), 173; fossils of, 40; hierarchies of, 49–50, 74; of ideas, 41; immortality of, 50; information fold and, 107; interiority of, 39; for Leibniz, 23–24; as microcosms, 144; naming, 43–44; not allowed to expand, 49, 51; processes creating, 42; as reading room (Leibniz), 23–24; rebellious souls, 53; what a body can do, 20, 41. *See also* monad

soul-assemblage: definitions, 22, 35, 45; activism and, 75, 250; affective analysis and, 157; Afrofuturism and, 44; artworks as, 59; bodies as, 221; boundaries of, 37, 46–47, 50, 77, 102–3, 251; collectives and community and, 243; computer-based media as, 128; cosmos and, 74–77, 140, 242, 244; death and dying and, 221; deterritorialization through, 45–46, 75; environmental degradation and, 145, 250; examples of, 40, 133; fabulation and, 75, 76; forest fires as, 250; Freedom Convoy as, 94; and great refusal, 77; health of, 45, 52, 55, 68, 70, 74–75, 117, 128, 136, 140–42,

145, 233, 241–42, 249–51; human-machine, 120, 124; interiority of, 62; involuting, 76; lines of flight of, 77; media, 138–43; nonconsensual formations, 117; objects (appearance as), 53; organization of, 59–60; perception as, 113; political movements as, 75; reshaping, 68; (de)territorialization and, 249; unfolding from cosmos, 102–3; unhealthy, 55, 117, 136, 140, 142. *See also* assemblage; collectives and community
sound, 39–40, 191, 196, 230
South Asian Futurism, 166. *See also* futurism
spectacle, 105, 106
Spencer (Larrain), 173–74
Spencer, Diana, 173–74
Spinoza, Baruch, 13, 16, 35, 95, 145, 148, 153, 156, 179, 254n34, 273n31
Spotify, 123, 124
spreadsheets, 120
Stalder, Felix, 105
standardization, 103
Starosielski, Nicole, 109
Stengers, Isabelle, 55, 61, 215
Stern, Daniel, 155, 272n20
Sternberg, Josef von, *Shanghai Express*, 245–46
Stewart, Kathleen, 152
Steyerl, Hito, 116, 132, 268n55
Stiegler, Bernard, 112
Stonesound (movie, Saouli and Aubry), 40, *41*
storytelling traditions, 164, 165–66
strategic enfoldment, 97–98. *See also* enfoldment
streaming media, 139–40
Strickland, Lloyd, 240, 259n32
Strong, Amanda, *Biidaaban*, 274n4
structure, 48, 60, 72, 91; interior, 16, 27, 64; narrative, 71, 72, 91, 217; of universe or infinite, 24, 32; of virtual, 8, 17, 48, 58, 60, 87, 132, 244, 245, 249
Stubblefield, Clyde, 219
stupidity (Deleuze), 61, 69, 92, 130, 132
style in manners of unfolding, 91–93, 134, 244
subjecthood: cosmos and, 109; humanism and, 210; as illusory, 279n14; individual-

ism and, 51; for Lacan, 279n14; liberal, 51, 54; machine learning and, 109, 136; of objects, 53; point of view and, 21; subjection and, 51
subliminal montage, 202, 206–7, 208. *See also* montage
Subramanian, Kalpana, 145
Substantial Motion Research Network, 277n40
sufficient cause (Leibniz), 63
sufficient reason (Leibniz), 11, 21, 27, 95, 224, 266n58
Sufism, 193, *See also* mysticism
Sun Ra, 164, 195, 210
Sun Tzu, 92
superfolds (Deleuze), 104. *See also* Deleuze, Gilles; folds
surprise, 92
surveillance, 101, 123, 124–26, 191; cameras, 5, 121, 191, 246; capitalism, 111; data extracted from, 99, 100; enfoldment and, 97, 125; *Meu Querido Supermercado* (Yankelevich), 4, 5; in *Only the Beloved*, 191
suspension in enigmatic action, 93
Swartz, Ellen E., 209
symptomology, 90
Syms, Martine, 68, 212
synaesthesia, 155, 248
synechism (Peirce), 79, 254n14
Syrian civil war, 101, 159, 160, 168
Szernyznski, Bronislaw, 42

Tackling the Carbon Footprint of Streaming Media (research group), 271n133
Tahrir Uprising, 75, 167
Taiwan Semiconductor Manufacturing Company, 43
talismans, 129, 147, 217
Tanaka Min, 146
Taoist cosmology, 32
taqīyya (strategic concealment), 98
taxes, 70, 128
technical images (Flusser), 112
technophilia (Eglash), 137
Teh, David, 188
teleology, 86. *See also* progress narratives
television, 97, 100, 142

temporality and time: in affective analysis, 151–52, 154; deep time (unfolding), 213–17; in diagrams, *85*; in *?E?anx/The Cave* (Haig-Brown), 165; in enfolding-unfolding aesthetics, 85, 98, 99, 106, 144; folded, 165; in implicate order (Bohm), 8, 24; matter as duration (Bergson), 17; in *The Mountain of SGaana* (Auchter), 165–66; of painting, 156; remix and, 218; in Riemmanian manifold, 87; synthesis of (Deleuze), 272n8; time ahead (*masa depan*, Malay), 115; unfolding the past, 68; wave functions and, 24

territory and territorialization, 42, 74–75, 77, 231, 249. *See also* deterritorialization

terrorism, 122–23

Tesfaye, Gabrielle, *The Water Will Carry Us Home*, 211–12, *213*

texture, 5, 67, 98, 139, 159, 171, 236, 246. *See also* granularity; molecularity

Thales, 214

theater: Butoh performance, 146; of cruelty, 145, 263n118

theater of cruelty, 145, 263n118

things (Latour), 44

Thirdness (Peirce), 84, 152, 155

thought, 16, 17–18, 159, 273n31

Tiananmen Square massacre, 101

TikTok, 128

time-images, 176, 225

Tohme, Christine, 167

Top Hat (Sandrich), 246

topological theory, 58, 95, 261n72. *See also* manifolds

torture, 31, 121, 125–26

torus, 58, 264n23

Toscano, Ignoto, 156

Toufic, Jalal, 97, 168, 180, 199

toxicity: of moving-image media, 139–40; soul-assemblages, 55, 117

Tracking Transience (Elahi), 122–23

tradition, withdrawal of (Toufic), 97

transcendence, 51, 196–97, 224, 243

trauma, 65, 70, 96, 122, 160, 161, 162–63

true-cost accounting, 100, 107, 129, 134, 203, 250

truth: cinema and, 204–5; desire for, 182; embodied responses and, 147; fabulation and, 172; futurism's rejection of, 172; for

Leibniz, 228; as manner of unfolding, 93–95; Nietzsche on, 172; in representation, 160, 193; as self-evident, 164; status quo and, 210

Tucker, Keith, 201

Turner, J. M. W., *Slavers Throwing Overboard the Dead and Dying—Typhoon Coming On*, 211

Twitter, 121

Uexküll, Jacob von, 221

Ukraine, Russo-Ukrainian War, 101–2, 127

uncertainty principle, 25

unconscious: fabulation and, 177; faces imaged by, 116; geometry in, 217; ideological interpellation and, 116; as the infinite, 47; origins as term, 259n32; perceptions as, 47; signifier/signifier in, 268n63; in *Neighboring Sounds* (Filho), 239. *See also* microperceptions

Undercommons (Moten and Harney), 70, 135. *See also* the Commons

unfolding, 81, 93, 144, 243; as term, 8; abstract line and, 249–50; actualization through, 88, 89–90; as aesthetic practice, 144; affect of, 6, 57, 94, 176; anamorphosis, 91; in Black science fiction, 195; the body and, 93; under capitalism, 243; from cosmos, 144; from databases, 202–4; decisions about, 68, 92, 250; differently, 35, 56, 58, 59, 61, 68, 69–70, 76, 91, 99, 107, 113, 128–36, 148, 168, 172, 173, 175, 184, 212, 250, 251; fabulation and, 90, 172, 173; from fragments, 195; haptic space and, 249–50; historiography as, 214; human-machine vision and, 113; imperialist ways of, 168; manners of, 89–91; methods for, 98; new embodiments, 196–97; non-extractive, 134–36, 203–4; point of view and, 20, 90; as remix, 217–19; resistance to, 96, 199–201; from ruins, 197–99; selective perception and, 47; strangers, 15. *See also* the fold; manners of unfolding

uniqueness, 132, 134, 222, 250, 251, 266n12

the universe, 86, 240, 264n23; "universe fiber" (Deleuze and Guattari), 46–47

univocity of being, 9, 18, 19, 253n8